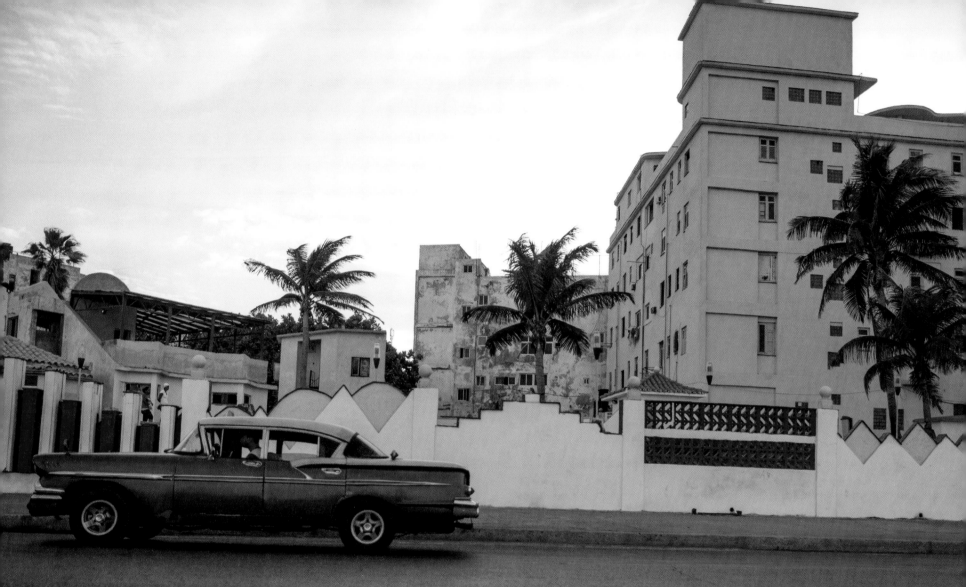

REEF LIBRE

FOR THE CUBA CREW: Fausto, Israel, Octavio, Manuel, Delphin, Pepe, Amarilla, Miguel, Manuel, Pablo, las juterias y iguanas, los cangrejos hermitaño y los peces pequeños y grandes—sisters and brothers in the bond of the Reef Revolution. As *Celebrity Deathmatch* referee Judge Mills Lane put it most succinctly in decadent terms: "Let's get it on!"

Published by Taylor Trade Publishing
An imprint of The Rowman & Littlefield Publishing Group, Inc.
4501 Forbes Boulevard, Suite 200, Lanham, Maryland 20706
www.rowman.com

Unit A, Whitacre Mews, 26-34 Stannary Street, London SE11 4AB, United Kingdom

Distributed by NATIONAL BOOK NETWORK

British Library Cataloguing in Publication Information Available

Library of Congress Cataloging-in-Publication Data Available

ISBN 978-1-63076-073-1 (cloth: alk. paper)
ISBN 978-1-63076-074-8 (electronic)

The paper used in this publication meets the minimum requirements of American National Standard for Information Sciences—Permanence of Paper for Printed Library Materials, ANSI/NISO Z39.48-1992.

Printed in the United States of America

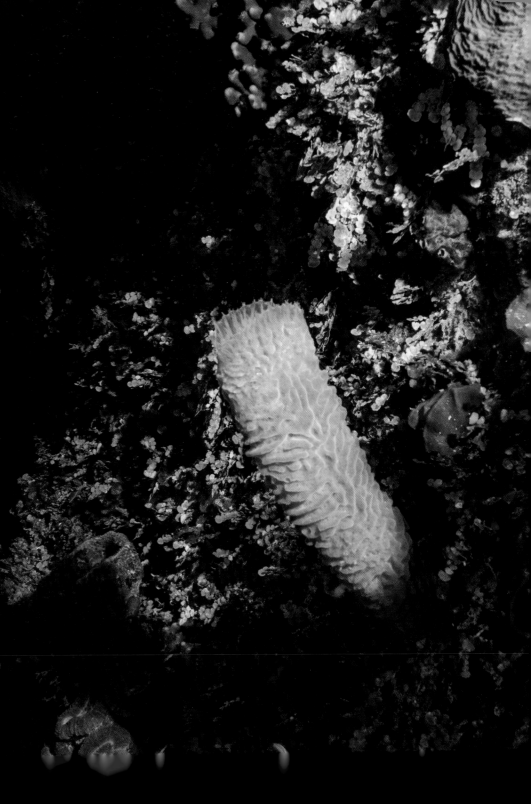

The Last, Best Reefs
in the World

REEF
LIBRE

ROBERT WINTNER

TAYLOR TRADE PUBLISHING
Lanham · Boulder · New York · London

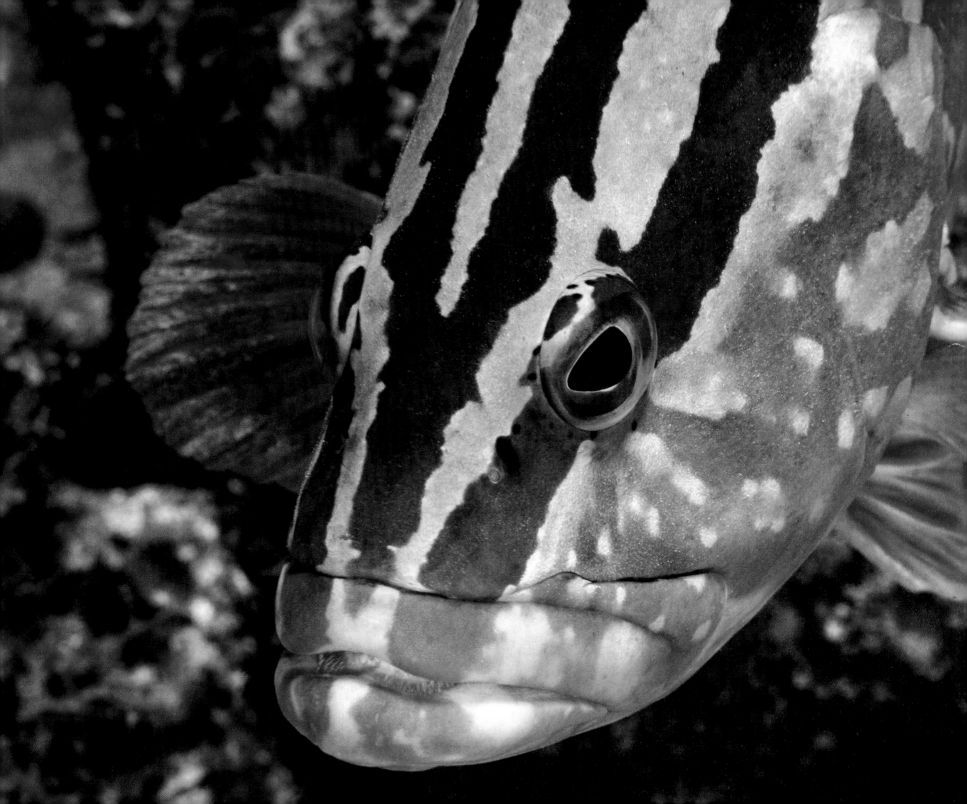

CONTENTS

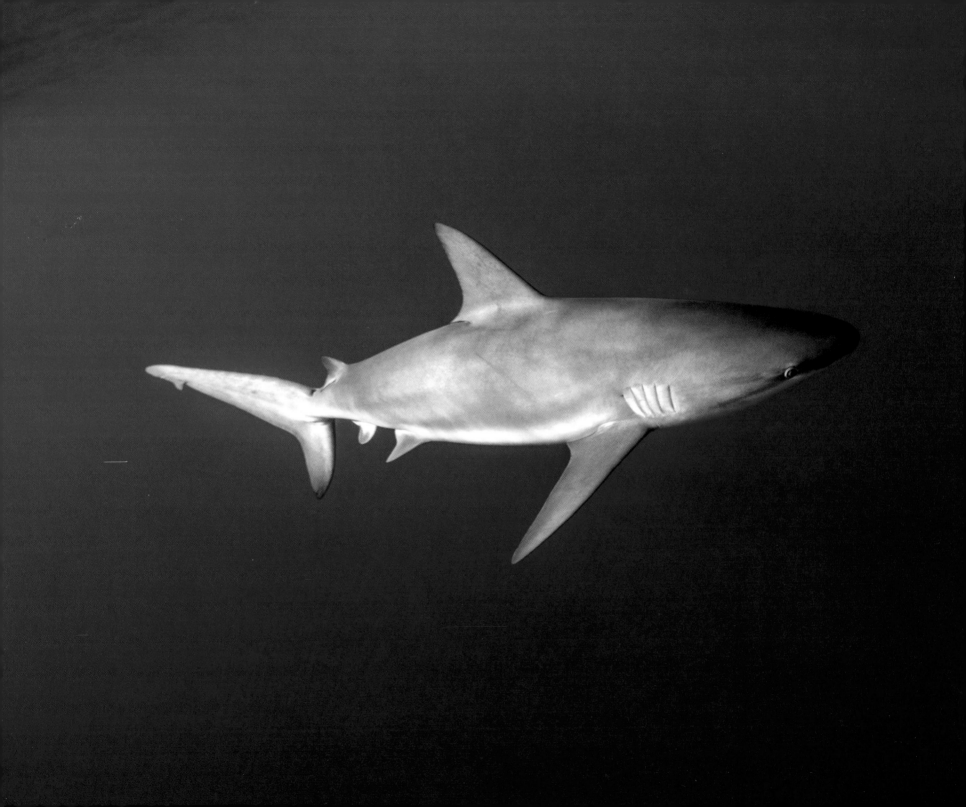

REEF LIBRE

Most travel is now formatted on brochures or ads as "Eco," so you can sense adventure and a solution at hand for what ails the world. Adventuring is now led by pros and rendered "safe," but the seasoned traveler can still begin initial descent to Havana and ponder fickle destiny. How could anybody live here? How did this happen? Will it be dangerous at street level, or even getting through the airport? Will I encounter mystery or a dramatic turn of events? Will I meet a stranger or stroll into circumstance?

Will I return to this place? Or even make it home?
What do they see at ground level, looking up?
Do they still look up?

The jetliner drops below the clouds with no shudder or jolt, and it feels amazing, with no help from the FAA. That's a laugh, a short one as Cuba firma reveals a deserted landscape with no clutter, which isn't the same as wilderness but has no roadways knotting the countryside, no lights, few buildings, sparse traffic. Details fill in as more key components of the modern world are left out—clarity comes on with conspicuously open spaces, with an absence of stuff. Country roads, fields, pastures, sparse living compounds, and little else to mar the natural beauty render feelings of rejuvenation and intrigue. Cuba is not a tourist display like Williamsburg or Disneyland; instead of plastic replicas, gingerbread adornment, and period costume, the time warp in Cuba has no props. The antiquated life and accoutrements are real, original equipment.

Most travelers subliminally know—wherever they go—what it might take to get home in a pinch. But distance in miles and logistics seems miniscule compared to Cuba's disjunctive present. Cuba's past and future merge to a single tense, and from a few hundred feet up, it seems oddly classic.

Deprivation in a police state as dictated by one man and his brother sinks in soon enough. Immigration is straightforward: "Look up, sir. Into the camera. Please, sir. Do not smile." Customs too would be a breeze, albeit stiff and chilly, even with a fifty-pound trunk filled with underwater camera housing, strobes, arms, batteries, ports, synch chords, rechargers, backups, and the like. Another fifty-pound dive bag on wheels filled with scuba and snorkel gear and two personal carry-ons heavier than most, filled with cameras and lenses, made for a profile.

The unfortunate machismo factor can bear down in any place, especially a Latin American place. We divvied the luggage, but my travel companion, *mi esposa*, is petite, blonde, and, well, female; complications ensued. Or rather they struck in the form of a tall, armed, uniformed man who glared at her and accused, "You. Stop. Here."

Long story short—and it was long, painfully, frightfully long, with a specter of indefinite containment in a Communist country at odds with the U.S.: no customs official would speak to or look at Anita once she was told to stop. For two hours she stood there as if invisible, unable to get a response. The rest of the expedition party waited outside, forbidden to reenter. Two adult, English-speaking males offered commiseration. One encouraged me to slip back in when the guard looked away. I asked him to join me. His eyes rolled back, like I'd asked him to jump off the ninety-fifth floor. The scene felt tiresome after

twenty hours of travel, and it felt threatening, in a Third-World Communist version of fear and loathing, call it fear and entropy, without initiative, without hope. The scene was wrong but nobody could fix it, so we waited another hour, stuck like a big corporation losing money and fooling the stockholders, like Enron or Citibank or AIG or the rest of the too-big-to-fail group. Cuba felt like that on arrival, like a giant, meandering hierarchy trickling to nowhere on a vague concept presented long ago by a long-since-faded CEO—like a failure, though this one has military backup.

O'er the ramparts we watched. . . .

I waited for the guard to turn away on his next attempt to control the crowd yonder, and I slipped back in—where two armed officers interceded immediately with no uncertain terms. So I explained, "*Es mi esposa alla.*" It's my wife over there.

"Get out."

An hour later a younger but equally severe armed officer finally responded to her plea, by that time conveyed with sincere fatigue and failing posture. In marginal English, Luis allowed the suspect carry-on to be lifted onto an examination table and opened. *¡Caramba!* This is not tourist camera equipment! This is . . . professional!

The word *professional* is most often enjoined in English-speaking countries to indicate a level of competence or standard of merit. While that connotation is widely accepted, the denotation of *professional* is that payment is rendered for services. *Professional* differs from *amateur* in critical essence. Payment for services reeks of self-enrichment, that hateful human behavior common to professional pursuits. Self-enrichment is anathema to the Revolución, and though we would come to observe its prevalence in Cuba, its pursuit is entirely incognito.

Meanwhile, the Revolución reveres its amateur heroes, like Teófilo Stevenson, the beloved Cuban three-time Olympic gold medalist boxer who should have been the heavyweight champion of the world and could have made the hundreds of millions of dollars that status would bring. He chose instead the amateur spirit—the spirit of the Revolución, which is love for the process and the contribution made, not love of . . . money. Teófilo Stevenson fought to 301 wins, twenty defeats without defecting or straying for a single syllable till the day he died at age sixty in 2012, a tribute to the pure ideal. He is iconic in Cuba and among boxing fans around the world.

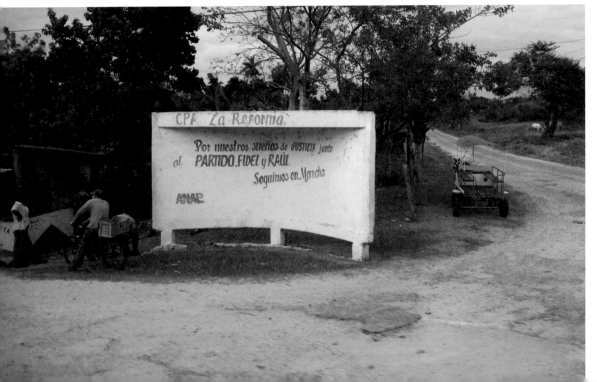

Cuban values are nationally ordained and required, so a beleaguered nation can better embrace its ideology—even as contenders still embrace the Cuban flag after defection, in championship bouts they would never get at home. Professional camera gear indicated self-enrichment and further contamination of revolutionary purity. Professional camera gear was obviously contraband being smuggled in for sale or transfer that could allow self-enrichment to taint the otherwise pure, amateur aesthetic. Maybe.

Political platitude feels soft as a faded billboard a few miles into the country, but the first blush of reality can come from a slap in the face at the airport. "For our dreams justice, together with the party, Fidel, and Raúl."

"Why you need this?"

"What you do?"

"Business?"

"You give? You sell?"

The correct answer came easily: "I love the little fishes. I take pictures. Do you know where are the very best reefs in the entire world? They are here. I am here to see and to take pictures. It is my hobby. Okay?" *Mi pasatiempo. Hokay?*

So they made a list enumerating each lens, camera, viewfinder, teleconverter, strobe arm, and strobe—*oy vey*; the single strobe in that carry-on got the Cuban customs agents excited. What could it possibly be, if not a detonation device meant to destroy the people's peace and property, after infecting massive segments with self-enrichment? I demonstrated: "Psh! Psh! *Es la luz por tocar las photos de los peces pequeños.*" It's a light that flashes for taking pictures of the little fish. Well, of course that sounded a tad nuts, but it also seemed adequately removed from detonation and self-enrichment. They rolled their eyes.

"What?"

"Fishes?"

"What?"

"Yes. I get that all the time." By that time, the fatigue factor had become international, recalling the first rule of direct sales: he who tires first loses. "Look!" I reached knowingly into the tangle for the camera body that doesn't really look like a familiar shape without a lens attached. They flinched, not as bad as the TSA guys who just know, know, know you want to blow them up, but with the same adrenaline. So I slowed down, smiling as if to comfort them, but nothing comforts anybody in any airport security system. I could at least console and let them share my joy over some shots still on the data card from a Maui reef visit only the week prior. "Just look." I moved fast but slow, deftly turning the camera on, acutely sensitive to the shrinking distance between trigger fingers and action. Pressing preview, I sighed, thanking Neptune for the gift of images and the foresight to grant them at the beginning of last week's dive, so they appeared at the front of the preview. A modern LCD screen on a real camera is only three inches wide but might as well be a drive-in movie if you rode to work in a '55 Rambler. "These are little swimps! I mean shrimps!" I turned the LCD their way, but they would not look, their eyes glued to mine. "*Los pequeños camaróne.*" Of course they thought me crazy, mumbling about shrimps on my way to the gulag, but down their eyes went. . . .

Advancing slowly from one to the next I softly identified the creatures, hoping their exotic beauty would outweigh the exotic value of the equipment—equipment that would presently be applied to Cuba's exotic beauty, if only we could reconcile

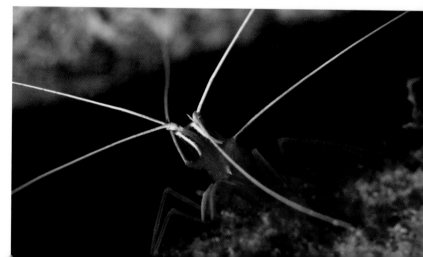

Cleaner shrimp, South Maui.

our understanding and appreciation of the greater good at this most difficult juncture. They loved what they saw. An artist can tell, even as they struggled to show nothing, or maybe because they struggled.

With beauty and understanding restored, trigger fingers relaxed and we proceeded to documentation so that the world could spin again, in peace. Getting into Cuba requires that a traveler satisfy two governments that have no official communication with each other. Besides a visa, a visitor from the USA needs a license to enter Cuba and can usually sign on with a tour group on a set itinerary to suit personal objectives. Short of finding a scuba tour, a U.S. citizen may apply for a license in a number of categories, including journalistic. *Do you have a publisher? Do you have publishing credentials? Do you have a publishing contract?* These and many other questions led to a series of license denials, each denial listing the wrong answers causing that particular denial. As the process matured, the wrong answers became fewer, on the way to license approval. The most memorable question: *Will the work produced be sold for a profit?* Without belaboring the fundamentals of one Revolución or another, suffice to say that a 501(c)(3) is a nonprofit, ergo, not profitable. *¡AND ALL PROCEEDS FROM THE SALE OF THIS BOOK WILL ACCRUE TO THE CAMPAIGN TO BAN THE AQUARIUM TRADE WORLDWIDE!* Now there's public service in deference to family and fishy values everywhere.

In only another half hour we were free at last, maybe not so free as in the land of the free, but walking freely out of that overlit, heavily armed, threatening process felt far freer than it had for the last few hours. So a 5:00 p.m. arrival at Havana International Airport led to an 8:30 p.m. slog to the taxi for the ride into town and the Copacabana Hotel. The cabdriver couldn't help but hear the tale recounted, and he said, "You know, the most difficult part of my job is seeing nice visitors like you detained at the airport."

"That wasn't nearly as difficult for you as it was for us," I reminded him. "We come as friends. We are here for the beauty. . . ."

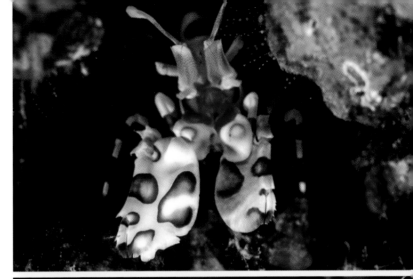

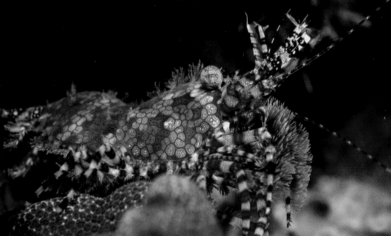

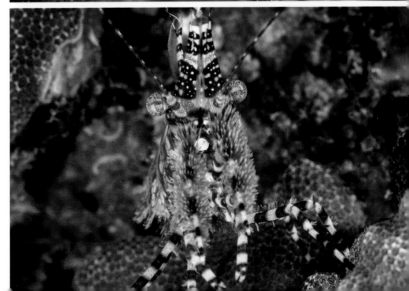

Right top: Harlequin shrimp, South Maui.
Right middle and bottom: Marbled shrimp, South Maui.

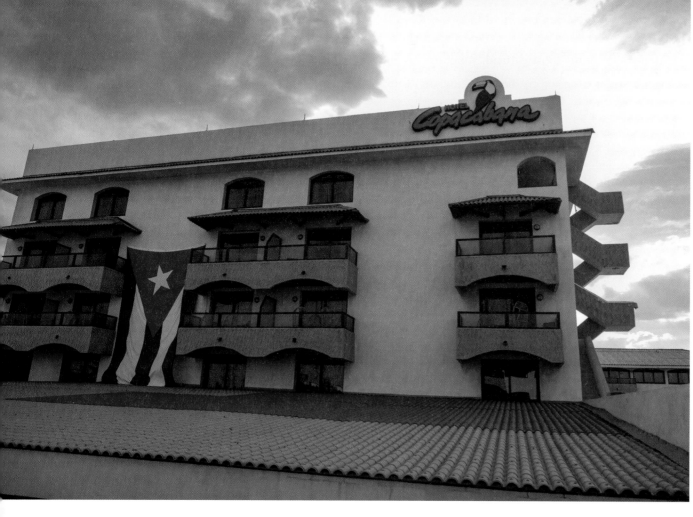

The Copacabana Hotel in Havana

"Yes. Yes. I know this."

"That was ugly."

"Yes. It was. I am sorry."

Many travel guides profile the Copacabana as a dump but it hasn't been a dump since a 2011 renovation. It's entirely tolerable, clean, and refreshing compared to customs detention at the airport. The bathroom was serviceable for *toilette* and disco dancing, with one light on permanent strobe mode. For quieter times with no downbeat, that light could be turned off and the other light turned on. Loose electrical socket covers indicated deferred maintenance, but again, a deprived country adapts as best it can to severe hardship caused by a trade embargo.

After checking in and stashing bags and another taxi ride to a *paladar*, a private (nongovernment) restaurant, we sat down to dine, twenty-five hours after leaving home. The next day would be two dives right off the dock at the Copacabana to get a baseline on flora and fauna in proximity to urban influence, urban effluent. Sleep deprivation became a theme early on, but adrenaline filled in. Dinner ran $150 for five *adultos*—about the same as full pay for a month for five surgeons in Cuba.

But that popular comparison of dollar values is bogus, missing the point of public service, which is fundamental to the Revolución. So the government pays a doctor $30-$50 a month and calls that a livelihood, and some doctors drive taxis to supplement—to get by, even though the average income is far less. What's lost in a dollar-for-dollar comparison is the value of public service, what a MasterCard ad in Cuba would call priceless.

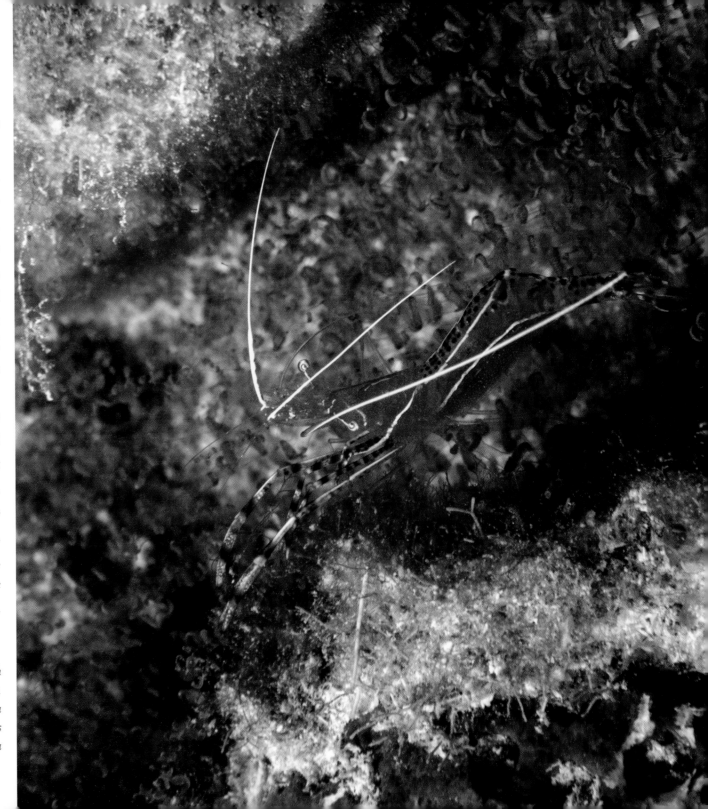

Which isn't to say that Cuban Communism is all hearts and flowers. It's not—it's a totalitarian dictatorship of ideologues determined to stay in power. But the priceless components are real, and among them are a few gems. Castro Communism first borrowed on Marx, Trotsky, Lenin, and Stalin. It adapts to global political exigencies, to stay in power, and in that process it has gained what no system ever imagined. Maybe it only stumbled onto what no system could imagine. In either event, it now owns the Holy Grail of Reefdom.

Practical constraint from no mo dough put the kibosh on industrial expansion, on shoreline development and resource extraction, on urban sprawl, mechanization, franchise sameness, strip malls, suburbs, convenience to church, schools, and shopping, drop ceilings, sheetrock, shag carpet, and of course much, much more for over fifty years.

This pequeño camaróne is a Pederson cleaner shrimp with the same beauty and reef value as Hawaii cleaner species. The critical difference is abundance and diversity as a result of human effect on habitat. Hawaii still mismanages reefs in service to greed, while Cuba did nothing in a default that saved Cuba reefs. Now Cuba steps up.

Landfills in Cuba seem blessedly empty, and limited "growth" has yielded a treasure trove of natural wonder, intact.

Many sponge species proliferate Cuba reefs.
Right: Havana sea fan

Sea fans, sponges, whip corals, and flamingo tongues typify Caribbean reefs in the best of times, which may be paradoxical in reef time; with Caribbean reef habitat and species in dramatic decline, only Cuba reefs thrive. What's right with this picture?

Whip corals in many colors are part of the 100 percent coral cover on many Cuba reefs.

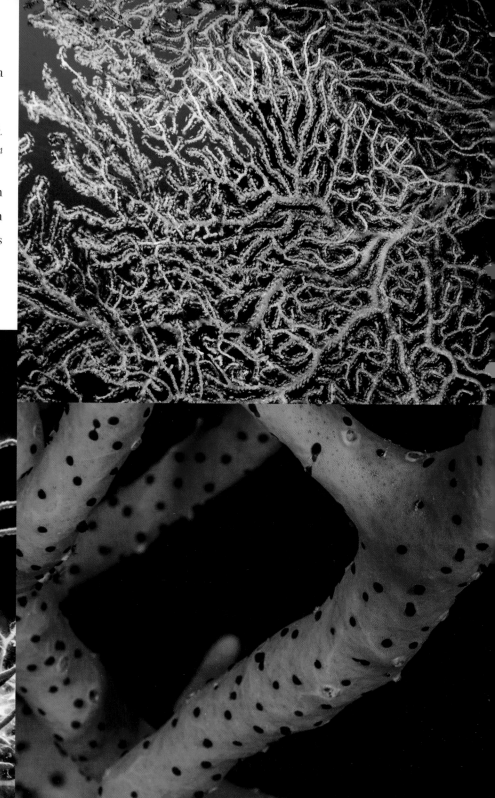

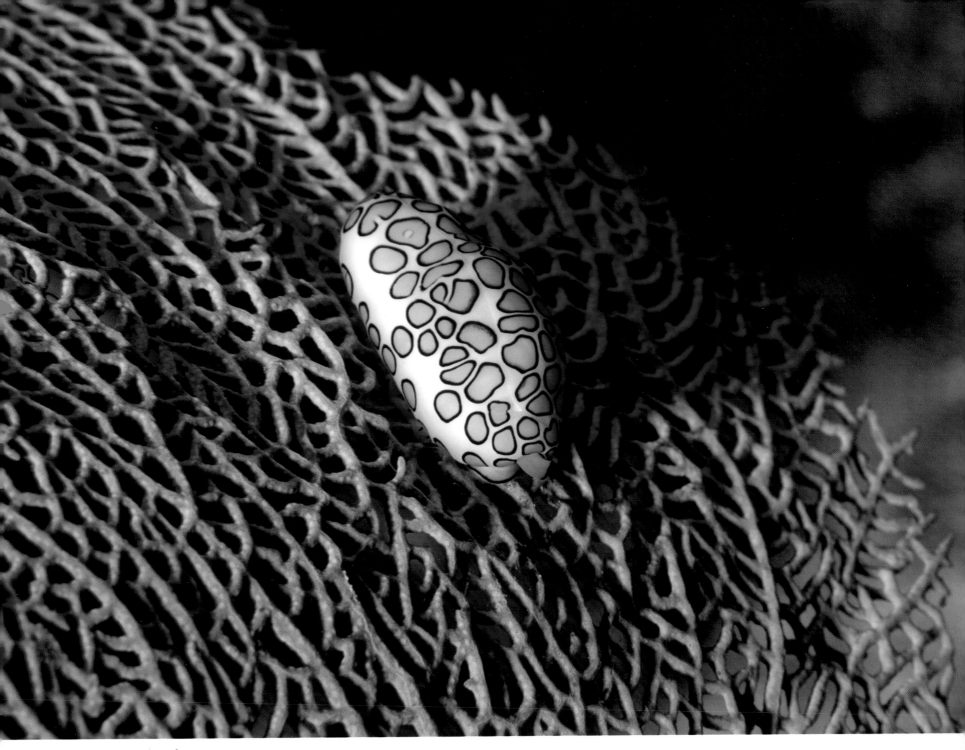

A flamingo cowrie on a purple sea fan, Havana.

Who'd a thunk it would come to pass in a place with so much prime waterfront real estate—commercial, too? But commerce went to seed, and the shoreline from the Copacabana balcony is vacant as far as it's visible, without use, without commerce, without people—without golf course pesticides, without injection wells, without the overwhelming volume of human waste.

Just beyond the shore break fronting the Copacabana are marine flora and fauna to beat the band. Havana coral habitat and wildlife are not the best in Cuba but would be the very best available in any free-enterprise country in a thousand-mile radius. Make that six thousand miles to include Hawaii, a state so compromised and stressed by bad reef management and vested interests that its dying reefs are as victimized and exploited as any community in the world.

Here's what happened in Cuba: with the Soviet Union collapse, the mainstay of Cuba's economic support vaporized, sending trade and revenue to oblivion. The early to mid-1990s was called the "Special Period in Peacetime," labeling sacrifice and extreme deprivation with Orwellian/Marxist rhetoric. Fidel Castro had hated tourism and saw it as a negative force prior to the Special Period—saw it as contamination by self-enrichment, black market, and private commerce. When push came to shove, practicality dictated, and he saw the chance to survive—saw a way out of the Cuban financial crisis that was far different from an American "crisis." A U.S. economic downturn loses jobs, money, health care, and other benefits. The Cuban economic crisis got down to fried lard, sugar water, and shark meat. Full stop.

Then came official recognition that sugar would no longer be the basis of the Cuban economy. Tourism would be tolerated, accepted, pursued. Tourism has given rise to a separate economy and a separate social class in Cuba, characterized by Cubans with exposure to foreign people with foreign currency—what is known as the dollar economy. Tourists tip, often in magnitude exceeding the fixed income of Cuba's highest-paid professionals. The Cuban people, ever resourceful, imaginative, and resilient, understand and promote the heady, giddy feeling of tipping a surgeon's monthly salary to a cabdriver. Tourism is now Cuba's top revenue producer, and a single facet of Cuban tourism now emerges as uniquely superior to anything else of its kind in the world: reef tourism.

Side notes abound. Also present in Cuba is a dysfunctional cultural mythology. That is, Cuba suffers rhetorical zeal for a Revolución that has failed to deliver. It also suffers no media, which may be a benefit with no TV and no Hollywood reinventing reality as perceived by a handful of megalomaniacs willing to sacrifice art and wisdom for ratings and returns. That's not to say that all U.S. media is greedy and worthless, but most of it is.

Cuban citizens not employed in tourism cannot enter a Cuban hotel.

We learned so much in such a short time, and at the end of a very long travel day retired to the Copacabana, where TV access is a reminder of the squirming tits-and-ass mentality we came so far to escape. Surfing a hotel TV is a nonstop display of sex-addled imagery and noise from the land of the free, and we were still free to turn it off. What a relief.

In eight hours we would meet the reefs.

Make that nine, since our leader, Octavio Laguardia, could not get his scooter started, and then once he did, he hit a traffic jam. What? Traffic jam? In Havana? Well, okay, not a jam, a fender bender that he stopped to observe. What was the rush? Besides, the breaking swell out front precluded a boat launch—a twelve-foot inflatable for one dive leader, four divers, one snorkeler, five sets of scuba gear and tanks, one video camera, and one still camera, the big-dog model. Not to worry, we would enter from the end of the dock, but were warned against walking out there until the carpet was laid, meaning carpet remnants to cover the black algae covering the concrete that looked innocent but would take you down in a blink.

Entry was easy, the cruise out disappointing over crusty brown bottom with occasional flotsam, abandoned pipes, and other hardware for a hundred yards or so, which was fairly predictable in any urban proximity from the sheer seepage of human waste, toxins, and trash. People watched idly from the hotel, obviously wondering who would want to actually swim out into that water, and what could possibly be there of interest. Or maybe they wondered how we could be allowed to do so.

Photo by Scott Wong

Then came the drop from fifteen feet to forty-five—to 100 percent coral cover with more abundance and biodiversity than Hawaii can claim in the 2 percent of near-shore reefs it "protects."

The baseline felt secure, demonstrating the efficacy of the theory that human constraint saves oceans.

That first reef visit introduced the Cuban theme of making do with what's available. The launch ramp at the Copacabana had been a cargo conveyance facility long ago. Now the old winches are high and dry, the electric cables cut. A long rope wrapped around those winches and leading to the slippery concrete edge above the ramp is the Cuban equivalent of a handrail. We made do, getting out safely by timing the surge and break, using the grab line and avoiding contact with the sharp corals along the sidewall. So many other observers have noted the make-do syndrome in Cuba that Cuban adaptability and ingenuity are old news, and substandard, aging equipment can only be expected in such an economy with embargo isolation.

Moreover was the other news, perhaps also old but to our eyes a revelation. Any visit to any reef may include trash encounters. For ages, snorkelers and divers maintained the common response: it's not my trash. But a reef is not a sidewalk in a city; it's a place in the heart where more snorkelers and divers are picking up on a theme than they used to do. We came upon an abandoned anchor surrounded by soft plastic debris. Octavio stashed the plastic into his buoyancy compensator and carried the anchor back to shore. In two hours we dove again, and he collected other bits. At sixty, Octavio is senior among the dive community. As jovial and engaging as a happy man can be, he was eager to know of Hawaii reefs. Are they this good? Do the people in Hawaii love their reefs as the people of Cuba do? Are they taking measures to care for their reefs?

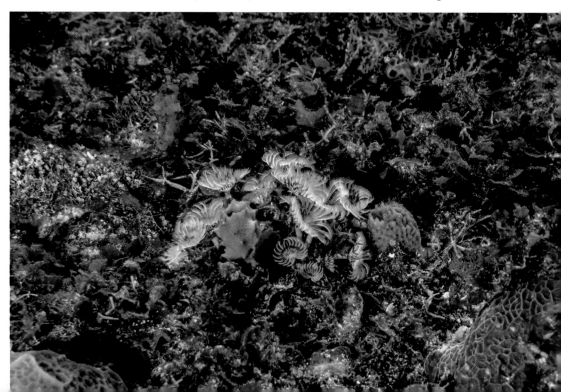

Among the aquarium trade's devastating impact on Hawaii reefs was its extraction of featherdusters. A featherduster is a polychaete tube worm who bores into a coral head and then filter feeds by means of colorful, vibrant "feathers" that grab passing plankton. Any movement nearby will startle the featherduster, who will duck into the coral. Aquarium trade extraction in Hawaii took nearly all the featherdusters from many places and all the featherdusters from Kaneʻohe Bay in typical fashion, selling out Hawaii's reef trust for about 35¢ each on the way to mainland retail sale for up to $35 each. Which sounds, uh . . . stoopid, and it is. What's worse, the featherdusters are collected with a crowbar—oops! Wait a minute. When I pointed out that pesky detail, a particularly self-righteous reef destroyer stood up and cried foul (!); they do *not* use crowbars. They use wooden sticks. I stand corrected, as those reefs remain devastated.

Don't get me started—but it's hard not to remember when gazing on the primary indicator of good water conditions for marine fauna, the featherduster. They abound at the reef in front of the Copacabana, which felt promising for things to come.

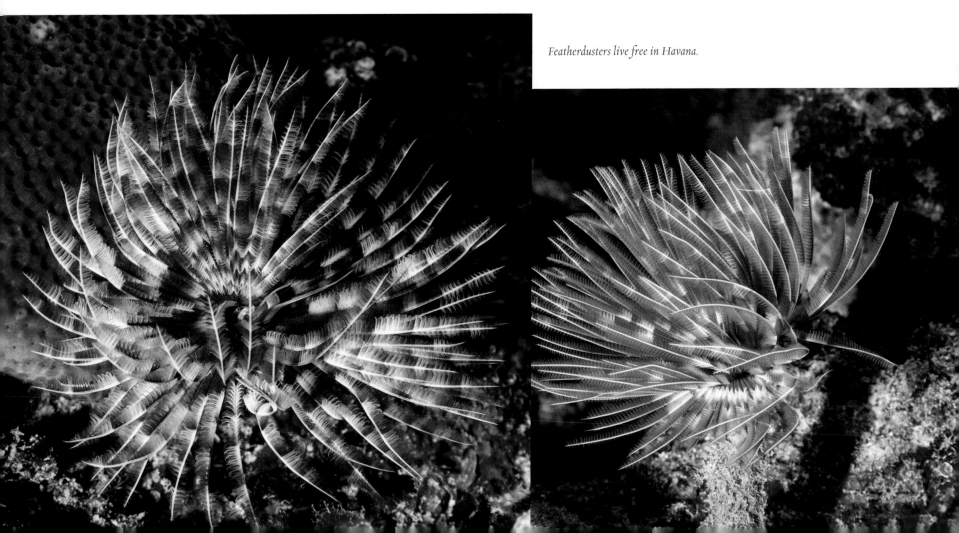

Featherdusters live free in Havana.

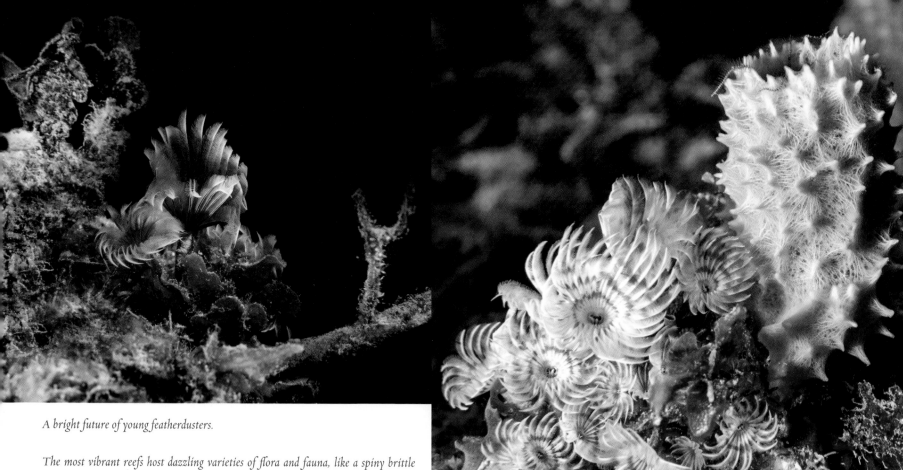

A bright future of young featherdusters.

The most vibrant reefs host dazzling varieties of flora and fauna, like a spiny brittle starfish lounging in a cup sponge beside a featherduster cluster, surrounded by corals and critters.

Invertebrates of varying species in garish colors and shapes indicate reef health and a functional feeding system. Most inverts are benthic—bottom dwellers—once they survive the early, plankton phases. Obvious exceptions are jellyfish and barnacles hitching rides on hull bottoms. Filter feeders and grabbers, like featherdusters, Christmas tree worms, barnacles, sponges, and anemones tolerate significant current and surge, but a large object drifting too near will trigger instant retreat. Less reactionary and often sociable, the pelagic fishes live between the bottom and the top. Like anyone in any habitat, they often show caution in the presence of large newcomers. But some do warm up and consent to a pose.

The harlequin bass is one of the smallest in the sea bass family, full grown at about 3 inches.

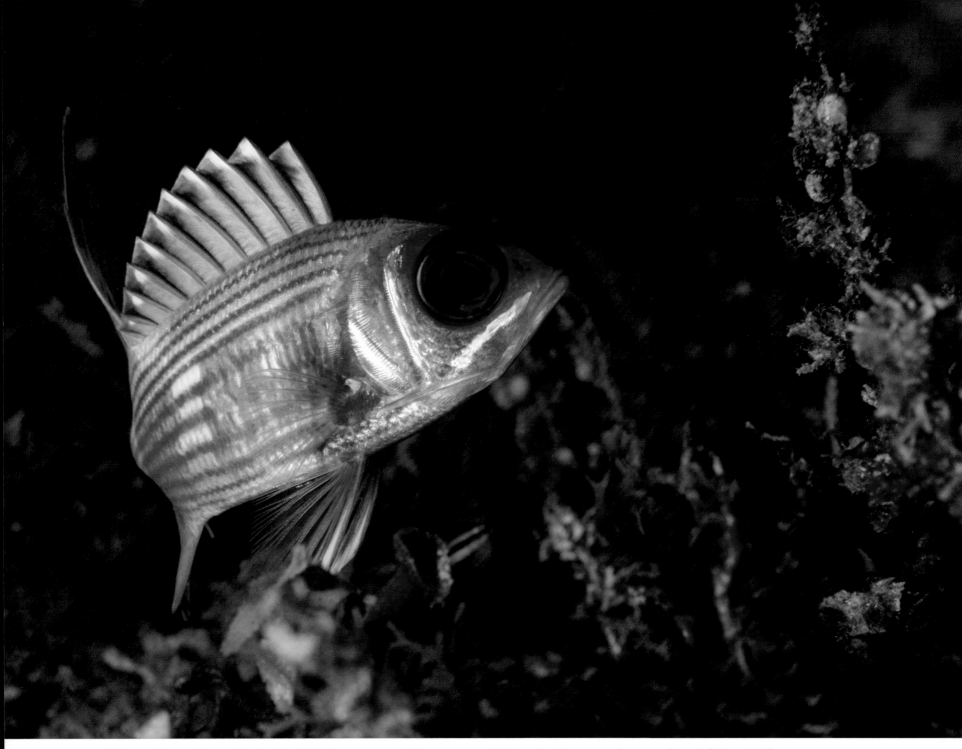

Longspine squirrelfish stop and turn in dramatic dorsal and caudal display, an apparent defensive posture to look bigger but also a posture that may reflect good feeling and self-esteem.

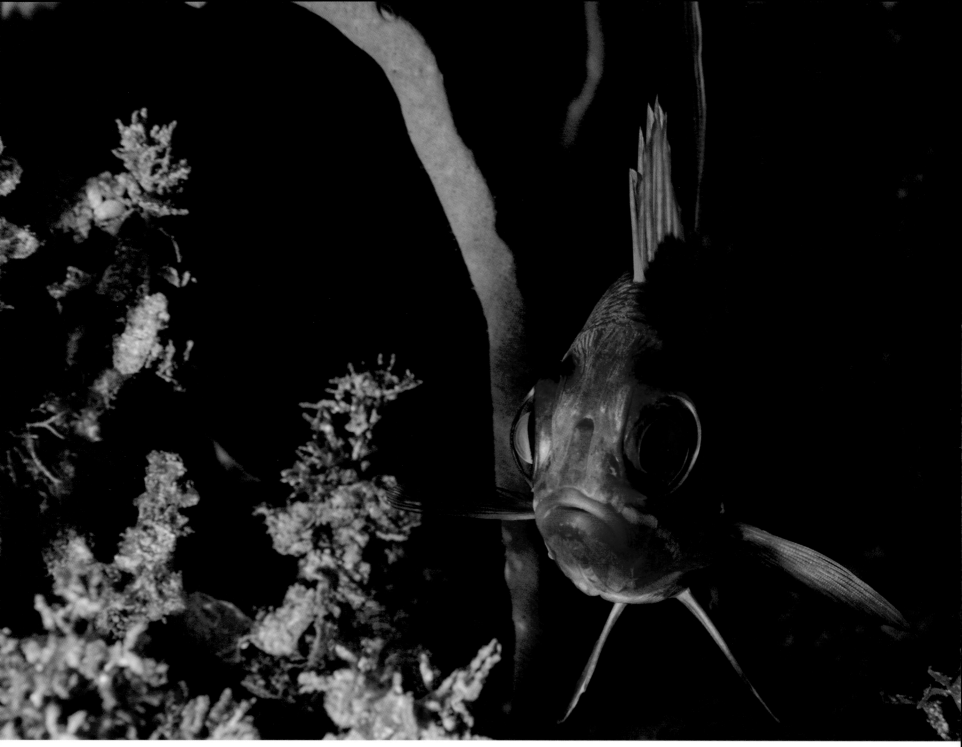

When the deep purple falls over sleepy garden walls . . .

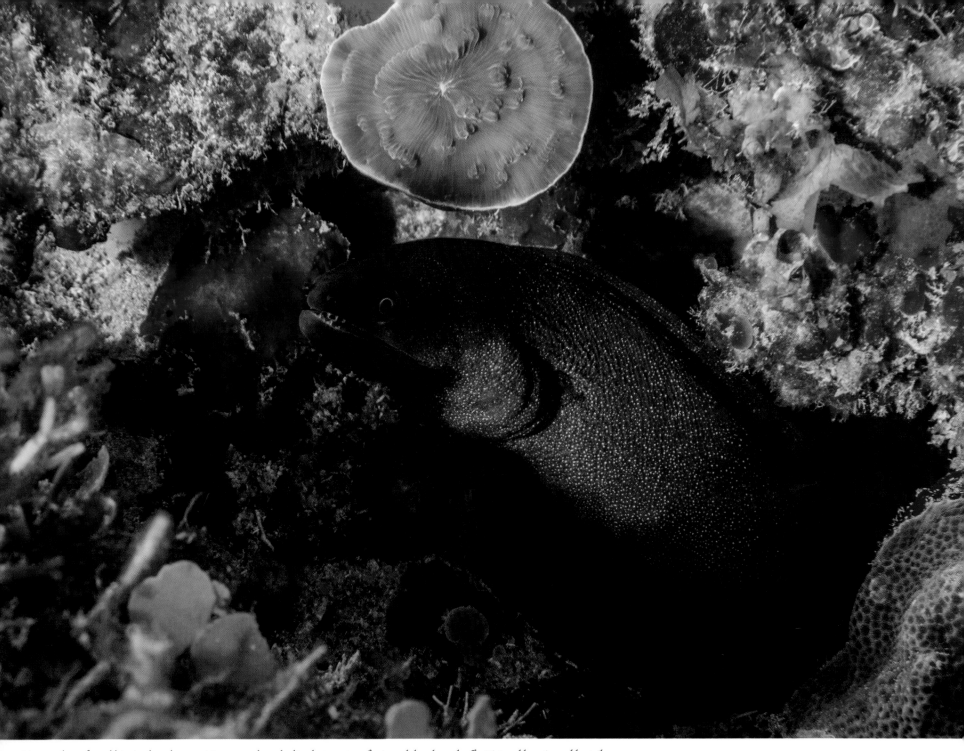

Moray eels prefer cubbies in the substrate. Morays are homebodies, but most prefer to grab lunch on the fly. Pictured here is a goldentail moray.

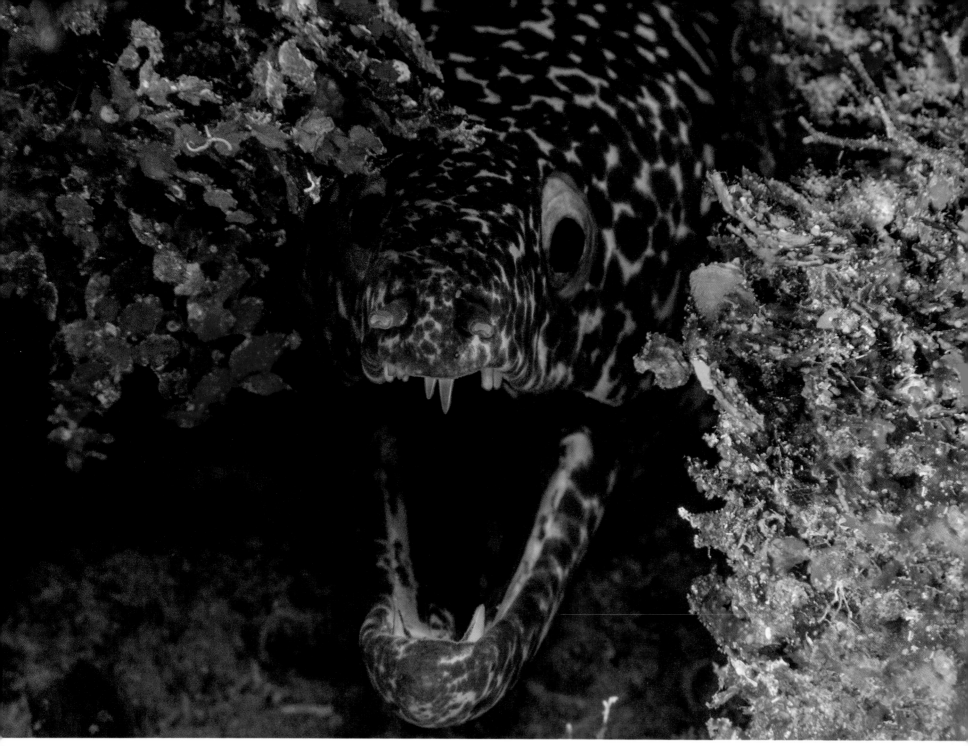

Portrait of the Dictator as a Young Eel.

The bluestripe snapper is integral to Caribbean reef health and Hawaii reef mismanagement. In abundance, this fish indicates a teeming food chain—except in Hawaii, where the Department of Natural Resources introduced the bluestripe snapper as a food fish. Hawaii predators don't know this fish, so it spread like brush fire, consuming many other species in its path. Mismanagement policy in Hawaii is based on "scientific data," or it benefits special interests—or it's honestly stupid.

If fish run free, why not me? It may be presumptuous to think that fish have moments of reflection and dialogue with Neptune, but what else could he be doing?

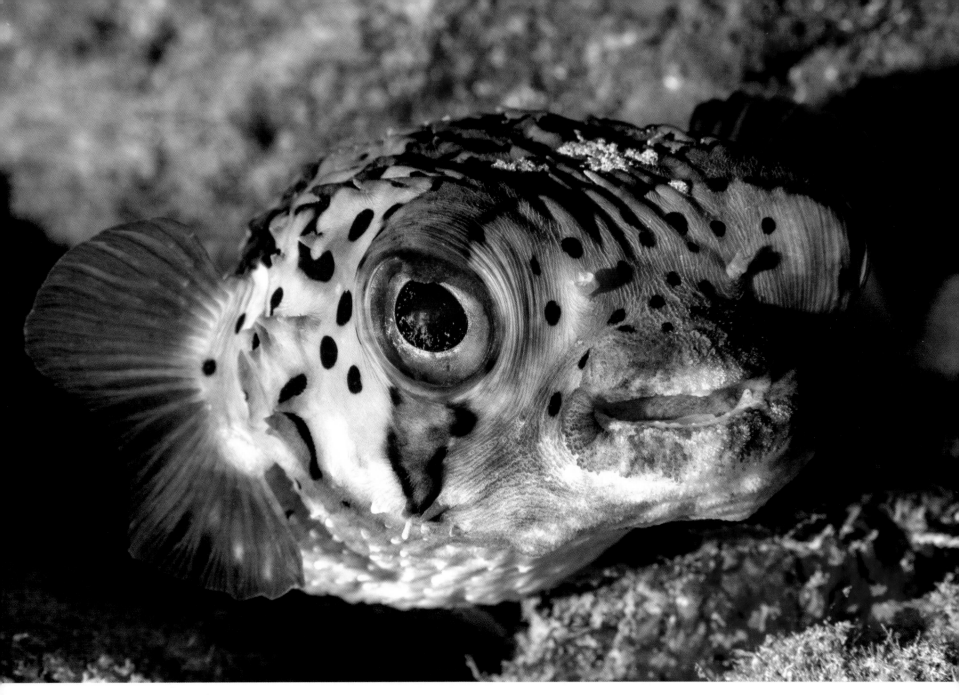

Puffers can also indicate reef health and good water conditions with clean skin, free of blemishes. Puffers recall aquarium hunter testimony to the Hawaii legislature: "We see puffers on almost every reef, so why shouldn't we take them?" The same guy complained of a fourth child on the way and no money for disposable diapers without new reefs to harvest.

Back in Cuba, home of family planning and no aquarium trade, these puffers are notable for the iridescent specks in the eyes. Other species use frilly lippets—skin formations partially covering the eyes—as camouflage. These iridescent specks may provide similar benefit.

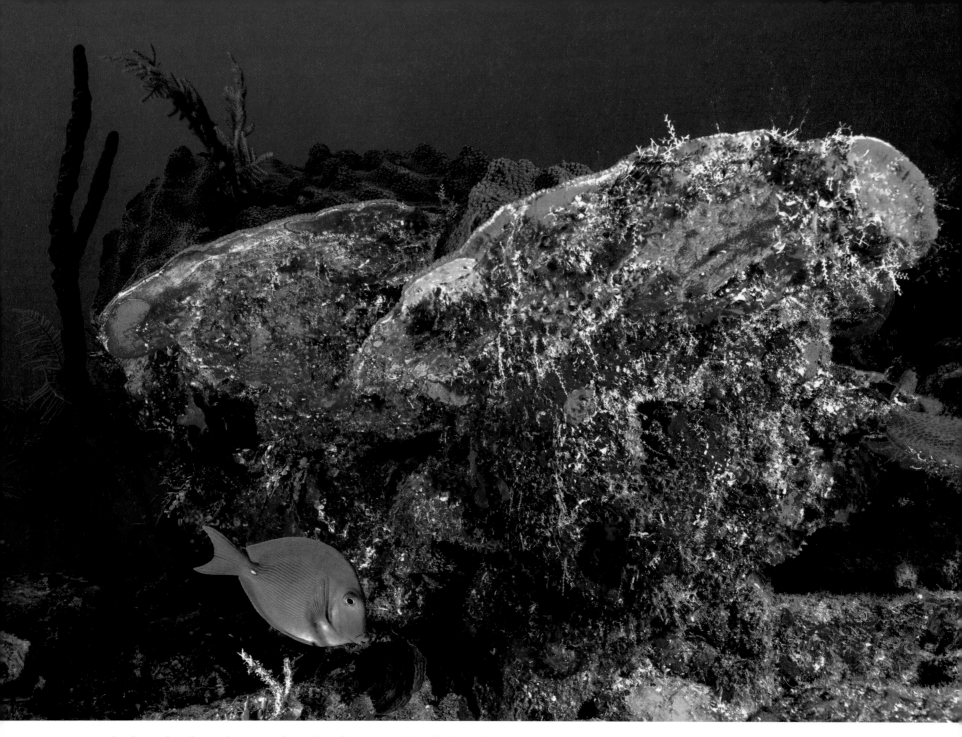

Encrusting corals, whip corals, and invertebrates cover these rocks, indicating optimal use of habitat, indicating prime conditions. Note the blue tang, bottom left.

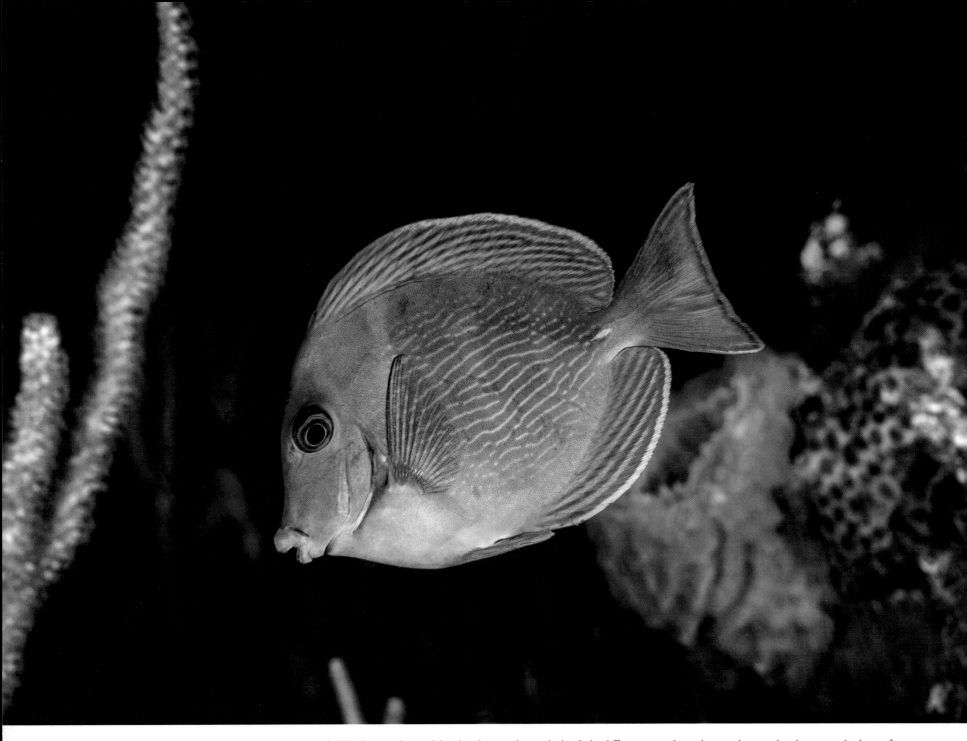

The blue tang is the Caribbean counterpart to the yellow tang in Hawaii, both herbivores who spend their lives keeping algae in check. The big difference is not their coloration, however, but their survival as key reef species. In Cuba, they remain abundant, while in Hawaii they ship out by the millions to serve a voracious aquarium trade, leaving many reefs void of tangs—without a maintenance staff.

The Havana baseline could have gone either way without influencing observations on the balance of the expedition. But seeing these reefs healthy supported a theory. Like many theories, this one also sought insight on what appeared to be obvious—that human activity kills reefs and human inactivity allows reef health. Our dive leader Octavio Laguardia lacked our firsthand exposure to human activity as it defiles reefs, with most activity in Cuba constrained to pursuit of personal needs. Or maybe he was adequately circumspect to avoid judgment on one system or another. And he is a naturally happy man.

Learning of our next stop, Cayo Largo, he said, "Ah! Perfect!" He would call his amigo Pepe, because Pepe would understand the needs of a photo/video outing to be apart from others who would get in the shots and kick us in the head. Then he picked up the phone and called Pepe, who had won several photo competitions in Cuba and would be happy to lead us, away from the madding crowds. Pepe was only fifty-four and at Cayo Largo. That is, our dive leaders got younger as we got farther afield, suggesting more rigorous water regimen in more remote places, requiring more stamina. And so it came to pass. But the emphasis and age hierarchy also became secondary to the dive family at all these places. Avalon, the fishing company, employed all these guys, but that too seemed incidental to the common interest, the common bond. These guys loved their work—they would, with the tips, but it seemed heartfelt.

Also of note is the standard procedure for boat dives in Cuba, whereby tourists are required to show passports on boarding. International travelers show passports frequently, but the most worldly among us stopped short on that one. *What? A passport for a scuba dive?* Of course the dots soon connect, with every Cubano a potential refugee and every boat a flight to the land of the free. The passport requirement seems silly and is silly and may have actually stopped an escapee or two over the years but can't have had much effect on Cuba or Cubanos or the Revolución, except to make it feel more oppressive and silly. To the great good credit of the excellent watermen and women of Havana and Cayo Largo, the passport exercise was scoffed at and forgotten—as if the Cuban people are simply too smart for that nonsense, and they are. Besides that, we sensed pride in these people and a true aloha spirit, welcoming the chance to entertain reef brethren, *Americanos* at that. The boat for the long cruise across open ocean to Jardines required passports, but Jardines de la Reina is a giant step toward the Caymans. *¡Caramba!* Security risk!

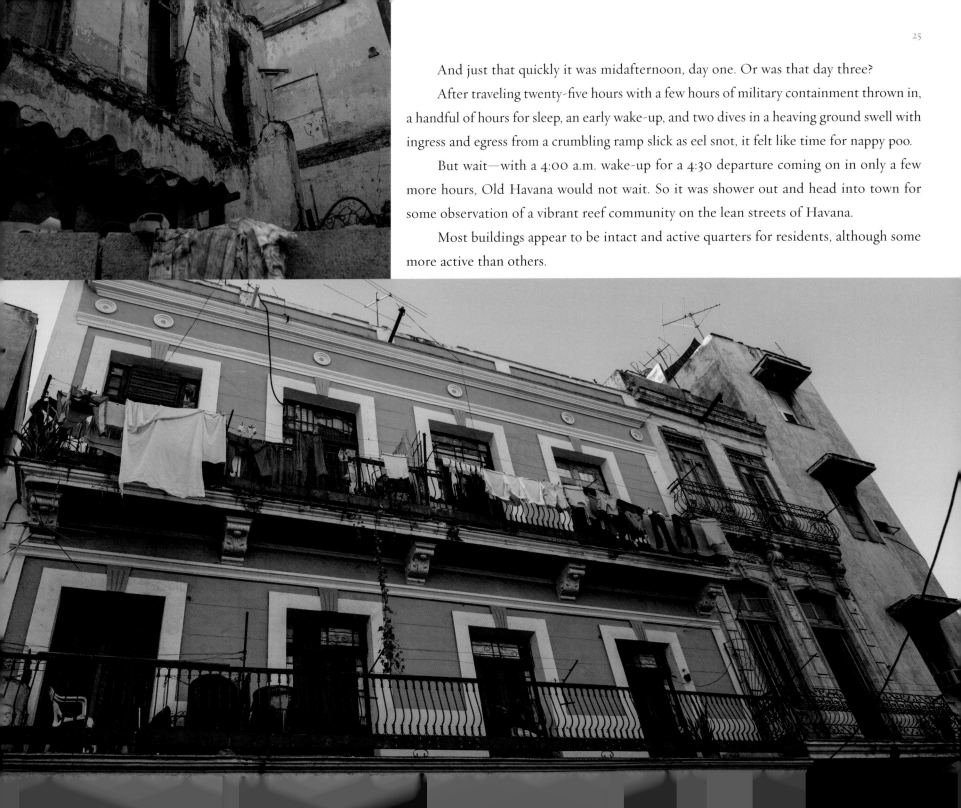

And just that quickly it was midafternoon, day one. Or was that day three?

After traveling twenty-five hours with a few hours of military containment thrown in, a handful of hours for sleep, an early wake-up, and two dives in a heaving ground swell with ingress and egress from a crumbling ramp slick as eel snot, it felt like time for nappy poo.

But wait—with a 4:00 a.m. wake-up for a 4:30 departure coming on in only a few more hours, Old Havana would not wait. So it was shower out and head into town for some observation of a vibrant reef community on the lean streets of Havana.

Most buildings appear to be intact and active quarters for residents, although some more active than others.

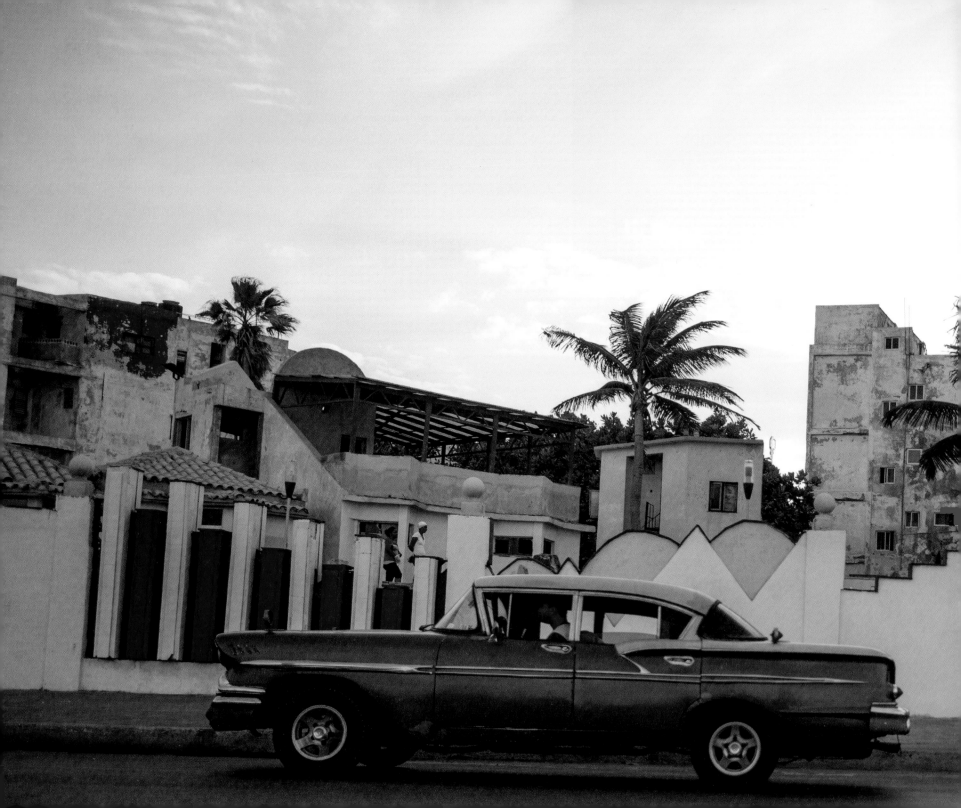

Even the more stable edificios have a grim ambience, in which neglect derives from historic magnitude, like Atlantis, though it was sudden and complete poverty that flowed over Havana's former greatness and buried it.

Havana Vieja—won't you come into my chambers?

It's a beautiful day in the neighborhood.

A Havana Vieja courtyard appeared to have been swept regularly since '59.

While not up to code, most habitation has adapted to functionality.

The real estate ad would read: Fabulous views from the spacious, open-air terrace! (j) A few blocks over, rehab has begun, apparently on a cash basis.

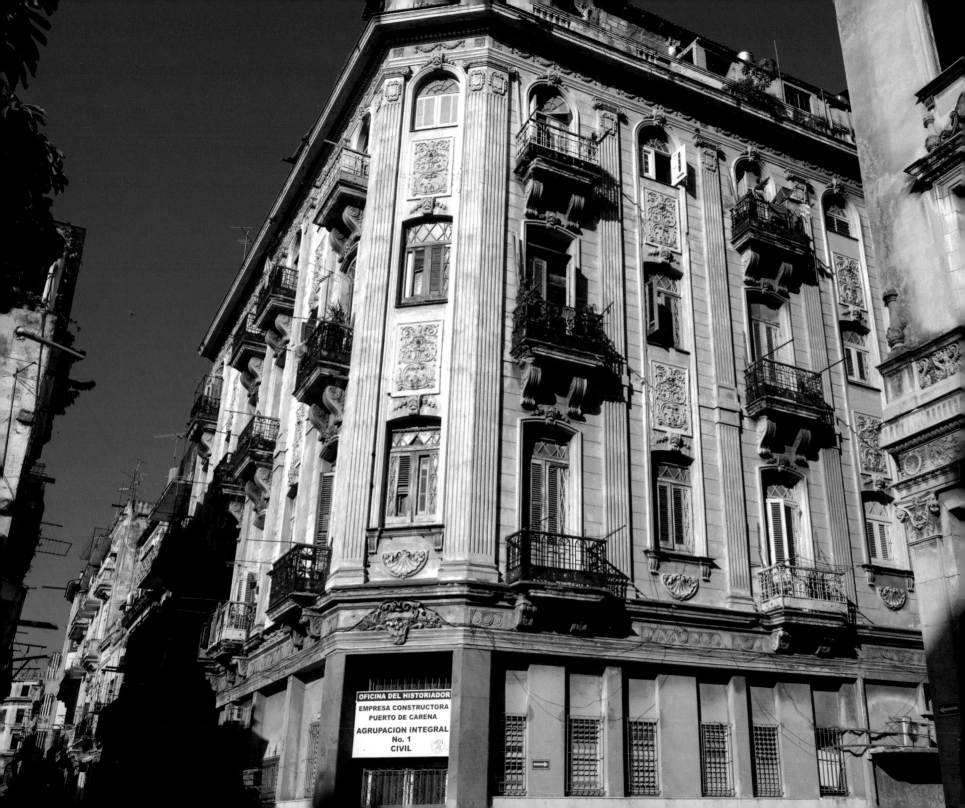

OFICINA DEL HISTORIADOR

EMPRESA CONSTRUCTORA
PUERTO DE CARENA

AGRUPACION INTEGRAL
No. 1
CIVIL

It's easy to judge, based on our own coddled lives. But the lack of material goods has yielded an equal lack of waste. The irony, or one of many ironies, is the Revolución's tedious refrain of efficiency; when you got nothing, you got nothing to waste. Yet a scene with so little waste feels like a blank canvas, uncluttered and pure. Survival at street level is a challenge, and efficiency gone to seed stimulates artistry. At times conforming to tourist tastes and trying to hustle a buck by rights, Cuban artistry is victorious.

Hey, I'm tryna make a living here.

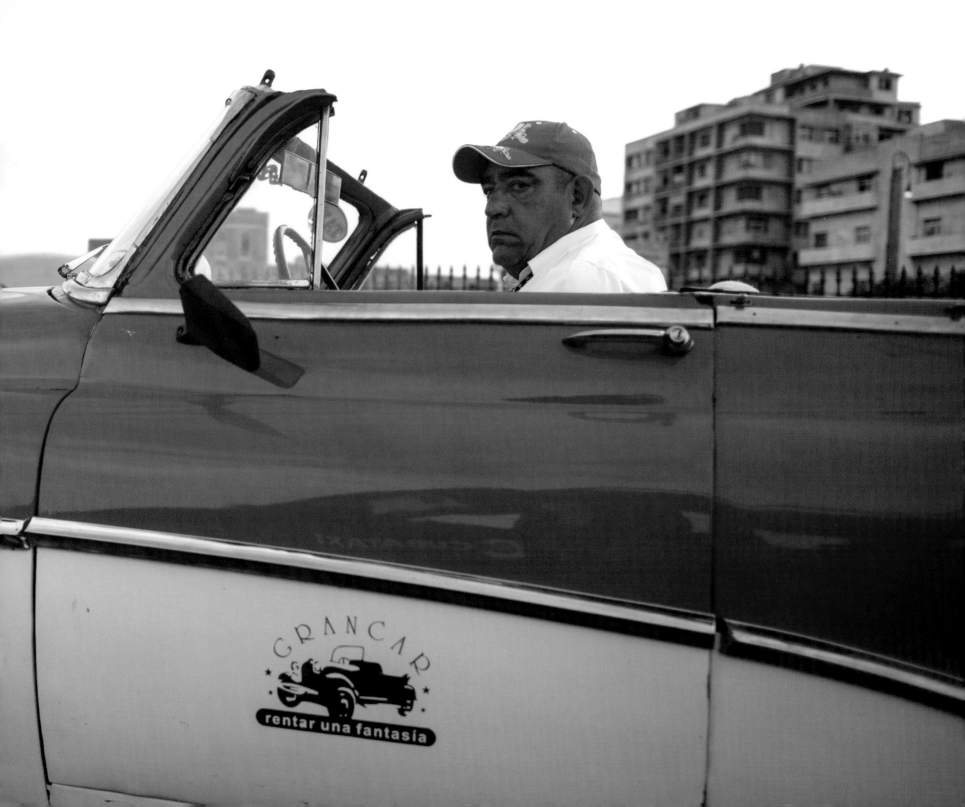

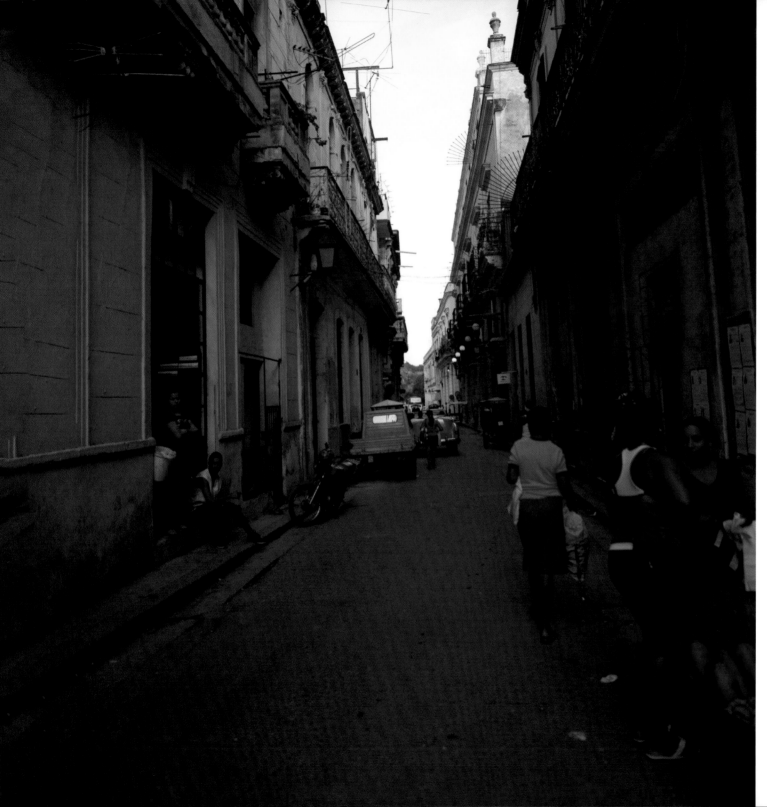

Havana Vieja felt easy, poor, nonthreatening, colorful, and inescapable. It can draw you in, a place and people beyond design or intention, making do, waiting—unless anticipation is all the Revolución will come to. The big push in American politics these days is the appeal to the middle class, because that's where the votes are. But has any population, group, social circle, or two friends ever achieved parity in material wealth?

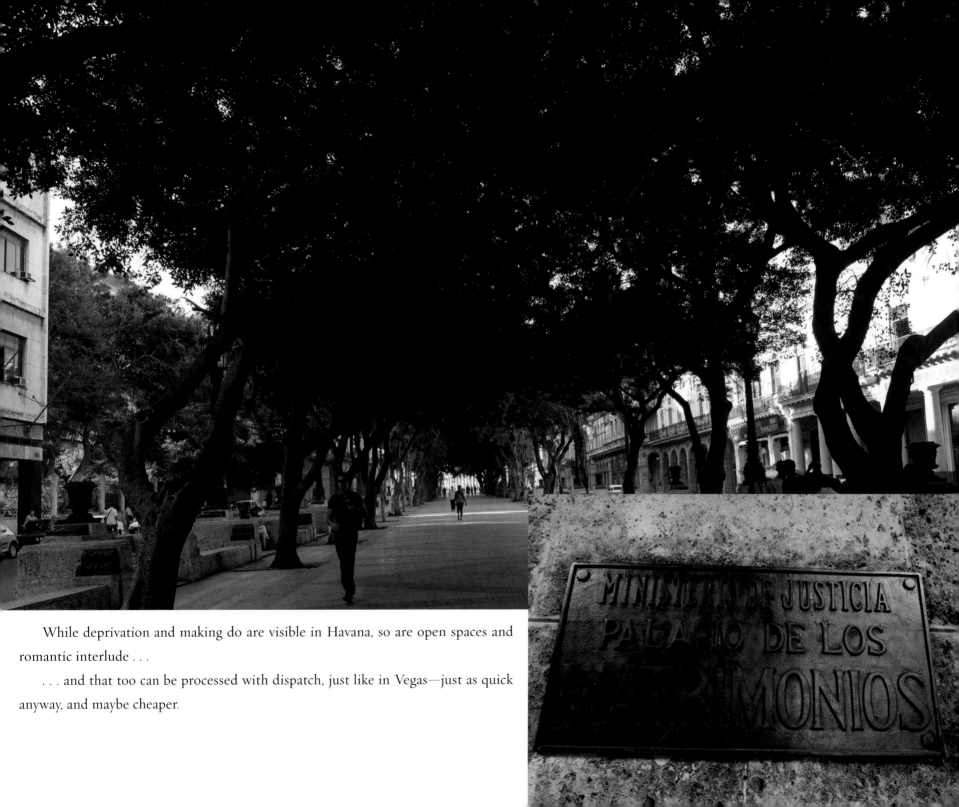

While deprivation and making do are visible in Havana, so are open spaces and romantic interlude . . .

. . . and that too can be processed with dispatch, just like in Vegas—just as quick anyway, and maybe cheaper.

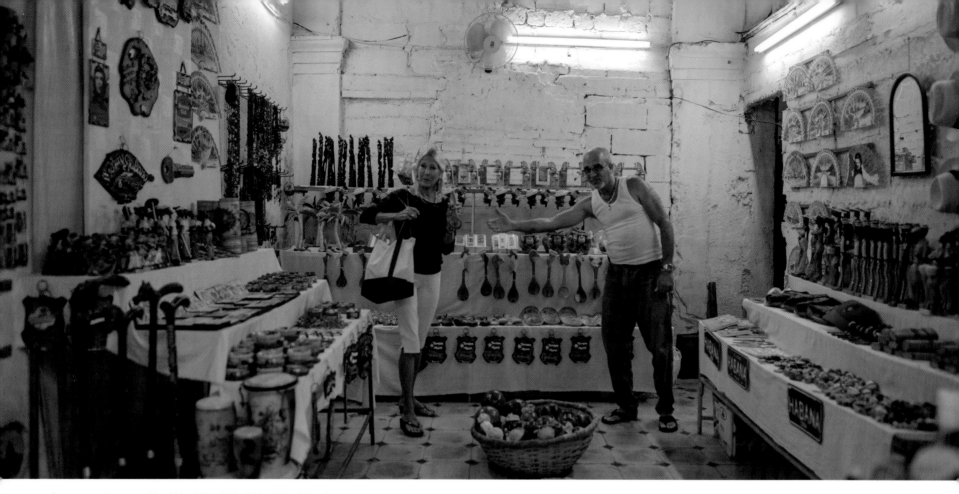

If I were a rich man, yubby dibby dibby dibby dibby dibby dibby dum . . .

A tourist shop operator hawking Havana license plates, Ché Guevara chef aprons, revolutionary coasters, Santeria dolls, caps, canes, clever amusements, and a vast array of chachkas encouraged us to buy. He knew we had the money, and that we could feel good spending it with him. Somebody remarked that a set of salad tongs looked perfect but said *Cuba*. The operator was ready—"Oh, you want Cuba? Look! I have these things that say Cuba!"

"No. It cannot say Cuba. We're from the United States. They'll take it away if it says Cuba."

"Ah! You cannot have Cuba!"

"No. We love Cuba, but no."

He shrugged quizzically and said. "I love Cuba, too. It is my country. Why shouldn't I love Cuba?" The bottom line was service and product knowledge and a good person with good inventory and a place to sell it.

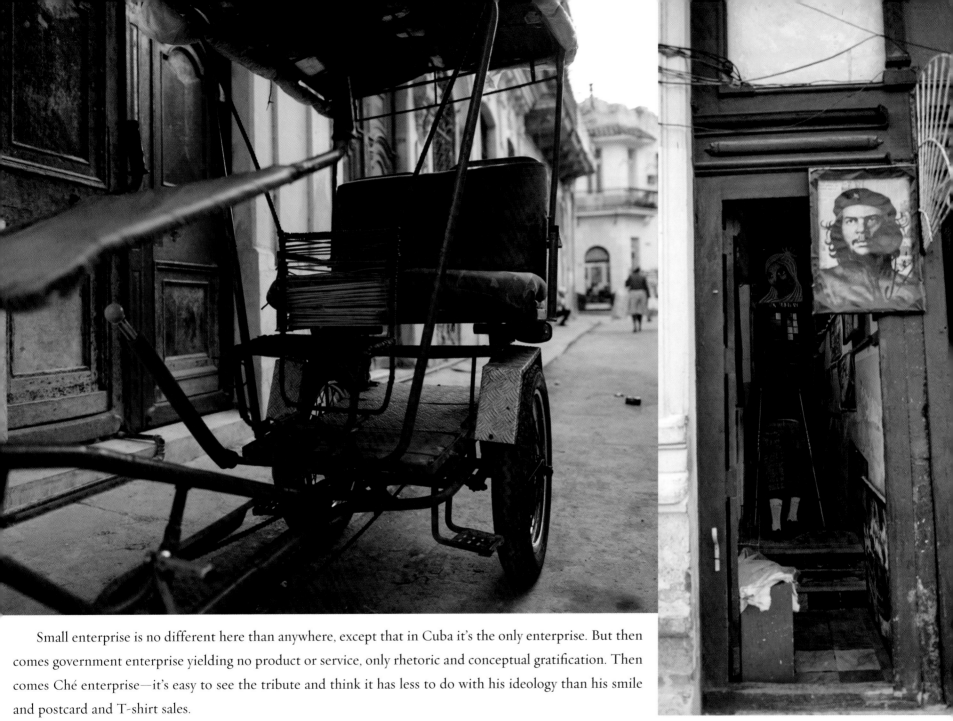

Small enterprise is no different here than anywhere, except that in Cuba it's the only enterprise. But then comes government enterprise yielding no product or service, only rhetoric and conceptual gratification. Then comes Ché enterprise—it's easy to see the tribute and think it has less to do with his ideology than his smile and postcard and T-shirt sales.

These colors don't run. They climb steps slowly, with the aid of crutches.

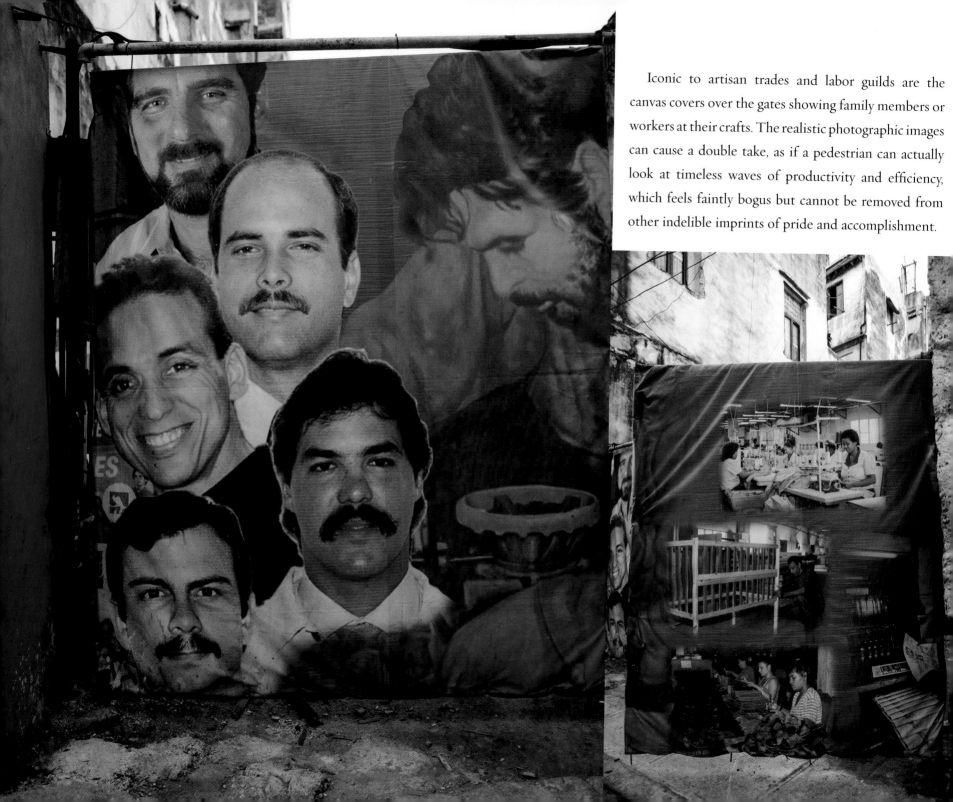

Iconic to artisan trades and labor guilds are the canvas covers over the gates showing family members or workers at their crafts. The realistic photographic images can cause a double take, as if a pedestrian can actually look at timeless waves of productivity and efficiency, which feels faintly bogus but cannot be removed from other indelible imprints of pride and accomplishment.

A cultural icon often taken for granted by those who have it is health care. Just as we in the land of the free can be street poor and still opt for emergency room care at top-dollar rates with no concern for payment, so Cubanos get free medical, although Cuban pharmaceuticals are not allowed to set their own prices with government guarantees.

Mitt Romney's worst nightmare—socialized health care.

Another Romney reminder, this working man's Rambler. Before George Romney ran Michigan, he ran American Motors.

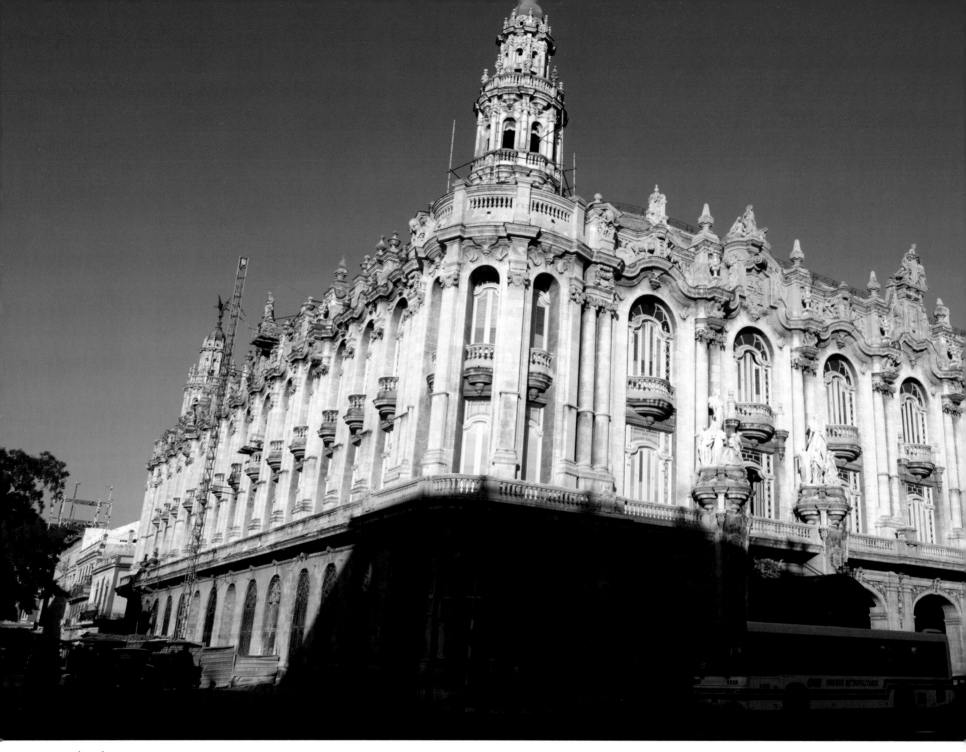

Teatro de Habana.

Parque Central at rush hour.

El Museo de la Revolución, rehab underway. Unlike some cities with spectacular architecture and comfortable neighborhoods, Havana Vieja shows colonial splendor in a tropical setting with a vibrant culture intact. How do they treat their children, elders and pets?

Whether an artist or artisan may work late on inspiration or to make ends meet becomes incidental in historic and artistic context, especially in a place with such abundance of artistic expression.

Portrait of the Artist as a Habanero, working late.

Characteristic of a non-economy is room to spare. A big, old colonial courtyard open to the sky is a refreshing oasis.

Just off the courtyard a cavernous room sits empty, except for the bass relief in concrete and the meaning of it all, which is presumably and without doubt understood.

Marta Lenol, herself, with artistry and aloha.

Two of Marta Lenol's primary themes are los gatos y las chichis. We admired this work in her doorway and she invited us in. U.S. Customs allows original artwork from Cuba.

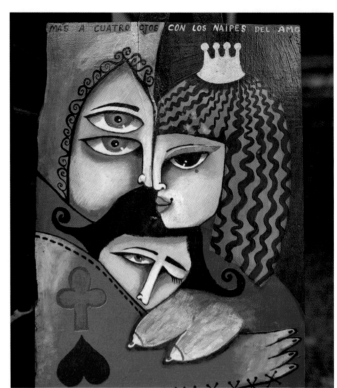

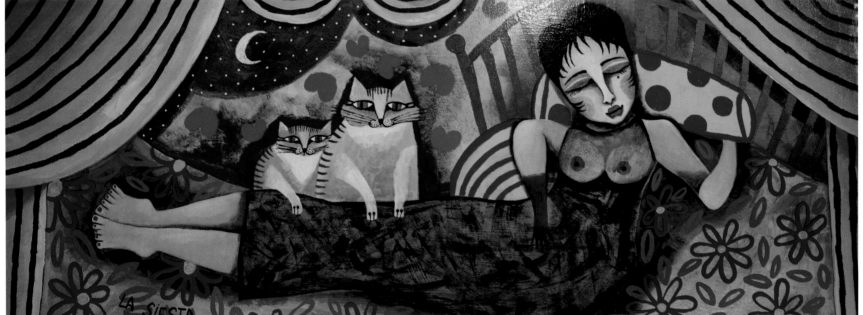

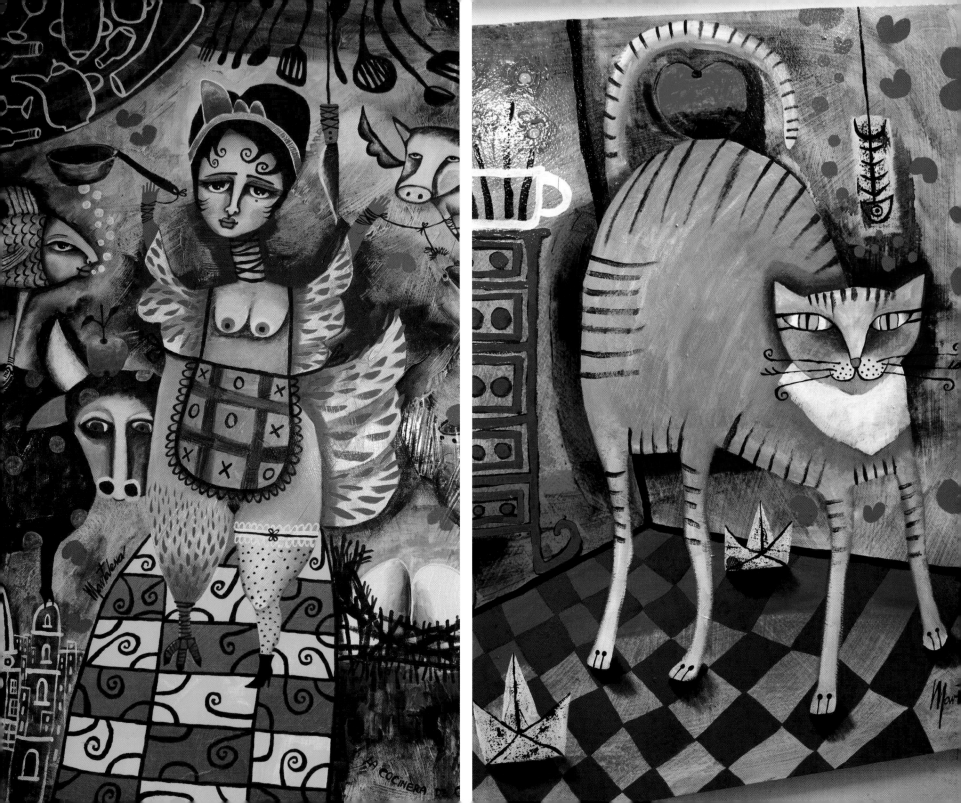

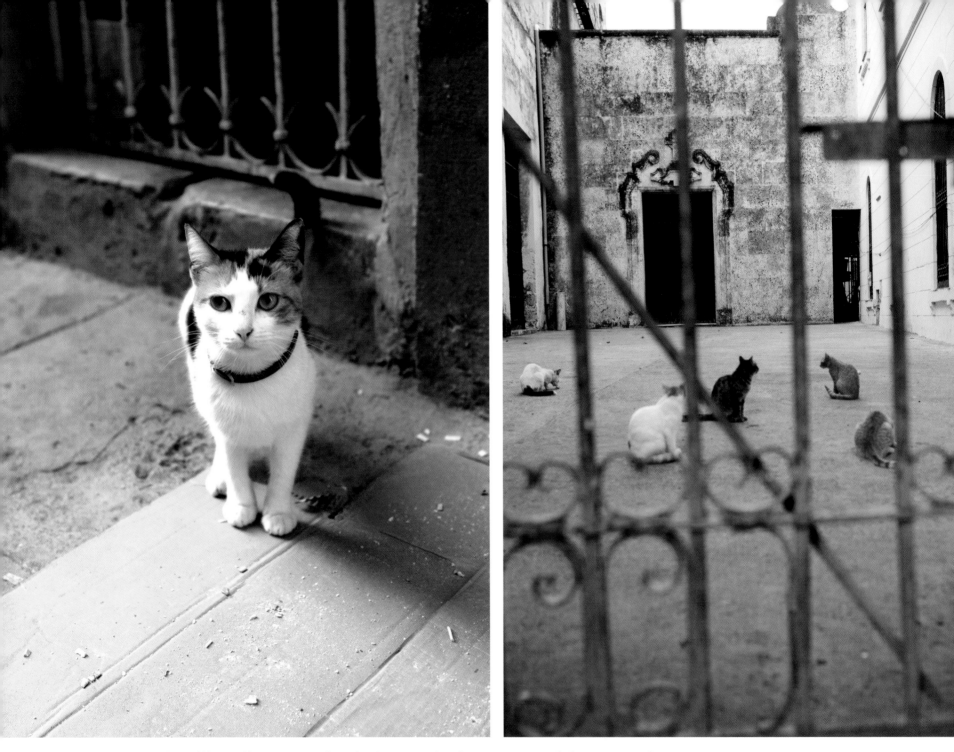

Un gato de Habana Vieja; dust, rubble, crumbling masonry, a collar and good grooming. Also, a kitty convergence, in which none appear too hungry.

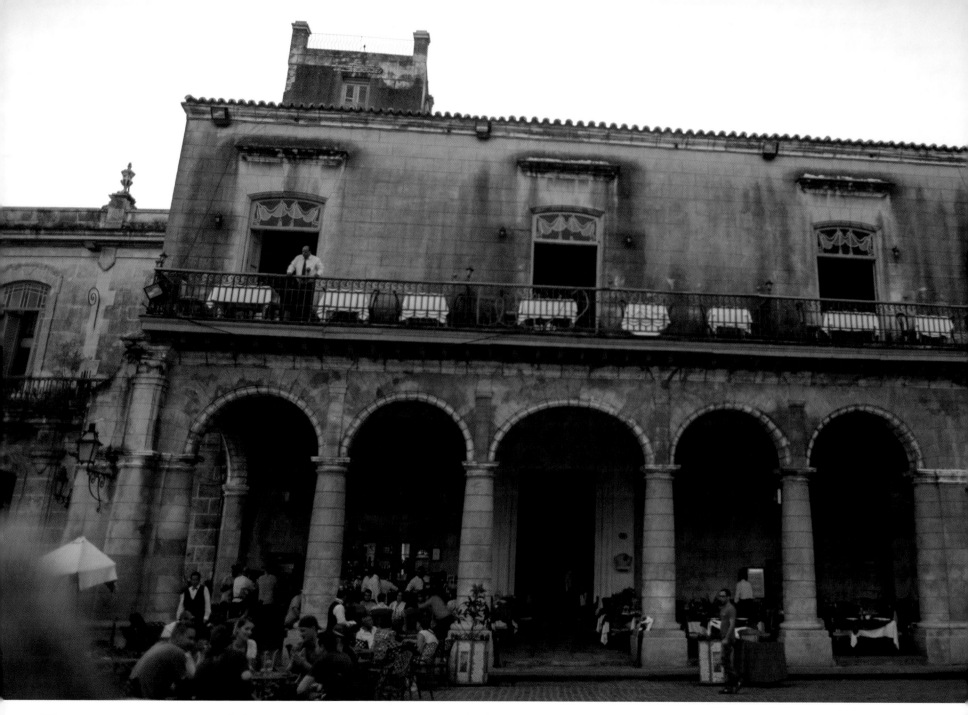

Then it was time to eat. This paladar is as picturesque as a prop in a low-budget movie, and sure enough turned out to be artificial, as in slick and awful. But in we went . . .

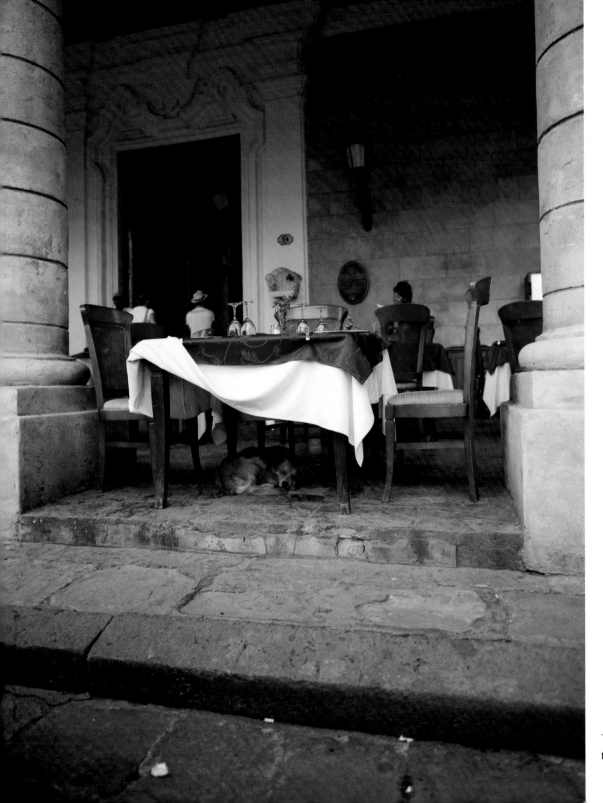

. . . because the dog under the table seemed well fed. Maybe that should have been a clue.

On the way back to the hotel from Havana Vieja the cabdriver pointed out a notable aspect of Cuban culture, so many women waiting for the bus, apparently headed to the same gala affair and sharing the same impatience. Some stepped off the curb for a better look up the road or into passing cars to see if they contained males. Maybe we stared; they looked so cosmopolitan, groomed, and coiffed but carefree, like Donna Reed gone wild. "Is okay in Cuba," the cabbie said.

Which made sense, considering Cuba's stable birth rate and liberal access to family planning. A few blocks down, two more women waited curbside, young, striking women. I glanced at the cabbie. He shrugged and nodded. I told him it was sad that the USA and Cuba could not be friendly. On the other hand, with good relations would come waves of tourists, displacing soulful character with sheer, numbing numbers of people on the go, seeking souvenirs and drinks and fabulous places to eat. He laughed short, as if he knew this, but how could he know? Maybe he saw it on TV in a hotel room. But writhing flesh suggesting sexual contact pronto with a heavy downbeat on TV seemed mundane by comparison, a sorry substitute for the real McCoy on the lean streets of Havana.

I feel so different when I'm with you.

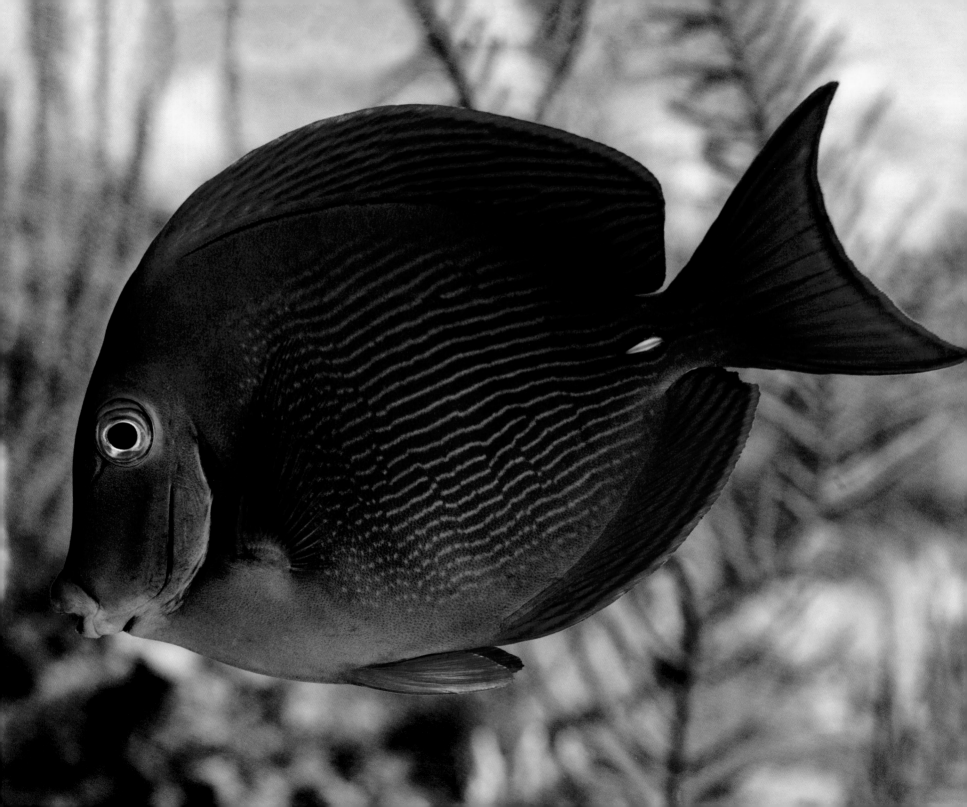

CAYO LARGO

Many nonstop flights from Montreal, Quebec, offload benumbed Canadians fleeing thirty degrees below, migrating to the tropics for a belly-up to the buffet in guayaberas, flops, and shorts for the all-you-can-eat extravaganza. All-you-can-eat is laughable in any system, maybe more so in a system suffering an obesity epidemic—maybe best spoofed in the Saturday Night Live skit "Trough & Brew." It touches a nerve in Cuba, engorging more on a single outing than some Cuban families eat in a day or two. Why would Cubans resent tourism?

While this question seems facetious, it touches another key variable that will swing one way or another when power shifts. That is, will a strong reaction against deprivation and hunger unravel the tremendous progress to date? How can a tourism paradigm of all-you-can-eat be acceptable to a starving people when they get their chance to choose?

Havana to Cayo Largo is a more arduous journey than Montreal to Cayo Largo, but *arduous journey* soon becomes redundant; all journeys in Cuba are arduous. This one began with a 4:00 a.m. wake-up for a 4:30 pickup at the Copacabana and an hour bus ride to the airport for weigh-in, passport clearance, security clearance, and another two-hour wait—time enough to ponder the ornate, over-the-top, fancy-pants paladar of the night before. Make that a few hours before, when three stuffed suits met our needs in theory, beginning with a theoretically edible meal. We know swordfish. We don't eat swordfish, because it's full of mercury, and it's caught on longlines with horrific by-catch, including sharks, seabirds, turtles, marine mammals, and other fishes. The biggest suit said, "No! Not swordfish." But it was swordfish, cooked to a turn then turned and turned again, maybe since Tuesday, until it could have served best with some nails and leather uppers. Ah, well, everything learned would be suspect, but prevailing currents, inclinations, and objectives did indeed trend toward the truth as represented, kinda sorta. A blustery, chill draft came in through one of the huge archways, but the shutters would not be closed. The big man said, "No! Impossible! Shutter must stay open." Totalitarian rule trickles down just like the character of any management regime in any hierarchy, making mealtime and much other time in Cuba a tediously Communistic experience, which is not a good thing but an oppressive presence made worse, delivered with the iron fist for your own good. Okay, for the good of the state, which is not your own good but their good, or a vague, conceptual good that is no good at all to anyone but a very select few.

Lest we spiral downward in perception, it's best to remember that the most methodical, deliberate exploitation of marine species in the Pacific Ocean is directed through WESPAC, the Western Pacific Regional Fisheries Management Council. Here too a most fragile segment of nature is "managed" by vested commercial interests—WESPAC resides in the Department of Commerce, not Interior where it belongs. WESPAC's history is infested with commercial conflict of interest, including swordfish longline fleet ownership, along with attempts to double and triple "take" (incidental kill) of endangered/threatened turtle species. Adding insult to injury, enforcement agencies apprehended swordfish longline vessels full of female swordfish caught in spawning time. WESPAC had a president whose son captained those vessels at the time of apprehension. That president stepped down, because discretion is the better part of corruption.

So the seas of the world churn in stormy weather and massive commercial extraction by any means necessary, mostly by corruption—by the activity casually branded as overfishing. The phrase is played so often that it loses meaning and consequence, except for the very real consequence of death to oceans.

So the sun rose on the modest block building serving as commuter terminal, and after two bare-bones espressos in a plastic pill cup at two and a half CUCs each it was time to go. A CUC (kook, rhymes with juke) is a Cuban *convertible* peso worth about $1. Cuba's two monetary systems facilitate tourism by separating the real world from Cuba world. The traditional Cuban peso depreciated steadily since the early nineties and now trades at about twenty-four pesos to one CUC.

The flight from Havana to Cayo Largo took forty-five minutes on a fifties vintage, top-wing, two-prop, Soviet airfreight transport with ten-inch portholes every four feet welded into place. Updated passenger seating appeared to have been installed in the eighties. The engines revved fairly high far longer than a normal warm-up. Had we taken off yet? No, not yet. Takeoff came a while later, just after seating assignments got sorted to make room for a Russian bodybuilder who probably never heard of Mr. Clean but was a dead ringer for the hairless hygiene hero at five foot one with grapefruit biceps, Popeye forearms, ham-shank shoulders, and adequate torso inflation for the Macy's parade. He sat beside Bubba, who presumed that the beefy fellow spoke no English, who handed his cell phone back for the photo op and said, "Be sure to get the top of his head."

Cayo Largo's big hotel is the Playa Blanca with hundreds of rooms, many bars, restaurants, chachka shops, and meandering grounds. It was likely rendered "beautiful" on the drawing board but got jam-packed with people—tantamount to Cuba tourism as Waikiki is to Hawaii tourism. Eaters and shoppers will gravitate every time to an overlit hubbub to eat and shop, stimulated by glitz coming on in waves with abundant lighting, many choices for many things and an air of "happening." The grounds felt like an event, with so many people mulling to nowhere, touching, buying, eating, and moving to the next wondrous attraction. Here too the staff is service oriented and likely grateful. The all-you-can-eat buffet seems egregiously contradictory to ambient conditions elsewhere, but the hungry countryside is soon forgotten.

Package deals on basic digs with a buffet usually bring in budget travelers, and the all-you-can-eat crowd tends toward a narrower worldview. So it was at Cayo Largo. But the oblivious attitude toward warm, clear reefs was, to a hard-core, free-spending snorkel exec, shocking. Many Cayo Largo reefs are compromised with invasive algae, likely caused by torrents of gray water running from the hotel laundry facility into the shallows and on to deeper dive

sites outside the barrier reef via direct currents. The dive leader sharing this theory did not hesitate to state his dissatisfaction. Eight hundred new tourists arrived early this morning, some of them already among the busloads delivered soon after arrival to queue up dockside at Villa Marinara, with their beach bags, bottled water, Styrofoam noodles, and, here and there, a snorkel set, but not too many. They would be delivered to the shallow snorkel area nearby in time to see the latest gray water outflow from the sheets and towels of their predecessors departed only yesterday. The relentless cycle had the reefs in submission, and snorkeling at an ebb in popularity.

Never mind, deteriorating shallow reefs at Cayo Largo with no recovery plan in place and continuing phosphate effluent would be a subject for review just ahead. For the time being, the deepwater drops outside the barrier reef in the phosphate flow were also covered with invasive algae. The inside reefs were nearly dead. Of some consolation were the reefs on either side of the outflow current; they remained free of invasive algae.

The good news was that the new management team had identified these reefs for emerging value and would focus on restoration directly. The bad news was that identifying these reefs for real value may also be theoretical—but maybe not.

Our dive leader Pepe picked the low scrub algae with thumb and forefinger while we communed with the fish—pick, pick, picked as we sought optimum angles on stills and video. Why did he pick? His effort seemed futile as trying to trim a plantation greensward with thumb and forefinger, but, "I am always cleaning the reef, always." Invasive algae covered many acres on slopes and crests, in canyons and crevasses. Prospects for the long term seemed grim, because reefs can take enormous punishment before dropping dead, and these reefs were on the brink. Once dead, they can take a lifetime or two in coming back—or longer if water quality remains toxic. Or they can disappear indefinitely. Recognition of the problem is a giant first step anywhere, and resolution in a system without committees, opposing viewpoints, or commercial interests is most often expeditious.

Fausto De Nevi was a dive leader at Jardines for six years until transferring to Cayo Largo, an ostensible promotion that took him from three dives daily, five days a week, to a desk, a cell phone, and a clipboard. On his day off, he flies home to Havana, where his girlfriend is a doctor. When asked for a few minutes to chat, he said yes, of course; we could take as much time as necessary to discuss anything, and that visitors from the U.S. were indeed an extreme rarity—a most welcome extreme rarity. He noted my strobes for their excellence, which is why

Cayo Largo manager Fausto De Nevi and his dog Fly, indicating honest intention for improving conditions.

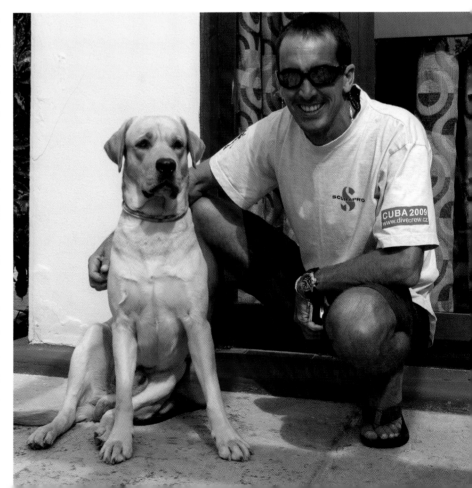

he also chose them for his rig. But his camera was an old Canon made to fit an even older housing built for a Nikon. His father, a machinist, saw the camera/housing incompatibility and corrected the mismatch by retooling a few things to make the system work. This was not a casual anecdote but a corollary. "This is Cuba. We work with what we have."

The many anecdotes and their common moral were endearing, as intended. But it was time to work with what we had, and I hoped to reconcile our predetermined differences as well as he had done. I told him, "We're not here for the U.S. We're not here for Hawaii. We're not here for Cuba. We are here for the reefs."

"Yes. Good. Me too."

I reminded him that many travel guides advise "getting off the beaten path of tourism if you want to gain insight to the real Cuba" to see what the place is really all about. But our task in Cuba was to take a closer look at the beaten path of tourism, to see where it might be headed and just how beaten that path might become. And where might that path lead relative to revenue at the expense of nature—relative to global tourist demand for the last, best reefs on Planet E.

Fausto listened and nodded, either fending off as he conjured his own natural defense, or soaking it up. Breathing deep to gather his thoughts as a

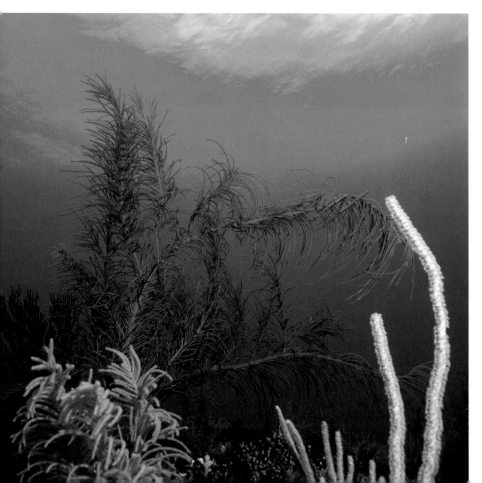

reflective, deliberate man, he said, "Our path will not lead to the place you fear." Sanguinely put, I thought, with subtle inference that my "fear" was culturally induced—U.S. culture, that is: swimming pools, movie stars. Never mind what I thought; the astute political representative must avoid confrontation and direct challenge, I thought, opting for nuance, so that little seeds could be planted, and they might germinate at some point of recall with insight. Moving onward, he politely pointed out that 1 percent of U.S. reefs are now protected, while Cuba effectively protects 30 percent of its reefs. Beyond that were the Cuban government's general rules currently in development and implementation that would protect 100 percent of Cuba reefs.

I nodded: point taken. I reminded him that those stats might roll off easily enough, but as we spoke the hotel laundry spewed phosphates into the mangrove shallows for direct delivery to the outside reefs where they triggered invasive algae infusions.

Fausto nodded, this time with heavier eyes cast downward; yes, he was aware of the laundry soap/phosphate problem and had notified the minister of

Cuba claims flora and fauna variation and abundance in clean, blue water. This pristine example in Cayo Largo does not show the problem.

tourism that a solution was warranted. "In our current program under Raúl, protection of reefs is on the fast track. The Coast Guard is on notice. I cannot say when a solution to each problem will be available, but I can say that this is a top priority. We will be working with the minister of tourism to get the changes in place in a few months, not years. A biological station at Jardines provides constant data on water quality, biodiversity, and numbers. If we get a biological station here at Cayo Largo we will have that data and can manage accordingly so the reefs will rebound."

The Cuban Coast Guard was on patrol for phosphates? This too sounded rhetorical, verging on fantasy. Then again, the U.S. Coast Guard will nail any vessel for dumping or even leaking oil, theoretically. So who's to say which rhetoric is fantasy? And who in the world, including its totalitarian dictatorships, could ever match the slick sophistry and propaganda spewing from the Gulf of Mexico after British Petroleum destroyed it—devastated an entire sea ecosystem on a mechanical failure and covered it up. *Come on down to the coast. The water's fine, and the folks are luuvin' the seafood.* Communist Cuba's got nothing on BP when it comes to rhetoric—make that lies, obfuscation, and distraction. But the Gulf of Mexico is another subject with other concerns. As a dynamic marine ecosystem or an example of anything but failure, the Gulf of Mexico is gone.

And Cuba reefs are on the rise, or should be. So Fausto's words seemed questionable. They could frame another blue-sky scenario for utopian harmony with angelic illustrations of reefs and humans thriving in close proximity. But I didn't think so. The Cuban government seemed keener on common sense to achieve the greater good—a greater good tied directly to revenue desperately needed to retain any semblance of stability and therefore believable. Whether Cuba's intention here is devoid of political corruption or evolves in spite of it seemed incidental. This was far different than in that other archipelago once occupied by U.S. interests, Hawaii, where the state government has declined for many years to protect its public trust and maximize tourism revenue potential. Why has Hawaii failed? Because the greater failure results in greater return for a very select few, and that select few is within the political machinery controlling Hawaii's public trusts. The irony is in the future, in which regime change in Cuba may allow degradation of reefs, while regime change in Hawaii may be the only chance for reef recovery.

Doing the right thing does not prove goodness, but it most often optimizes return on effort. The Cuban government displays more foresight, leadership, wisdom, and political will on reef redemption than the Hawaii government has ever done, and Cuba's reef policy will yield exponentially greater return in revenue and natural stability. The Cuban Communists get this. We don't know that Hawaii politicos don't get it, but we do know that self-interest and corruption trump reefs in Hawaii.

The Cayo Largo challenge: the prevailing vegetation is small, flat-leaf algae smothering massive segments of Cayo Largo reef and substrate. Hotel laundry detergent likely triggers and then accelerates algae growth.

I shared my sadness with Fausto that the U.S. and Cuba were not friends, and offered consolation: that the continuing embargo would at least mean less tourist pressure. He wagged his head as if weighing the pros and cons of fewer tourists and less pressure, and I elaborated, "Because I have to say that the busloads of tourists queuing up dockside don't seem to care one bit about reefs or reef species, and in my experience, that's because your shallow reefs are dead. So you attract people who don't care, who tend to have less money to spend than people who want vibrant reefs." Fausto nodded, no longer fending off. Then he shrugged and shook his head, as if for the record. His nuanced gesticulations seemed designed to convey the full range of acceptance/rejection nonverbally, in case of a hidden camera. Or maybe they were second nature. But he did care, both personally and professionally. He was on assignment, to bring Cayo Largo up to standards—the Cuba standard—and that would mean demographic discrimination if a more informed class of tourist would be attracted. Deference to the, shall we say higher, classes seemed contrary to the Revolución and more immediately challenging to the all-you-can-eat format just up the road at the Playa Blanca.

Well, a single mind cannot sort everything at once, so never mind the engorgement at Playa Blanca; Fausto's focus was on Villa Marinara as a dive destination and on Cayo Largo reef health in general, with faith that peripheral concepts like demographics, caring, and spending would take care of themselves, maybe. For the moment, he would begin with solutions to the most obvious, fundamental factors threatening those reefs. Raúl Castro has been known for ages as a non-waterperson, but that too seemed incidental to his commitment, to following through on the reef redemption program that his brother Fidel began. Surprising to a mixed free-enterprise/free-speech snorkeler visiting a Communist country was the range and frankness of opinions expressed freely on many subjects.

No spearguns in Cuba? I thought things seemed more relaxed around here lately.

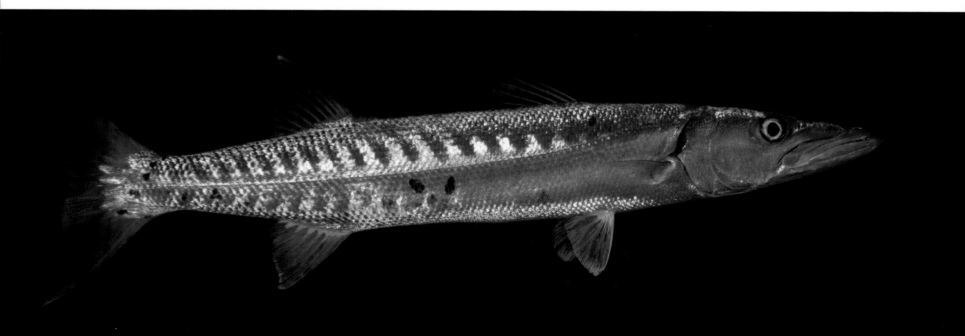

Down the road in Jardines de la Reina, dive leader Michael (Miguel) Echemendia, age thirty, who dove since age eight and learned the tough side of diving in the Cuban military, would praise Fidel for establishing the reef values so critical to *el Jardines*. Back in Cayo Largo, Fausto said, "Fidel was not a waterman. He was a predator. He always loved Jardines and went there to fish. He knew what he could kill with a speargun. Today, spearguns are banned in Cuba. If you are caught with a speargun, it will be confiscated."

That was news, but speargunners represent far less threat to marine life than do nets or longlines or any mechanical form of life extraction from the sea. A spear can only kill one fish at a time, and though unethical, unsavory practitioners occur in any pursuit, speargun damage is light compared to the rest. Then came the big news: "We have very few [fishing] nets in Cuba. After this year we will have no nets. Nets and spears will be confiscated. The government may also confiscate boats that are caught with spears or nets."

I listened, nodding to counterbalance my disbelief. Banning spearguns and nets? What would such bold moves require in Hawaii? "Your effort here seems honest. I mean the effort in Cuba. What is the motivation? Why now?"

Fausto said, "We realize what we have and how important this effort can be. We are also aware that other reef systems are in serious decline, and that ours can be maintained in excellent condition if we pay attention to a few fundamentals."

"You are aware—do you mean because of media exposure?"

"Yes, of course."

"Like last year, when CNN sent Anderson Cooper down?"

Fausto laughed short. "Yes. That. Yes. Many people saw, and from them more people became interested. But we couldn't understand why CNN came with so much equipment, more equipment than several boatloads of

What is the motivation? Are you kidding?

divers would bring over several weeks, and they came away with less than a minute showing nothing but Anderson Cooper underwater."

"That's what they do. Showcasing the anchorman shores up ratings. Media coverage on any subject often tends to be more about a celebrity and a personal drama than the news item, but still you got the coverage."

"Yes. More important than CNN are the scientists who come down to tell us that our reefs are in exceptional condition."

"You must know that Cayo Largo reefs are not in exceptional condition."

"Yes. We know. We hope to make things better."

"Two more questions, if you don't mind. The first goes back to the celebrity syndrome. The Hemingway Fishing Tournament is an annual event out of Havana. It's gone on for decades as part of a status quo, because Hemingway was so celebrated, and you have postcards showing him shaking hands with Fidel, with both looking satisfied to revere the other."

"Yes. I think you have accurately described this fishing tournament. But I can tell you that all sportfishing in Cuba is catch and release now."

"I can tell *you* what I think you already know—that a big billfish brought to the boat for a photo op and measurements and release will die anyway. I'm sure you've seen them go from shimmering green and blue, turquoise and yellow, and orange and red to ashen gray. They don't come back. They sink and drown, or the sharks get them first."

Cayo Largo is a tarpon haven. These big, gentle fish are not eaten but fought—or they're approached gently with an artistic eye, which they seem to prefer. But then who wouldn't?

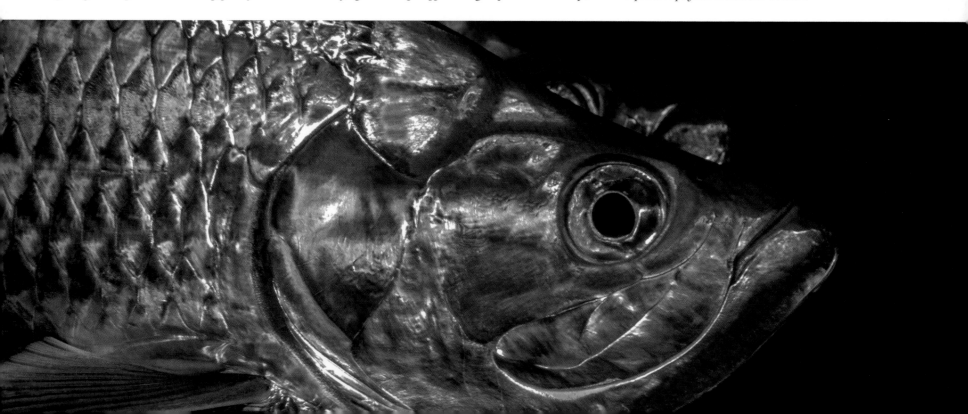

"Yes. But our catch and release is different now. It must happen very fast. The fish must not come out of the water, and it must be resuscitated fully. We are committed in this effort. We know that the big marlin and sailfish are sensitive, and our commitment is strongest at Jardines. Every fishing guide is trained in fish resuscitation. If a fish dies, the guide will lose his job."

Billfishing does not occur at Jardines de la Reina, where fishing boats cruise the shallow flats for bonefish and go a bit deeper for permit and tarpon.

Okay—Fausto would rather not dwell on the multifaceted psychological problems of billfishing. He would focus on reef recovery efforts and respect for marine species—efforts that are more than a promotional program; they are a life commitment, like so many things in Cuba. I didn't mind, because Cuba has rarely fallen short on commitment, and the fishing program at Jardines de la Reina is aimed at quick, effective results with a do-or-die approach to the objective, one more time.

So we moved to the most difficult aspect of marine resource management: the money. At any tourism destination, quality, service, and the caliber of the experience often decline as traffic increases. Cayo Largo is an example, with a single component of a wildly successful tourism destination—laundry detergent—severely compromising the reef ecosystem, discouraging reef tourism. Jardines, on the other hand, remains intact with only a thousand visitors

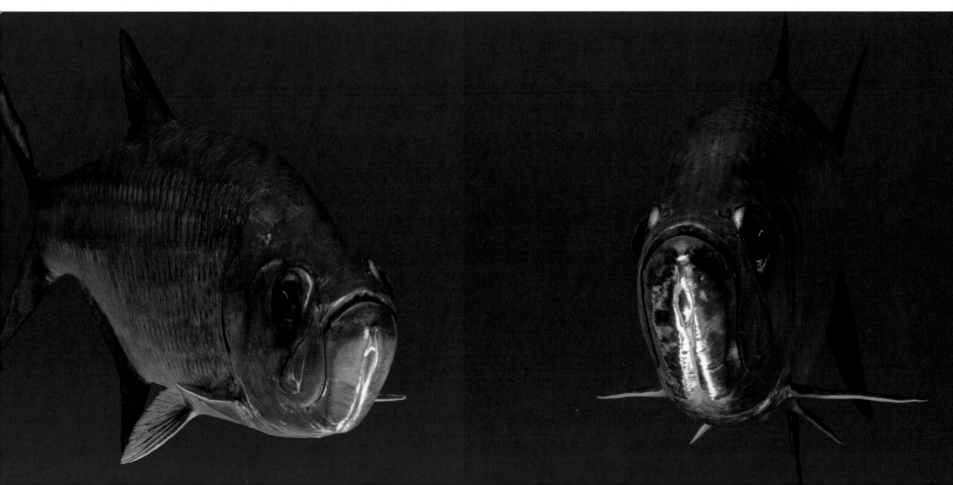

annually, with an average stay of six days. The six-day stay is another commitment, because of the arduous journey out—six to seven hours across open ocean, about seventy miles. The boats make the journey once a week for guest turnover and restocking.

Jardines visitors are about 70 percent fishermen and 30 percent divers. The two groups are segregated, maybe because of dramatically different appetites, behaviors, perceptions, and values in regard to reef habitat and habitués. Remember: the aquarium trade invasion of Palau began with boatloads of reef pillagers snagging colorful fish alongside boatloads of diving/snorkeling tourists. The pillagers were taking, taking, taking, while the diving/snorkeling tourists were spending an average of $1,000 per day, each. The reef raids sweeping life off the reefs of Palau ended as quickly as they began. Hardly dumbstruck for long, reef advocates prevailed in spreading the word, until a national plea and plain common sense led to the Free Republic of Palau banning the aquarium trade in short order. Fishing at Jardines is not brutal like aquarium collecting, but fishermen and divers often bond differently and not with each other.

Fishing at Cayo Largo and Jardines occurs in and near the mangrove flats for three species: tarpon, bonefish, and permit. Only fly-fishing occurs, requiring very light tackle. As with many topics in most places, the more opinions gathered, the wider becomes the range of answers. Still, a general attitude emerges, that fish protection is primary. Fausto displayed the big-stick rods with four-wheel-drive transmissions historically used to muscle giant fish to their deaths, so fishermen or women otherwise inadequate to match strength, wits, and skill with such a beast might claim victory after all. "These are now illegal. Now we use only this." He then displayed the ultralight, wispy-thin fly rods and fly reels with twenty-pound-test lines requiring more skill if a fish is to be brought to the boat. Ten-pound test would make a more level fishing field, but it's not utopia yet.

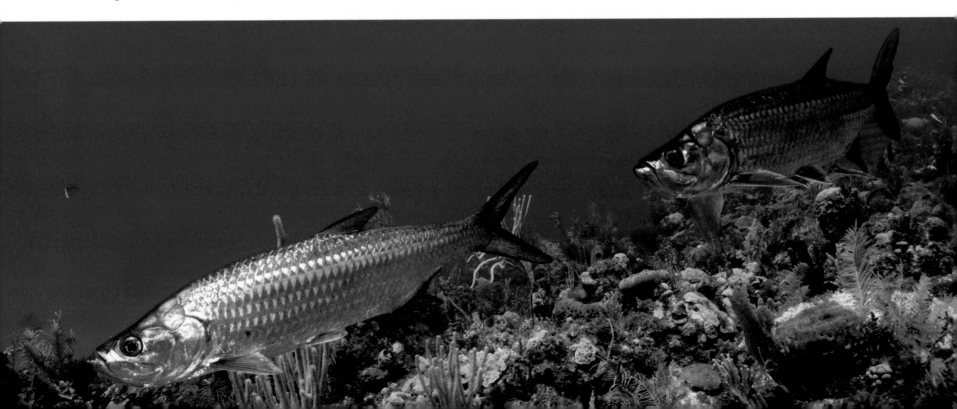

Fausto's demonstration of ultra-light fishing tackle was meant to impress and please, but I reminded him that the fish still has nothing to gain from the encounter. He was like-minded, or at least placating: "Yes. I know. But we do what we can to reconcile our need without hurting too much."

Methodical but likeable, official but sympathetic, Fausto seemed cautious but also sincere and committed. We moved to tougher questions. "Are you aware that Jardines de la Reina and all Cuba reefs are already compromised as never before?"

Looking quizzical, as if a trick question might pull the rug on the Revolución's reef redemption, he stuck his chin out to take the shot—"I would like to be aware."

"Do you know how the lionfish got here?"

Lionfish occur naturally in the Pacific Ocean in moderate numbers that are kept constant by predators, mainly sharks. Lionfish are known for their uncanny beauty, their facial expression and many flourishing squiggles, fins, and quills. The venom in those quills can ruin your day. Their voracious appetite in turn controls the food chain links beneath them.

Lionfish now ravage the U.S. Atlantic Seaboard south and into Caribbean and Gulf waters. They come from the aquarium trade that fills home hobbyist tanks with these and many other reef species, destroying reef habitat and compromising species in source waters, then devastating reef species in destination waters. Fausto said, "The Miami Seaquarium lost its lionfish in Hurricane Andrew in 1992. The first lionfish report at Jardines came in February 2009."

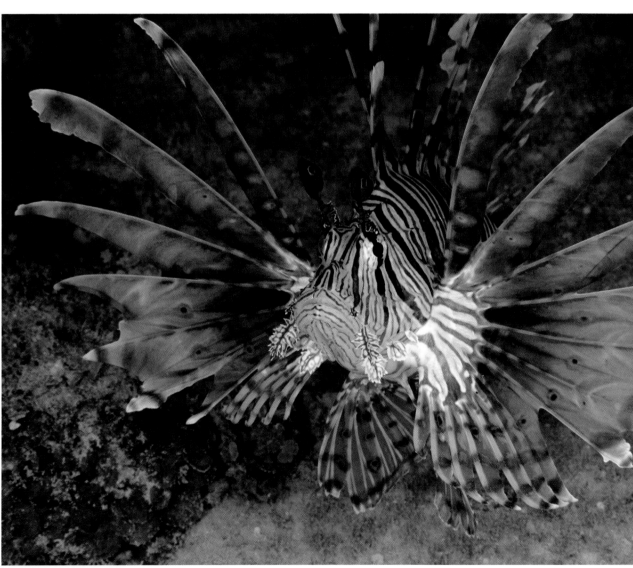

Lionfish occur naturally in constant population numbers as beautiful creatures in the Pacific. They now occur uncontrollably in the Atlantic and Caribbean as a lasting curse of the aquarium trade. Trafficking in wildlife for the pet trade is a bad idea, even if a few lowbrow grunts really need the money.

Well, it took seventeen years, which would be a harsh sentence but is no time at all to significantly compromise an ecosystem, one of the last best at that. Fausto also knew that the Andrew/Miami release was a cathartic accelerator of a process that began long prior, when home hobbyists realized their lionfish were too big and too voracious to keep, and so released them to the wild. The same phenomenon occurred with Burmese pythons, now threatening to engorge South Florida. Wildlife trafficking for the pet trade is bad in any political system and will kill nature around the world for as long as a greedy few are allowed to continue.

Lionfish serve as a scapegoat species in the Atlantic and Caribbean, taking the blame for irreparable ecosystem compromise, while the culprit is the aquarium trade, a voracious scourge of self-satisfied hobbyists and commercial facilities fed by a commercial juggernaut that voids reefs and sells the critters by the millions every year. I shared with Fausto a typical response to the lionfish devastation from an aquarium trader: "You know, we've taken the rap on this lionfish thing for way too long."

"The lionfish didn't swim here." Fausto said the lionfish population exploded because of no predators in the Atlantic—because Atlantic shark species never learned to eat lionfish, and lionfish easily discourage any predators with large, venomous spines in their fins. Now indignant people frenzy to kill them one at a time, but that proved futile long ago—except to appease the most zealous humans and take the heat off the aquarium trade. An experiment in the Cayman Islands, south of Cuba, has proven effective. The Cayman experiment called for spearing the lionfish—not with a speargun that looks like a big-clip assault weapon but with a Hawaiian sling, a three-prong shaft with a surgical-tube wrist loop at the end.

Lionfish hover and make easy targets. The lionfish are then de-spined, a dicey process that renders dead lionfish with no venom threat, and fed to sharks, who soon develop a taste for them and become willing to suffer the sting in exchange for a meal. "We are teaching our morays, sharks, and groupers to eat lionfish. The groupers don't like the sting, but the sharks and morays don't seem to mind." Focusing on particular reefs, Jardines divers began killing forty to fifty lionfish per dive, de-spining and feeding them to sharks perhaps attracted to the activity on those reefs and to moray eels who live there.

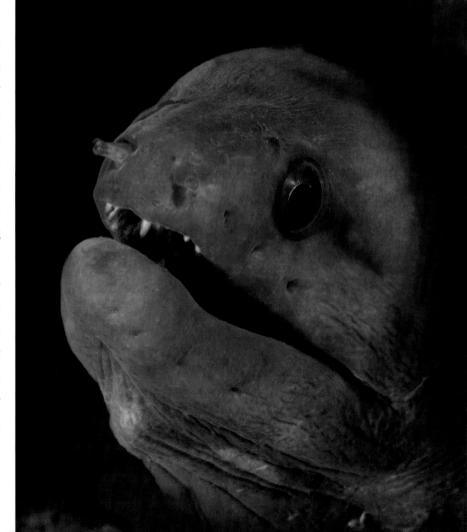

A green moray eel reflects: Frankly, I'd prefer canapés.

Now those reefs show only two or three lionfish per dive, and the sharks and morays are taking live lionfish. "We think the problem is stabilized but it will not likely go away. We may see only two or three lionfish on a dive, or maybe none, but then going in shallow to the mangrove nursery, we find them by the dozens everywhere."

"Do you think the Cuban government would ever sanction the aquarium trade? You have so many fish on your reefs, and the aquarium trade swears up and down that its harvest is sustainable."

"I think not. Scientists and academics in Cuba are very good. I think they would demonstrate to the government that aquarium harvesting would be as damaging here as it is in other places."

"So you are familiar with aquarium extraction and the devastating consequence?"

"Yes. Of course the damage can be proven scientifically, with money and effort. But common sense tells us that chasing fish with nets through delicate corals and then taking all species to satisfy market demand will damage a reef system, as it has done in other places."

"Do you know that the former director of natural resources in Hawaii was an aquarium collector who worked to entrench the aquarium trade on Hawaii reefs?"

"How could that be?"

"The former governor appointed him for political reasons. The governor before that appointed a wholesaler from the aquarium trade as chief policy advisor."

"Shit."

Cubera snapper klatch: I have an idea!

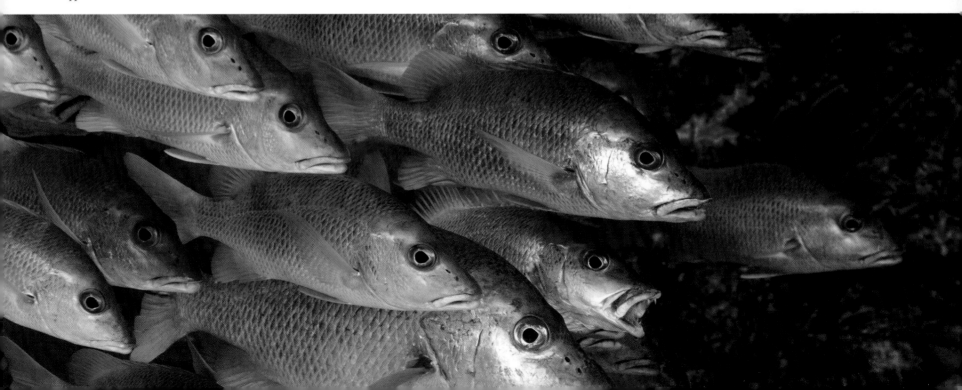

"Yes. It is shit. You have Communism. We have political machinery that compromises the public trust for money and power."

"The Cuban government would also not allow the aquarium trade because it calls itself part of the fishing industry. So no, it cannot be allowed here."

As a reef conservationist, I love the sound of *no commercial fishing. No nets. No spearguns.* Yes, fishermen often call themselves conservationists—the most oppressive agency in the Pacific, WESPAC, calls itself a conservation agency, under the aegis of the Commerce Department. The aquarium trade calls itself conservationist with bogus claims that taking vital species from reefs will help those reefs. Maybe the conservation ruse began with Ducks Unlimited, an outfit that does spend considerably on protecting wetlands, so Elmer Fudd can strap on his waders and blow the snot out of a few ducks, which seems, uh, self-sewving and skewed. And yes, tourism also has its destructive side. Tourism is still better than any killing or extractive behavior, because sensitive areas can be protected with specific segments designated for tourists. When WESPAC organized a campaign in Hawaii (2005) to do away with Marine Protected Areas, it violated federal law by tampering in state legislation. But that didn't bother WESPAC then and hasn't slowed them down since then. Hundreds of fishermen showed up to support a sentiment, that they have the right to fish everywhere, no matter what. I testified that some Hawaii reefs need protection from fishing—*murmur, murmur*—and snorkeling and diving. More murmurs rolled around the room, seeking consensus on the tricky maneuver proposed, but it was true then and now. Wilderness requires no extraction and limited human traffic, which happens to be the format developed at Jardines de la Reina.

What is the definition of wilderness? Limited human contact; no extraction.

But other facets of totalitarian government factor into the equation. The first is the Revolución framing itself in terms of the greater good. Never mind that official policy under any government can favor one population segment or small group over all else; no system lives up to the purity of its original concept. Common sense dictates that civic contribution can begin only when basic needs are met—that would be the fundamentals of food and shelter. The paradox of the Revolución is that each person's civic contribution should be a priority—must be a priority. But food needs are marginally met for most Cubans. Tourism has spawned a separate economy among tourism employees who serve visitors from the free world. Tips alone can change a life in Cuba, elevating a person or a family to stable levels with needs met. Given the acceptance and development of two classes, how can the government simply shut down commercial fishing in the name of reef recovery, yet continue to serve *mucho pescados* to the tourists? Especially here, where food shortage is dire among Cubanos?

The future won't go away and here again becomes another tricky facet. What if . . . What if the Castro era dissolves into mixed free-enterprise democracy? That may seem an extreme pendulum swing, but the question persists on pent-up demand—compounded by the all-you-can-eat buffet—for something to eat. Will the world's best reef program end in tartar sauce?

Fausto recognized the dilemma of starving people to save reefs and said the challenge is worldwide, not limited to Cuba. Nets, seine trawlers, aquarium hunters, and poachers are threatening marine species and habitat around the world, and those who work the extraction machine cry foul at every attempt to stop them, because they "must feed their children." Aquarium hunters in Hawaii scream bloody murder over a million dollars of gross revenue divided among fifty families—that's $20,000 each, but of course it's far more than that. They're poaching, exploiting the opportunities of democracy, where they can scream bloody murder as they commit their crimes and repeat as necessary until they're stopped, by enforcement of the law or the formulation of new laws, once voting constituencies can effectively support protective caveats. And that takes time—in a democracy.

Wilderness confidential. The baby blues and this fish are juvenile creole wrasses.

Fausto summarized in rational terms. "Every system has its problems to solve. We have the ability to bring our reefs back to health now, and that will mean better lives for all people in Cuba. As you may know, our view is usually long term. And I will say again that this long term view is on a fast track."

All info and opinion were subject to contradiction from other sources, *mas o menos*. But the general picture came into focus. For example, a Cuban man passing by the dining terrace at Villa Marinara was openly dissatisfied with the ban on fishing at Cayo Largo—"Fishing is not banned here because of the park but because the fishing company pays the government a fee, so only Avalon can go out to catch fish. But not us." I reminded this man that if the place was fished out, as so many places are, we wouldn't have visited (wouldn't be dropping a surgeon's weekly salary as tips). He said, "Yes, tourists bring money, but not enough to support the government, and we need to eat." So it seems that dissent is tolerated in Cuba, and the Cuban conservation movement is not motivated by love of nature but defers to practical gain. That should come as no surprise. Conservation is a nonstarter everyplace if it can't reconcile with commercial interests. What is surprising is that the fishing company, Avalon, is Italian, operating at a government-run resort in a cooperative arrangement with the Cuban government. The Cuban who complained that he has no fish to eat called it "fifty-fifty partners." We don't know the details, or if the split is computed on net or gross, or if self-enrichment creeps further into the system with tiny tendrils that could be competitive.

Black coral is gone from many reefs around the world—harvested down to 120 feet for the curio and jewelry trades. With it went vital habitat for many species, also gone from those reefs. It thrives in Cuba, often at 40 feet.

Another key in Cuba's Evolución is self-interest—an ever-present part of the human condition or the condition of any species keen on survival. Political doctrine tends to parse the obvious into complex theory that is most often painful to those who must apply the theory to themselves—like in Cuba, with sacrifice and deprivation for a Revolución that never delivered anything but. Self-interest most often recognizes human need in the host human first. With luck and a dash of altruism the best interests of nature and other people are then addressed. Or, the self-interest of a very few humans may lead to compromised reefs. Anyone who complains of no fishing does so on the presumption that plenty of fish wait just out there to be caught and eaten. One particularly shrill person in the Hawaii aquarium trade referred to exotic, high-dollar reef species as "sea rabbits. They're out there breeding so fast we can hardly keep up with enough catch!" Nobody took her seriously except for her husband, and he seemed confused, or maybe distraught. The fish are not plentiful, and they don't wait to be caught. Fisheries around the world are in decline, so the only solution would be to eliminate fish from tourist menus as well, and that would be another giant step in the right direction. Eliminating fish from tourist menus would ease the angst and resentment of a starving people, while shoring up the objective—healthier marine ecosystems. Most importantly of all, it would better serve the parity principles of the Revolución and insulate the reef recovery program from changes in Cuba's political system. More of the same or whatever comes next will continue to value Cuba reefs once that value accrues to all people equally.

Big groupers thrive on Cuba reefs—Nassau, tiger, black, and Goliath groupers like the one shown here. These big boys dart up nose to nose, curious as pups in passive-aggressive play sure to slam a sphincter shut. Friendly intentions are incidental at four hundred to five hundred pounds coming on full throttle. Fished out to zero on reefs around the world, a monumental species was converted to human waste. Where people cry out for more, no means of livelihood remain.

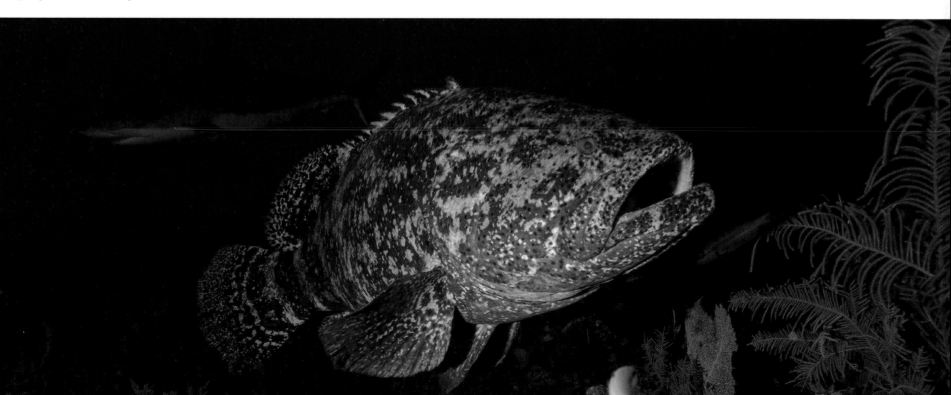

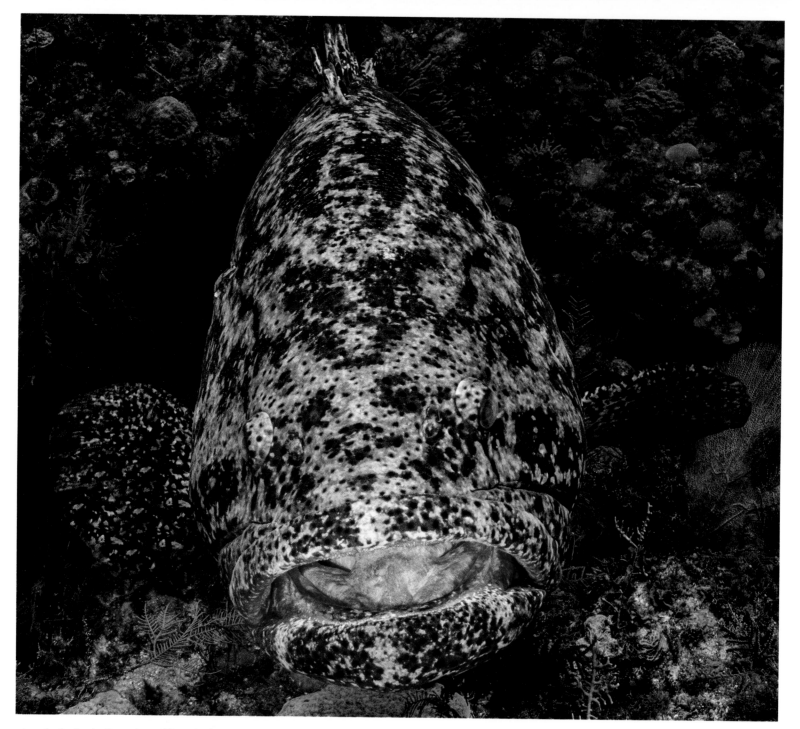

Won't you come in and relax by the fire? This cuddly Goliath seems curious, measuring about five feet between pectoral fin tips. How do you measure the value of her panache, her élan, her joie de vivre? Most places measure her value by the pound, once, and then she's gone. In Cuba she glows eternal—generating money on every visit. ¡Viva!

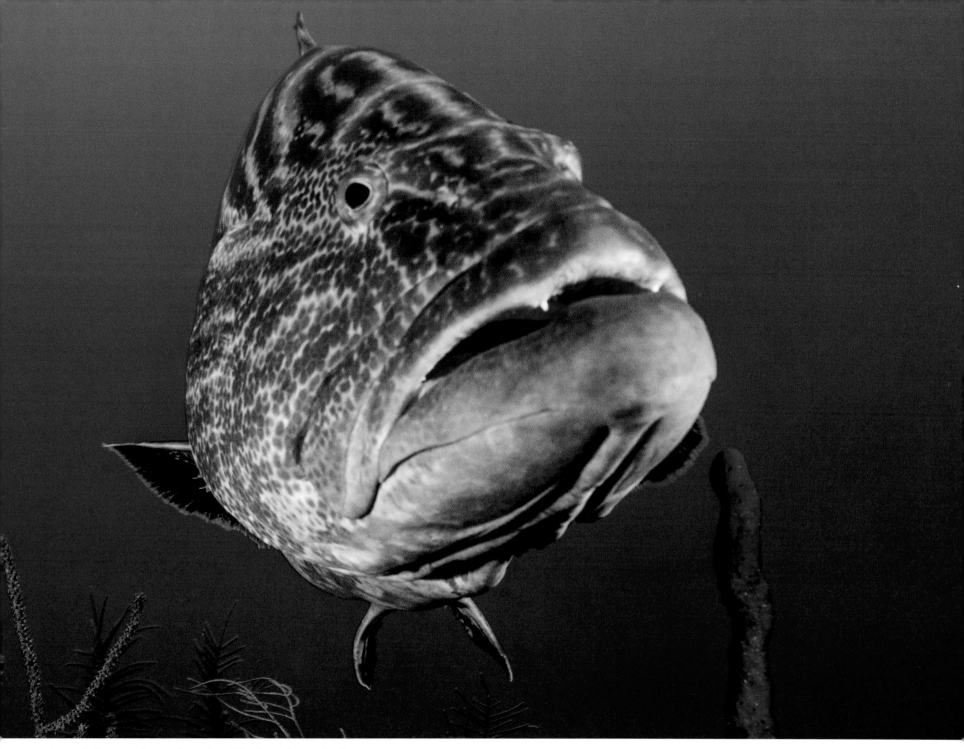

Nassau's gone funky. Nassau's got soul. Hardly a fish to be outdone on the photo op, Nassau groupers mug up on cue.

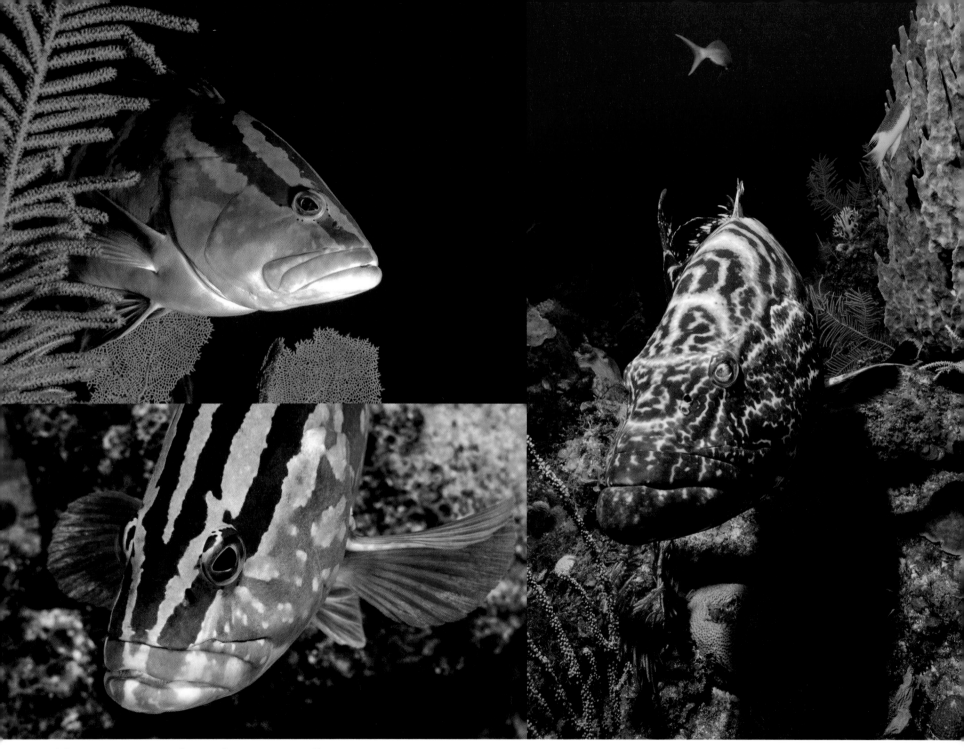

While some Nassau groupers are known to favor more artistic profiles . . .

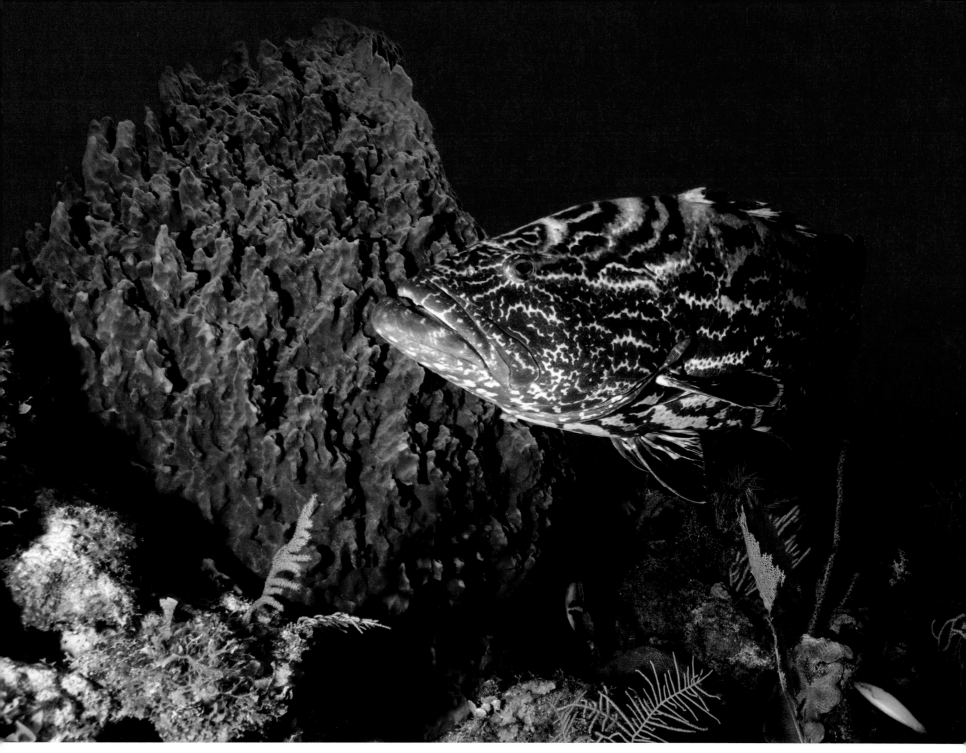

...other Nassau groupers strive for drama and composition. But alas...

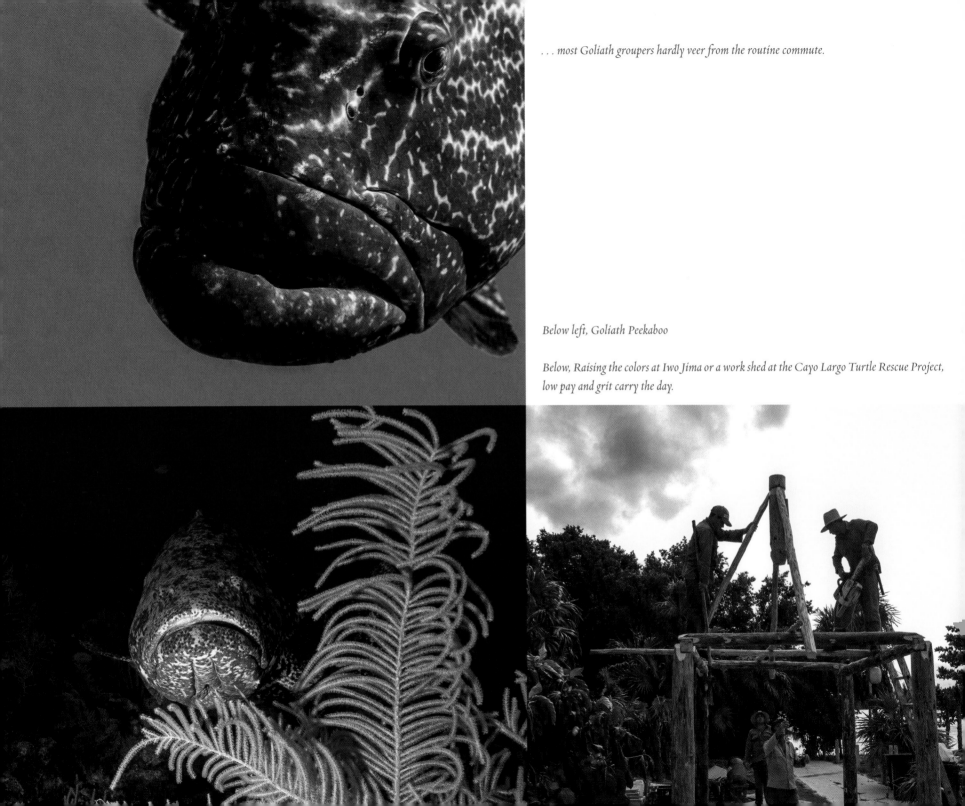

. . . most Goliath groupers hardly veer from the routine commute.

Below left, Goliath Peekaboo

Below, Raising the colors at Iwo Jima or a work shed at the Cayo Largo Turtle Rescue Project, low pay and grit carry the day.

An example of self-interest transcending the Revolución and undermining the conservation movement involves the turtle hatchling recovery facility near Villa Marinara at Cayo Largo that charges a CUC for admission. That CUC hardly covers costs, and the Cayo Largo turtle recovery staff of dedicated naturalists has proven return on turtle population recovery. Boat operators promote the turtle recovery facility and sell vouchers. The boat operators keep the money—so said the turtle recovery staff, which was where we came in. Some things don't change.

A Canadian tourist elucidated further on self-interest enterprise with dark potential—his boat's operators shagging lobsters, *langouste*, for tourist lunch, a free-enterprise practice in black-market wildlife, if you will, charging ten CUCs for lobster lunch on board. The tourii are said to love it. One day our

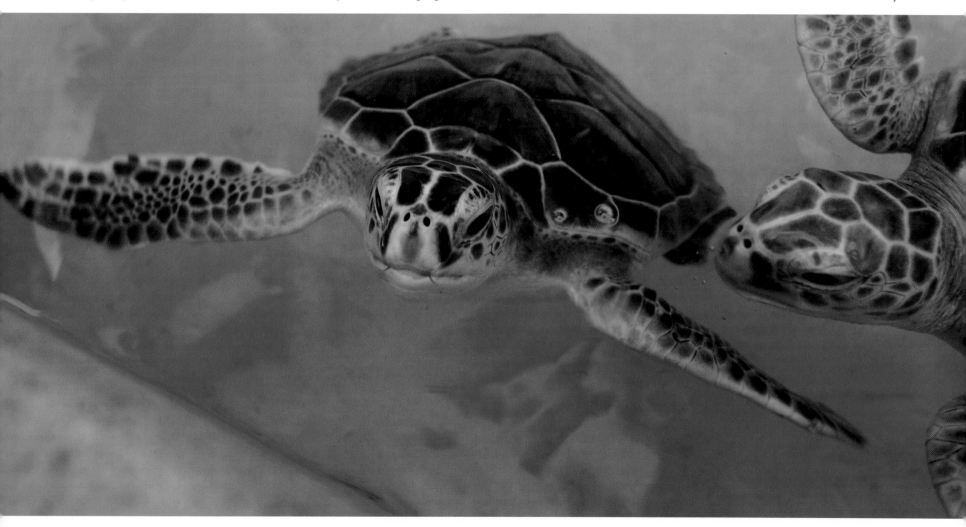

Cayo Largo green sea turtle youth cavort in shallow pools till they reach maturity and release in the open ocean. Meanwhile, their shells are brushed daily to discourage algae and bacteria that become toxic quickly in a closed system.

source counted twenty-six bugs taken. Some people will swear that many thousands of langouste inhabit those waters, and we call them bugs because they breed like insects. If not, this may be the next chapter of Snorkel Bob's bleeding heart saga of reef degradation. At any rate, a dive photog who loves a mug shot of a lobster can see one more survival hustle, a bad one favoring a small group of humans in the very short term.

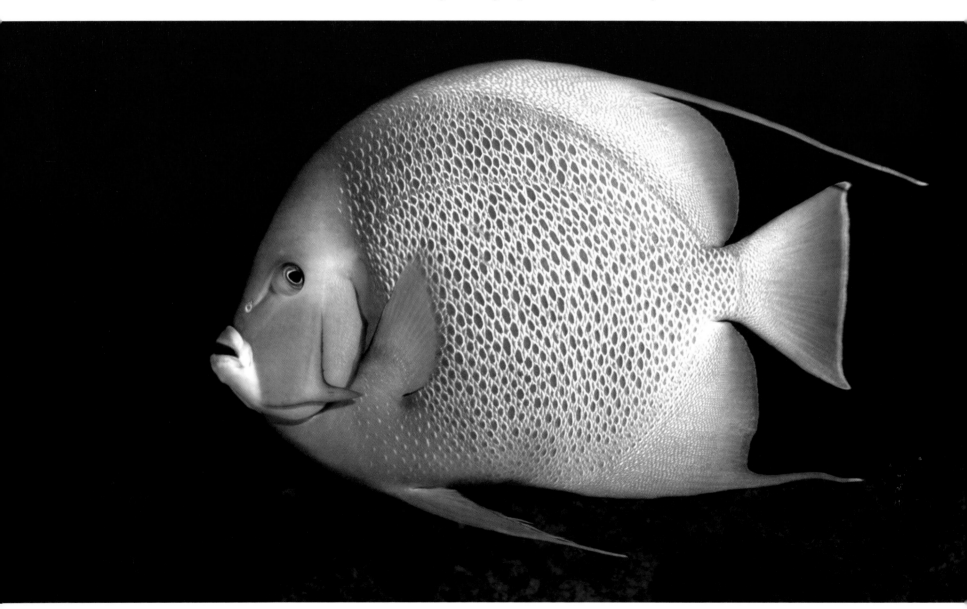

A gray angel

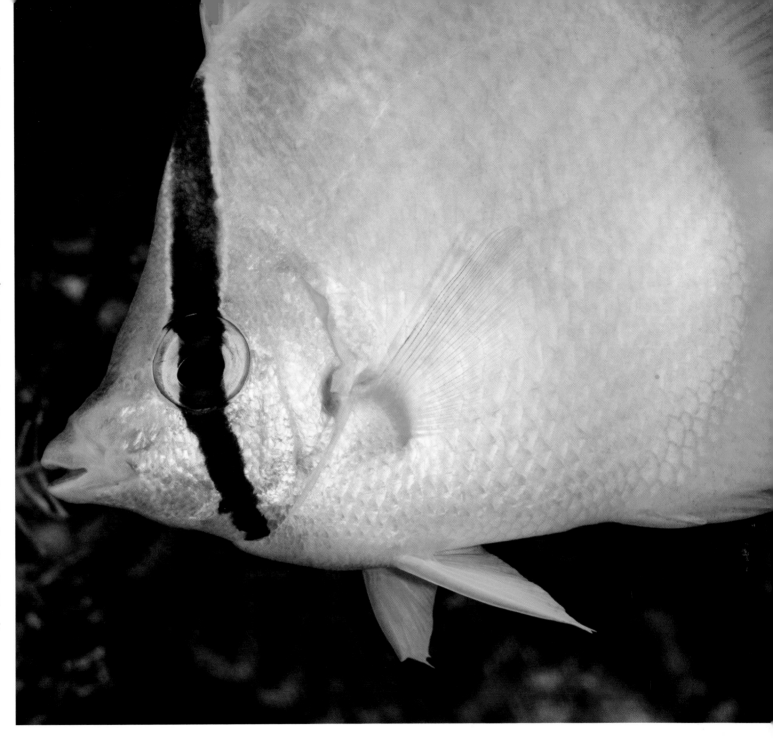

The Free Republic of Palau demonstrates evolving reef etiquette, in which dive leaders don't disturb corals or touch wildlife. Tourism can be a hustle for tips, but tourist divers are sensitive to local values. Tourists of affluence and mobility—those two endearing characteristics of the average traveling reefdog with scuba gear and camera equipment—comprehend values from one place to another. Insight to other people and their approach to reefs is part of the joy of travel.

Several Cubano dive leaders grabbed little critters to present for the photo op, as if a tiny, delicate creature would endure the pinch between thumb and forefinger none the worse for wear. But it won't.

A spotfin butterflyfish.

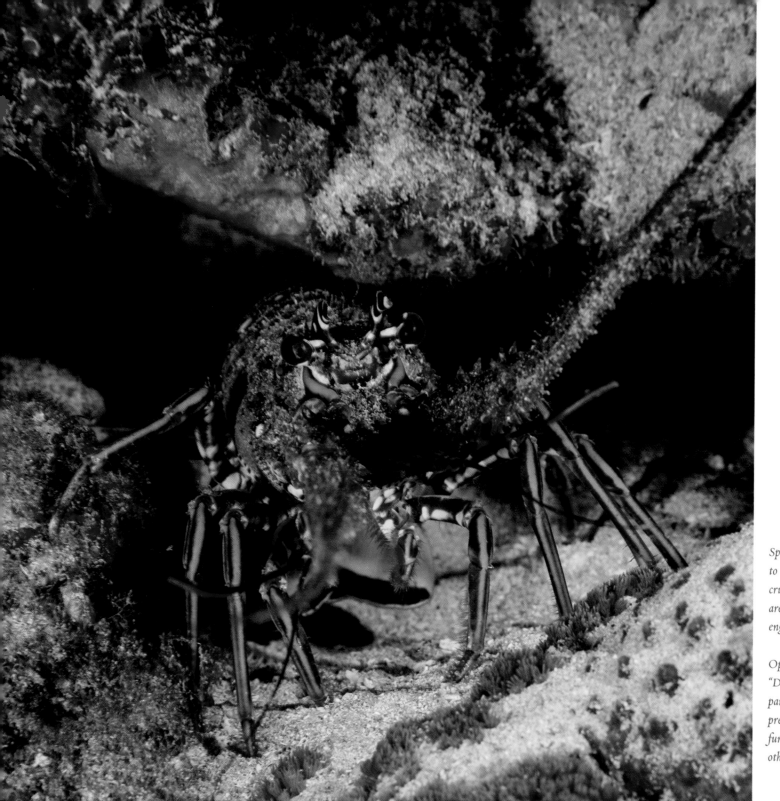

Spiny lobster, langouste, are common to healthy reefs. Circumspect as any crustacean low on the food chain, they are nonetheless more colorful and engaging than many vertebrates.

Opposite: The Tubes said it best in '76: "Don't touch me there." Tiny moving parts cannot maintain their clockwork precision once grasped. Relocation will further expose a critter to predators or other unsavory exposure.

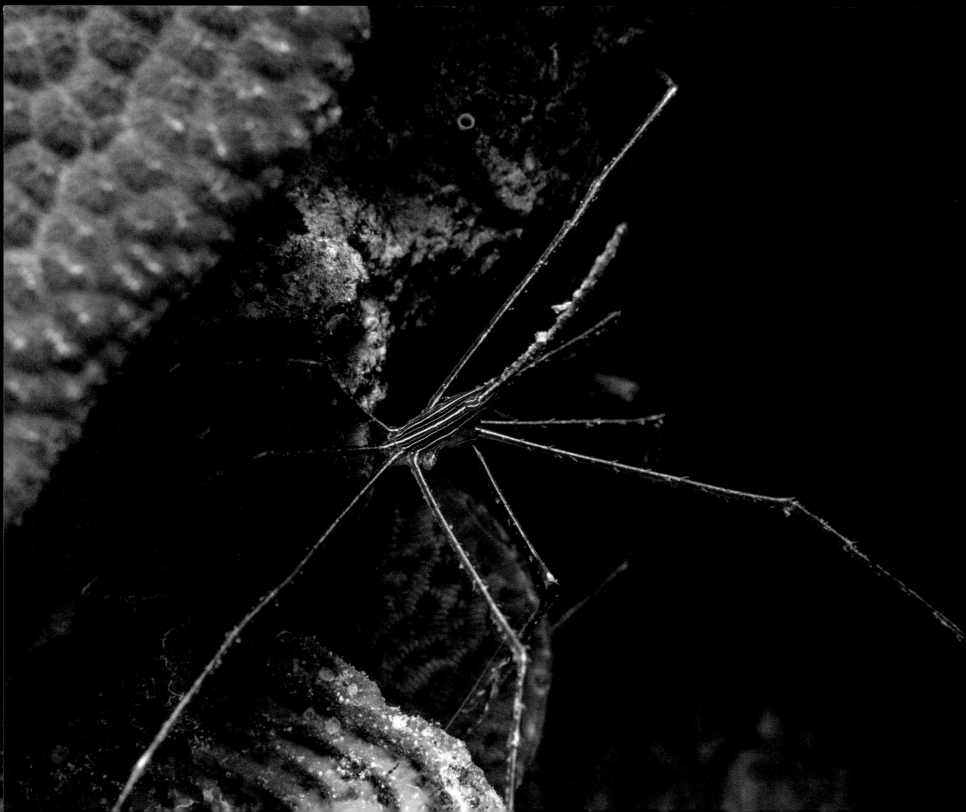

Handling critters has been common to the dive trade for ages, ensuring rich experience to paying guests and all too often highlighting dive leader machismo. The practice is rarely seen in this age, in those dive destinations that respect the fragile system. Cuba livelihood most often requires a hustle. But an expanding tourism trade without the high level of respect seen in other tropical tourism destinations will debilitate Cuba reefs in short order. Tourist divers can cause damage. That damage can be controlled with standards set by dive leaders, or the damage can be worse, enabling those dive leaders to generate a few dollars more in the short term, maybe.

A yellowhead jawfish burrow complies to the reef building code but can lose everything in a single touch. Such compulsive behavior is better directed at other holes on the home turf.

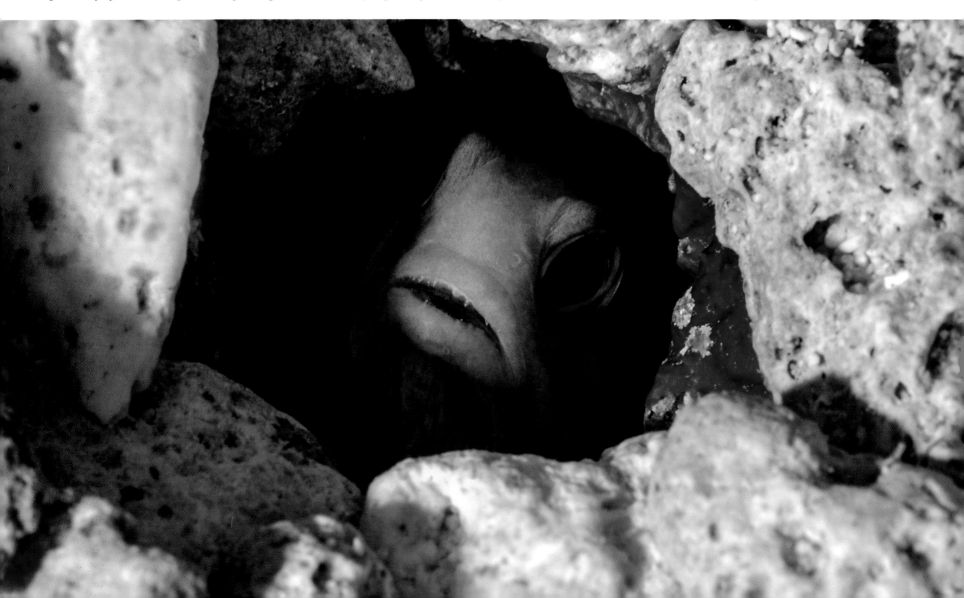

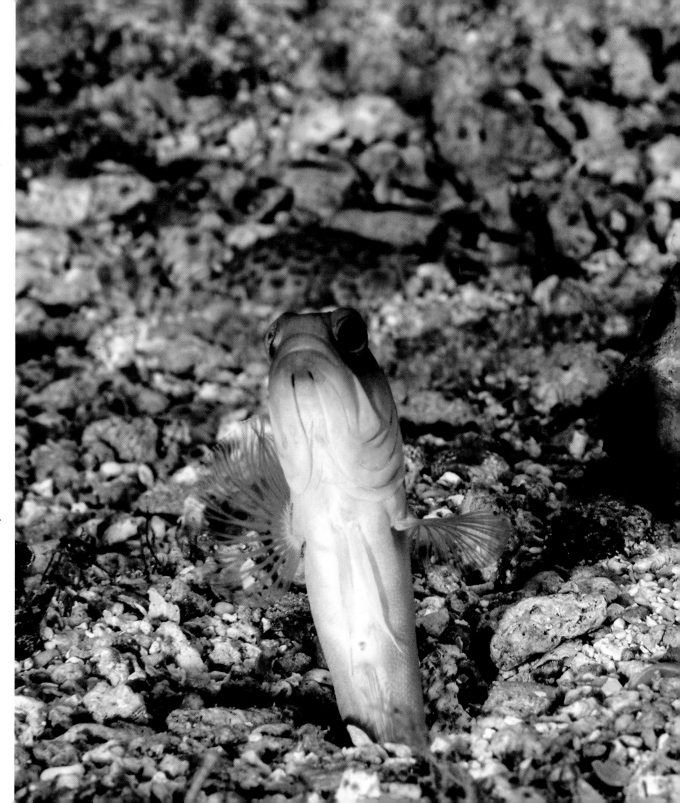

Which is not to say that Cuba dive leaders are not good watermen—they are. Octavio picking up trash and an anchor in Havana was no different than Pepe picking invasive seaweed or Israel poking lionfish. But a few stalwart watermen cannot change economic hardship or raise standards among dive leaders. *Pono* behavior is a personal choice. Pono is a Hawaiian word, meaning doing the right thing, and it often defers to the sideline hustle and self-interest, because every hustler hopes that thousands more langouste await.

Anna Marie came to visit Cayo Largo from Hungary and cruised those reefs with us. Prior to our arrival, she dove with a group of Rooshins, thick fellows top heavy on equipment with many extra hoses and calf-wrap dive daggers pulled on every dive to poke and probe, as if their curiosity were the dominant component of any given reef at any given time. Behavior conforms to host standards. These Russians demonstrated machismo and reef ignorance, or maybe they knew and didn't care, or maybe chronic control and superiority are burdens they'll carry for a few decades more. All dive scenes

Reef dwellers withdraw when big strangers arrive but re-emerge if the newcomers don't poke. Make like flotsam, show no threat, and a yellowhead jawfish will stretch to see: Who dat?

are subject to the macho display, but some scenes are fragile with greater consequence, warranting assertive leadership.

The Cubans have plenty to show for their efforts, like conchs aplenty on every dive, unlike Nassau, where only mounds of crumbling conch shells remain in the parking lots, because the Bahamians ate all the conchs.

The paradox here is that reef welfare left to Cuban dive leaders in a stable economy would allow these reefs to flourish—and that may come to pass. Meanwhile, one day after a strenuous session in open ocean with twelve-foot rollers and two hours diving in surge and current, it was back to the dock and *hasta luego* to the dive and boat crews and off to lunch and a lie-down. I forgot my dry bag and went back to the dock to fetch it an hour later—to find the crew headed back out with a fresh group for two more dives. Crew endurance and stamina are phenomenal and focused with love, often in spite of management. Sound familiar?

Back in Fausto's office, I sensed movement in a good direction: that Fausto is part of the solution and loves reefs from the heart, meaning that he works with an objective beyond self-interest. Why did I sense that? Because Fausto is now integral to management. He has influence. He's vested

Conchs are abundant in Cayo Largo and Nassau with a critical difference—Nassau conchs are shells of their former selves, piled in parking lots.

in success, but success in conservation rarely comes without love of nature. I proceeded to tougher questions yet, and he came through.

"What about poaching? In the Pacific we have poachers from many Asian countries. Most are from Taiwan or Korea. Some are independent and some are part of fleets that pay off corrupt governments to avoid prosecution. Cuba is far away from Asia, but you're still surrounded by hungry countries."

"The world perceives us as crazy Communists. This tends to scare the poachers, so it's working."

"You mean they're afraid because they won't make bail and won't have their day in court?"

Fausto's half smile seemed practiced in conveying a harsh truth with practical benefits. He welcomed practicality for its efficiency and effectiveness as most people do, but practical benefits can be problematic—I didn't care if poachers feared Cuba or they wouldn't make bail, but that same practicality could come back to haunt Cuba's reefs. That is, Cuba needs revenue in a very big way and sees tourism as a source of that revenue. "You say that Jardines now has a thousand visitors annually. You have a capacity of three thousand visitors annually, but you want to reduce the number of visitors and raise the rates, so the same revenue can be generated with less traffic."

"Yes. We will better protect Jardines with less traffic."

"That's nice. It indicates your recognition of tourist pressure and the toll it takes on reefs, with fishing and diving. But if this were Hawaii, big developers would present a package. They would precede that presentation with huge donations to political interests, and they would show how their package would yield far greater traffic and jobs for the people and enough revenue to make everyone prosper. The developers would prosper, and all through the process they would claim that their package of huge condo complexes, gated communities, retail outlets, and vast opportunities would not only preserve reefs, it would make them better, with more fish, more biodiversity, and healthier everything. What happens if the rates go up at Jardines, and traffic expands exponentially?"

Fausto nodded again, eagerly this time on cold fact. "That won't happen."

"And why won't it happen? We see self-interest everywhere. Cuba is no different than Hawaii. Need is a universal motivation."

"I think you are no different than me."

Bingo!

"I think we will do everything in our power to protect Jardines. Nobody can say what will happen or not happen. But I think if what you suggest begins to happen, then we will fight for Jardines. We know how to fight, and we will do this."

Banded shrimp in Cuba and Hawaii appear to be identical with one big difference. Hawaii banded reef shrimp are now rare, taken en masse to feed a voracious aquarium trade, while Cuba banded reef shrimp thrive in optimal abundance.

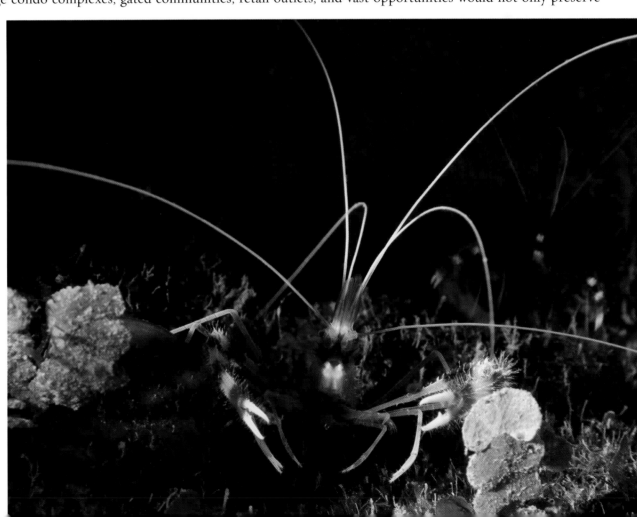

I assured Fausto that we are in this campaign together.

Never yet called shy, I hesitated to press on reef recovery potential, should the Cuban system change to a system more focused on all-you-can-eat. What could he say? How could he avoid self-incrimination? Yet he sensed the question, and his answer conveyed a priority transcendent of political systems. I hoped his estimation of values in Cuba would prove accurate in any event, and assured him that I played devil's advocate because of what I'd seen so often in Hawaii.

He smiled. "Fausto is like Faustus, who made a deal with the devil. You know? I have never met the devil, so I couldn't make a deal, until you. I promise you: we will fight for Jardines."

"Yes, thank you, I think." I asked him to call on me for any support, even if we couldn't yet imagine what that support may be. We exchanged contact info, and he said, "It's like the movie *Shark Waters*. That movie showed the key to victory for reefs, which is simple, really. It requires diligence, enforcement, and of course a few people who care. Did you see it?"

"Did I see it? Snorkel Bob's funded most of the main campaign covered in *Shark Waters*. I was on board the *Ocean Warrior* for three weeks and now serve as vice president of the Sea Shepherd Conservation Society. . . ."

Fausto did not nod but glanced quickly up as if to see for the first time. He stood and reached to shake my hand. . . . "I salute you! Give my regards to Captain Watson. Tell him he has friends and supporters in Cuba."

Oy vey, I thought but stayed mum and welcomed the friendship and support, albeit from a totalitarian Communist country, because there comes a time to set aside the anticipated rant and rave of bad people who kill nature for money. And the gesture felt sincere, coming from a brother in the bond who did not take ovations of friendship lightly.

Bi-color chromis incredulous: Did I see the movie?

He sat back down and put the situation in a nutshell: "It's the sharks."

"Yes. Sharks are important."

"Sharks are more than important. Sharks are everything. They are the most important fish in the ocean."

"But you have no shark threat here. You're too far from Asia and its insatiable appetite for every fish in the ocean, especially for shark fin soup."

"We have no Asian pressure, but we ate our sharks. Shark meat was our staple food. We ate more sharks than anybody, the whole sharks. Thousands of sharks. No more. Now our sharks are protected."

And so he explained that Cuba has now established a shark sanctuary/reserve with all Cuban waters to the south designated as a Shark Protected Area. "But Cayo Largo is off the south coast. We visited these reefs every day and saw no sharks. Okay, one sleeping nurse shark."

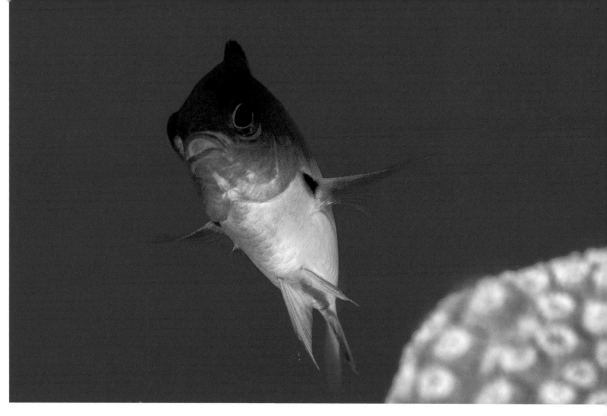

I was in that movie!

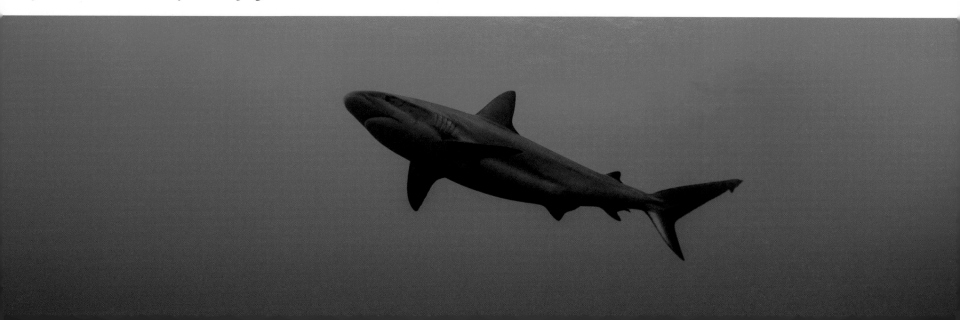

"Our work at Jardines began eighteen years ago. Our shark program is new. It was implemented first at Jardines [one thousand square miles] and now will cover thousands of square miles. You will see what difference it has made at Jardines. Oh, my friend, you will see some sharks."

What reef photographer wouldn't want to see sharks? Yet Fausto's gleeful anticipation lingered with certain knowing on his part and equally vigorous uncertainty on mine. Back at the terrace patio I asked Juan Cardona what sharks we might encounter at Jardines. Juan manages his family's dive company in Cancun, with hundreds of dive boats, which seem like way too many, though he insisted that so many boats only help him dive more, not less. He shrugged. "You will see the usual suspects, silkies, Caribbean reef sharks, bull sharks, maybe, maybe a hammerhead if you're lucky."

"Tigers?"

"Maybe. They're here. But don't worry. None of these sharks will threaten you, if you're careful. But you don't want to break the piñata."

"Break the piñata?"

"Don't get them excited. Don't spill candy all over the floor. Then they get very naughty."

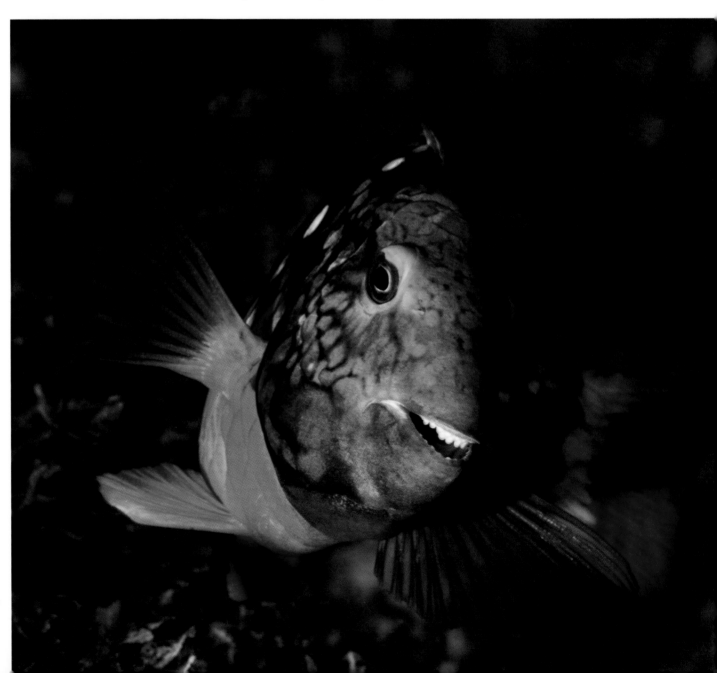

A stoplight parrotfish at the moment of comprehension: I get it!

Cayo Largo reefs are dramatic, with excellent fish populations and diversity. Yes, the invasive algae are a significant factor but may be remedied, maybe soon. Beyond that, random observation helped round out the big picture that is so amorphous from long distance, especially from the U.S., which views Cuba through the wrong end of the telescope. Things looked much different through the right end of a macro lens:

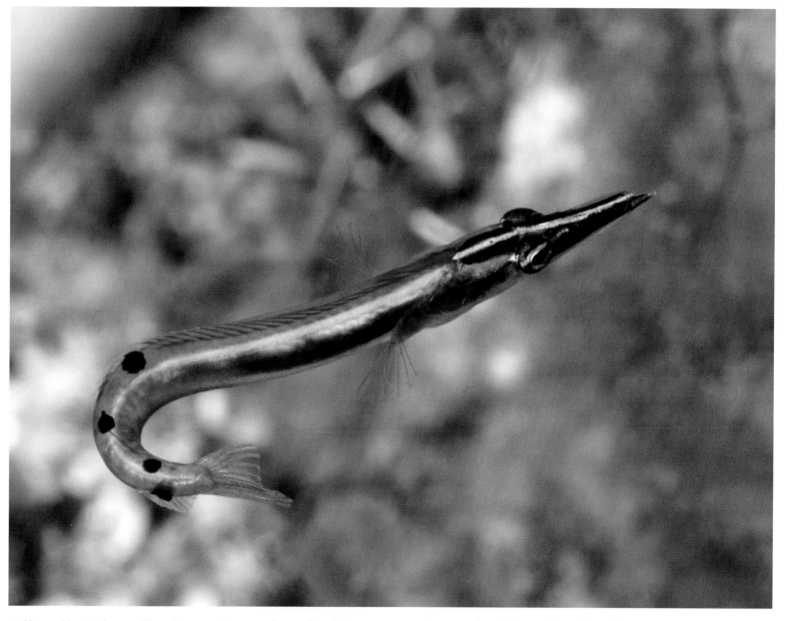

Unlike most blennies, the arrow blenny does not use its pectoral fins to walk on the substrate. It prefers hovering, tail crooked, prepped for a flick to grab snax, or to flee.

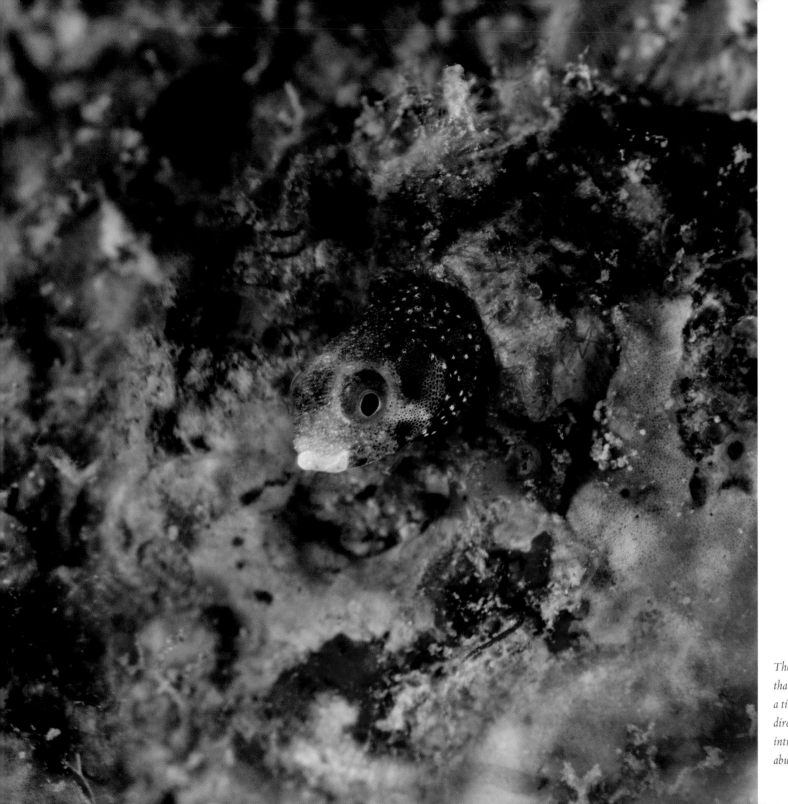

The spinyhead blenny is slightly smaller than a pencil eraser and tucks neatly into a tiny burrow, unseen by many who gaze directly at him. This fish tolerates huge intruders and is curious and generally abundant among diverse flora and fauna.

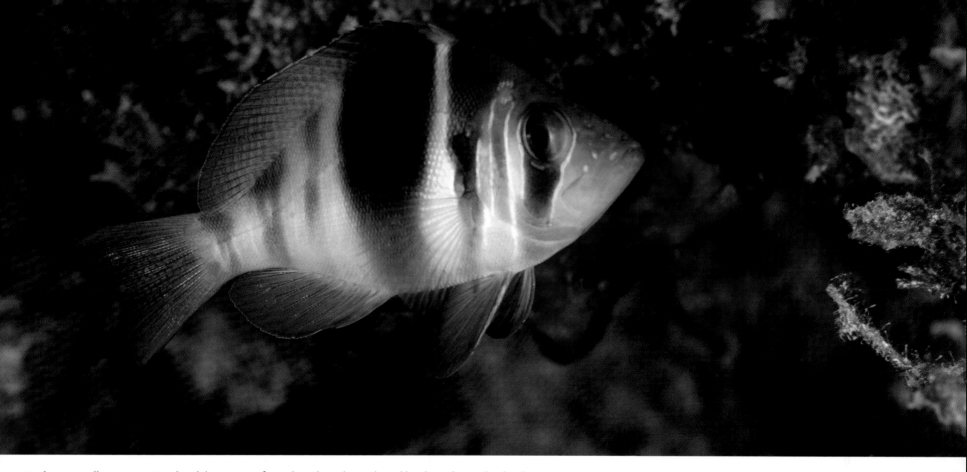

Hamlets are smaller groupers. Hamlet adults grow to a few inches. Shown here, a barred hamlet. Below: Indigo hamlets.

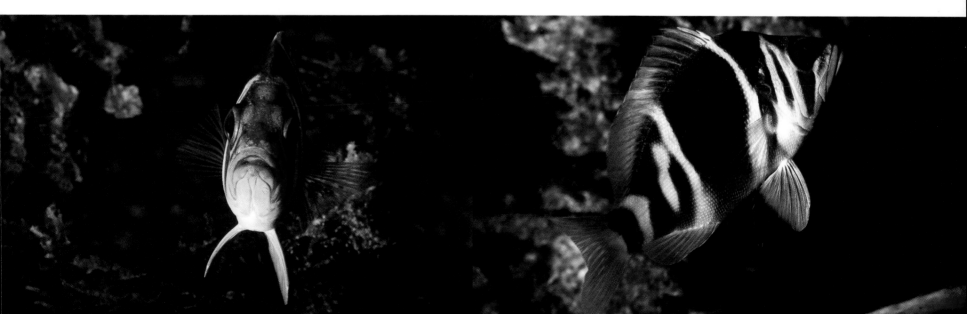

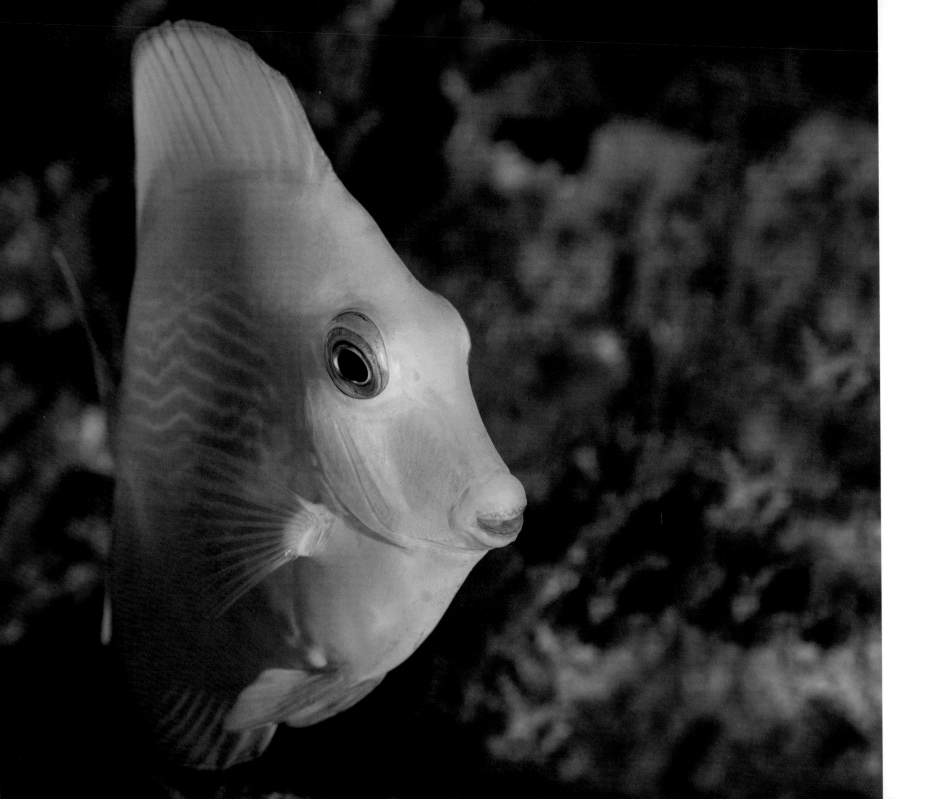

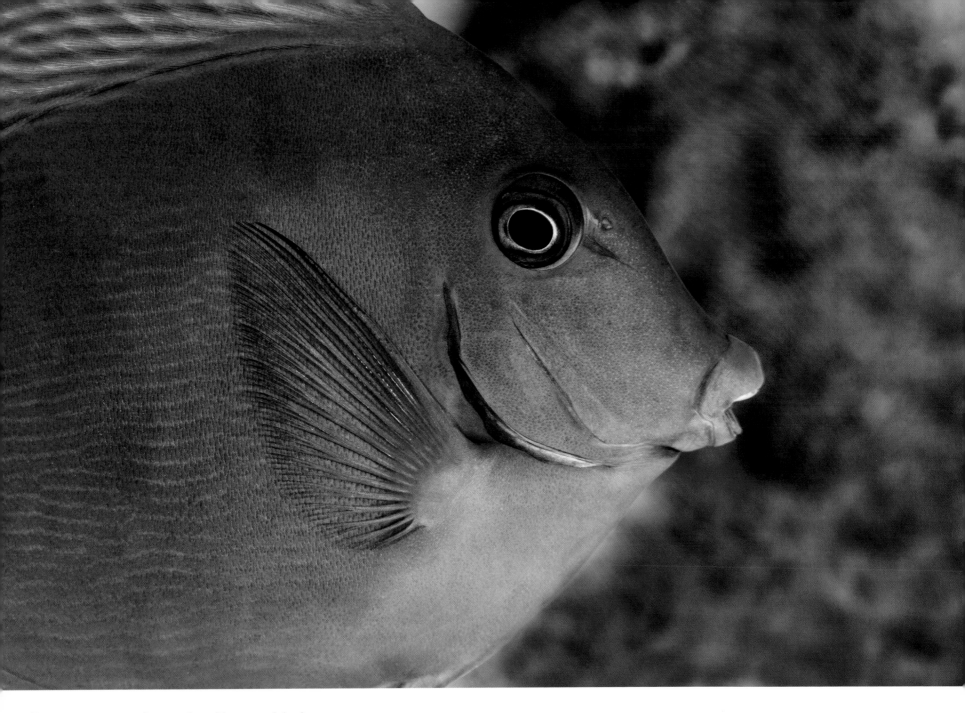

A blue tang in maturity, on the verge of gray, like me, Snorkel Bob.

Opposite, Blue tangs are born yellow but turn brilliant blue in the intermediate phase. All tangs graze algae dawn to dusk, and achieve highest dollar value on reefs, not as chump change ornaments in aquariums.

The bluehead wrasse is well known for its artistic ability in composing reefscapes . . .

A yellowhead wrasse adult.

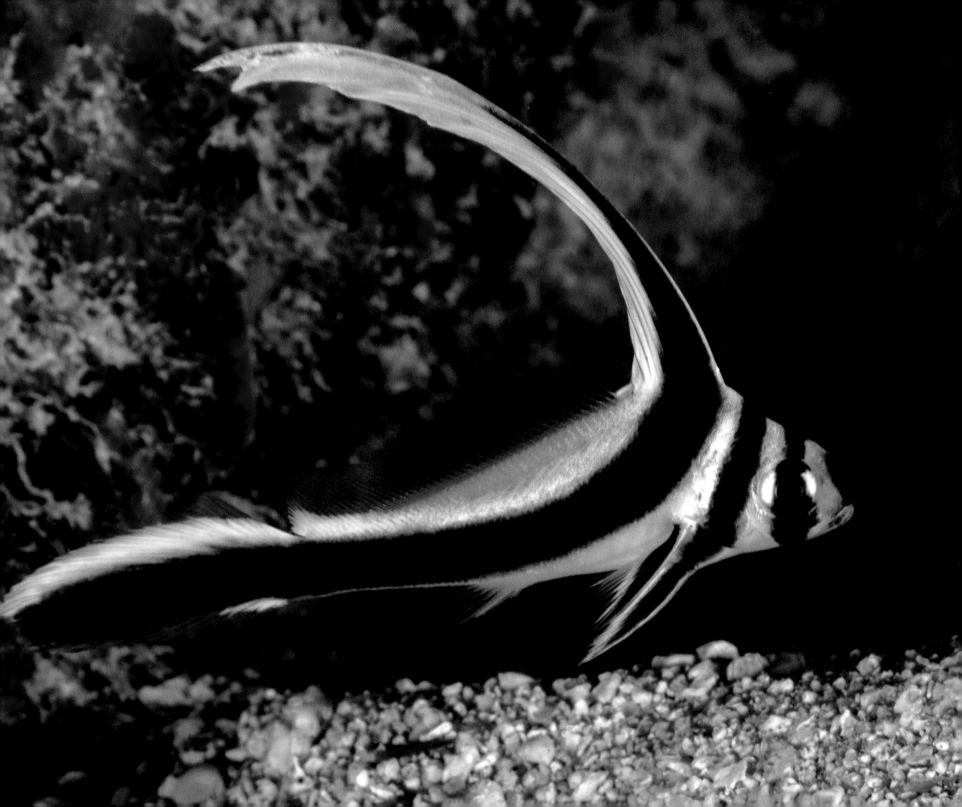

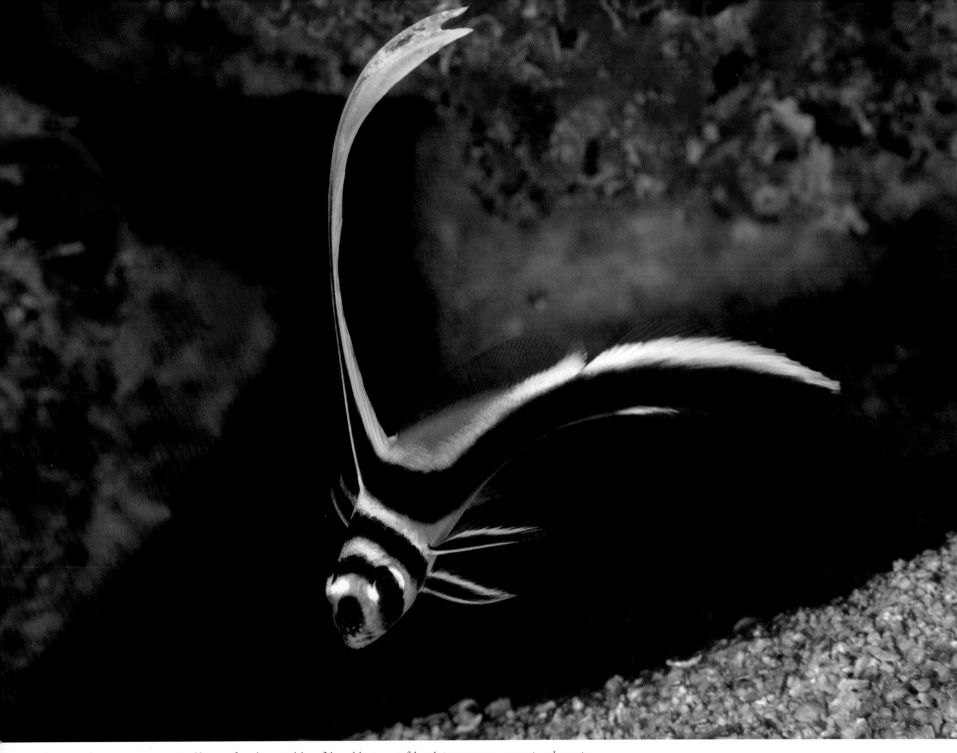

Among the most endearing juvies on any Caribbean reef are the spotted drumfish: so delicate, graceful, and circumspect yet energetic and engaging.

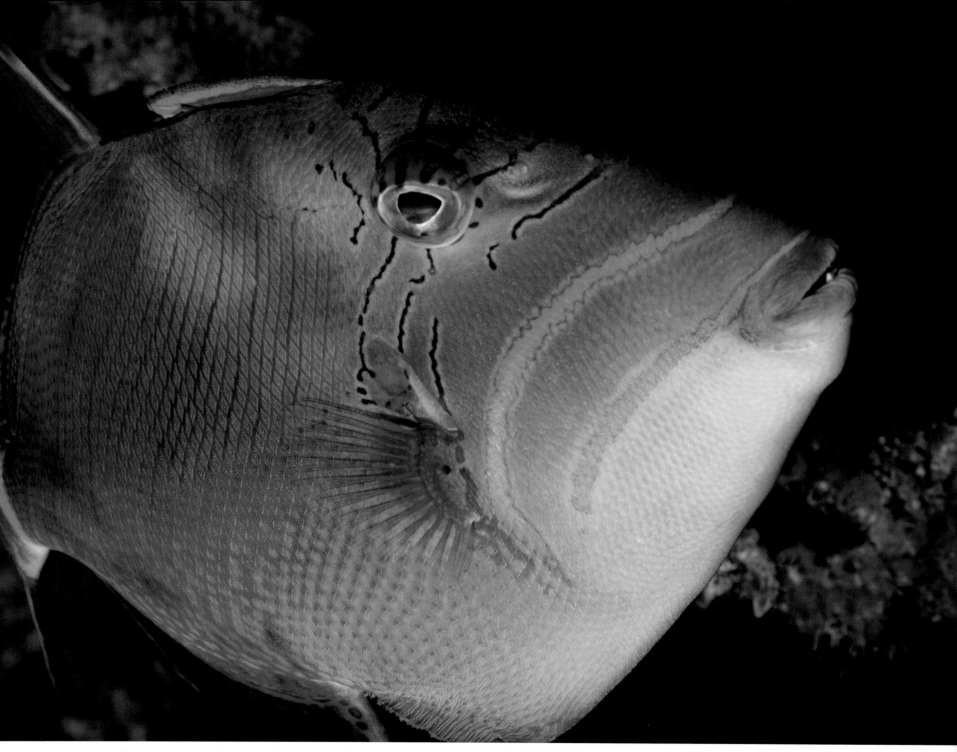

Among the most alluring Cayo Largo reef denizens is the queen triggerfish. Oooh, baby . . .

Angels and butterflies round out the pelagic array at Cayo Largo, including:

A banded butterfly juvie, who may soon grow into...

...a banded butterflyfish adult

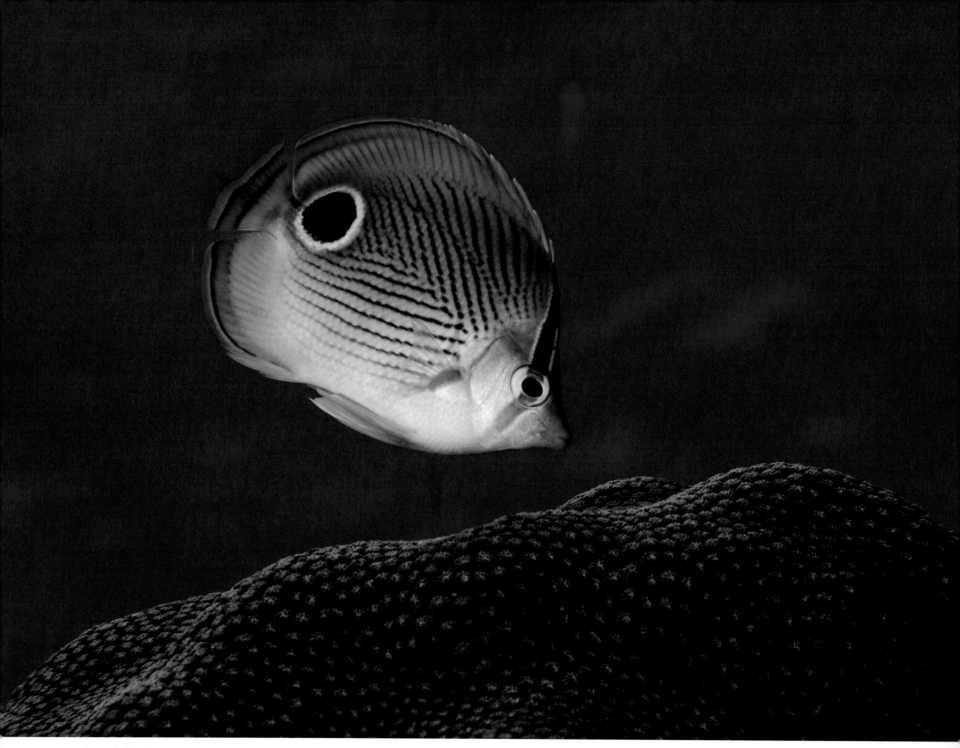

Four-eye butterflyfish, Cayo Largo.

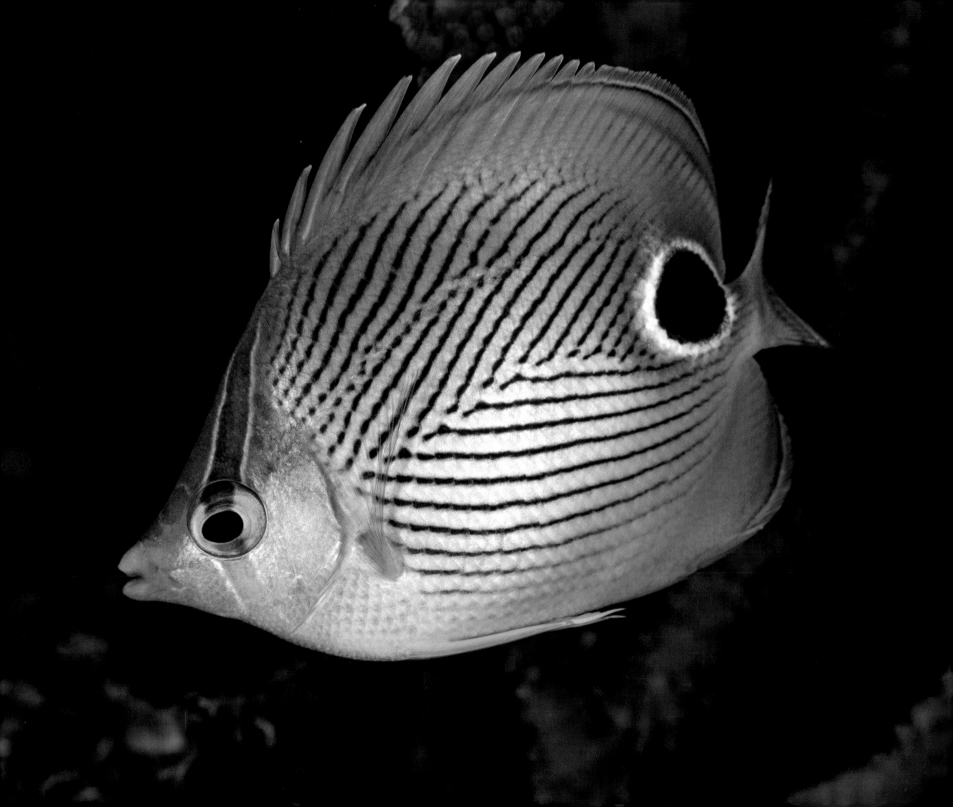

The queen angelfish is shy as any angel.

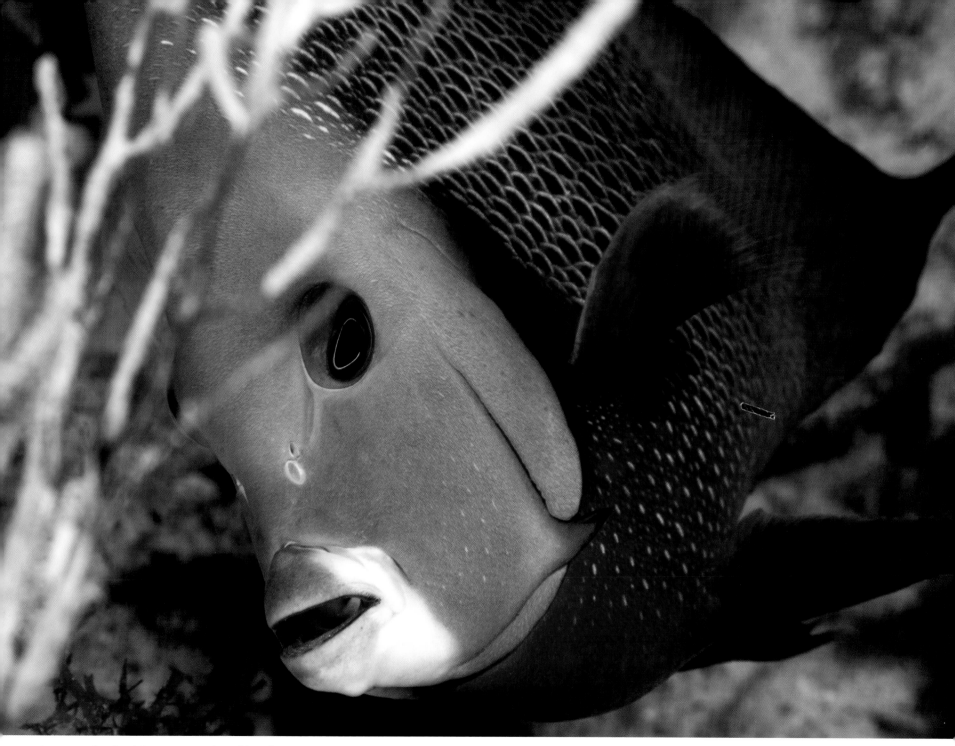

So is the gray angel, unless she's . . . Gray Angel Confidential.

Soon after the Snorkel Bob expedition, Raúl Castro announced his retirement—in another five years. Still, he stirred the embers, sparking U.S. and Cuba voices to remember the *Maine* and every other potshot, assassination attempt, invasion, insult, embargo, imperialist maneuver, and dirty dog deprivation since Fidel's modest minion beat Batista's army. On one hand Fidel was a Commie; on the other hand Batista was corrupt. American media poked the coals, resuscitating old flames to better revive the bickering. Cuban media is not a formidable news source, but it joined the refrain. Both sides have been ruled for ages by political parties bent on survival—on keeping power for the individuals in power, and the most pressing requirement of power maintenance was, is, and shall be practical contentment for the people. The United States of Americans wring their hands and gnash their teeth if gas goes up 7¢. Cubanos are happy with far less—but not content or satisfied. The point is: self-interest is constant from one system to the next. North Korea defies the concept; they been down so long it looks like up to them.

So when Raúl Castro proclaimed that Cuba would not return to capitalism—"I was not chosen to be president to restore capitalism to Cuba. I was elected to defend, maintain, and continue to perfect socialism and not destroy it."—he was blowing smoke, even as it rose from the stirred coals. We may speculate on continuing reforms that Fidel Castro called "comprehensive and necessary" as he too pledged, "We will not return to capitalism." These assertions are common throughout history:

We will win in November.

There's nothing wrong with the economy.

Poland is not a Communist country.

We don't know for certain where he was born. He's a socialist!

And so on, denying the inevitable failure of one thing or another. Just as Medicare frees individuals from debilitating financial consequence and makes them socialists, so does Communist China now have "state capitalism," whatever that means. Consistent in Cuba's Communism is inconsistency—its practical adaptation and uniquely Cuban character. Now Cuba is widely perceived as favoring "the Chinese model." Whatever the model, it doesn't matter, because all models depend on practical success. Take the Soviet model, dependent only on ideology and Cold War military expenditure. It failed.

Analysis in a monthly U.S. journal claimed that all power and prospects in Cuba have depended on loyalty to the Castro brand and predicted that in the future, power would ultimately depend on the military. That proposition

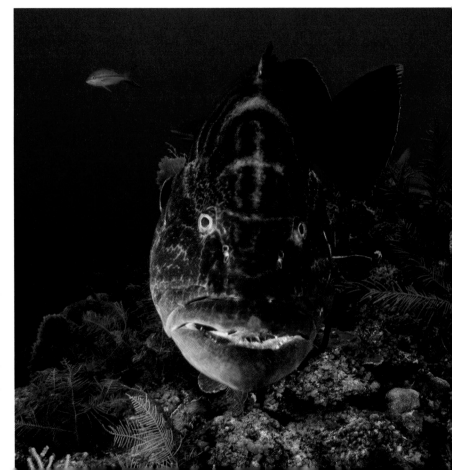

I am not a crook! A Nassau grouper.

restates the obvious, long way around—as many U.S. journals do. What system, especially in relatively young countries, did not depend on the military? And what military ever wanted anything but power? Analysis continues to marginal avail. What can be seen with the naked eye and will matter is contentment at street level, a measurement long forgotten, now coming into play, as if by popular demand. Cubanos convey artistic imagination—it reflects a common spirit and intelligence. It articulates the national consciousness, and without measuring happiness the big picture cannot be clearly rendered.

Among memorable Cayo Largo outtakes was the dive leader Israel, an undeniably happy man. He wore a shark tooth on a lanyard around his neck but assured visitors that he found it, which was credible, because shark teeth emerge in rows that move from inside the mouth forward toward the outside throughout a shark's life. Ripping and tearing dislodges loose teeth from the front, outer row. When a tourist asked if that was a shark tooth, Israel didn't miss a beat in replying, "No. This is from my grandmother. She is very old."

That's because tourists tend to ask the same questions every day, and a tourism expert learns how to field relentless questions amicably. The alternative is getting pissed off at the same stupid questions, but that would render a tourism expert without a job—or, in a mixed free-enterprise system, a tourism professional without a position.

Israel is a dive leader at Cayo Largo and an essential waterman.

A redband parrotfish looks happy with an ecosystem in good working order.

Israel also poked a stringer of lionfish on most dives, cutting the dorsal spines before stringing. It's a heinous, ghastly procedure on a beautiful gem of the oceans wrongly placed in the Atlantic and Caribbean by a vicious aquarium trade. But lionfish removal is necessary. Has Israel ever been pierced? Only once, when a spine sunk nearly two inches into the palm of his hand. It didn't hurt until it did. Then he thought he would die for two days. Israel worked his catch in the galley between dives, slicing a paltry fillet from each lionfish. Even the extra-large individuals at fifteen inches yielded only four- or five-inch-square fillets, very thin. Israel voiced the common corollary. "This is Cuba. We make do with what we have." Then he tossed the carcasses overboard to teach anyone and everyone below how tasty lionfish could be. The task remains, teaching anyone and everyone above the surface how destructive the aquarium trade is, and that wildlife trafficking for the pet trade must be banned everywhere.

Winter weather prevailed at Cayo Largo, so we leaped into rolling seas in the early morning and surfaced an hour later in steep ocean rollers, ten- to twelve-footers that made the boat disappear as it rolled into the trough a half mile away. Captain Delphin was the only man on board older than me, I think. Or maybe he only had more sea time. He came alongside us in short order, veered away, and then backed down in those hurly-burly waves to within easy reach of tired divers—held the transom steady with time enough for five divers to doff fins and climb on board. Delphin spoke no English but was fluent with a universal smile, a helping hand, and supreme water skills.

Lionfish did not swim to the Caribbean but were transported by the aquarium trade. Neither trafficking in wildlife for the pet trade nor scapegoating is nice.

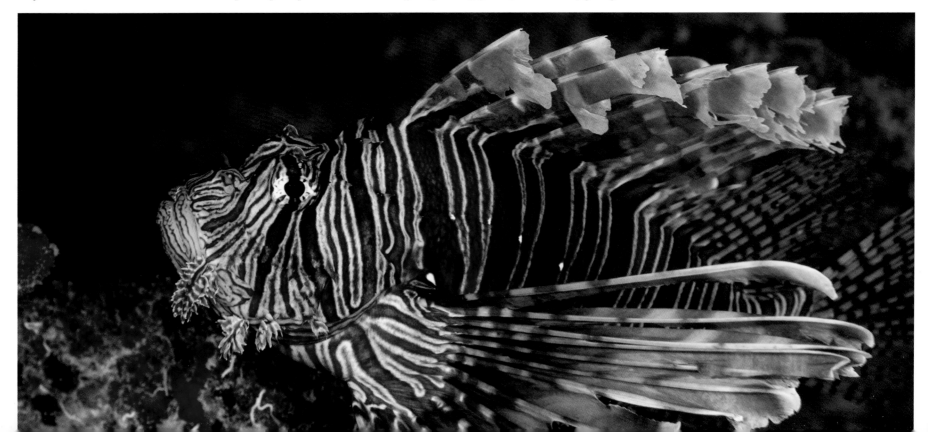

Captain Delphin is a waterman and helmsman extraordinaire.

Above, Pepe is a dive leader, waterman, and conservationist. Below, Juan is the Cayo Largo scuba tech.

Other peripherals help to flesh out the adventure that is Cuba and the spirit that is Cuban. The big hex nut on my regulator loosened between dives, and though it would hand-tighten back to a safe, working position, maybe, it needed attention, what would call for specialty tools in the land of the free. Short of that, or rather beyond that, Juan serviced the Cayo Largo's own dive equipment, much of it vintage issue. He studied my reg, nodded once, and went back to the workshop, a half-lit cubicle lined with stone-ax implements—ice picks, chisels, cudgels, and pestles, mostly, along with a few box wrenches and vice grips. Finding the precise substitute for high-end modern technology, he fixed it with a smile, conveying the common attitude at Cayo Largo that we're in it together, down there together, depending on each other.

Another playful peripheral of life at Cayo Largo is the two-lane bowling alley in the Villa Marinara complex. Guests and boat crew can socialize over a beer or a mixed drink, and bowling runs one CUC per frame. Avant hip-hop music reflects local appetite and tastes—or rather those of the staff; nobody lives at Cayo Largo. Staff stays in dormitories, mostly on a monthly cycle with twenty-one days on and nine or ten days off. The lyric that night was "Loca People" by Sak Noel, an intriguing refrain enveloped in eerie melody with a solid downbeat:

When I came to Spain, and I saw people partying

*I thought to myself, what the f**k*

All day, all night

All day, all night

Viva la fiesta, viva la noche

Viva los DJ's

I couldn't believe what I was living

So I called my friend Johnny

And I said to him, Johnny, la gente esta muy loca

*What the f**k*

Johnny, la gente esta muy loca

*What the f**k*

A fading mural at Cayo Largo illustrates tobacco love and Cuban artistry.

Apologies to Mom 'n' Dad for exposing Bud 'n' Sis to the real world. They'll giggle and get over it. Perhaps more intriguing than the music was the twenty-four-inch LCD TV over each alley with animated shorts of about five seconds each to accompany every ball rolled. In these brief cartoons an ongoing struggle ensued between personified bowling pins and bowling balls with variable drama based on the number of pins knocked down. A gutter ball would trigger something like the pins ganging up on the ball and beating it into oblivion. Or, my personal favorite but one we couldn't trigger so often, a strike, would show the pope briefly as the ball in a distorted image but with identifiable robe, hat, and scepter. The scene then shifted to the pins, tied to a stake and surrounded by kindling. The ball/pope would light the fire beneath them and the pins would flare up and burn to ash. Next player, *por favor*.

Here again, irrepressible artistry and imagination provide a playful romp that some extremists in the USA would find threatening to stability and a potential challenge to their Second Amendment rights.

Detail from the Old Man and the Ceegar.

The adventure never ended, even as it ran out of time. Like departing from Cayo Largo with a return flight scheduled but then unavailable until the morning of departure and then unavailable until noon. Unavailable at one and again at two, it remained unavailable through the afternoon, until it became available at six, chop-chop, hurry! The uncertainty threatened the balance of the expedition, and the delay meant that the day in Havana would be lost. At least the expedition was still on—after another mad scramble to check luggage, clear security, ride the bus from the airport back to Havana with many hotel stops on the way, check in back at the Copacabana, find a restaurant, and get four hours' sleep before another pickup in the lobby at 4:00 a.m. to ride another bus for seven hours to Jucaro (HOO·ka·roh).

Meanwhile, the bus driver transferring us from Villa Marinara to the airport didn't know of our travails, so he led the passengers in a romantic ballad en Español, accompanying himself on guitar while steering his massive passenger bus with his knees.

The Old Man and the Ceegar pay homage to Cuban tobacco, Cuban pride, and Cuban artistry in cement.

The Cayo Largo bus driver, another tourism expert, eased travel angst by steering the big bus with his knees while singing a romantic comedy love ballad—ho boy, they'll never believe this one down on the farm.

Or maybe the bus driver did know of our travel travails, just as I suspected our waiter Joey of being undercover Cuban intelligence—or maybe CIA—when he knew that I'd skipped the floor show at the big hotel to re-sort my camera gear, clean and grease my O-rings, download images, and recharge my batteries. "How was the show? You didn't go? Oh, you stay back to recharge the batteries." How did he know I had batteries? Well, it's a figure of speech, meaning that I stayed back to rest up, maybe. Maybe second-language skills are most fun when demonstrating facility with another culture's idiom. They say you really know another language when you dream in that language, but maybe making native speakers of that language laugh is the proof of insight. Joey? Undercover? Well, it doesn't matter because we're surrounded no matter what or where.

"I am a waiter!" But he was an artist and an animal nut, here resuscitating a hummingbird who had hit the window.

Put 'er there, pardner. This Cayo Largo land crab was obviously undercover; note the left-leaning handshake and inscrutable good cheer.

Of historical interest with a dynamic blend of irony and pathos is Robert Vesco's imprint. Vesco pioneered modern financial fraud on a grand scale. He fled the U.S. with $12 million in cash to avoid prosecution in the early eighties, back when $12 million was big money. After trying several Latin American countries on for size, seeking asylum with insulation from extradition, he finally settled in Cuba in '82. No extradition there. Fausto made a joke, kind of: "Fidel Castro has such a good relationship with the U.S. government, you know. . . ."

I was about to speculate that Fidel may have asked Vesco, "Do you have anything smaller?" But of course discretion is often the better part of humor.

Fidel and Vesco got along until 1989, when the Cuban government indicted Vesco for "fraud and illicit economic activity," what was loosely referenced as drug smuggling. Finally convicted in 1996 for "acts prejudicial to the economic plans and contracts of the state," Vesco was sentenced to thirteen years in prison, where he died in 2007. Villa Marinara, the smaller, more serene, and quaint of the Cayo Largo resort lodges, the one now designated for divers and snorkelers, began life as the house that Robert Vesco built. It's easy to squint and see the grand life played out by a man eternally convinced that crime does pay.

Further relevance lies ahead: Vesco fled South Florida aboard his luxury yacht *Halcón* (hal·KON), now converted to service as a dive boat in Jardines de la Reina. *Halcón* would be our home for that week.

The legend lives, hardly the worse for wear.

This is not meant to be a tourist guide, but of note are the differences in accommodation and board between one stop and the next. Meals at Cayo Largo were mostly substandard with the occasional drop or rise in quality and a few failures or successes of astounding magnitude. Nobody in their right mind eats pig anymore, yet days of diving and striving for quality calories and protein made pork roast done to a turn a most gratifying repast. But the primary ingredients at the Villa Marinara cucina came from a #10-tin-can cornucopia of beets, carrots, fruit cocktail, corn, green beans, beets, and fruit cocktail. You can take a pass today with confidence that you'll get another shot tomorrow and/or the next day. It depends on you. Fruit cocktail comes straight up on day one, in the flan on day two, and in the sweetbread on day three. Please forgive no photo memories at this juncture—the images come back often enough in dreams.

You will not snorkel at Cayo Largo—or you will snorkel and be disappointed. The heavily promoted, heavily sold Cayo Rico Iguana Tour runs fifty-six CUCs/person (about $60–$70 depending on currency exchange charges, surcharges, and other fees) and delivers seven hours of sand and sun, full stop, except of course for the

captive iguanas who perform daily by demonstrating survival on a small vat of spaghetti, as the tourists watch and shriek with delight. And yes, they slurp, both iguanas and tourists. ¿Como se dice iguana en Español? Iguana. Beyond that the shallow reefs on that outing don't exist. In their place are heavily smothered substrata that may or may not recover. Of interest is the combination of invasive algae that includes the same weed with conical berries smothering some favorite, beloved reefs in French Polynesia, where water temperature increased by two to three degrees Celsius in recent years and spawned the crown-of-thorns starfish invasion. Crown-of-thorns starfish can inject severe neurotoxin from many ghastly thorns. Worse yet, they devour coral polyps in their march across reefs, leaving trails of nothing but bones.

A few fish swim at random across the shallow wasteland bottoms at Cayo Rico. Most visitors carry Styrofoam noodles, beach toys, and no snorkel gear in a pattern tragically symptomatic of reef decline. I did not press Fausto on his plans to improve visitor demographics, to move away from gluttony toward communion, which is not quite Communism, but I sense he is aware of the shortfall.

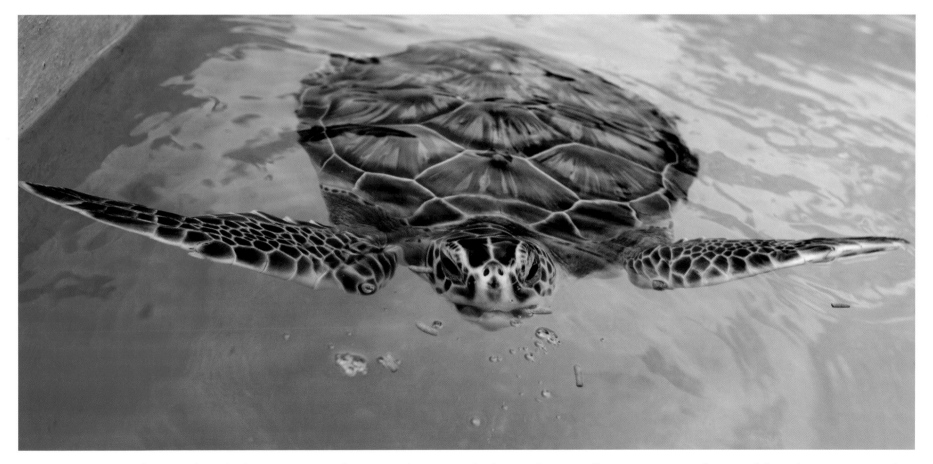

A green sea turtle snacks on pellets in a carefree pool at the Cayo Largo Sea Turtle Recovery Facility, a committed, endearing, and impressive effort to prevent extinction of a species in decline with waning nesting grounds.

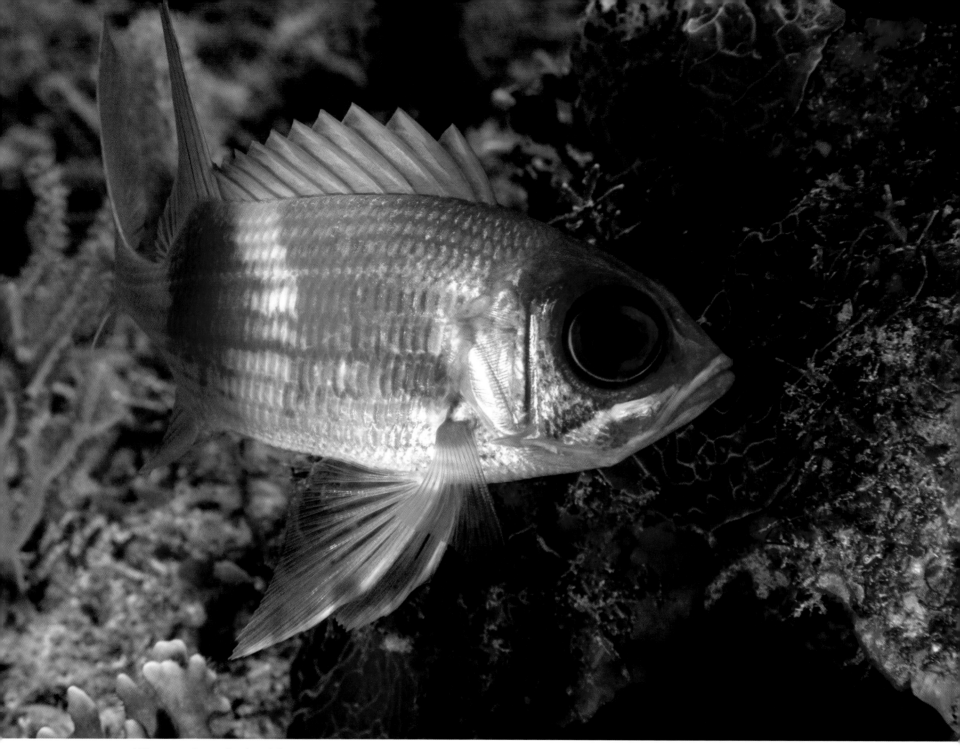

A Cayo Largo squirrelfish turns south toward Jardines de la Reina.

Stingrays often hide on the sandy bottom, fluffing their wings to cover up.

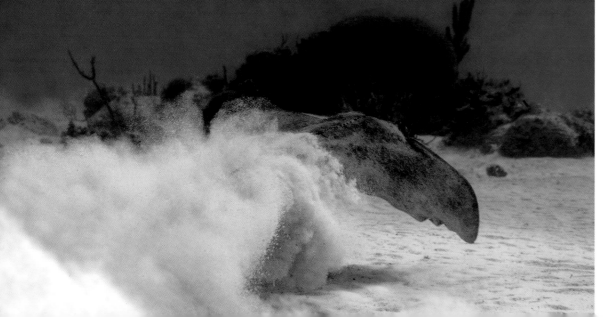

Sudden liftoff may serve to confuse predators in a cloud of smoke and a hardy Hi oh, Silver, away!

Queen triggerfish

Bluehead wrasse is yellow in the juvenile phase.

Cuba today. The journey is the adventure; from process comes insight.

So we made the Cayo Largo Airport in time for the 6:05 back to Havana International, arriving at 7:00 to catch another bus back to the Copacabana with stops along the way and hotel arrival at 8:30. With Havana Vieja a half-hour taxi ride across town and another 4:00 a.m. wake-up looming, we opted for convenience. Checked in and showered out by 9:00, we were back down for easy pizza at the place between the snorkeling lagoon and the dive shop.

Our waiter spoke with no accent, like a fellow from Keokuk. When someone complimented his English language skills he informed on cue of his university degree in English literature. It's a pattern, an academic badge of courage, to have and to share advanced credentials, to underscore the Cuba situation, which is underemployment for skilled people. I didn't have the heart to tell him that most pizza parlor staffers who were *Borrrrrn in the USA!* also have degrees in literature or psychology or sociology or any number of humanities pursuits best applied to serving pizza. The pizza place at the Copa, like many places in Havana, serves vegetarian selections, and the pizza was superb.

The 4:00 a.m. wakeup for a 4:30 pickup felt painful but routine. The sameness of the big busses made the hours melt together and stretch like goo. En route at a plodding pace with many stops were long waits for ponderous people with gravelly accents and no concern for wasting time—or maybe wasting time demonstrated something else. We could only speculate, and idle fancy helped pass the time. A few of the ponderous people drank liquor from pint bottles and laughed loud, as if to shape the ambient mood. Cuba's history of occupying nations is grist for the revolutionary mill, but the Cuban sense of humor and self-effacement still seems more naturally aligned to U.S. temperament than to those of roughshod Slavs and ham-handed alcoholics of the frozen north. Well, the sun hadn't even risen, and cynical conjecture best suited the empty, dark moments meant for sleeping.

The long ride to Jucaro stutter-stopped at many hotels to the Hotel Nacional for the longest wait, forty minutes, for the last group of Rooshins. They boarded casually, making everybody glad that the Soviet Bloc delaminated, but then we learned that they were not Rooshins. They were Fins who drank like Rooshins, drinking liquor from bottles and finally greeting the dawn with two beers each at our first rest stop three hours out. They too were headed down to Jucaro for the long crossing to Jardines, to catch fish, granting insight to the segregation of fishers and divers. We did not chat or mingle in any way.

Plié in Broken Glass, in which the artist demonstrates the wits and wherewithal to gather materials, then compose and produce a work of art.

They had no motivation but to pull life from the ocean in an exercise of dominance, an extension of behavioral characteristics already displayed. The gap between them and us felt wide and deep, abysmal as it were, with hooks and dead fish on one side and reef communion on the other. Then again, it was still dark; maybe they were nice people after all. I love beer, too, just not at 7:00 a.m.

Cubano latte is called *café con leche*, but it's the same, brewed with excellent Italian espresso machines and tasting like the little cup o' joy that best recalls the home of the brave. *¡Perfecto!* Anyone familiar with the latte boost will know how it might burnish perceptions in the heart of the Cuban countryside as it awakened us to a brand new day in a bygone time.

History was marked that day with a Cuban government decree that the people of Cuba were henceforth free to travel anywhere in

On the road to Jucaro the first rest stop is three hours out, just in time for latte.

A vintage sunrise on the way to Jucaro.

South Cuba countryside. No conveniences, no luxuries, no 1.7 TVs or 2.3 cars, washers, dryers, shag carpet, drop ceilings, convenience to church, schools, and shopping. But here is a place called home to many people with apparently good reason to feel the love.

the world and free to return. A few days prior Fausto had pointed out this milestone that would take Cubanos from captivity in their own country to global mobility. It seemed good—too good, too simple, easy, and freely given, and even Fausto was unabashed in pointing out the discrepancy, that Cubanos could no more travel than a car could run with no gas. "Now we need the money to go somewhere."

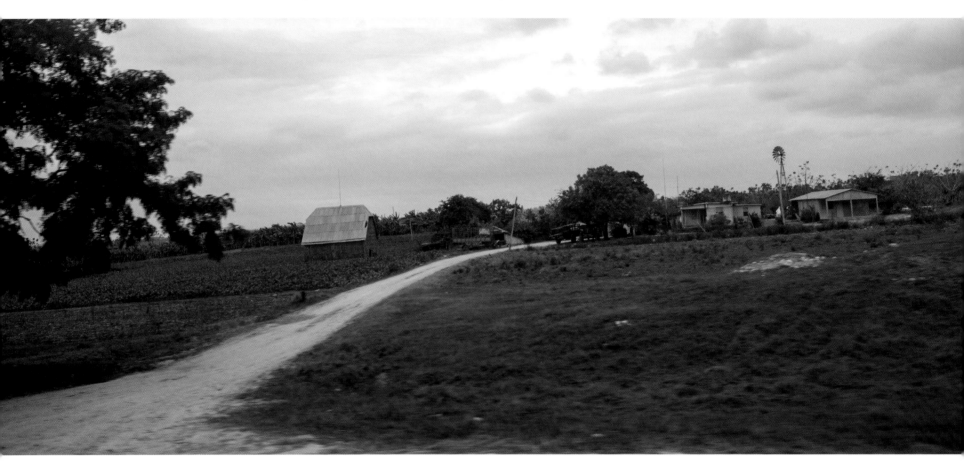

The Cuban Dream: not too little, not too much, but that seems a long way off.

The historic decree freeing Cubanos to travel the world may be as unreal as any rhetorical claim by any system ever was. Reid Slaughter runs a "missionary" relief program, traveling to Cuba often with volunteers, delivering over-the-counter drugs widely unavailable there. If that sounds mundane, go a week without ibuprofen, aspirin, or Tylenol, and you'll feel the pain of many boomer Cubanos. I say "missionary" with quotes to offset literal meaning, because the group is Presbyterian and more focused on practical assistance than soul saving and resource redemption. Reid Slaughter is careful to point out

that among the gifts delivered is the notion—an all-new notion to many Cubans—that they have a friend in God. I take him at his word, with faith that the friend-in-God message and three ibuprofen tabs can make a difference. Beliefs aside, Reid Slaughter is familiar with Cuba and fast-changing times.

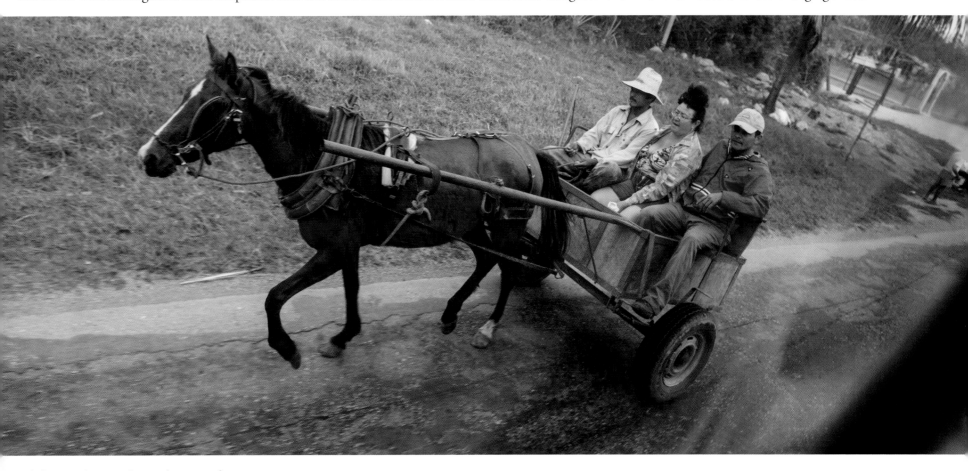

Oh the times they are a changin', but not too fast.

He is familiar with embargo politics, Cuba's strategy in regard to the embargo, the real cost of the embargo, and the extent to which the Cuban government is willing to look the other way in the spirit of revenue. U.S. citizens can now travel legally to Cuba on several flights opening up from Tampa, Miami, and LA to Havana. Special clearance is formative. A special visa for group interaction from the State Department may be required, but some groups already have those visas. The flight to Cancun from DFW was full of U.S. citizens who connected from Cancun to Havana (at that time, no commercial flights connected any U.S. airport to Cuba). Did these U.S. citizens travel illegally? Maybe. Maybe not. Some of them requested that Mexican immigration

not stamp their passports on the return from Cuba through Mexico, because stamping would have shown two entries into Mexico, inferring a side trip to somewhere else with no stamp, inferring Cuba.

Because Cuba won't stamp your passport; instead, Cuba gives you *una Tarjeta de Turismo*, a tourism card to carry separately in your passport. Because Cuba does not want to inconvenience you, because Cuba wants your *business*. In the case of a Presbyterian group bearing gifts, Cuba turns a blind eye to repeated visits and the godly message, because Cuba understands that visitors need hotel rooms, rental cars, and restaurants—and supplying those demands means money. Cuba knows that U.S. visitors spending money also fly in the face of the fifty-year embargo. And a few ibuprofen might ease this frikkin' headache.

Reid Slaughter dismisses the decree freeing Cubanos to travel the world as another posture—a symbolic step in the right direction but one that will have no practical value in the foreseeable future. All athletes and males of military-service age must still apply for special permission to travel abroad under the new, liberal rules—that's on top of documentation that must comply with strict state guidelines. Obtaining special permission requires travel to the correct office in Havana, often a long journey from the hinterlands, requiring time, transportation, and lodging. Once in Havana the applicant can stand in line for hours or days, but not likely more than three days. The effort and expense to that point are greater than most Cubans can muster. Beyond that point is a $160 application fee, or four months' wages for a surgeon. Then comes the tough question: *What country do you plan to visit?* Permission to visit that country will not be granted without a visa to do so from that country in advance, and most countries are limiting visas to Cubans, because Cubans are not likely to go home—because home is not a contented place for many Cubans, because Cuba has been rendered immobile by the U.S. trade embargo and staunch Communist constraints.

The embargo is a lingering legacy of former times and another symptom, whereby the greed and corruption of a very few cause extreme deprivation to many. The embargo also illustrates the selective perception of U.S. media, whereby "values" are assumed, as defined by one group or another, with special interests masquerading as the greater good. More specifically, a TV host on MSNBC specializing in liberal politics had occasion to reference the embargo when Raúl announced his retirement. That commentator, also known for speaking fast through many assumptions, quickly dismissed the embargo as necessary, as a natural result of a Communist takeover of family lands held for generations that were confiscated overnight, and that was bad—all this in four seconds flat with no look back. "It was awful! They're bitter! Who wouldn't be?" While that summary may be essentially true, it lacks perspective. The big picture is unknown by many commentators and kept under wraps by special interests controlling the embargo.

Current U.S.–Cuba embargo policy began with the Reagan administration, strangling tourism revenue to stanch Cuban military adventures in Africa. A more cynical update on embargo policy was the presidential election of 2000, where 500 votes in South Florida turned the tide of American history—from flood to ebb. Saul Landau said it best in the *Huffington Post* on January 26, 2013. The gist was that a few Cuban Americans are exempt from the U.S. trade embargo on Cuba, and under the guise of sending supplies to families and loved ones, a significant private trade route has evolved. While no commercial flights connected any U.S. airport to Cuba, many charter aircraft on any given day fly to Cuba loaded with goods for private sale.

Saul Landau is professor emeritus at California State University and the author of *Will the Real Terrorist Please Stand Up?* His *Huffington Post* blog concludes:

Since 1960, commitment to overthrow of the Cuban government has functioned as U.S. foreign policy on Cuba, a policy now controlled informally by south Florida Cuban-Americans. The Cuban-American ethnic enclave assumed the political power needed to turn south Florida into an autonomous Cuban settler state inside U.S. boundaries, so that the embargo does not get applied to the Cuban-American enclave. The enclave barons use the embargo to secure, for themselves, a protection of the Cuba trade monopoly. This challenges stated U.S. national interests.

Camouflaged by ubiquitous anti-Castro rhetoric, the Cuban-American entrepreneurs have manufactured a lucrative business with the island, regulated by the very government they pretend to hate. The rightwing congressional representatives pretend to fight for every law to punish the "Castro regime" while in practice turn a dead eye to the growing trade that helps Florida's and Cuba's economy. Preserve the embargo, but make an exception for Cuban Americans.

By recognizing the facts about this trade, the White House might become inspired to lift the embargo—a move to benefit all Americans. U.S. government revenue would grow from opening trade and travel with Cuba. In the process we might also regain a missing piece of U.S. sovereignty!

Where were we? Oh, yeah, cynicism and the 2000 U.S. presidential election, where a small junta of Cuban American businessmen delivered Cuban American votes to the Bush camp in exchange for continuing input on U.S.–Cuba embargo policy.

Not long after the *Snorkel Bob Jardines de la Reina Expedition* to document the last best reefs, Fidel Castro appeared on TV looking stooped, white haired, gaunt, frail, and nonthreatening. He addressed a group of schoolchildren with the kinder, gentler demeanor of a man whose time has come and gone, a man with a fixed message, that in fifty-three years of embargo, the great United States of America remained a failure in bringing Cuba to her knees. Success and/or failure on either side of the embargo remain problematic, but his point and his process are duly noted. Fidel Castro uses the embargo to advantage, which the U.S. opts to facilitate.

On the road to Jucaro, a rural taxi.

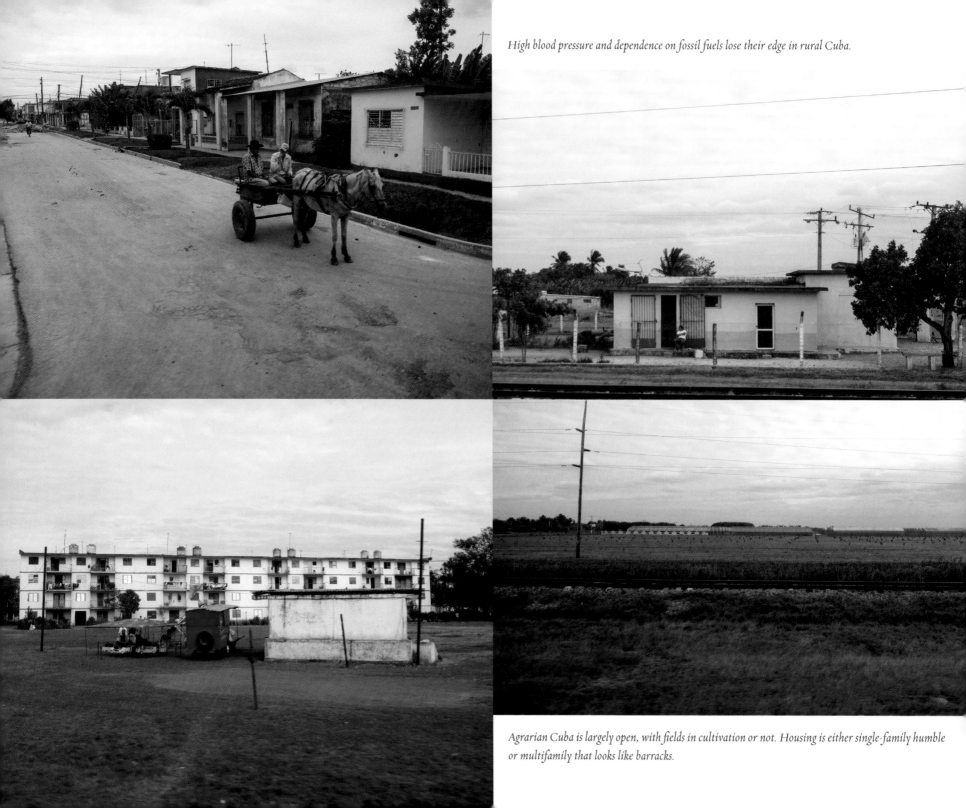

High blood pressure and dependence on fossil fuels lose their edge in rural Cuba.

Agrarian Cuba is largely open, with fields in cultivation or not. Housing is either single-family humble or multifamily that looks like barracks.

Which may segue perfectly to the takeaway message of this idle analysis on the road to Jucaro:

Cuba can be soulful and loving. The Cuban people show indomitable spirit and artistry, and the Cuban countryside is storybook beautiful. The jewels in the crown are Cuba's reefs and the zeal to protect them. The good things in Cuba can simply be better without the embargo that hurts everyone and benefits a greedy few. Didn't that same greed and corruption give rise to Castro's Revolución in the first place? Was that a lesson of history? Yes, ending the embargo would enrich the Cuban government for renewed mischief internationally—unless that government is wiser and more sanguine on improving the lot of its constituency, a concept also harking back to the big bang. John Lennon is a lefty icon in Havana who may have sung the remedy most concisely: *Give peace a chance.*

A well-stocked street vendor.

After school in rural Cuba.

Which segues perfectly to a lead story in the *Havana Times* four days after the decree on Cubano freedom to travel the world:

"As of today, the U.S. government has lifted all restrictions on U.S. citizens wishing to travel to Cuba. This is not true, but reciprocal measures will be a good idea if rapprochement is to have a chance at success."

I agree. And do you think for a New York minute that the *Havana Times* says anything not sanctioned by the Cuban government? Let the embargo and the pissing contest end:

"As of today, the Cuban government will freely accept U.S. dollars as legal currency in Cuba. This is not true, but bold steps will be the best path if rapprochement is to succeed."

That was me. The embargo is bogus, a sham at the expense of peaceful life between America and Cuba. The Cuban–American business junta is descended in part from families who lost everything, including legacy farmland handed down for generations. So they are justified in their anti-Castro rhetoric, beliefs, and motivation. But it's over fifty years, and the embargo will not bring Castro down; rather, it shores him up with a portrayal of U.S. trade oppression and failure. If Fidel Castro drops dead tomorrow, he wins. If the U.S. drops the embargo, the Revolución will lose its argument and suffer—make that absorb—the cultural diplomats, social influence, tourist traffic, and free trade in goods, services, and idiomatic idiosyncrasy of the United States of America. *Which* idiosyncrasy, in case you haven't noticed, is uniquely similar to that of Cuba, most notably in its sensitivity to irony and pathos, its intellect, artistic expression, high-minded values, and, yes, its morality.

Many hours on a big rumbling bus rolling southeast from Havana to Jucaro allowed time for reflection and comparison. Arcane Marxist rhetoric on billboards felt amazingly bold at first blush but then seemed mundane in a few hundred miles. *Patria o Muerte*— Country or Death—is very similar to Patrick Henry's patriotic last words that drove the American Revolución. I mean Revolution. But seeing the death ultimatum in Spanish on a huge billboard in Communist Cuba felt chilling, not thrilling. But the chill soon warmed to ambient temperature, as chills will do when they come from the same old platitudes available on billboards anywhere.

In *This Is Cuba*, Ben Corbett captures the irony and pathos of Cuba's outlaw economy in a chapter title: *"Turismo o Muerte."* It's not as bad as tourism or death, but Cubans are allowed access only to peso hotels or cabin camping in mosquito-swarming wetlands. Premium hotels and the best beaches are reserved for tourists. Segregation also "protects" Cubans from outside information but may foment resentment and come back to haunt tourism policy in the future.

More productivity and efficiency: Revolution.

Cuban billboard messaging is as corny as *These Colors Don't Run* or *Freedom Isn't Free* and the objective is the same: Believe this. Does billboard rhetoric make a difference in collective consciousness? Most likely it does, probably with effectiveness fading slow as the billboards themselves. But two other questions emerge: What's the difference between collective consciousness and mob rule? And what consciousness is more malleable than insulated, uninformed consciousness with limited contact to the whole wide world?

Literal translation: The CDR is vigilant (watching) and ready to fight. Fidel founded the Committee for the Defense of the Revolution in 1960, the year after overthrowing Batista. The watch phrase is still meant to encourage el gente in the fine print: en cada barrio—in each barrio, or neighborhood. Next door is la escuela; get 'em while they're young.

"Los Espirituanos seguimos en combate" states that a group, Los Espirituanos, is still fighting. The same sentiment was composed by Karl Rove: Support Our Troops. In both systems we see political interests seeking power entrenchment by highlighting a threat. The threat must be perceived, even if it doesn't exist.

Without losing one day, we have gained all this. Note the detail, lower left. It says Jardines de la Reina. We must be getting close! Unless a few more hours remain.

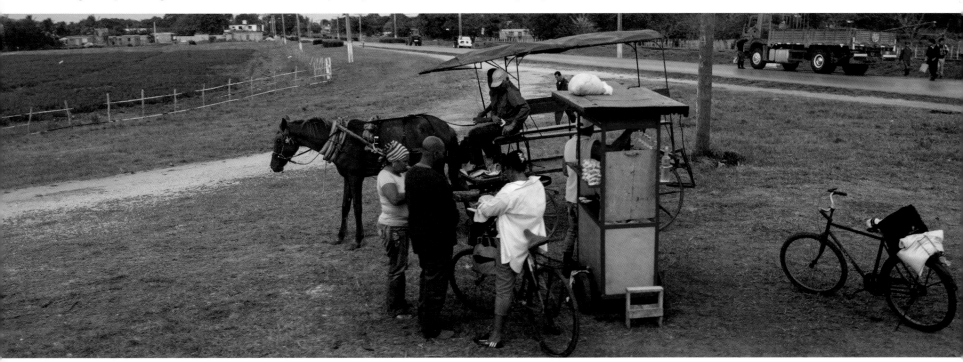

The sweet simplicity of rural commerce. Note, lower left, the woman is wearing a stars and stripes do-cap—demonstrating the diluted impact of political messaging in a rural area.

Small-town rural Cuba.

So the pastoral countryside rolled along, many miles of it refreshingly free of power lines, phone lines, and other clutter of modern times. The road is paved but fresh and unencumbered as horse-and-buggy times, and the pastoral beauty belies the deprivation—after all, no power or phone lines mean no power or phones. And life seems good, abundantly beautiful, and simple as ox-drawn plows tilling family plots and people engaged in simple pursuits. Life in rural Cuba is an illustrated storybook, not mechanized but muscle powered. A man behind two oxen and a harrow plowed a small area in front of a small house with no noise, no smoke, no fossil fuel. Lean and lithe as a Thomas Hart Benton farmer, his movement matched the setting with rhythm and no bloat.

In rural Cuba the nineteenth century endures alongside the mid-twentieth, with fifties vintage cars marking time from the beginning of the Revolución and embargo. American classic cars are not in the dozens or hundreds but the thousands across Cuba, nearly all remachined and rerigged with Russian diesel engines emitting varying degrees of clatter and smoke.

A dog with a view.

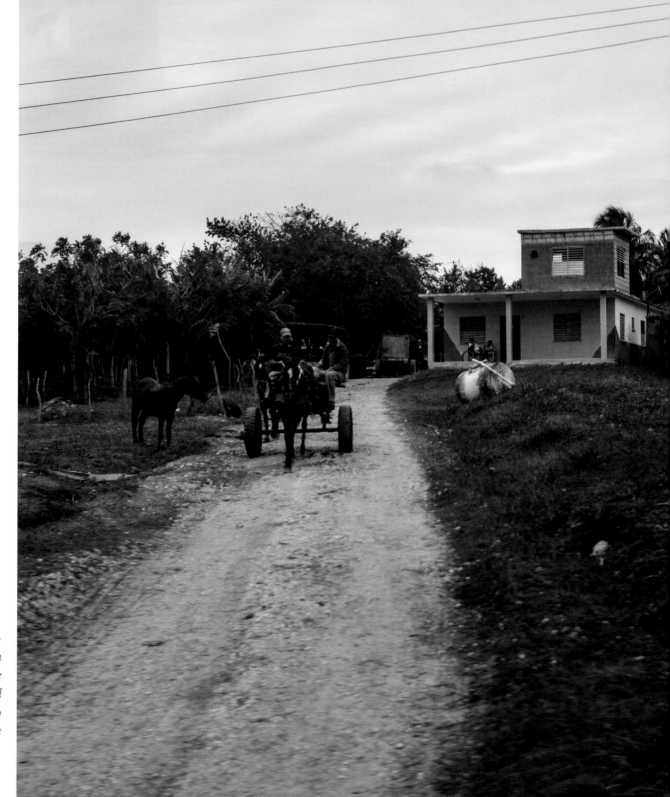

Rural Cuba combines the nineteenth century with the mid-twentieth, often with a unique blend. This buggy rolls on rubber tires and wheels with bearings, and the power or phone lines overhead may indicate a brighter future or enhanced communication. Whatever machine once worked can be made to work again and keep working. Cubans waste nothing, as a spirit endures and evolves.

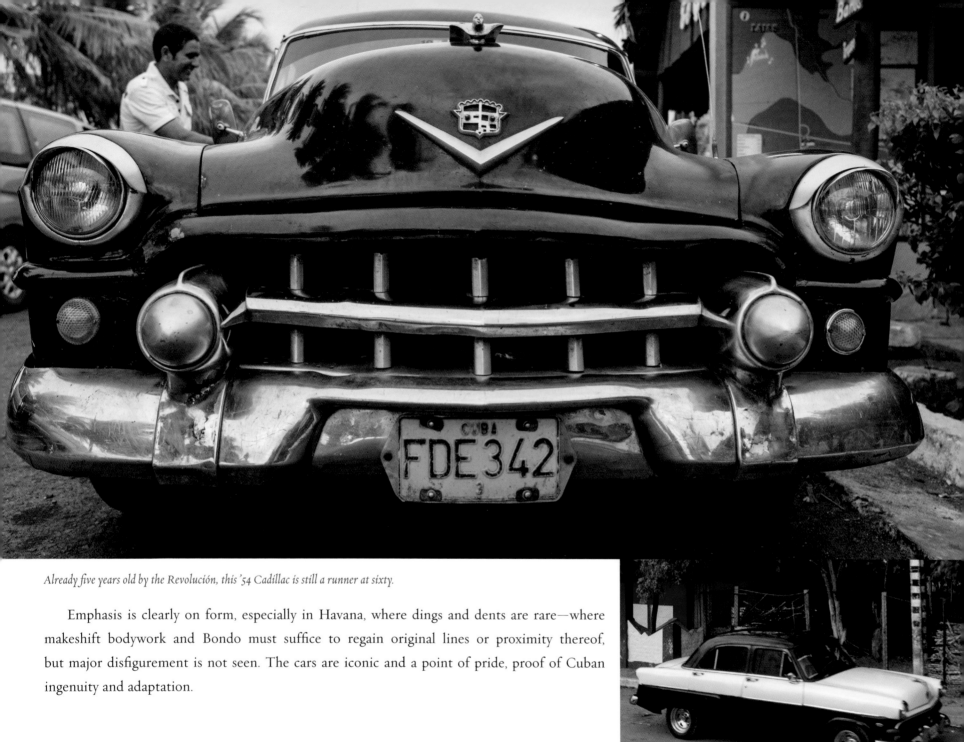

Already five years old by the Revolución, this '54 Cadillac is still a runner at sixty.

Emphasis is clearly on form, especially in Havana, where dings and dents are rare—where makeshift bodywork and Bondo must suffice to regain original lines or proximity thereof, but major disfigurement is not seen. The cars are iconic and a point of pride, proof of Cuban ingenuity and adaptation.

Likewise, a '54 Ford still delivers as a mode of transportation and a point of pride.

The contrast with *What We Know* was so startling that idle fantasy crept in, in which the only thing better than another latte would be a reasonably convenient convenience stop among the scrub-covered flats and banana groves in the land that time forgot. And presto! Stopping for fuel and a peepee was never better. Seasoned travelers learn to carry paper napkins or tissues, though a bathroom accessible to tourists in Cuba may have an attendant to keep things clean and stocked with toilet paper. The attendant expects a tip, representing one of the great bargains of the not-so-free world.

A seasoned animal nut will measure a place and its people by its treatment of animals. Stray, starving, mangy animals are not seen—not like French Polynesia, where they do nothing but round them up and kill them once a year. A typical perro Cubano makes a living in South Cuba with access to tourists and their tips.

Back on the road, time is again forgotten, passing lowland rice paddies and sluice gates. A man on a hillside cutting weeds with a scythe also seemed remarkably free of fossil fuels, noise, and smoke, his zero body fat a testament to the obesity epidemic that will not likely occur in Cuba. Sugarcane grows only four or five feet high here, because it's grown as a viable crop, unlike Hawaii, where sugarcane is cultivated for a projected loss that becomes profitable with federal price supports. Hawaii sugarcane grows to twelve or fourteen feet with enough fertilizer to kill reefs, with nuclear pesticides to make sure those reefs stay dead. Hawaii sugarcane leaf is too heavy to harvest by hand and even too heavy for machine harvesting, so the cane fields are burned, producing

pillars of smoke and fire unseen since Charlton Heston demonstrated the wrath of God in *The Ten Commandments* just prior to the Revolución. Hawaii sugarcane is wasteful by design and destructive, yet the alternative is tract housing—known locally as track housing—in another familiar lesson from Hollywood meant to appease our masses: *if you build it, they will come.* Back in Cuba, papaya orchards and vast mango tracts round out the agricultural pursuits visible from the main road, along with working tractors that appeared to be older vintage than the cars and maintained with equal pride and necessity.

Small-town rural Cuba is deprived, but with materials in place to fix a hole, conditions here can only improve, maybe. Note the small paper sign on the wall: "Se vende un televisor Panda". Television for sale Panda. Now where would Panda brand come from? Hmm.

Before TV, people hung out together, played games, and exchanged ideas. Dominoes is a popular game across the Caribbean and in South Florida.

And here's a *fun fact* filling in like a puzzle part, rendering the Big Picture more clearly as we look back, perhaps a tad wiser, on our foibles: poverty and deprivation have rendered Cuba poor, with *nada mucho* down to fundamentals. The biggest hit since the Revolución was not the U.S. trade embargo but the collapse of the Soviet Union, when support vaporized and the *Special Period in Peacetime* began. Perhaps taking a lesson from American ingenuity in WWII, when "peace gardens" proved that home gardeners could achieve dramatic yields from very small plots, the Cuban government encouraged Cubanos to grow their own. Results were equally dramatic in yield and more dramatic in economy and quality. With so much excellent produce grown without mechanization or fertilizer or pesticide, the Communists proceeded to make organic farming the law of the land. They can get ham-handed that way, but on that front it was a good thing.

On first blush, the average tourist might think a country serving 100 percent organic fruit and vegetables charming but in Cuba paradoxical. We pay a premium for organic produce while an economically depressed country *requires* purity from nature. On second blush comes the realization that a fundamental reef killer around the world is toxic runoff—what free-world agribusiness calls "nutrients." Those "nutrients" come from nitrogen-laden fertilizers and other dukey effluent of industrial magnitude—massive farm waste finding its way to the sea. One small example in recent years were pig farms in North Carolina where thousands of pigs lived in hellish conditions with no room to move, wallowing in mud and pig shit. When a nearby river topped its flood banks, all the muck got blended into "nutrient soup." Things got worse, with pigs drowning in the mire. Then everything flowed to the sea. Multiply this by ten, or a hundred or a thousand or many thousands, then factor in the noneconomic components, like animal cruelty to the point of brutality, along with the hormones, antibiotics, and the pesky bacteria growing relentlessly immune. Then pretend you have a PhD in common frikkin' sense and you will be ready to *see*: Eureka!

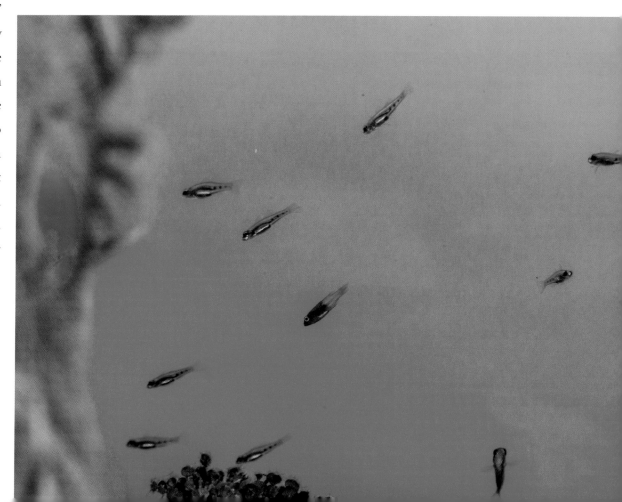

Agribusiness corporations focus on massive quantity with no regard for reefs. Cuba has no fertilizer or pesticide, so Cuba has healthy reefs.

Cuba reefs are spared industrial runoff, shoreline development—*and* "modern" agri-toxins.

Of course it's all too easy to imagine a perfectly innocent agri-corporate fat cat crying foul on the accusation that industrial farming kills reefs. And it's also easy to fall into fresh-eyes syndrome, in which a place seems dynamic compared to the same old familiar home place and all its blemishes. *Reality* in Cuba is not all hearts and flowers, and if an objectively jaundiced eye were to assess down to details, the facts in Cuba are also harsh. On the niggling side of things were the elevators at the Copacabana; they smelled like ass. The severe end of the spectrum came to "Don't drink the water." Official word in Havana—meaning the message cleared by an acutely image-conscious government—was that surging numbers of cholera cases had not yet achieved epidemic status, but it was close. Factoring informational buffers in a place with practically no hard news and a chronic soft sell on difficult times, the official word could easily have meant that cholera had reached epidemic proportions in Havana. We opted for a conservative, cautious response to the cholera outbreak. Not drinking the water meant not running your toothbrush under the tap or gargling in the shower. The cholera potential warranted avoidance of fresh produce, since irrigation water can get into the skin of the vegetables, rendering a green salad hazardous unless soaked in a chlorine solution, which seems unlikely. *Sin hielo* means without ice and is the common request for beverages in dicey times—drinking straight from the bottle is best.

A billboard said: "Cienfuegos—Lajas, mi rincón querido". Lajas may be a dance place worth checking out. But for the time we were just passing through, hell-bent for Jucaro. Burma Shave.

JARDINES DE LA REINA

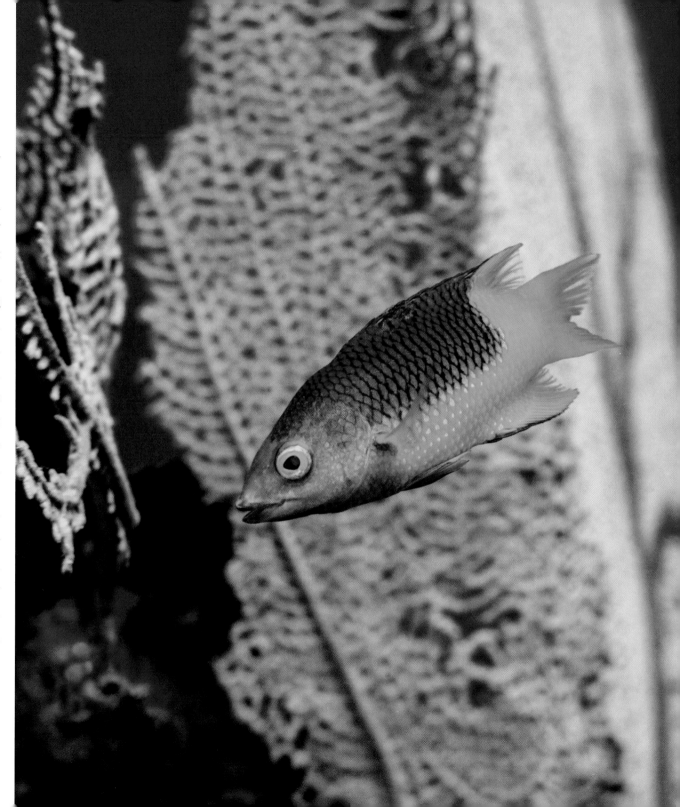

Gardens of the queen. Rising at 4:00 a.m. got us on the bus at 4:30 and to Jucaro by noon. It's a small, seaside town bereft of anything familiar or convenient, except for a bathroom dockside with no attendant but stocked with toilet paper, indicating governmental presence and a possible watchful eye. While two toilet paper references might suggest aggressive consumption in deference to internal disturbance, all was well. Elders on the road often adjust in small increments. More notable was the potential for government monitoring, but that's also likely exaggerated. Cubanos love to fantasize on hidden government cameras. But if they can't afford basic conveniences, high-tech surveillance also seemed unlikely. Beyond that, a worldly elder achieves road wisdom, what might be called sangfroid in New York,

Rhapsody in Blue—a hogfish reefscape at Jardines.

in which he flat doesn't care who's watching, and in fact just might . . . Never mind.

The transition team got the bags off the bus and sorted as if by psychic phenomenon, with each boat's passengers and bags directed to the right boat for boarding in mere minutes. Hurry, hurry, chop-chop, we were casting off for another six hours slightly more roly-poly than the bus but not too bad. The documentation process was mostly personal, requiring passports to ensure that we were not Cubanos fleeing the Revolución, asking age, health, and dive experience and stating many disclaimers on liability with many lines to sign for hold-harmless agreements. What could we do, sue Cuba? Of course Avalon developed these forms and procedures—Avalon is the company managing reef-based tourism in Cuba, and suing Italy would not likely be any easier than suing Cuba.

Travel days in Cuba were long. The trip from Havana to Jardines de la Reina beginning at 4:00 a.m. ended at the mooring line about six, at dusk. With reasonably calm seas, the ride south was time for unpacking, staging camera equipment, and laying claim to electrical outlets for charging batteries. Then came a few hours of rest.

The *Halcón* was another example of Cuban ingenuity, a luxury yacht pushing forty years, still in full-time service with a full complement of passengers and crew. The fittings and finish on the *Halcón* were not all fitted and finished, but all functioned at optimal levels by means of adaptive machining and, yet

Between the dock and bus parking is the support facility for skiffs and outboards serving the dive and fishing operations at Jardines. Typically Cuban, this engine/ machine shop is threadbare, minimal, eminently skilled, and efficient.

again, ingenuity. Where original yacht hardware was missing, like a perfectly countersunk set screw in stainless steel that once bolted the bow roller to the deck, in its place was a moderately hunky, not too cosmetic but thoroughly functional hex bolt, galvanized. The stateroom portholes had once opened on yacht-smart brass hinges, uni-body molded into the porthole frames for majestic appearance *and* effortless operation—in calm weather of course. So near to the waterline, that foofoo crap always goes awry with tourists on board, or else it plain wears out. Not to worry: the *Halcón* portholes will leak a few drops at most and certainly won't let rowdy seas rush in, because they're welded shut and sealed with tar and oakum, like the old salts used to do. That was fresh tar, with a scent so nostalgic it could make a reformed smoker break open a fresh pack or spend more time topside. The smell subsided in a day or two, or we acclimated, and it was good to know the maintenance crew was on top of these things.

The *Halcón* was not designed as a dive boat, so it had no steps or rear deck for easy in and out of the water. It was designed for the life of luxury as fantasized by people who want to be rich, rich, rich, so they can idle the hours away in chaise lounges sipping cocktails and watching clouds drift. The swim deck along the transom was about eighteen inches wide, but with everyone moving carefully, everything flowed well. Beyond that, the crew handled tanks and dive gear and remained ever ready to take the handoff on heavy camera gear, leaving us to maneuver ourselves into the dinghies. All diving and snorkeling was formatted with five- to ten-minute runs from the main boat to mooring sites on flat water. Transit was in flat-bottom boats with outboard motors. Reef access was easy. The telltale standard of smooth function on any vessel, especially a charter vessel in the tourist trade, is the marine head, regularly and often abused by tourists trying to flush what they shouldn't. In the olden days, when the *Halcón* was brand new and Bristol bright, marine heads typically ran directly through the hull with a seacock and valve operated manually from the driver's seat. Those were the days of unlimited ocean, and dumping your sewage into the sea seemed only logical, what with drop-in-the-bucket imagery so prevalent. Opening the seacock and working the pump would drive the dukey into open water with no blush or second thought—but maybe a laugh if some fool was caught swimming nearby. A few more pumps would flush the works with seawater. This system prevailed for decades and failed often. Leaving the seacock open could sink a vessel.

Now we know that a drop in the bucket is actually a dump in the cup, and we have technology to bless these basic functions. The *Halcón* was refitted with modern marine heads with one button to activate an electric pump for out and a lever to activate another pump for in—that would be out of the commode to a holding tank and in with fresh rinse water from the sea. Nine passengers and four crew suffered not one clog in four heads over the following week. And the true standard of luxury on a boat is working heads. As if that wasn't enough, each head had a shower with enough hot water to restore good feelings and keep morale high.

But fundamental morale on any vessel originates in the galley. The personal weight loss program was well under way after a week at Cayo Largo, where #10 tin cans had provided dietary staples. One afternoon at Villa Marinara I wandered into the dining room looking for a bottle of water. Finding nobody, I wandered into the kitchen where the chef, a friendly, jovial fellow with a striking resemblance to Leonid Brezhnev, looked up with a smile. I asked for a bottle of water and he gave it to me—not minding in the least the interruption of his chefly duties, at that moment lining up six #10 cans to open with his can opener and so begin building Cayo Largo *cucina* for the next two days. Ugh.

Coming from Cayo Largo may be the best preparation for life aboard the *Halcón*, where nautical cuisine maintained superb levels of freshness, quality, and flavor at every meal.

After the last dive Amarilla served hot pizza cut into squares with tomato sauce made from scratch and a cheese topping so light and nuanced it caused goose bumps. Water activity burns calories like no tomorrow, so any replenishment felt good. That replenishment was grounds for gratitude. Then came cocktails and love.

Dinner was served around eight aboard the *Halcón* and every night included fresh lobster, a startling change from the #10-tin-can fare of the prior week—and we ate it. We ate it lightly poached, sautéed, broiled, and baked. We ate it in a stew with a subtle tomato puree and straight up with garlic and butter sauce. We had anticipated lobster, but not twice a day. When I had challenged Fausto on the wisdom of pressuring this single species as a food source, he splained that seine trawlers—conventional shrimp boats—destroyed much bottom habitat in surrounding waters. Seine trawlers commonly run a "tickle chain" on the lower, leading edge of the net, so that any lobsters—or fish or shrimp or turtles or any life form ever known to the ocean—will jump off the bottom and into the net, so humans can eat their fill. In the process, bottom habitat is destroyed as the chain crumbles everything like a disc harrow, throwing the entire ecosystem off balance. Fausto presented the premise that lobsters rebound like insects, as only insects and lobsters can do. So, the lobsters were plentiful.

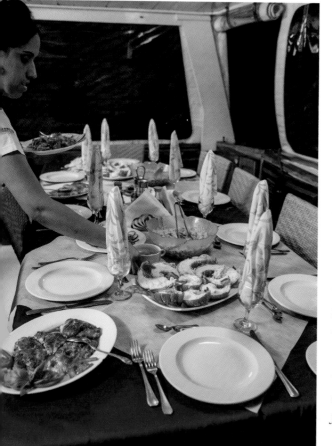

But how can one species rebound without the bio-support that species would require for a rebound? Hmm. I suspected the langoustes were taken in traps and the langouste catch had not yet been depleted, since we saw plenty of them on the reefs. Still, such steady, significant lobster catch in a place framed as "protected" made a ripple on the assessment pond.

And an assessment can make a difference. Anyone working the conservation front for results instead of fund-raising or "raising awareness" will point out specific problems and call for specific solutions. A shrill lament from aquarium hunters in Hawaii is, "You eat fish, don't you?" But individual habits have very little impact on any situation, and solutions are mostly based on the supply side. Aquarium hunters might as well run through the suburbs of America netting songbirds to deep-fry for all-you-can-eat, calling out, "You eat chicken, don't you?" Frontline activists can be most effective in adapting to the moment and making the big change later. The big change on langouste remains to occur at Jardines, but given Cuba's comprehension of reef management in general, it seems far more likely to occur in Cuba than in the tropical outpost of the U.S.A. called Hawaii.

The afterdeck was enclosed with nylon and transparent vinyl panels to fend off evening breezes. A banquet table set for nine transformed the 9 x 15 space into a perfect dining salon. Golden light and sumptuous fare prepared with skill, growing friendships and a quart of rum after three excellent dives made for very good life aboard. Here, Amarilla sets the table for dinner at eight.

We'd heard about the *Halcón* menu from Fausto in Cayo Largo in a moment of pained nostalgia. He had just outlined the Cuban government's focus on reef habitat and species abundance, and to that end its elimination of commercial fishing and its predictable hatred for the aquarium trade, as all reasonable countries do. So far, so good, in aligning his values and Cuba's values with reef advocacy values around the world. Most important of all these values is the relatively recent Cuban ban on shark fishing, to optimize prospects for ocean redemption in the area. He'd mentioned the delectable menu aboard the *Halcón* casually, in passing, as one might gloss over a former romance still tender in the heart. Of course a significantly different menu at Cayo Largo underscored his loss, but I pressed for clarification. "You say we will have fresh-caught fish every day at Jardines. Is that a special dispensation to tourism? Because it might not seem like much of an effect on fish populations, but it is, moreover demonstrating special treatment for those able to pay."

Fausto understood special dispensation and the toll it takes on revolutionary principles—or maybe he only remembered the fish he ate at Jardines. "I will

The Halcón galley, where chef Manuel and hostess Amarilla maintained a high standard of on-board morale.

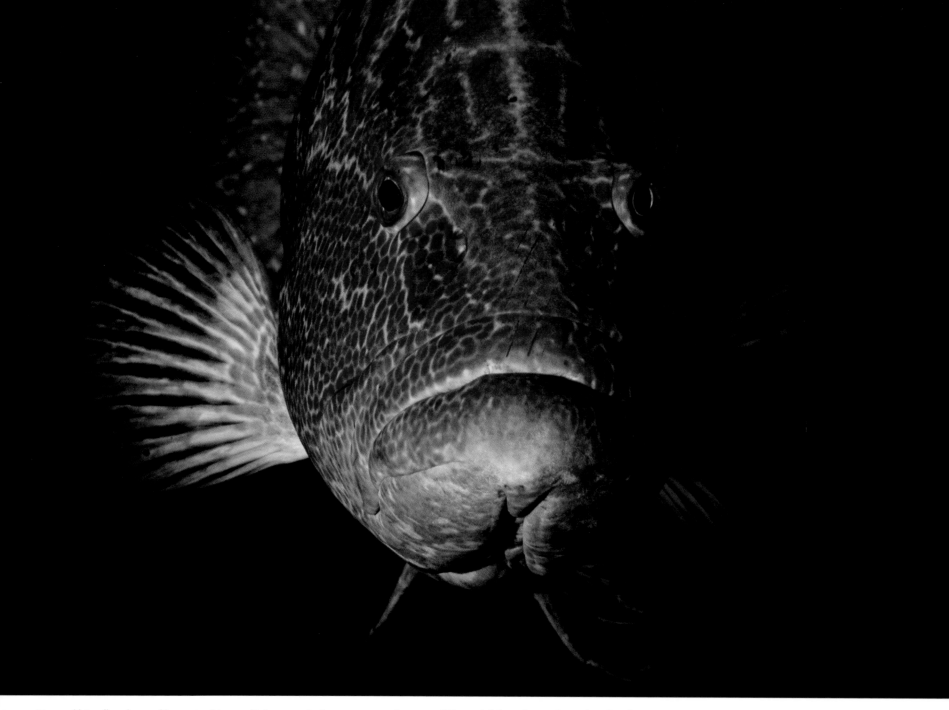

You wouldn't pull my leg, would you? Catching a Goliath grouper in the 200–500 pound range would be overkill for so few people on a live-aboard, not to mention unseemly. Yet these fish have been wiped out in many areas so people can eat them in a blink and want more. But the oceans have no more. President Remengesau of the Free Republic of Palau attributed the empty-ocean syndrome to "the insatiable Asian appetite" for every last fish. Palau then purged itself of the aquarium trade.

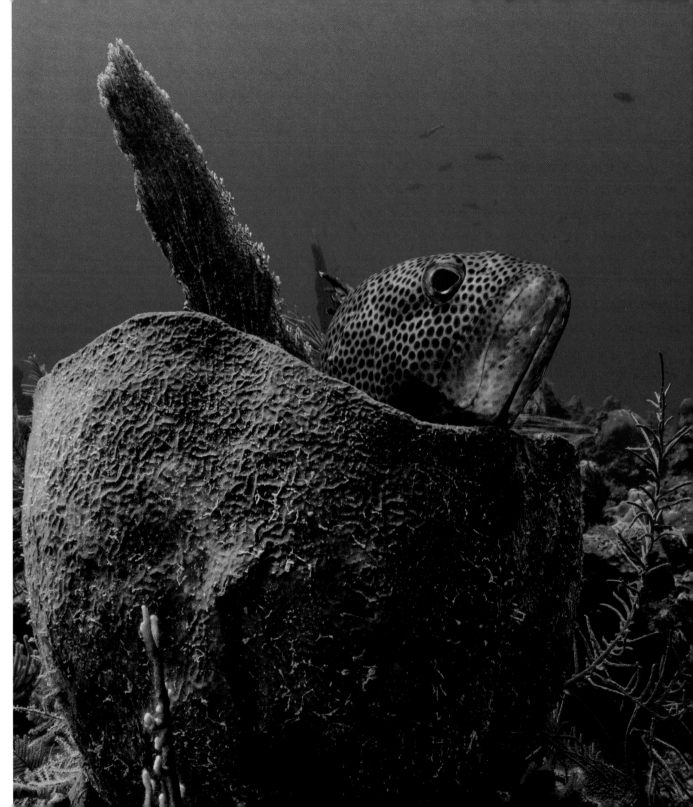

tell you that all the fish eaten at Jardines is taken outside the park. The boats that go to catch the fish must leave the park first."

Jardines de la Reina National Park is one thousand square miles, so I doubted for practical reasons that all the fish eaten were taken outside the park—fuel cost and open-ocean conditions among them. Daily? Who or what could possibly support such an effort in the spirit of spoiling the tourists? The short answer is nothing and nobody. Maybe they go for meat fishing trips and stock up. But that would require sophisticated flash freezers and fishing vessels. Or maybe they plunk a line down for a few fish to feed the visiting divers and fishermen and call it "outside the park." Again, information seemed at times contradictory in Cuba, not necessarily as a means of misleading or misrepresenting, but because information is sparse and sources are few.

Fausto recovered well from his unlikely premise, stating that everything would soon change, that fresh fish will no longer be served at Jardines. All fish eaten at

Is it safe to come out yet? A sea bass in a basket sponge may be relaxing or taking cover.

Jardines will be shipped in frozen, likely transported from Jucaro along with the huge larders of fresh *pawpaw, guava, piña, y naranjas*—papaya, guava, pineapple, and oranges—all served generously at every meal to support a rigorous dive regimen. I suspected more practicality than morality in this menu shift, but as with all solutions in Cuba, Hawaii, and the world, a turn for the better was welcome no matter the motive.

Another milestone adaptation in the fast-track program to optimize Jardines de la Reina as a unique reef destination will be the advent of nitrox about

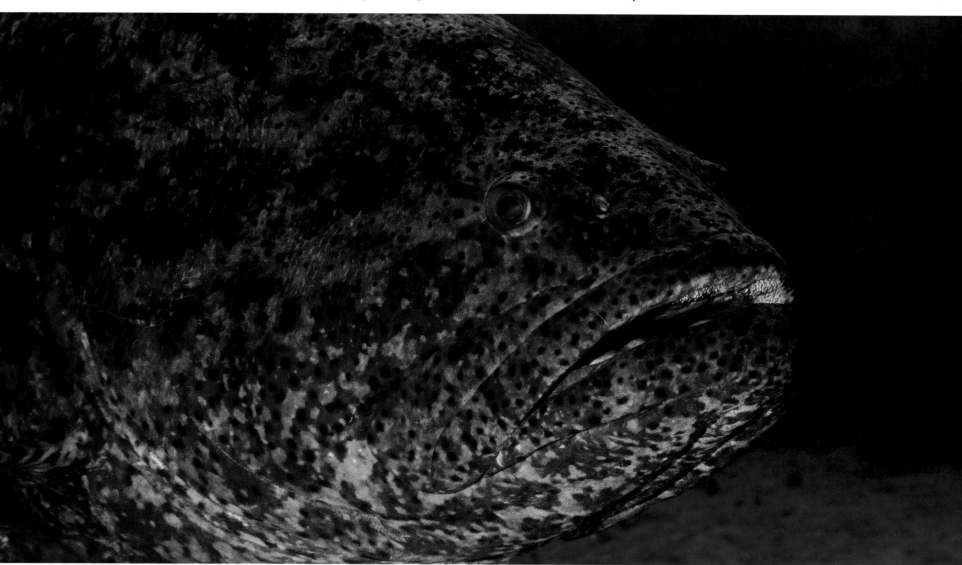

You want motive? I'll give you motive. Like any fish on a tourist reef, the Goliaths at Jardines are familiar with bubble-blowing, hard-shell, neoprene-skin marine mammals. The big groupers are curious, sometimes engaging and always have the right of way.

the same time as frozen fish. And though the fresh fish served aboard the *Halcón* brought a rejuvenating shimmer to a tired body, it would gladly be traded for nitrox. In short: the air we breathe is 80/20, nitrogen/oxygen. A fundamental hazard of scuba diving is excess nitrogen, leading to the bends, in which nitrogen cannot escape the bloodstream fast enough and rushes to the easy exits—the joints—in trying to escape. Hence, the body bends. By pumping scuba tanks with an altered mix, say 68/32, the odds drop like a stone on getting bent—and bottom time soars. Nitrox is to repetitive diving no less than seat belts, ABS brakes, and intermittent windshield wipers are to modern car travel.

Which poses the tough question to people who grew up eating fish, who feel healthy eating fish, who don't want to stop eating fish but must ponder the

Among the grateful for the shift from fresh fish served at Jardines are a yellowtail snapper or two.

. . . a few schools of cubera snappers . . .
. . . right down to a solitary yellowtail snapper striking the perfect pose for an artistic profile.

fate of the oceans and the consequence of an all-you-can-eat world. Dietary decisions are personal, often based on health, morality, conservation, or self-destruction, like all-you-can-eat. For example, I came nose to nose with a bull mahi some years ago and sensed a kinship, a schooling of spirits, and a willingness to run. Cruising the deeps together proved impractical, but I stopped eating mahi. I thought sardines would be good, so low on the food chain, but then I saw that sardine populations are so depleted in some areas that billfish populations—big, apex predators—were collapsing. What's left? Well, salmon swims upstream to spawn and die anyway, so maybe . . . So salmon remains on the menu, but only wild caught, not farm raised, because aqua farming is so dirty. But then how do we know a wild-caught salmon wasn't an alpha survivor prevented from spawning? Dietary decisions get layered and tricky in a more layered, densely populated world, and in the end most decisions are absolute, because the potential of bad people to kill nature for money is certain.

I hear the troglodytes already, screaming bloody murder that renting snorkel gear to people who

then walk on coral and try to ride turtles is a crime against nature. But it's not. Snorkel gear is nothing more than footwear and eyewear for use in water. Extracting life for money is a crime that won't be so easily covered up or reframed.

Few things in life look as good up close as they do from afar, and an early request from our crowd demonstrated changing attitudes in reef stewardship worldwide. The casual request was for something seen and heard, some harmless fun in a shark encounter unique to Jardines. That was shark spinning, a technique developed for subduing sharks, putting them into a trance so they could be more easily tagged, to better monitor their meandering and general health. Like hypnotizing a chicken or rubbing an alligator's belly, spinning a shark can mesmerize the critter, rendering sharks completely malleable. All fish have lateral lines running along each side, usually about a third of the way down from the dorsal fin.

Lateral lines are subtly visible and acutely receptive to pressure, vibration, electronic impulse, and other senses unique to fish. In sharks, lateral lines converge

Big, muscular rays are not to be taken for granted, since they represent nothing to some cultures but meat. Have you ordered "scallops" lately? They cost far more than ray steaks but may be the same. Big rays visible to reef tourists in Cuba represent wise planning with far greater payout in the long term and reward richly in the moment.

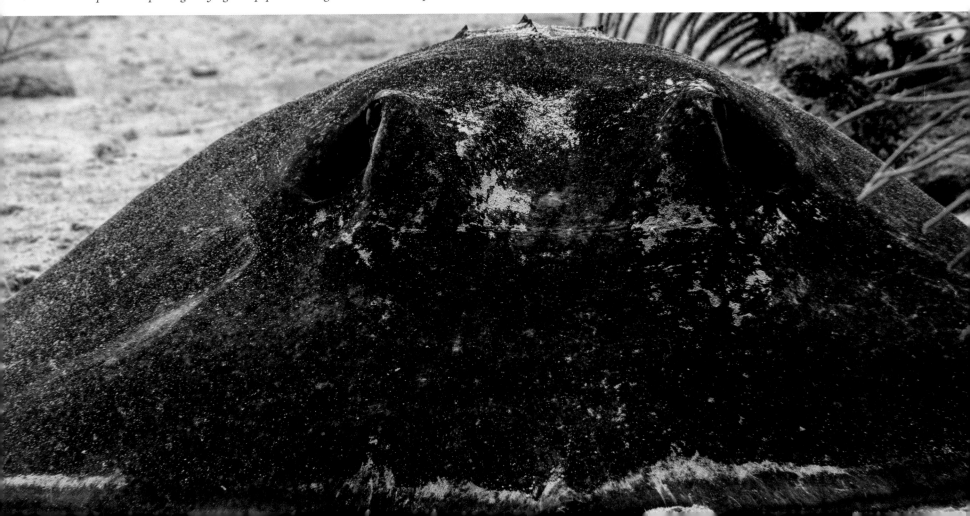

just under the nose—and on a shark, the nose is over and forward of the mouth. Our dive guide at Jardines, Michael Echemendia—or as we called him, Miguel—is a waterman extraordinaire, with more fish sense, facts, and figures at his fingertips than an entire Hawaii Department of Land and Natural Resources could garner in twenty-five years of grant and government funding for "research."

Also at Miguel's fingertips had been the convergence point of lateral lines on many sharks. "You put your fingers under the nose, and you play the piano." He lightly tapped his fingers in the air. "The shark goes to sleep." The actual placement of fingers on a shark's lateral line terminals is certain and exact, like finding the sweet spot on a crystal goblet rim with a moist fingertip. Once the groove is secure, it's easy, but anything short of the groove won't work.

In their endeavor to know their local sharks' movements, the Jardines dive crews put sharks into the trance and tagged them, observing that the sharks didn't mind the

The lateral line is more visible on some fish, like this hogfish. It's the darker line from the tail, following the general contour of the back, breaking at the gill plate but continuing just forward of that with faint definition running under the eye and above the mouth to the nose. Lateral lines provide a sensory trove of information to the fish.

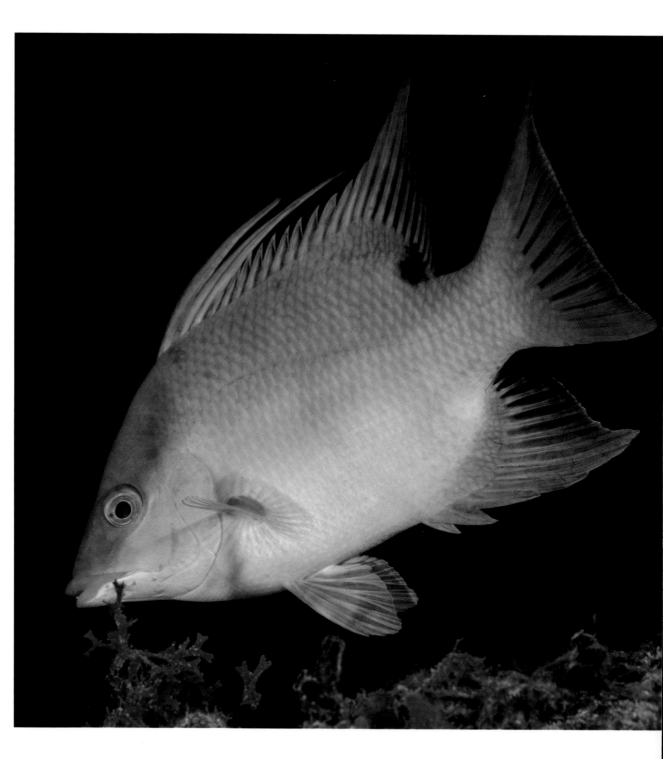

trance and seemed none the worse for wear after tagging. The tagging was greatly facilitated with the big sharks so easily handled while entranced. So they stood a shark or two on end in a posture similar to the big-fish photo op, tail up. Though undead, the sharks were helpless—even as they were spun like tops, around and around on their snout ends. Guileless tourists loved the show, and so it became a feature of the Jardines visit, an experience that didn't hurt the shark, "not really," just as reef hooks don't hurt the substrate in Palau, where dive crews love to have tourists hook into the coral in current, for the thrill of the thing.

But problems arise with so many vigilant eyes on rapidly shrinking reef systems around the world that still show viability and potential today but may die like the rest tomorrow. Reef hooks damage coral, and shark spinning is an abuse and an insult. Shark spinning doesn't hurt the shark any more than disrobing in front of an appreciative audience would hurt yo mama while she was hypnotized. Still, it would be perceived as an affront, as unnecessary and exploitative. Or as Miguel put it: "We have competition around the world. Many places want reef tourists. Some people complain when we shark spin. So we stop."

Or as I put it: "Good. I'm one of those tourists who would have complained. Instead I congratulate you on doing the right thing."

Notable here is practical recognition of and deference to market competition in terms of quality and perception. Do these subliminal adaptations to mixed free enterprise go unnoticed?

Free-market imagery is a far remove from imagery of the Revolución. Marxist rhetoric is predictable and sometimes amusing

Michael "Miguel" Echemendia, waterman, dive leader, naturalist, and diplomat: "My name is Michael. Tourists prefer to call me Miguel. Is okay. We do not spin the sharks anymore."

in its naïve approach to world problems and solutions—and it may be embarrassing to the more informed Cubanos—just as some imagery in a free-market enterprise system is embarrassing to us. How can Cubanos be informed if they can't travel freely, and they get very little media news? For starters, the coconut wireless is international, feeding tiny bits of information that germinate in a collective consciousness. Cubanos watch far less TV than most people, so they have more time to think and a habit of thinking free—without the onslaught of brain-numbing stimuli and mind-altering "values" flowing forth from American media that can seem like effluent through a broken sewer main. People who don't watch TV are amazingly reflective and often capable of original thought. This too seems paradoxical, that thinking may be a more free-form process in a Communist country than in the USA—that media influence in the USA tends to come from very few sources of central supply. Corporate conglomerates are not people, my friend, but they do shape thought and values in the U.S. Most American news media these days is either left leaning or right leaning, with the Murdoch empire standing out like a sore thumb. But the syndrome is global—the Kremlin did it in the USSR, albeit without the glitz and cheesecake.

Thought control by any other name is still thought control, and the cultural disjunction between the U.S. watching TV and Cuba sitting on the stoop, thinking, is apparent across Cuba. These colors don't run, for example, but they're losing a cultural identity and integrity as yet undiluted in Cuba.

Marxist slogans are everywhere in Cuba. Conspicuously absent are images of Fidel or Raúl, as if to demonstrate that the Revolución is of the people and of far greater purpose than the aggrandizement of a single family. Alas, Cuba knows better but it has no military. The Castros have a military and so they persist. Maybe Fidel's most sympathetic moment in his waning years was his stumble on the steps and sprawl onto the floor. An old man taking a fall is a guy, maybe not just a guy,

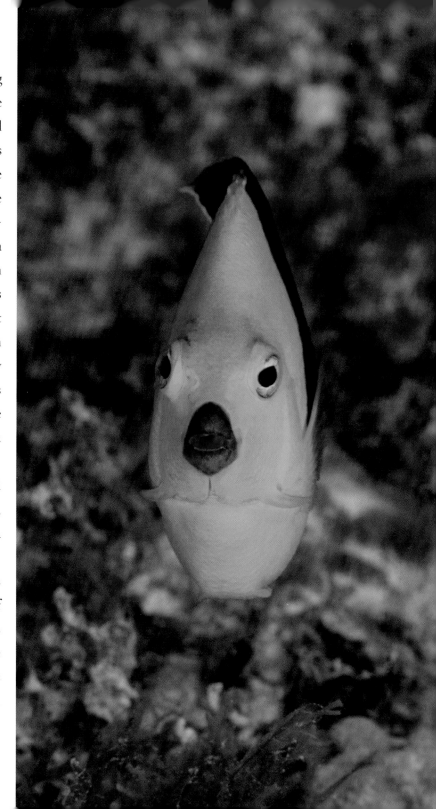

but human—a guy sprawling headlong into old age and the frailties therein.

While a single family is indeed part and parcel of the Revolución, prevalent visual imagery is that of Ché Guevara, the gregarious revolutionary who aided Fidel before he was killed in Bolivia at age thirty-nine. José Martí is the other dominant face of Revolución, because he also stood against corrupt government in the late nineteenth century and died at the hands of the opposition.

Revolución is the ideal, the pure standard from which all policy derives. Although Cubans get no TV as we know it, they do get relentlessly long-winded explanations from Fidel on the meaning of Revolución, along with proper interpretation, application, rejuvenation, supplication, and control of the nation. Fidel wants Revolución understood as he intends—to be cast in stone and the mind of the Cuban people. Can you imagine sixty years of George W. Bush splaining things? How gray and polite could Barack Obama get in half a century?

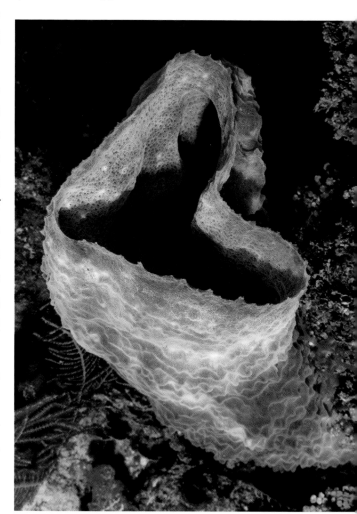

Here's the rub: changing things in a democracy takes time and most often must confront private, vested opposition that is far better funded than public trusts. Many population segments of a free society must see the wisdom and benefit of change and then speak out, so that others might also see it, until consensus evolves. For example, a huge majority of U.S. citizens wanted background checks on gun buyers, along with smaller ammo clips and a ban on machine guns. Yet a tiny, deep-pocketed few stonewalled change on behalf of gun manufacturers. What could be done? Nothing, because of political payola. That's democracy. Another example of failure in America was the U.S. Supreme Court's decision on Citizens United, effectively allowing secret money to control the democratic process. The court decision cited freedom of speech as the basis for secret money controlling the electoral process. That seemed counterintuitive to many people who learned the tenets of American democracy in junior high civics class. In fact the Supreme Court decision on Citizens United seemed oddly similar to what the founding fathers sought to escape in the English monarchy.

Or the head guy can issue a mandate. That's another extreme, but it seems intuitively correct in the face of dire threats to reefs around the world.

Dive leader Miguel at thirty had been a diver for twenty-two years. He knew reefs by second nature, including sponge species and their role in ecosystem balance. He knew the difference between coral in decline and coral growth—the difference between adaptive change and new life.

Miguel knew the cleaners, groupers, sharks, tiny gobies, blennies, and the rest.

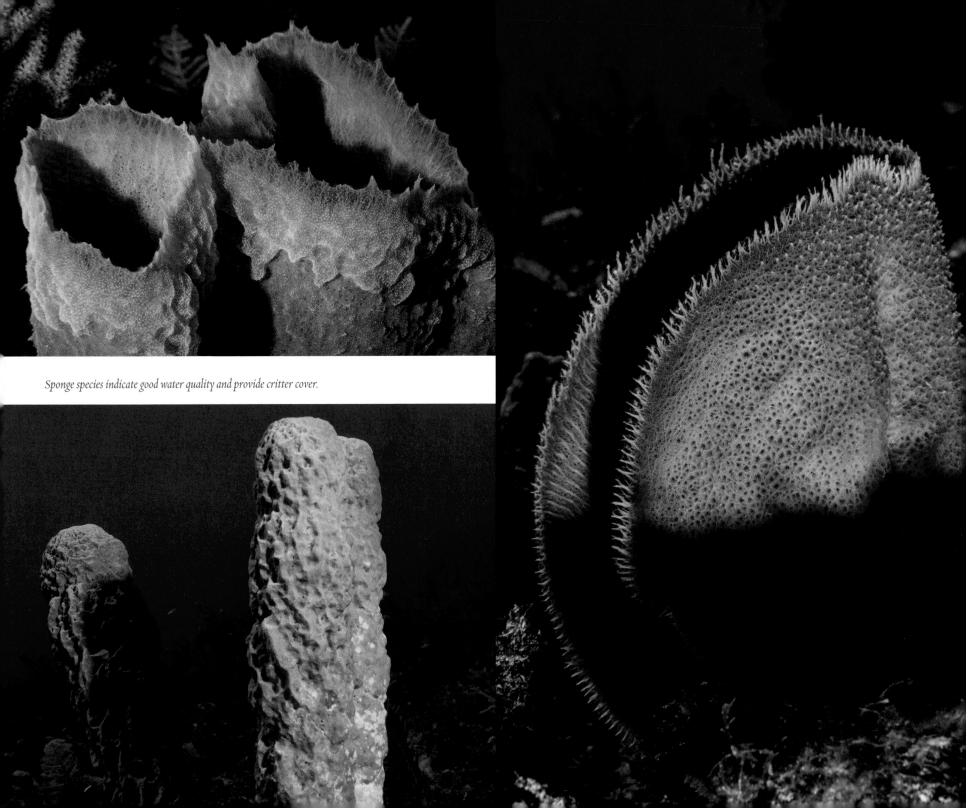

Sponge species indicate good water quality and provide critter cover.

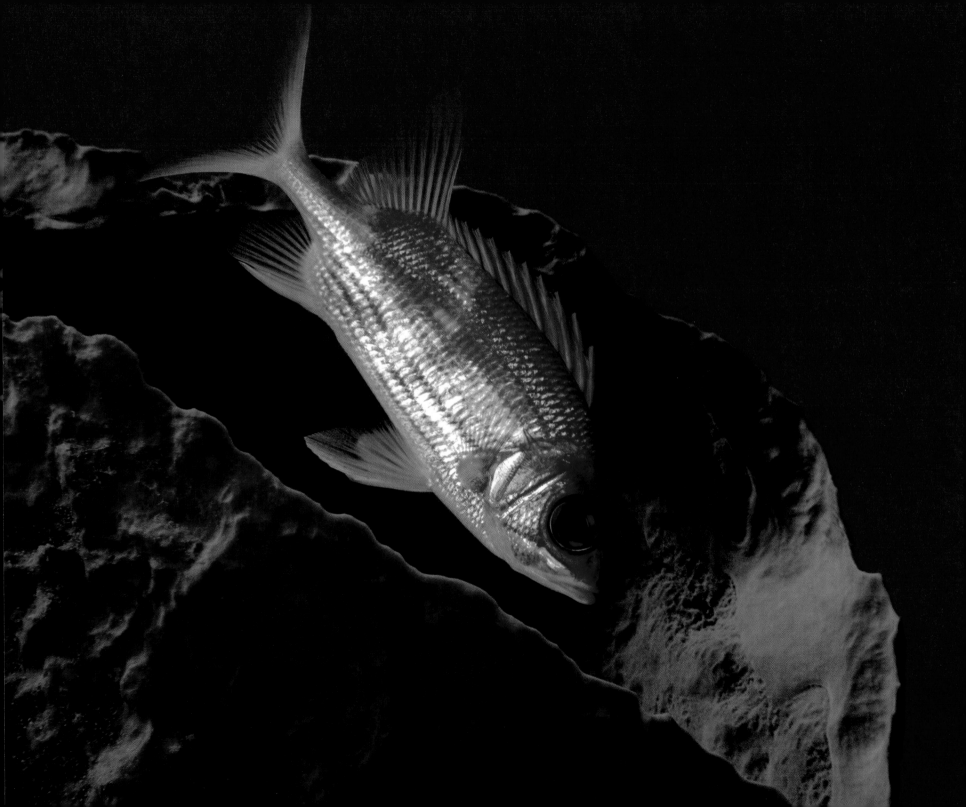

Fire coral is hazardous to the touch. Here, it reaches for growth, indicating optimal water quality and balance.

He also knew the Latin beats from the cha-cha-cha to the tango and on to the rumba, and salsa. He knew which rhythms are Cuban, like the mambo and guaguancó (wah·wahnk·OH). This last is "very hard to do without the right beat. It is a simple beat, meant for the people, so they can dance anywhere in a small space." Miguel concisely conveyed the values of the Revolución and intelligent, informed people everywhere. How did he learn so much? By reading,

observing, and smiling, even at the guaguancó's small victory for dance and rhythm and the happiness that a beat and a melody can bring to the people—in their small spaces. Miguel knew life at street level and nature at reef level.

"We have Jardines because Fidel Castro is a waterman. He can't dive anymore because he's too old, but he used to dive here, and he loved it. He said to save this place. Protect it from everything. That is one good thing you must say about Fidel."

And there you go.

"Raúl is not a water guy. He is the extreme opposite of Fidel in every way. He doesn't dive or care about this sort of thing, but Fidel's family still comes to Jardines to dive—on the *Halcón*."

"Wait a minute. Don't they have their own boat?"

"Oh, no. They are very frugal. Fidel Jr. is an engineer [nuclear—oy vey]. He looks just like Fidel. He loves this place, too." Fidel Castro the younger is commonly known as Fidelito and is not, by the way, widely anticipated as a national leader, because he has no political aptitude or aspiration or favor from his father. A toothless man in Havana promoting massage services from his two women, one white, one black, for the variety you will surely love, felt that Fidelito's political problems began during his university days in the Soviet Union. Why would that be a problem? Well, man-on-the-street assessments are more or less accurate in one country or another, but in Havana the response was a headshake and a nod toward a building just yonder, where the toothless man sensed a police camera observing.

We have more cameras in the U.S., at intersections, convenience stores, watching from lampposts, though sinister intention was more easily sensed in a totalitarian state. After all, ours are meant to prove traffic violation or apprehend terrorists in crowds, while theirs are easily imagined as tools of the gulag. We may not fear our disappearance, never to be seen or heard from again. But it happens. Back on the park bench, the toothless man believed that Fidel had been in direct contact with "Bush hijo," meaning George Bush the son, to advise Bush that the embargo was hurting the people of Cuba, but Bush would not stop the embargo. "*Bush hijo no pudo detenerlos. Y fue muy estupido. Pero Barack . . . quizas.*" Bush the son could not stop it. And he was very stupid. But Barack . . . maybe. Bush hijo perhaps could not stop

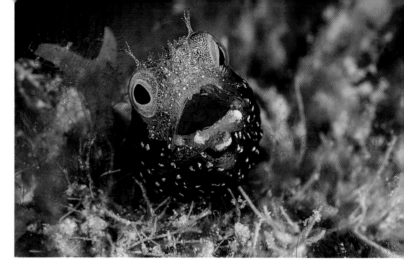

Photo by Spencer Burrows
Though similar in size, habitat, diet, and behavior, the roughhead blenny has distinct white forehead fuzz, while the secretary blenny is cleaner cut.

"A la izquierda de la José Martí," said the man with no teeth. "How can anyone be to the left of José Martí?" I asked, but he shooed away my foolishness. There was the hidden camera, watching us. I couldn't see it, but he assured me that if he grabbed my camera, the secret police would swarm the area. I didn't take his picture.

the embargo because of political debts incurred in the 2000 election. Consensus on Bush hijo's intellectual capacity appeared to be international.

The toothless man also resented the Castros and the deprivation they required just as he resented the embargo as it has been formulated and controlled by the South Florida Cuban contingency stroking its own, private black market. He most resented that the people of Cuba have suffered the political battle most, and he made sense. He insisted that only 45 percent of Cubanos are Communist and many of those are practically motivated. The rest are "neutral." Who would rule after Raúl? "*No sé.*" He didn't know—not the son, but maybe a nephew, a colonel, or a general and certainly a Castro or a Castro disciple. It didn't sound much different than the political machine in Hawaii, which isn't based so much on nepotism but is wholly framed on alliances within the machine serving power and money and not the public trust. Thank Neptune that Neil Abercrombie won't advise the Cuban people on meaning and relevance and the benefits to surely accrue, so the sellout could begin in earnest. Of course such whimsical speculation reflects petty political bickering—and the sellout of Hawaii reefs.

Back in Cayo Largo, Fausto had told of a complete ban on spearguns in Cuba. Yet divers take bugs from Cayo Largo reefs with Hawaiian slings. That seemed a fine distinction, between spearguns and pronged slings, but a speargun ban did suggest commitment and resolve on reef and marine species recovery. Fausto also lauded Cuba's aggressive steps with a fishing-net ban, freeing the Cuban archipelago from massive, unchecked extraction, whereby a single net can haul tons of fish from the ocean in a single pull and destroy benthic habitat on the way.

Fausto further promoted Cuba's catch-and-release program that focused on resuscitation of every fish caught, with no fish coming out of the water. Obviously a few fish do not recover. Obviously Fidel was both a waterman and a predator. Obvious discrepancies abound. But the value set emerges with its faults and successes.

The promotional discourse continued to barbless hooks mandated throughout Cuba, and along with barbless hooks came a special tool for hook removal, after which each fish is monitored for coloration and released only when it can swim.

At Jardines we learned yet again that all fishing was done with barbless hooks, so we asked to see a barbless hook, to photograph it and show it to a world waiting for reef guidance. When the hook did not appear, we asked again and again. Then came the news that too many fishermen complained of losing their catch with barbless hooks—losing their photo ops, bragging rights, and all the stuff that fishermen hate to lose. So in a step nearly as effective as barbless hooks, the Jardines fishing program has gone to "very cheap steel that will dissolve quickly."

"How quickly?"

"Very quickly."

"Hours? Weeks?"

"Very quickly."

"Can we see one?"

"Yes. Of course. We will bring one from *La Tortuga.*" La Tortuga (the turtle) is the floating hotel.

Alas, all the hooks were in use—gone fishing—so we didn't get a shot, though we sensed the common use of standard, barbed hooks available at any tackle shop outside Cuba, along with the use of whatever language could best promote the program, as if intention was the same as reality.

Ah, well—commitment and objective still seemed tangible, and the world is less than perfect. The reefs at Jardines are very nearly a perfect example of Caribbean reef habitat with optimal populations and biodiversity. As stated, lionfish introduced by the aquarium trade represent a major compromise and threat to reef health, and many dive crews kill many lionfish every day to thin them out, to eat the fillets and to feed dead lionfish to sharks, moray eels, and groupers, so those predators might learn to make lionfish part of the local predator diet.

Apex predators at Jardines de la Reina include healthy populations of moray eels . . .

La Tortuga (the turtle) is the floating hotel for fisherpersons at Jardines de la Reina. We passed it slowly nearly every day but saw no barbless or cheap hooks.

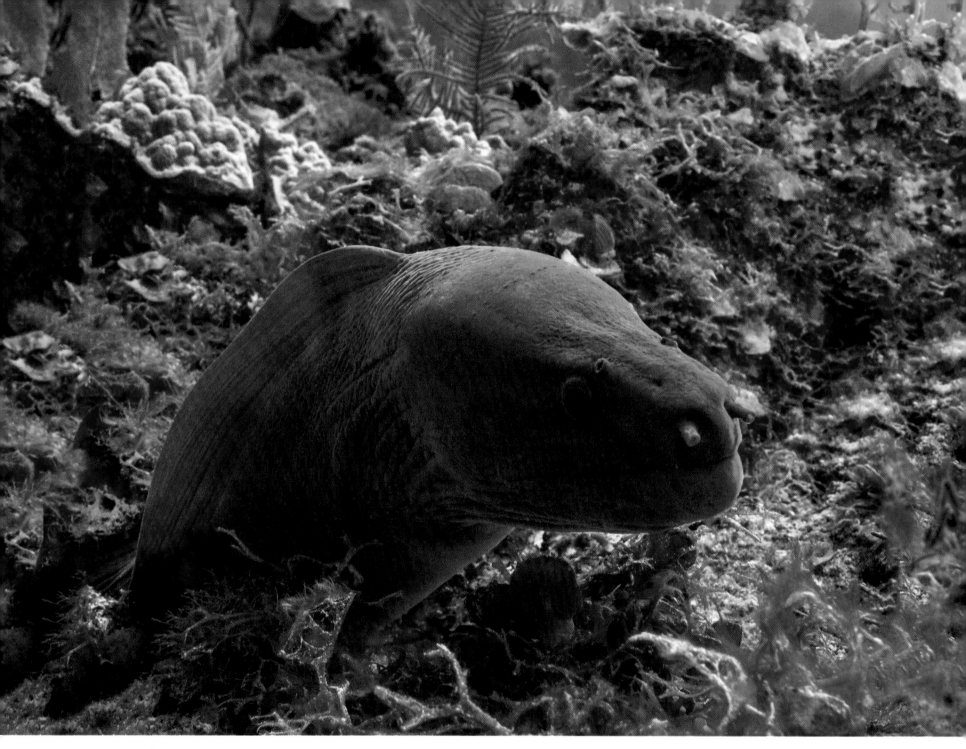

So you want to be a wizard?

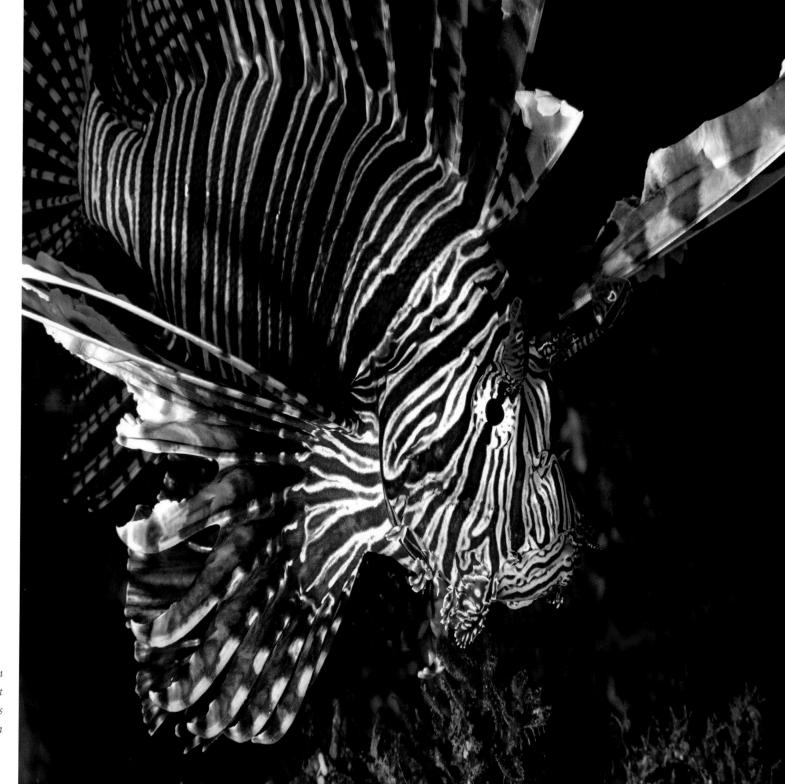

Lionfish—the curse of the aquarium trade. Trafficking in wildlife for the pet trade harms the species taken and harms those places the pet trade infests with invasive species. Boycott PETCO.

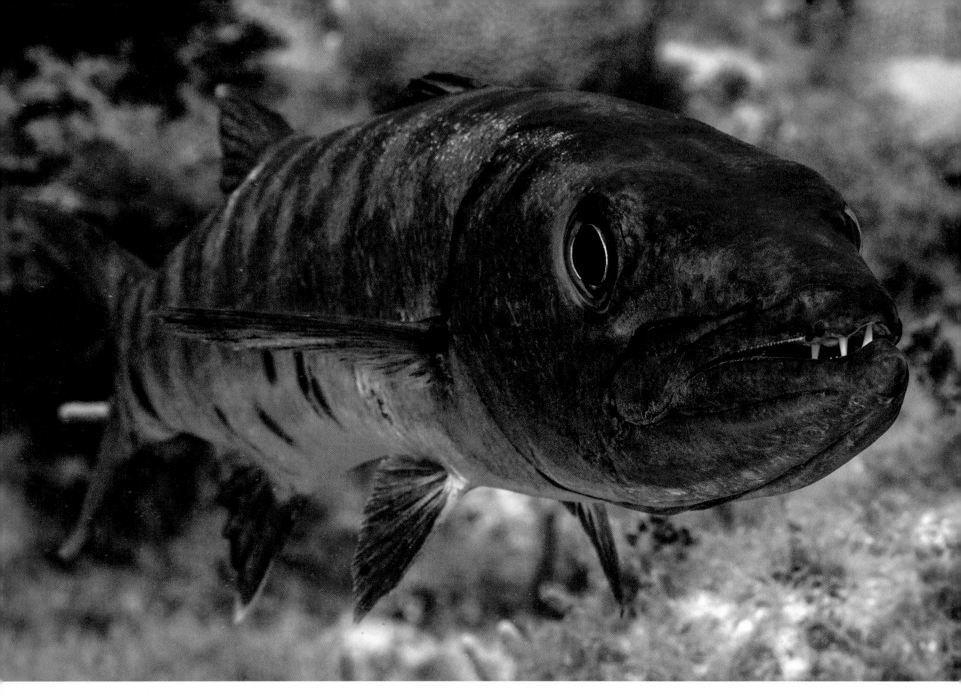

. . . and healthy populations of barracuda.

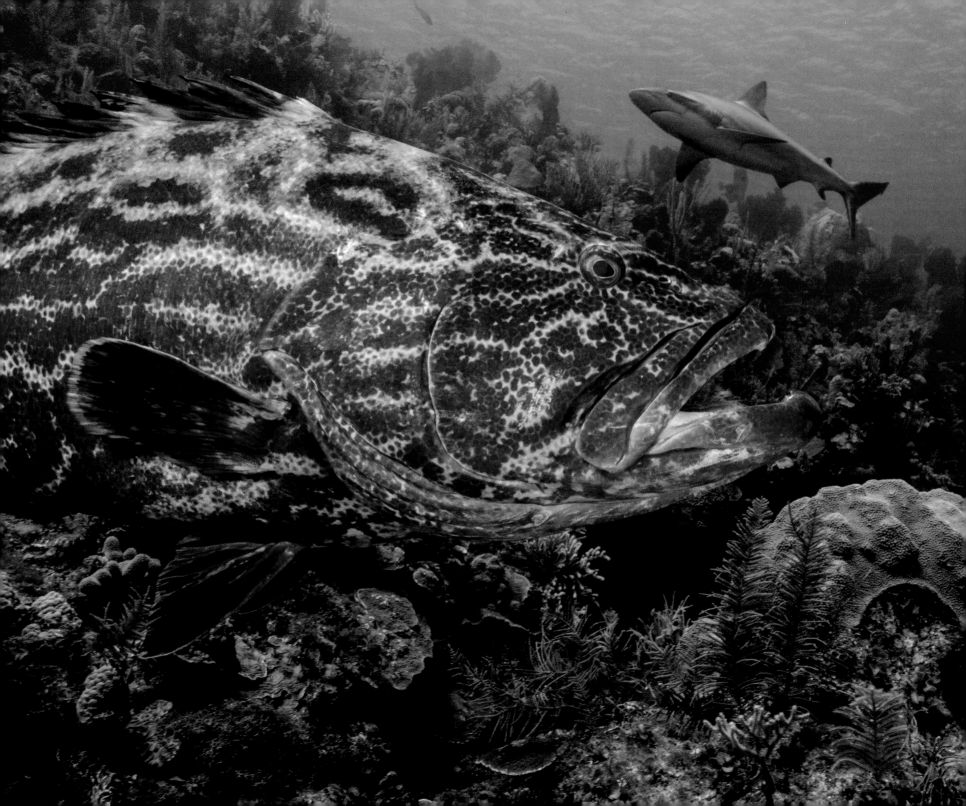

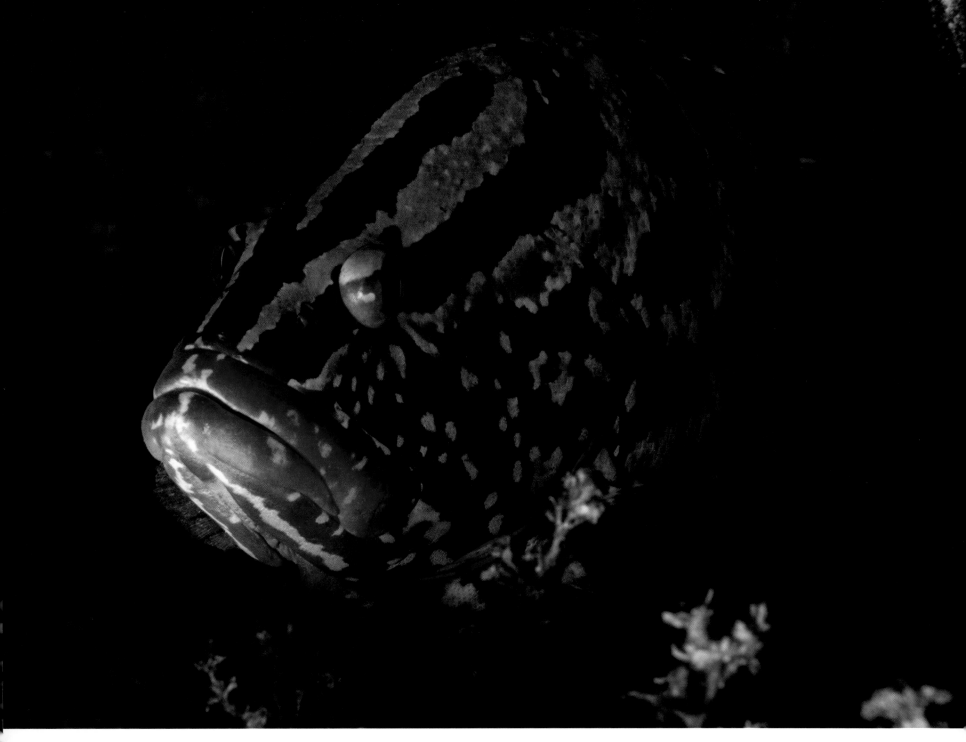

Why little fish don't want to turn on the nightlight.

Sharks are the most beautiful yet maligned and oppressed animals in any habitat in the history of the world. Other species were driven to extinction, but none were so loathed and feared as the shark. Sharks are gone from many reefs around the world because of *Jaws*, because of shark fin soup, because of fear and loathing and what the Palau president called "the insatiable Asian appetite."

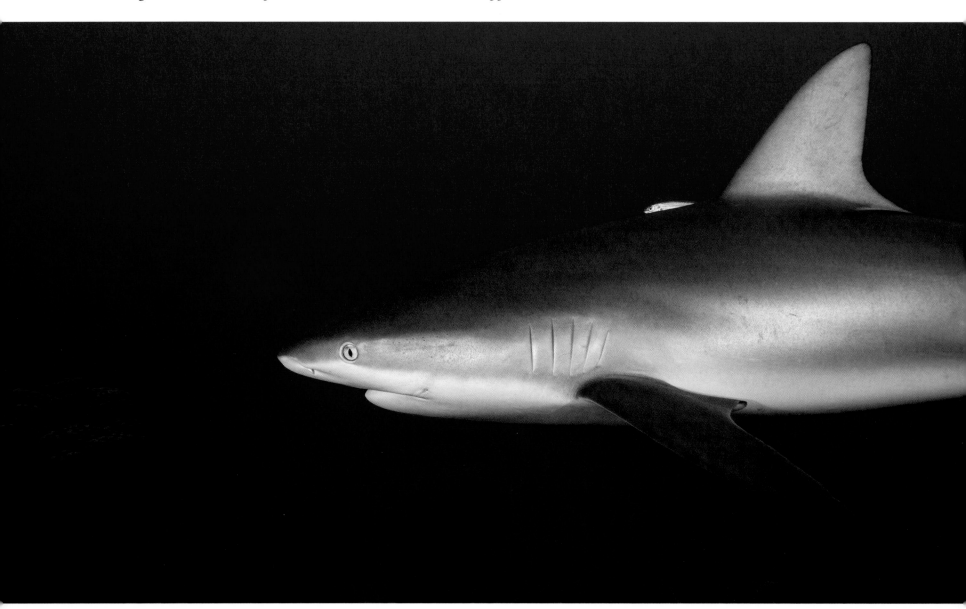

Apex species in abundance make Jardines de la Reina a world-class reef destination that, in time, may set Jardines further apart from the rest. And the stars of the show are sharks.

Reefs around the world are in decline, and the process accelerates. In another unfortunate example of reef mismanagement, the state of Hawaii's Department of Land and Natural Resources authorized and managed a "shark eradication program" in the 1970s to make Hawaii reefs safer. That program ran its course, with shark populations decimated on Hawaii reefs. Oops. Since then that same Department of Land and Natural Resources has mismanaged an artificial reef program, beginning with a bad drop of tons upon tons of concrete blocks on a huge, vibrant, healthy reef at *Keawekapu* on South Maui. Instead of adding to that reef, DLNR buried that reef under concrete when the drop boat forgot to note its drift. Oops.

That same Department of Land and Natural Resources mismanaged its trail signage program, placing trail markers in the wrong places on the Na Pali Trail on the island of Kauai, leading two women to fall to their deaths. That same Department of Land and Natural Resources introduced three new fish species to Hawaii reefs, to serve as food fish. But those three species proved voracious and have eaten vast numbers of indigenous fish. Those three species are also a dietary hazard—prime carriers of the ciguatera toxin, which doesn't hurt the host fish but makes humans itch for a year or two and then die. Oops.

That same Department of Land and Natural Resources took twenty-five years to *begin* the ban on collecting coral and live rock by the aquarium trade, because people were working at jobs and making money in coral extraction, so limiting that extraction was not convenient. That same Department of Land and Natural Resources took a second twenty-five years to *complete* the ban on coral and live rock extraction by the aquarium trade. In the meantime, aquarium trade collectors turned entire reefs into rubble. Now that same Department of Land and Natural Resources is the most ardent defender of aquarium collecting on Hawaii reefs, because the former director is an aquarium collector with strong ties to the trade, including ongoing dialogue with huge resellers and retailers, including the reef nemesis PETCO. Now that same Department of Land and Natural Resources wants to "monetize" wilderness parks throughout the Hawaiian Islands with paid parking lots, gift shops, food vendors, and concessionaires.

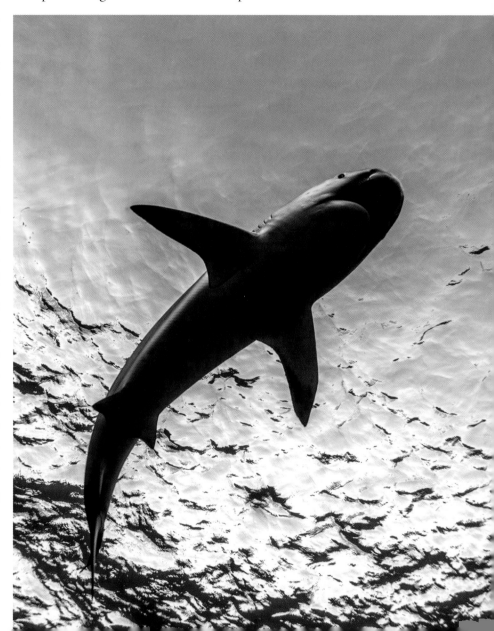

It's no wonder that Cuba—the other archipelago in proximity to the land of the free—has the last, best reefs in the world today. Old Hawaii gives way to commercial onslaught with no vision to the future. Cuba is trying to save its reefs with a different pragmatism that factors long-term benefits instead of short-term political entrenchment.

Back at Jardines de la Reina, we pulled up to a mooring for our first look at a reef. How different could it be from any classic Caribbean reef, other than having excellent coral cover, biodiversity, and abundant populations? We anticipated more of what we'd seen in Havana and Cayo Largo, with tube sponges, colorful whip corals, sea fans, and the usual thicket along the bottom, maybe more dense, more colorful, more abundant. Miguel advised that this would be our checkout dive—an exercise every tourist diver must complete at the outset at any dive destination in the world, so the dive crew can determine fitness, breathing habits, comfort level, and calmness. Comfort and calmness may reveal potential response to potential challenge. Arm sculling, riding the bicycle, cartwheeling, up-and-downing, and crowding indicate poor trim or anxiety or inexperience—and shorter dive time, which can affect the entire group.

No sweat; we had the experience and had been in the water plenty with sharks. Yet even as Miguel went through his monologue, that "this is a very special place, not too many sharks, only very few" dorsal fins broke the surface. Big brown bodies gravitated to our little skiff—scratch big; make that huge (!)—and a counterintuitive process preempted standard prep. We sat. We gazed. "Get in the water and go down. It is okay. The sharks will not bother you."

Counterintuitive may be a euphemism for fearful, and the first approach of a shark in the twelve-foot range—a big, hunky, muscular shark more than three feet in girth—could not help but trigger the old adrenaline shot. Maybe that's where shark experience pays off, in knowing that neither fight nor flight will save your bacon, that a shark is an honest opportunist reviewing a

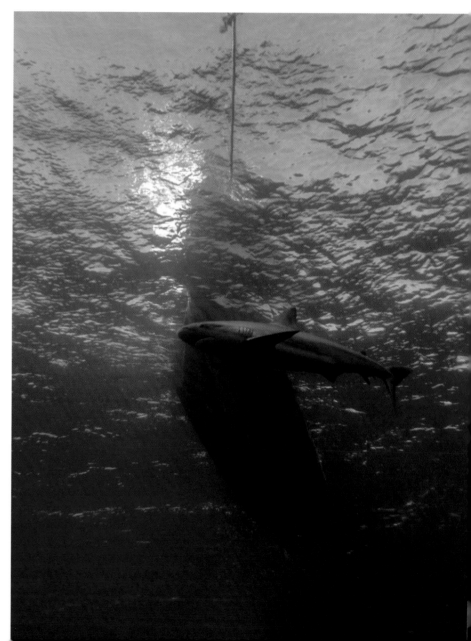

What the sharks saw . . .

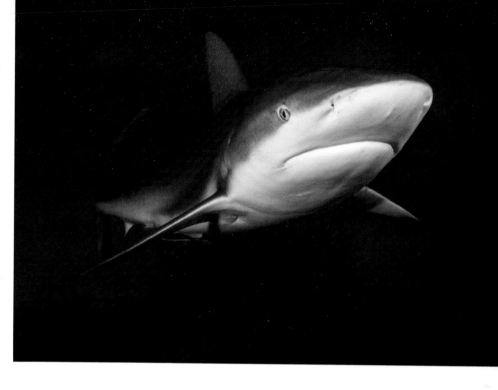

situation to see where she might find work with reasonable benefits and low risk. So it's usually best to attempt a good format and focus with optimal lighting, no matter what might get toothy. So we maintained our posture descending to depth, raised our cameras—which movement alone is likely to appear defensive or offensive—and fired away. The pattern immediately became clear, that this gathering was social and curious, that these sharks knew and understood this drill.

Oh, they weren't shy, and in they came, touching, brushing, testing. The solid truth of the experience took a while longer to sink in. That is, any visit to any reef can seem lovely, colorful, sprightly, social, and full of life. But if half the species are not present, the casual reef visitor won't know—can't miss what's never been met. An extreme example of the blissful-ignorance syndrome was Honolua Bay on West Maui with the highest, most protected status of any ocean area in Hawaii, a Marine Life Conservation District. In the late nineties it was still a spectacular reef habitat to behold, with 98 percent coral cover and thousands of fish. Yet a few years later it was gone, decimated by red dirt runoff from multimillion-dollar houses in construction just above, leaving Honolua Bay nearly dead. It was a few years after the decimation that a charter boat delivered about a hundred snorkelers, part of a Christian dentist convention—so optimistic—and when the Christian dental snorkelers jumped in, a wide-eyed lad sputtered up, "You should see this! It's amazing!" The only amazing thing by then was the fall from grace, from 98 percent coral cover and abundance to less than 10 percent and a smattering of what had been.

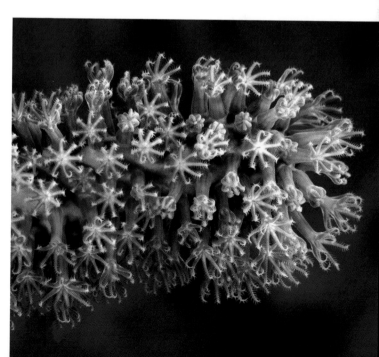

Not-so-amazing, severely compromised reefs became the rule in recent years as host markets pumped reef tourism for its wonders, even as those wonders faded to gray and brown. The closest scuba, snorkel destination to Jardines de la Reina outside Cuba is the Cayman Islands, with reef habitat and biodiversity a paltry vestige of what they were very recently. Jardines, on the other hand, leaves no doubt on the true meaning of 100 percent coral cover, no browning because of no effluent, no invasive algae, and an abundance of fishes with species variation to boggle the mind of a seasoned reefdog.

Coral polyps, Jardines.

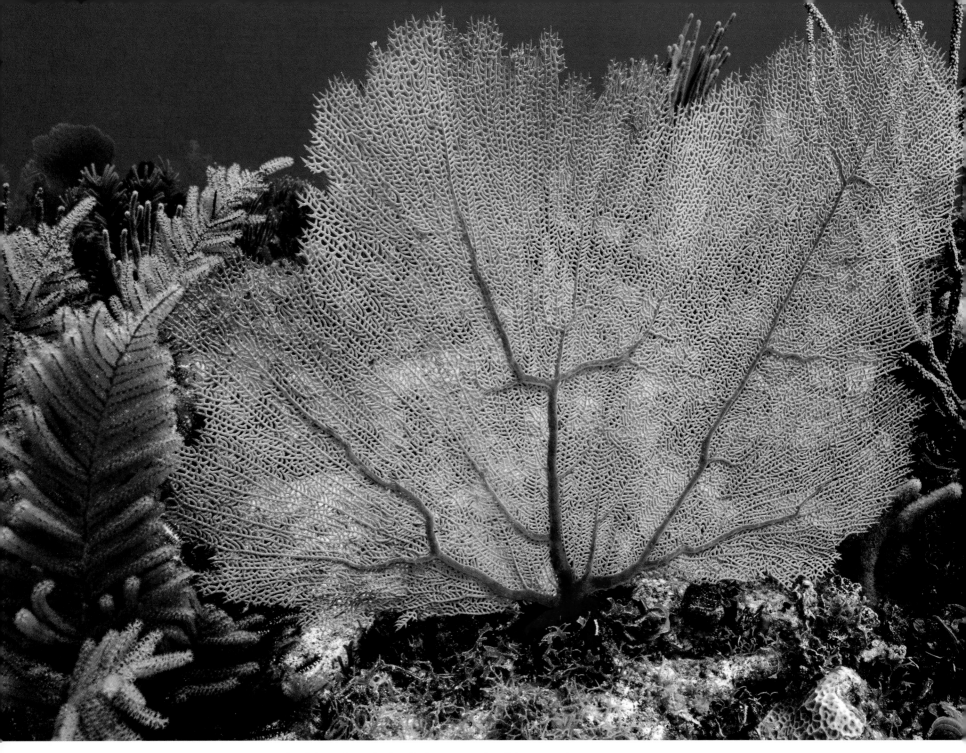

Some reefs are visibly healthy. Mana is the Hawaiian word for life force. The coral and sea fan here are in Jardines de la Reina, Cuba.

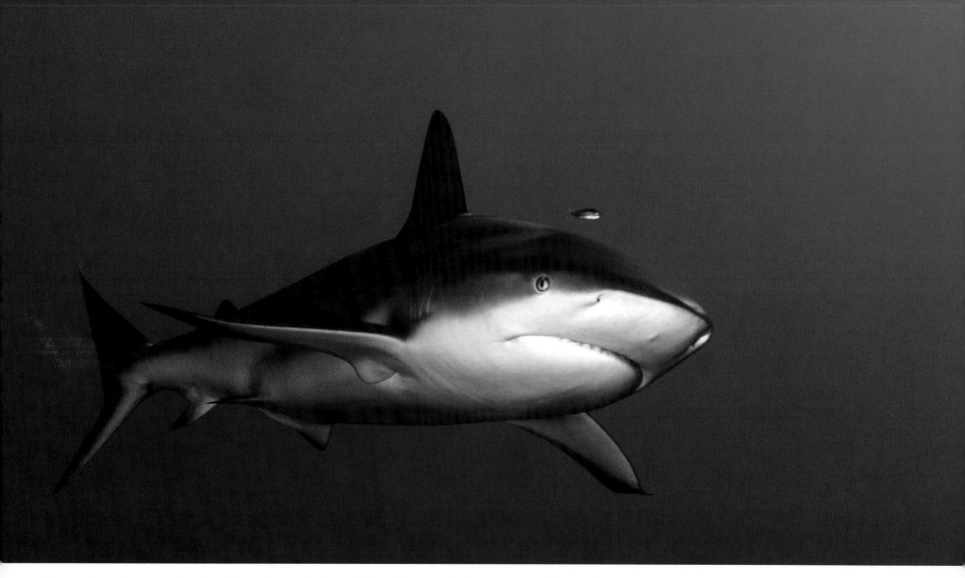

Any reef can have its day, but those days and days of abundance and diversity at Jardines—those shark encounters over and over—underscored the epiphany available in Cuba: the oceans of the world depend on sharks.

Without sharks, reefs die.

With sharks, reefs thrive.

It's just that simple, though the world in its abundance of a single species has traded reef health for a bland soup with no taste, and it has begun to eliminate the most vital of reef species because of subliminal fears implanted by Hollywood.

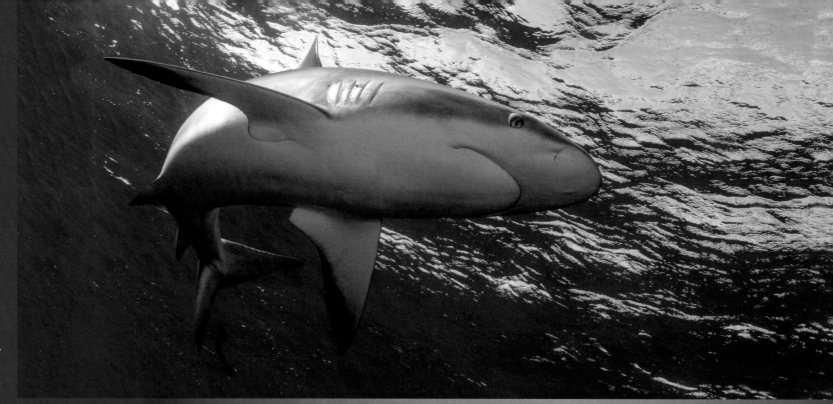

A Shark pirouette.

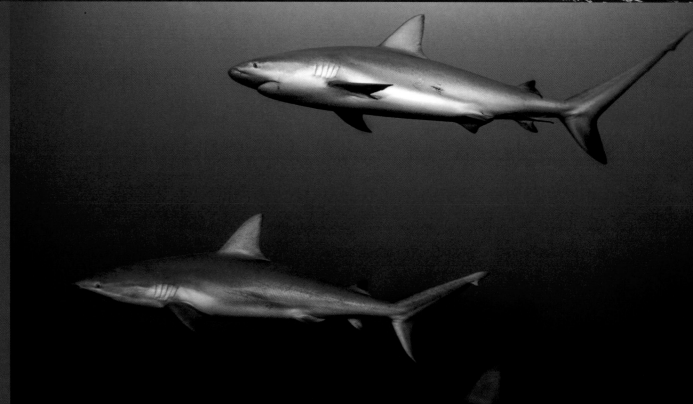

Shark patrol.

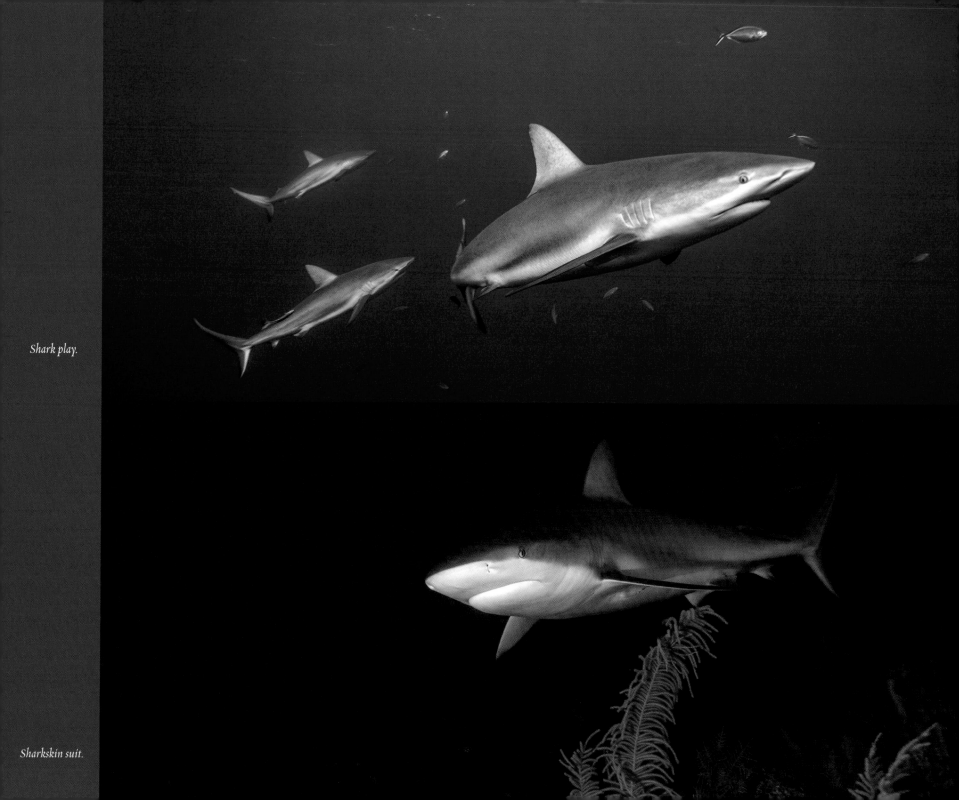

Shark play.

Sharkskin suit.

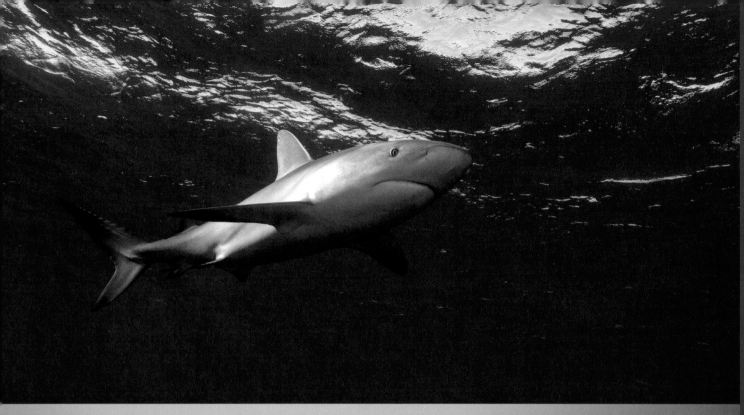

Shark-populated waters.

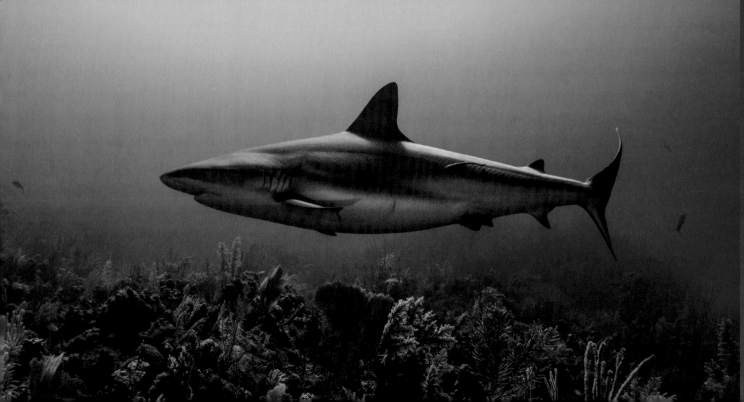

Right rudder.

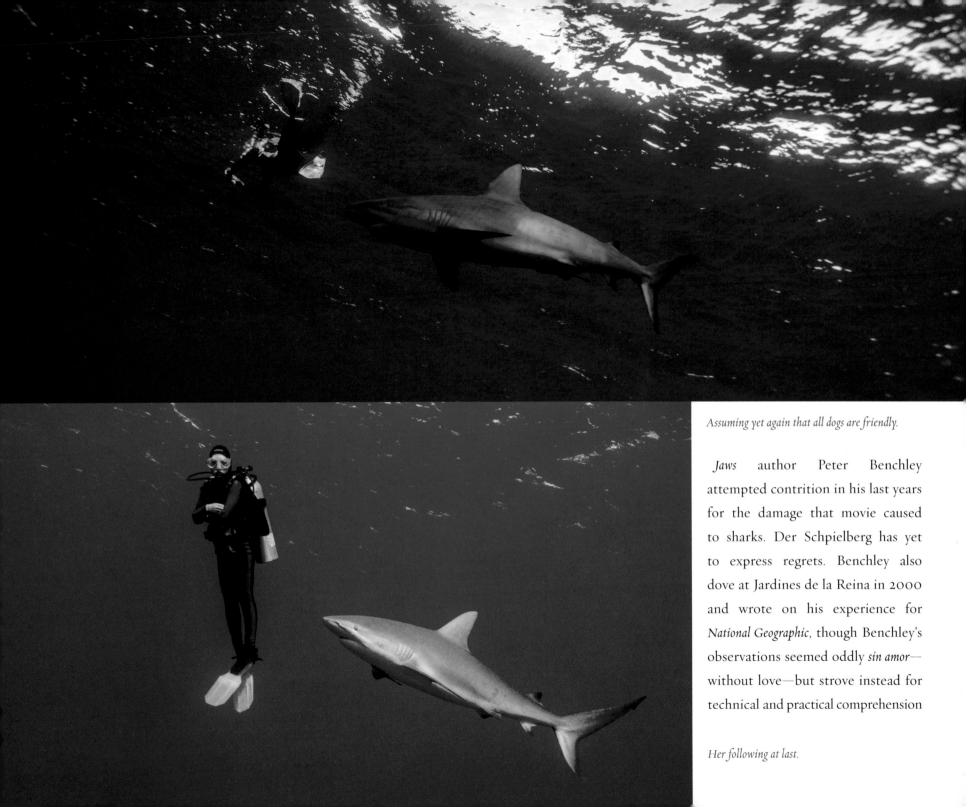

Assuming yet again that all dogs are friendly.

Jaws author Peter Benchley attempted contrition in his last years for the damage that movie caused to sharks. Der Schpielberg has yet to express regrets. Benchley also dove at Jardines de la Reina in 2000 and wrote on his experience for *National Geographic*, though Benchley's observations seemed oddly *sin amor*—without love—but strove instead for technical and practical comprehension

Her following at last.

with cloyingly superior erudition. *Jaws*, the book and the movie, was also loveless, a crime against sharks and nature, giving rise to shark destruction, to a blind eye on shark species devastation and to destructive phrases, like "shark infested." Likewise, *National Geographic* has co-opted its former integrity to better penetrate popular markets with new products, including *National Geographic*–brand snorkel gear. They don't make it; they label it. It is not a viable competitor. In alignment with those values and quality standards were Peter Benchley's notes on the small rodents common to the mangrove islets at Jardines:

"To my pampered palate, jutías were barely edible—slimy of texture and vile of flavor. But I, of course, had no firsthand knowledge of hunger or malnutrition. If I had, jutías might be as savory to me as veal."

Did he say veal?

Yes, but veal was popular then. Far more people ate veal without questioning its production. You can't very well condemn a man for behaviors common to an entire generation.

Oh yes, you can and must. Otherwise it's like claiming innocence, because you were only following orders. Making veal is not a production. It's torture. Do you know how veal is grown?

Yes, I do, and we don't need to belabor the horrors or drag animal cruelty into this. Veal is not relevant to shark decline. Not directly relevant, anyway . . .

Except that a man responsible for shark loathing loved veal. Can't you connect those dots?

That was a long time ago.

Do you eat veal?

Only a few years after Peter Benchley's gourmand observations we visited a jutía colony with a different approach. Values change as people change or give way to the next generation. Tastes and constraints overlap as the generations overlap. Benchley did not relish jutía—not like

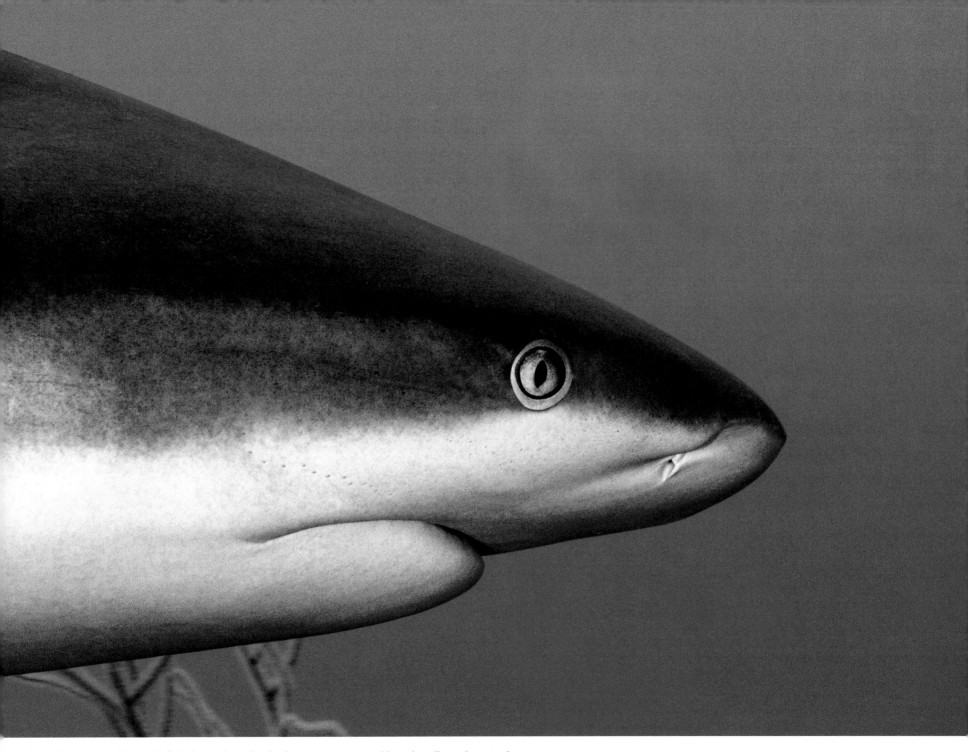

Shark whisper: I would eat veal if I had some, but I'd rather have eaten Peter Benchley. Ah, well, another missed opportunity.

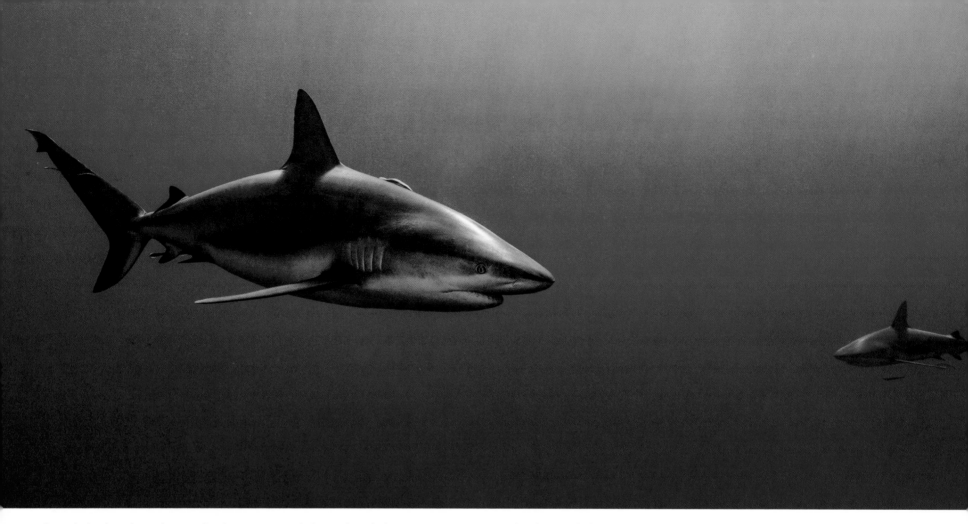

he relished veal. To his credit, he recognized the isolated charm, immense natural value, and dynamic condition of Jardines concisely, attributing these last, best reefs in the world to:

"... an unlikely combination of factors: autocracy, bureaucracy, paucity, wisdom, ingenuity, dogged persistence in the face of a lonely ideology, and, finally, common sense ... all of which are characteristic of the constantly changing enigma that is Cuba."

Jardines de la Reina teaches the most important lesson available in ocean health and reef recovery today: without sharks, species disappear. Consider the food chain. If the top tier goes away, then the next levels below, the secondary levels, will expand to overpopulation, with no natural predators. That causes the next levels below secondary, the tertiary levels, to dissipate, because of too many predators, and that dissipation will cause the levels below that, the quaternary levels, to expand, and so the cycle continues down the food chain.

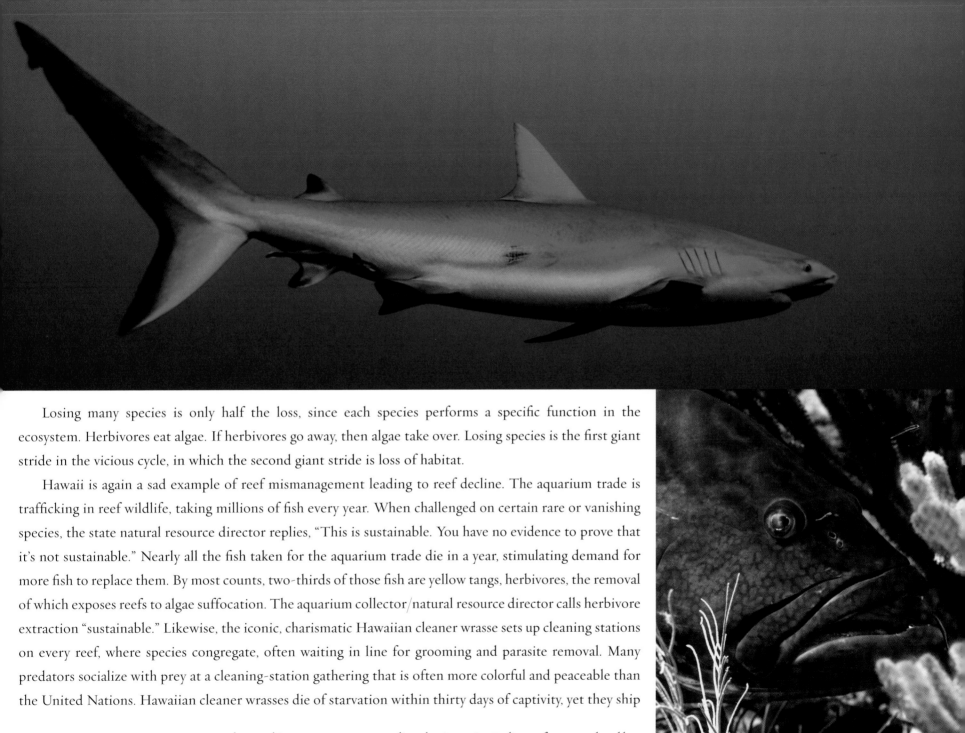

Losing many species is only half the loss, since each species performs a specific function in the ecosystem. Herbivores eat algae. If herbivores go away, then algae take over. Losing species is the first giant stride in the vicious cycle, in which the second giant stride is loss of habitat.

Hawaii is again a sad example of reef mismanagement leading to reef decline. The aquarium trade is trafficking in reef wildlife, taking millions of fish every year. When challenged on certain rare or vanishing species, the state natural resource director replies, "This is sustainable. You have no evidence to prove that it's not sustainable." Nearly all the fish taken for the aquarium trade die in a year, stimulating demand for more fish to replace them. By most counts, two-thirds of those fish are yellow tangs, herbivores, the removal of which exposes reefs to algae suffocation. The aquarium collector/natural resource director calls herbivore extraction "sustainable." Likewise, the iconic, charismatic Hawaiian cleaner wrasse sets up cleaning stations on every reef, where species congregate, often waiting in line for grooming and parasite removal. Many predators socialize with prey at a cleaning-station gathering that is often more colorful and peaceable than the United Nations. Hawaiian cleaner wrasses die of starvation within thirty days of captivity, yet they ship

Cleaner gobies groom a grouper at a Jardines cleaning station. Jardines reefs are not vulnerable to parasite loading like Hawaii reefs, because Jardines has no aquarium trade extracting vital species.

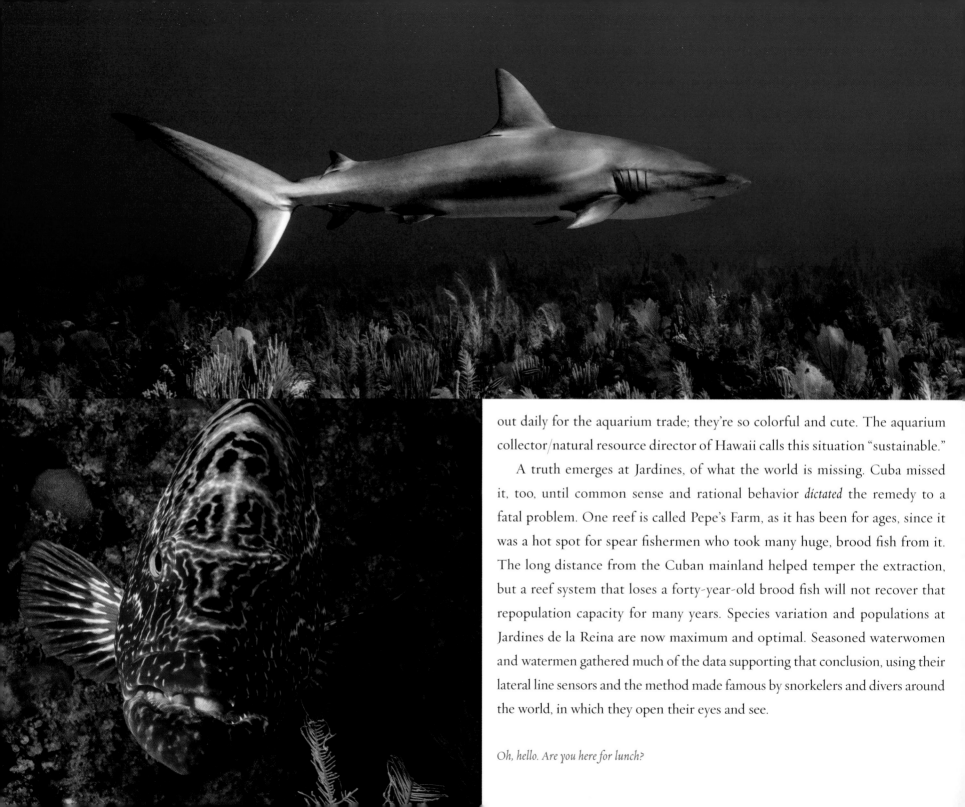

out daily for the aquarium trade; they're so colorful and cute. The aquarium collector/natural resource director of Hawaii calls this situation "sustainable."

A truth emerges at Jardines, of what the world is missing. Cuba missed it, too, until common sense and rational behavior *dictated* the remedy to a fatal problem. One reef is called Pepe's Farm, as it has been for ages, since it was a hot spot for spear fishermen who took many huge, brood fish from it. The long distance from the Cuban mainland helped temper the extraction, but a reef system that loses a forty-year-old brood fish will not recover that repopulation capacity for many years. Species variation and populations at Jardines de la Reina are now maximum and optimal. Seasoned waterwomen and watermen gathered much of the data supporting that conclusion, using their lateral line sensors and the method made famous by snorkelers and divers around the world, in which they open their eyes and see.

Oh, hello. Are you here for lunch?

Groupers round out the apex predators—black groupers, tiger groupers, Nassau groupers, and the big bruisers, Goliath groupers, deliver communion, affection, curiosity, and fear on fast-forward. Quick as torpedoes they rush in to sniff a dome port, and Miguel advised, "Please. Do not try to touch them. Do not stick out your hand." Well, a grouper bite can't hurt, not really, because they have no teeth to speak of, but a quarter-ton beast gets startled when the tidbit in its mouth is connected to something else, say, a wrist and a forearm and an elbow. She may well bolt for the quick run. Here too, a seasoned diver and conservationist will know that other species may not understand or want to be touched. Beyond that, touching can interfere with a fish's natural immunity, disturbing its surface slime or introducing bacteria, as invasive humans have done to native populations on many occasions. Touching on a reef is best left to cleaner wrasses and gobies.

But it's the sharks, the sharks, the sharks that are key to reef recovery. The insight and lesson were so obvious and profound that it took a few days to achieve clarity—days of diving with so many sharks, twenty or thirty sharks on every dive, sharks passing within inches or no inches, bumping strobe arms with pectoral fins or body checking. What began with the internal red flag that this makes no sense, jumping off a perfectly good boat into shark-healthy waters, became casual and familiar. Pablo was our other dive leader, a jovial, outgoing, big man with exceptional water skills.

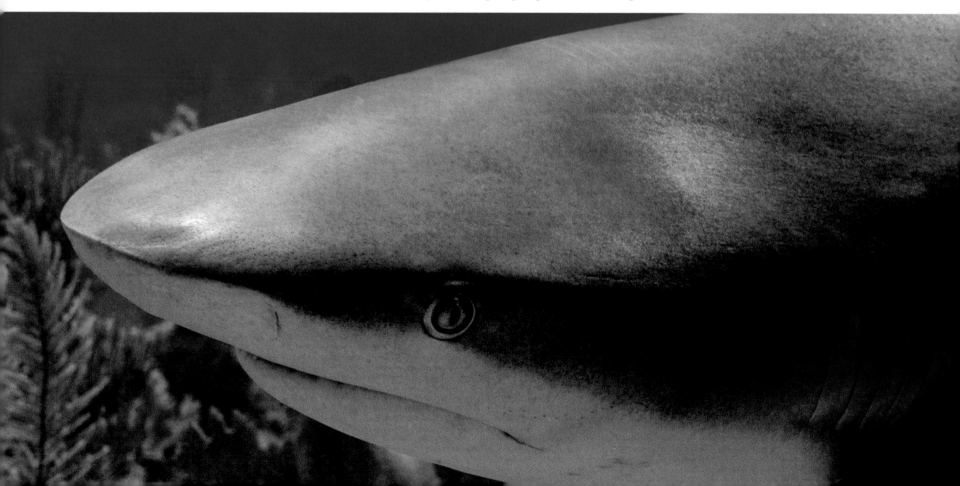

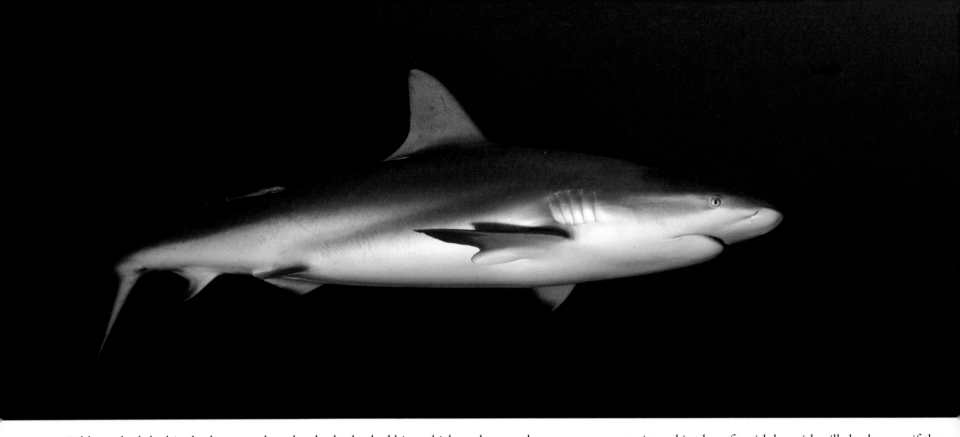

Pablo pushed the big sharks away when they body checked him, which made sense, because an opportunist seeking benefit with low risk will check to see if the benefit has any resistance—if the benefit still shows a pulse. The push back lets the shark know that the benefit is not yet dead and may indeed bear some risk.

And the shark experience available at Jardines may be the most valuable shark gift available. Reef photography often requires good angles, so we circled each other in futility as I tried to round on a mug shot of my new friend, Scarback, so named for a pronounced slash between her eye and her gills on the right side. Scarback showed up at different sites, always eager for another chance to mingle. Like a typical human, mindful only of my own pursuits and needs, I soon realized that circling was for me an effort to improve the photographic angle, while for her it was step one in classic shark feeding behavior. Sure enough, Scarface reduced the radius between us, circling, then cutting the angle to come straight in almost near enough to bump. The classic pattern is circling, then circling closer, then the bump, then the quick turn and taste. Just below us, cleaving the bottom, a narrow ravine dropped another few feet, so I descended into it, thereby interrupting Scarface's circling pattern. Sure enough, she swam away.

Yet as I ascended, she shot back, so I swam over to Meesta Wong, a former stockbroker, also known to bare teeth in many rows; Scarface got spooked, as if one gray suit could intimidate another. The shark play seemed predictable and formidable yet thoroughly manageable. Yes, it was one of those situations that seem scary but then exhilarating if you don't die, and it was a gift from Neptune.

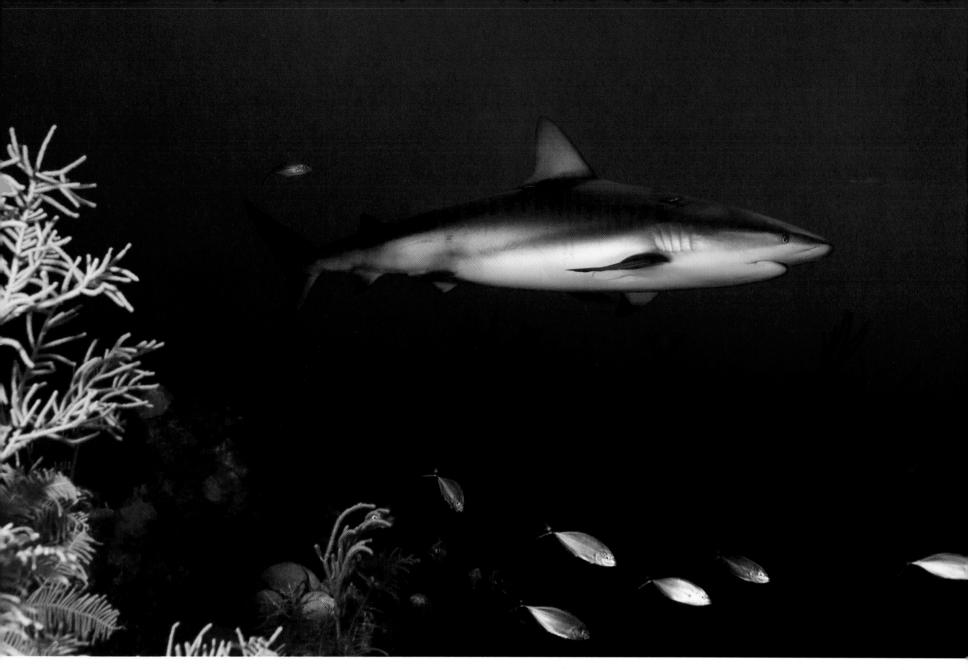

Another dive late one afternoon, near dusk, found us in a crevasse, kind of a crater dipping another fifteen feet into variable vegetation and considerable small crabs, shrimp, nudibranchs, and other macro beauty.

Besides the unique setting and subjects fifteen feet below the regular bottom, about fifty feet, the late sunbeams penetrated the depths at dramatic angles, providing the shadow and dramatic light play that a photographer craves. And it was late in the day, time for the shift change from diurnal to nocturnal; so some critters scurried for cover, for a safe place to hole up through the night, while other critters emerged. In Neptune's glory and upwelling warmth and color, goodness, and light, merrily we rolled along. The other three divers meandered out after a while, but I hung back, engaged with an arrow crab who'd caught a worm and wanted to show it off in the sunbeams. Reef photography is so distracting that a diver can look up after the briefest interlude to find himself alone. Not to worry, finally emerging from the crater to mosey back toward the mooring, I navigated easily with slanting sunbeams as a reference. It was one of those times, late in the day, when light and life turn in on themselves to reveal new layers of gold and movement, and there alongside eased a huge shark who

seemed twice my length and four times my girth. We glanced in passing, each at the other, and she neared, as if to better sniff, and my next exhalation produced a big bubble that said, "Oh, it's you."

Scarback turned toward me. I slowly raised my camera, and in she came. She veered slightly at the first shutter click, a foreign sound in her sensory range, though she'd heard it the day before. On the next click she veered farther, so we were parallel again. Then she faded, opening the space between us as she lolled casually away. How far I'd come in a few short days.

Opposite, Fairy basslets are shy but some individuals will engage. With acid flashback brilliance, they fool camera sensors, turning the spectrum inside out.

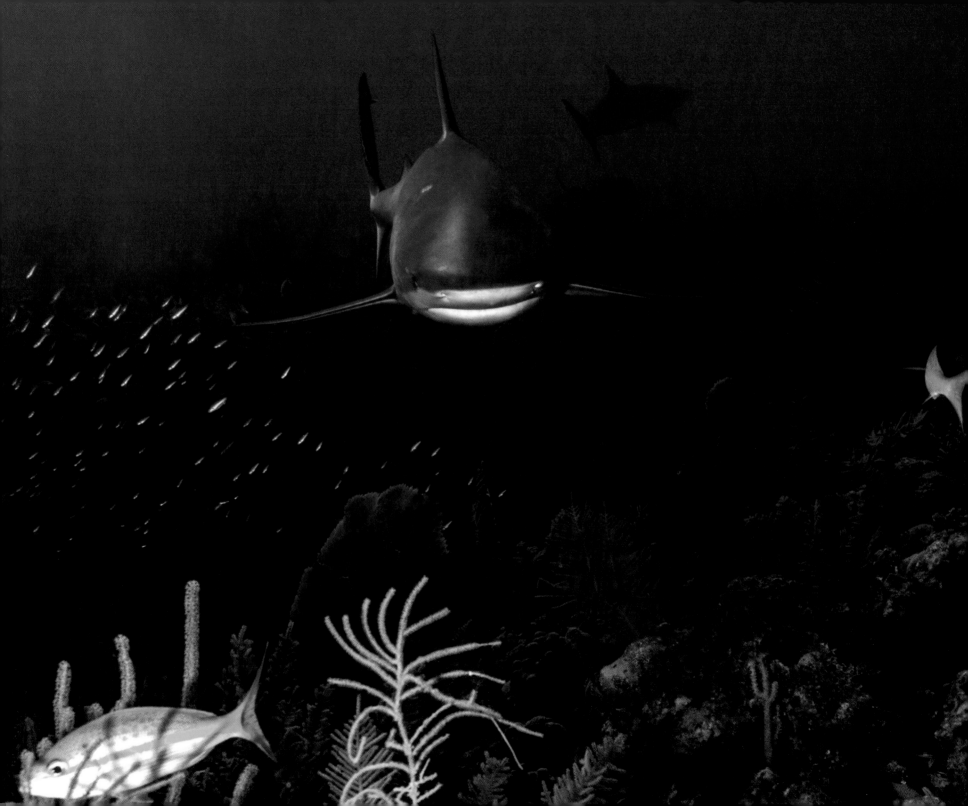

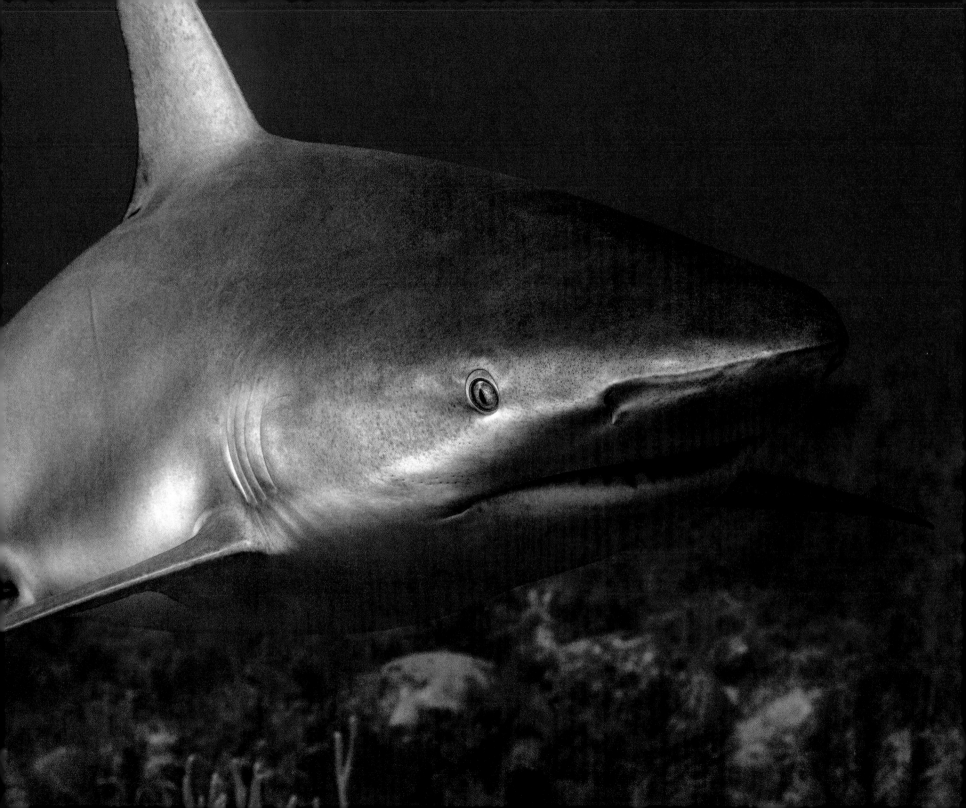

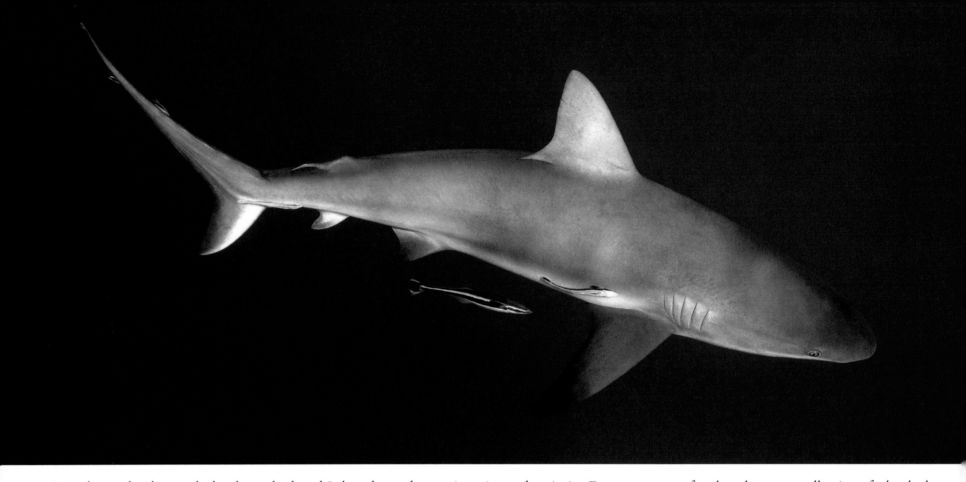

Together at depth near dusk, a huge shark and I shared casual commiseration and curiosity. Fear came as an afterthought, as a recollection of what had been so wrongly ingrained.

No shark is ever more frightful than the shark unseen. With so many sharks seen over and over at Jardines—sharks approaching, touching, and checking—the fear went away. That's not to say that all sharks are friendly as pups; they're not. Snorkeling was not allowed in the shallows without a guide and a boat, because the big three "aggressors" come into the shallows for the easy prey available there—abundant smaller fish with minimal escape routes. They are the tigers, bull sharks, and hammerheads. Caribbean hammerheads can go to fifteen or seventeen feet, and generate fear by virtue of sheer size, but they have relatively small mouths and school up in some places for no known reason, in mystical gatherings near the surface. The big danger of tiger sharks is that they don't look dangerous and don't mind approaching humans slowly, where they can bump and bite in a blink. It's usually only a taste, and that taste nearly always determines that humans are not on the menu. That taste also results in injury, loss of limbs, or death for most tastees, so tigers are considered dangerous. But tigers are deepwater sharks who may come into the shallows for a feeding opportunity but spend most of their time deep. Bull sharks are equally unpredictable.

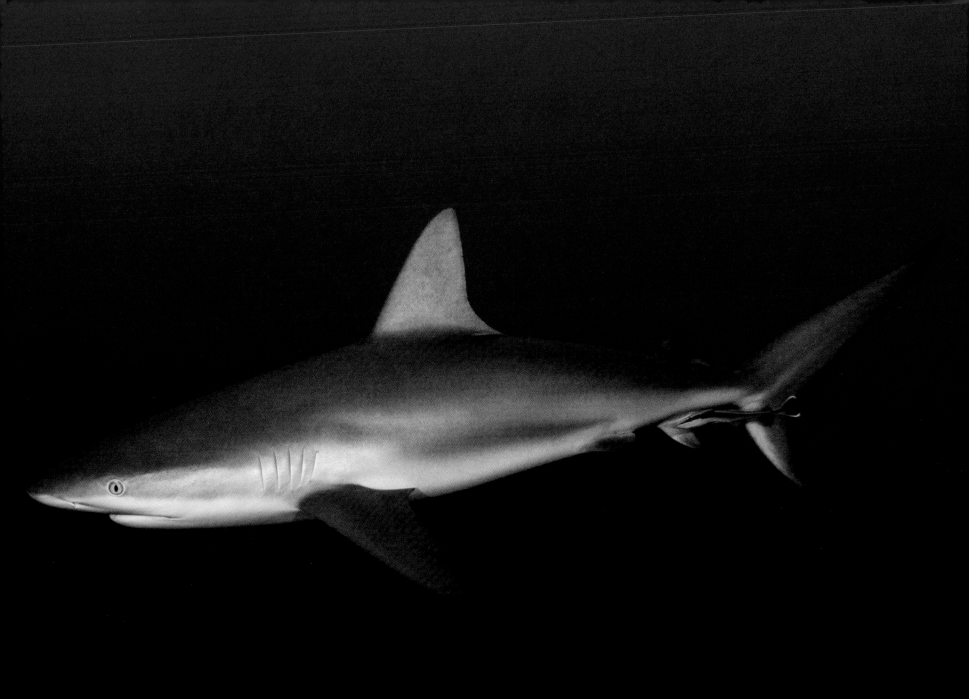

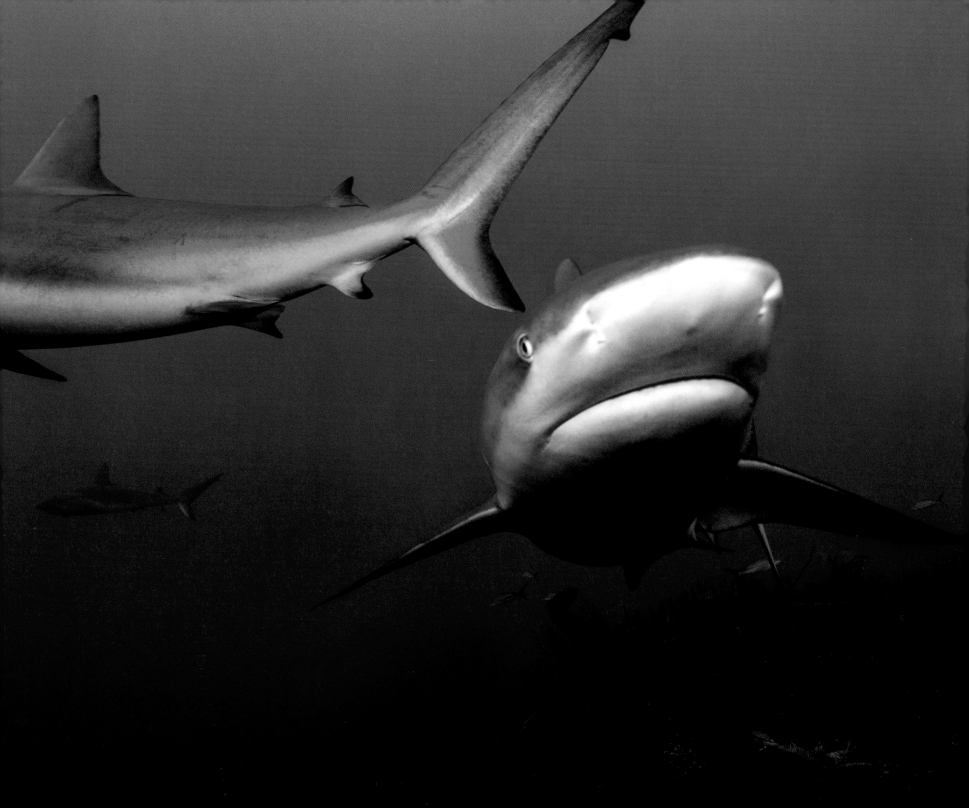

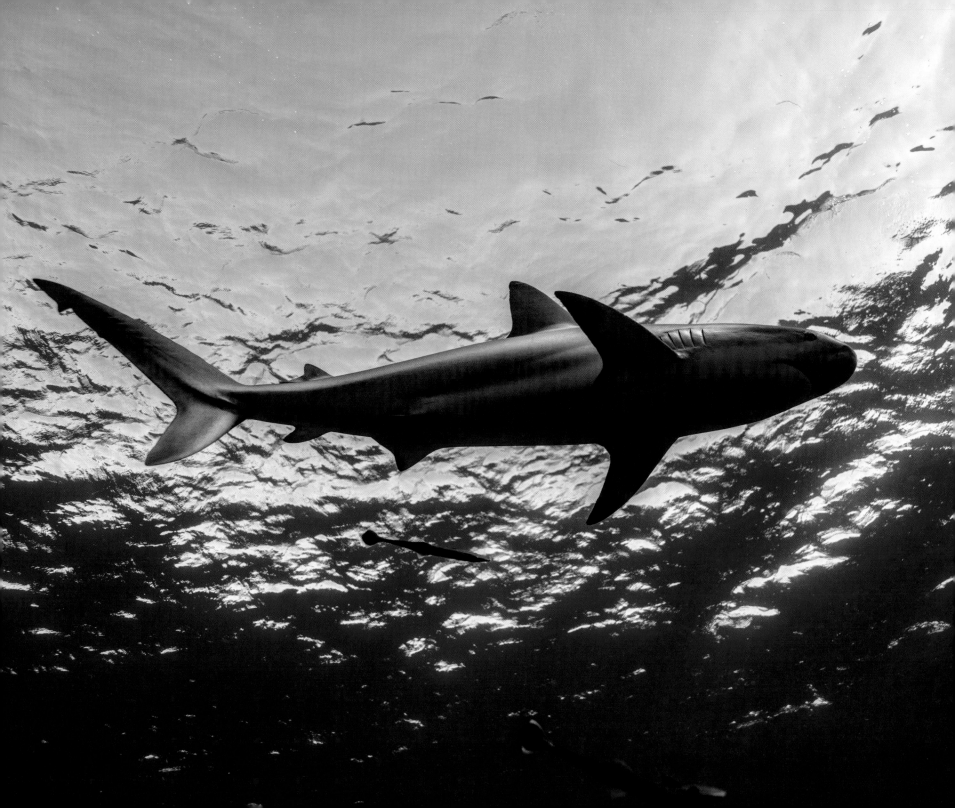

But familiarity with sharks in general, with their presence and behaviors, their movement and curiosity, their ability to learn and to know, is a gift that keeps on giving. We are surrounded, and it is good.

Unspoken yet conspicuous at Jardines de la Reina is the connection between the dive leaders and the sharks. Calling it Pavlovian would be too simple, because they are friends who meet and socialize frequently, who recognize each other and seek each other's company. But a more fundamental attraction is apparent. Pressed on the delicate subject of feeding the wildlife, Miguel spoke freely of the primary objective at Jardines: showing off the sharks in optimal contact with visitors, showing that the sharks are not dangerous and are in fact familiar, intriguing animals who will not harm humans and want to bring their Neptune-given gift back to the oceans of the world, if only they are allowed to do so.

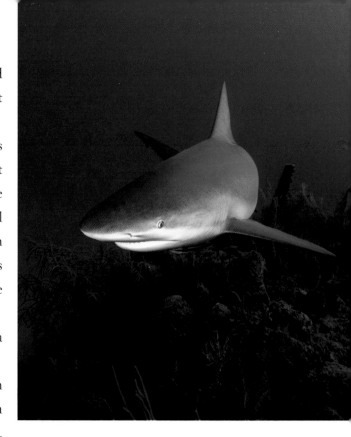

What's not to like about that objective? More importantly, it's not deviously stated like a developer's proposition in Hawaii; it's demonstrated every day with resounding success.

Feeding the wildlife remains questionable. Among the downsides is the distraction from each species' obligate function, in this case to maintain reef balance by adhering to food-chain hierarchy. Won't feeding the sharks distract them from their natural diet? Miguel thought not, because the sharks are not actually fed. Yes, raw fish is carried to the bottom and placed inside very large tube sponges or basket sponges, "but the sharks don't get it. Sometimes they do, but it's nearly always the groupers who get it." Well, that may be a dubious relief, that one apex predator instead of another is getting fed. But Miguel believed that the feeding is of such a small scale that it does not distract from natural predatory feeding in any measurable way. Miguel pointed out that sharks continue to hope for something to eat on the very smallest hint that it may be available again, even if it was last available some time ago. In this case it's a regular regimen of associations, including scents of food and divers, boat arrival, recognition, and the social exchange, all drawing the sharks near for another enjoyable gathering.

The issue of feeding the wildlife will not go away or entirely resolve. In about 1990, when reef peril was a faint blip on the radar, the Snorkel Bob team responded to customer demand for fish food, because the fish made such a great show when fed. Not only did fish food make the tourists happy, but a fifty-pound bag of trout chow at $20 or so converted to hundred$ in no time via an ingenious fish-food-o-matic designed and developed on the premises. Basic components included a half slab of plywood with a hopper at the top that would empty trout chow into a single-portion bin with a fill handle just below. The measuring bin emptied its trout chow into a waiting section of sausage casing that got sealed at both ends with two Seal-a-Meals, and the operation

cycle was completed with one throw of the hopper lever, another throw of the measuring bin lever, and a final throw of the Seal-a-Meal lever—one lever controlled both Seal-a-Meals. The rig cost about $60 to build, and yielded a finished unit cost on a sealed packet of trout chow in biodegradable sausage casing at about 7¢. The fish food packets sold for $1 each, or $5 for the ever-familiar, ring-of-truth six-pack. The six-pack sold hugely—until 1992, when some fringe reef watchers penetrated the bulwarks and got to me, Snorkel Bob, with the hard truth: fish food kills reefs, primarily by discouraging fish from showing up for their reef assignments, bloating their little bellies with trout chow and also adding another layer of dissolved schmutz onto the delicate coral polyps. A very lucrative, seemingly innocent commerce had provided fun for many fish and people, but it stopped on a dime. Some Maui dive shops continued to sell fish food in huge volume, grossing about $10,000 per month, *mas o menos*, for the next twenty years, giving free advice with the sale. I went, just to see. Sure enough, the helpful clerk said that it's best to feed the fish outside the reserves, because the rangers will nail you in the reserves. Today, no informed, caring reef community allows fish food.

We also doubted Miguel's contention that the sharks rarely get the food. On one occasion Pablo arrived at the stash sponge a tad late. That is, instead of managing to pull the fish from cover and shove it down to the bottom of the sponge prior to the sharks smelling it, he was still a body length from the sponge when the sharks noted the scent. Seeing incoming sharks as big and fast as SCUD missiles, Pablo pulled the fish from his buoyancy compensator and

kind of tossed it toward the big tube sponge. By that time he was way late and caught in cross traffic—the front linemen began snout-pushing and body checking, as if to see if he had more, or maybe the more of it was Pablo himself. He pushed back and punched one or two of his rowdier playmates and got out before a huge shark shot in for an indelicate grab on the fish and shot out, away from the other sharks who followed in hot pursuit. This is what Juan Cardona warned against, breaking the piñata. Within the ensuing frenzy, Pablo let his shark friends know he wasn't yet dead, and that they were not playing nice. They let him know that survival is often full contact, no pads.

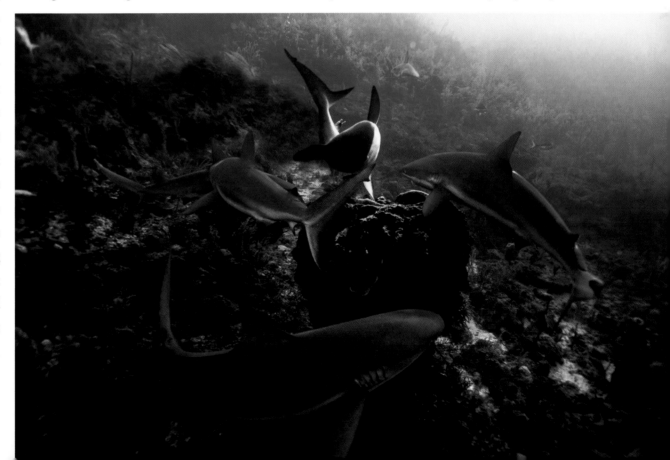

My 2¢: fish feeding is a compromise in any situation. Yet the proof is in the puddin', and the watermen at Jardines are proving that management can bend the rules without breaking the rules—and without breaking reef balance. How do the dive leaders at Jardines compare to, say, aquarium collectors in Hawaii? As my old man used to say in a bygone time: it's like ice cream over crap. On Cuba reefs you have an objective that is clear and true. In Hawaii you have greed disguised as commerce with smoke up the collective anus that "this is sustainable."

What happens at Jardines de la Reina is so far superior to what happens in Hawaii that an observer can only hope for change in the land of the free. Another comparison conveys the difference between the two places and the two approaches to reef management. In 2007 during the early years of campaigning against the aquarium trade, William Aila was an aquarium collector who spent much time at the state capitol to pursue his political ambition. He's still ambitious, but at that time he'd just come off a run in the Democratic gubernatorial primary with a grim showing, and he'd come to the capitol to lead his pals, the aquarium collectors, in their opposition to any regulation whatsoever on their massive extraction from Hawaii reefs. Any one of them or group of them could visit any reef outside a protected area—that would be 98 percent of Hawaii's near-shore reefs as open area for massive extraction—and take every single fish for sale to aquarium hobbyists. They could leave reefs void of fish just as they had turned entire reefs into rubble, and it would be legal—still is.

One testimony opposing the aquarium trade included a photo of a yellow tang in a plastic bag ready for transport and, in very few days or weeks or months, death. The fish looked sad, and though some people in the hearing room had never recognized emotion in a fish, with that image they could see: the fish looked sad. That kind of imagery is tough to counter, but William Aila was next to testify, and he came to the podium with a grunt and a laugh at such bleeding heart sentiment *for a fish*. And he said, "I should have brought *my* favorite photo of a yellow tang. He's on a grill." The aquarium scourge in the hearing room grunted and guffawed in kind. That's who William Aila is, except that he became the Hawaii Department of Land and Natural Resources director. What would Jardines look like with William Aila managing? Or with Neil Abercrombie nearby, masquerading as governor and approving extractions by sticking his head up his anus? Those two would maximize benefit to *the people*, generating a few more bucks with some political payout on the side, as Jardines would fade away, but not all that fast. But they're gone, Aila and Abercrombie—voted out. *¡Viva!*

What's the flip side of this *Tale of Two Archipelagos?* An illustration best conveys the difference between the two places with regard to wilderness values and animal love. Jardines managers and staff are natural resource stewards. The Department of Land and Natural Resources, its director, and the ex-governor of Hawaii were not. During a dive interval at Jardines one day, we pulled up to a beach on a mangrove island—natural habitat for iguanas, land hermit crabs,

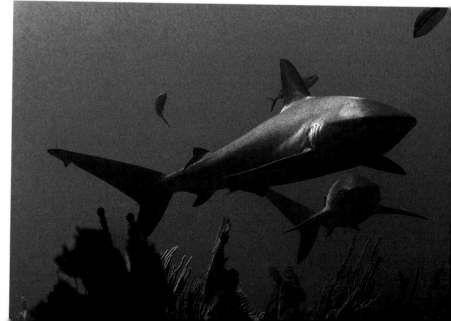

and a rodent about the size of a rabbit with a pointier snout, a squirrelly tail, and small, pert ears, the jutía (hoo·tí·ah). This is the same rodent Peter Benchley profiled as disgusting and not delicious like veal for *National Geographic*. All three species, hermit crabs, iguanas, and jutías, emerged from the tree line, though the iguanas held back, and the hermits plodded down slowly. But a few jutías did not hesitate. Down they raced to the water's edge where they practically jumped for joy as the skiffs approached and the bows scraped sand. As big, bald Pablo jumped out and secured his skiff, one large jutía leaped to his ankles and began to rub like a cat, then rose on her hind legs to paw at Pablo's knees. Pablo paid no attention but went directly to set out the fruits and snacks and drinks for this dive interval. He filled a plastic cup with water and then bent to the jutía who obviously recognized her friend, who stuck her snout into the cup for a grateful glug, glug, glug.

Above right: The original Iguana Lounge. They stayed cool, but not for long.

All the jutía jumped for joy—not delicious like veal but engaging as pups, and thirsty, too.

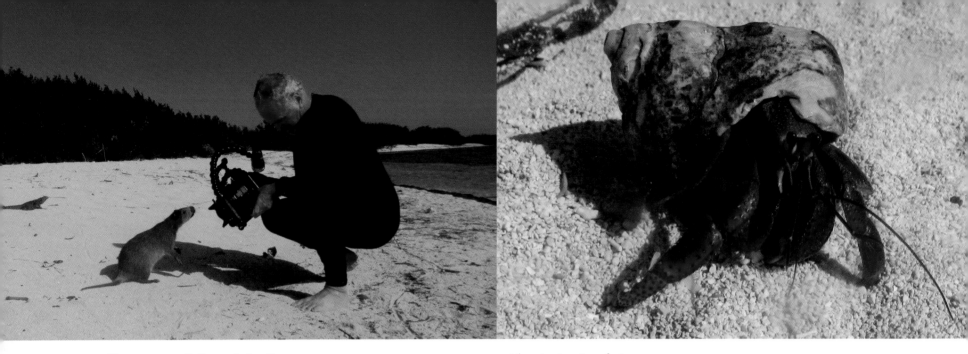

Jutía meets Bubba—Are you really from Podunk Holler? *A hermit tries to jump for joy.*

This too is feeding the wildlife, but humans and wildlife engaging in tourism together cannot avoid contact—can't help but establish familiarity and friendship, especially when visits include fresh water and sliced fruit. Once quenched, the alpha female jutía again rose to put her paws on Pablo's knees, to wait for her slice of piña, her piece of papaya. As she held each gift and nibbled it, Pablo scratched her back and her head.

Hardly as sociable, the iguanas approached more cautiously but with apparent experience in the rewards of contact. The land hermits finally arrived as well with more open social contact than crustaceans normally display, carefully taking pieces of fruit with a single claw and eating it, and then waving and asking for another.

A baby stingray about five inches across played in the shallows just down the beach. This wilderness is happy, not because humans come with food and drink but because humans don't come with nets, hooks, spears, or other means of removal. Wilderness happiness does not occur randomly on a last, best vestige of reefs in the world. It occurs because good people take care of what they love. Wilderness management at Jardines is as different from "natural resources" in Hawaii as a beautiful tropical shore is different from Siberia.

When it was time to leave, Pablo's jutía friend rubbed his leg with her body again as he freed the skiff and pushed off, following him into the shallows to bid farewell, to convey her gratitude and love.

Dive regimen at Jardines is three per day, beginning before or after breakfast on consensus of the guest divers. We opted for first thing, then breakfast and a second dive around eleven. Then came lunch, another full-fare, sit-down feast replete with salad, tropical fruits, and more substantial entrees for the

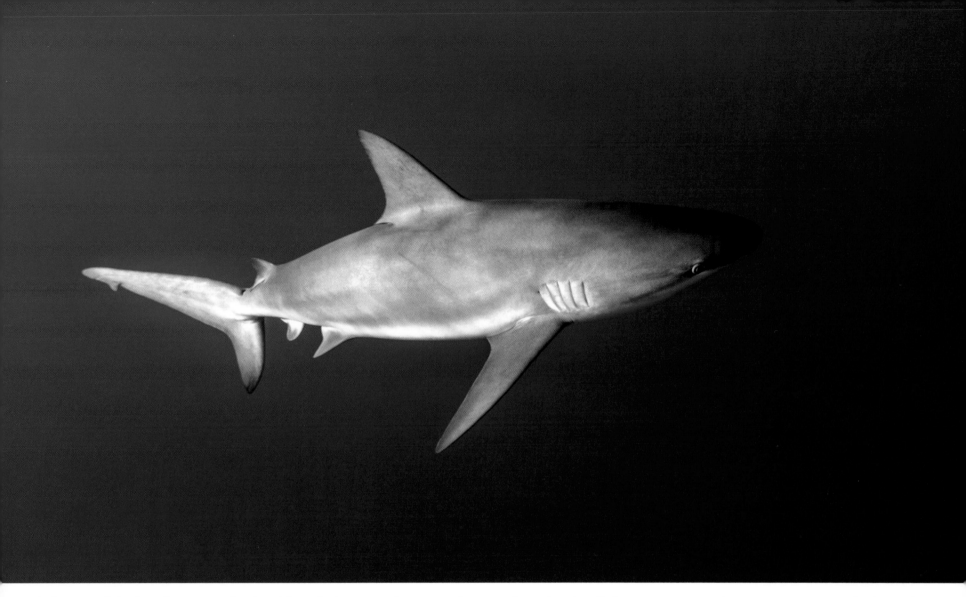

truly hungry. If the first dive came after breakfast, the between-dive interval occurred on a beach. All the maintenance, adjustments, repairs, and other tasks required by scuba gear and camera equipment, including downloading files and recharging batteries, occurred between dives. The third dive of the day came after the longest interval and began at two or three or four, fairly late in the day in January, and timed for dramatic lighting, with slanting sunbeams and, if the hour got late enough, the changing of the guard. Around dusk, the day critters began to turn in, and in a few minutes more, out came the night people. I mean fish.

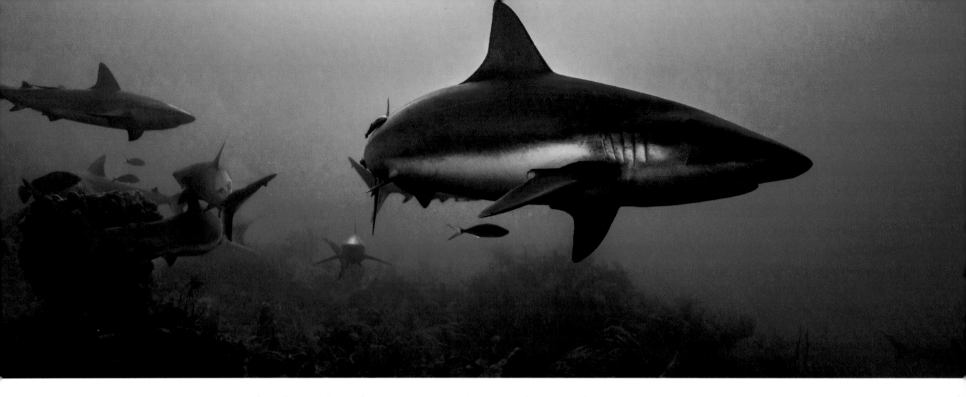

Above, Late in the day at Jardines de la Reina and for reefs around the world. Below, Late in the day, lost its glow a few minutes after dusk.

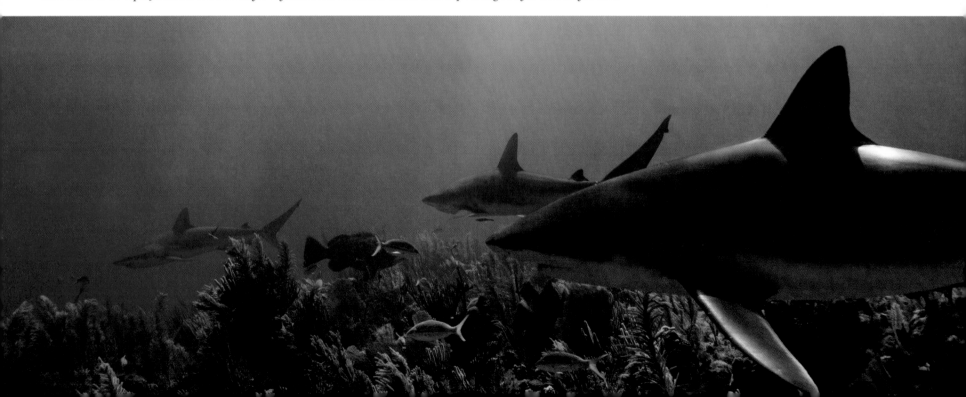

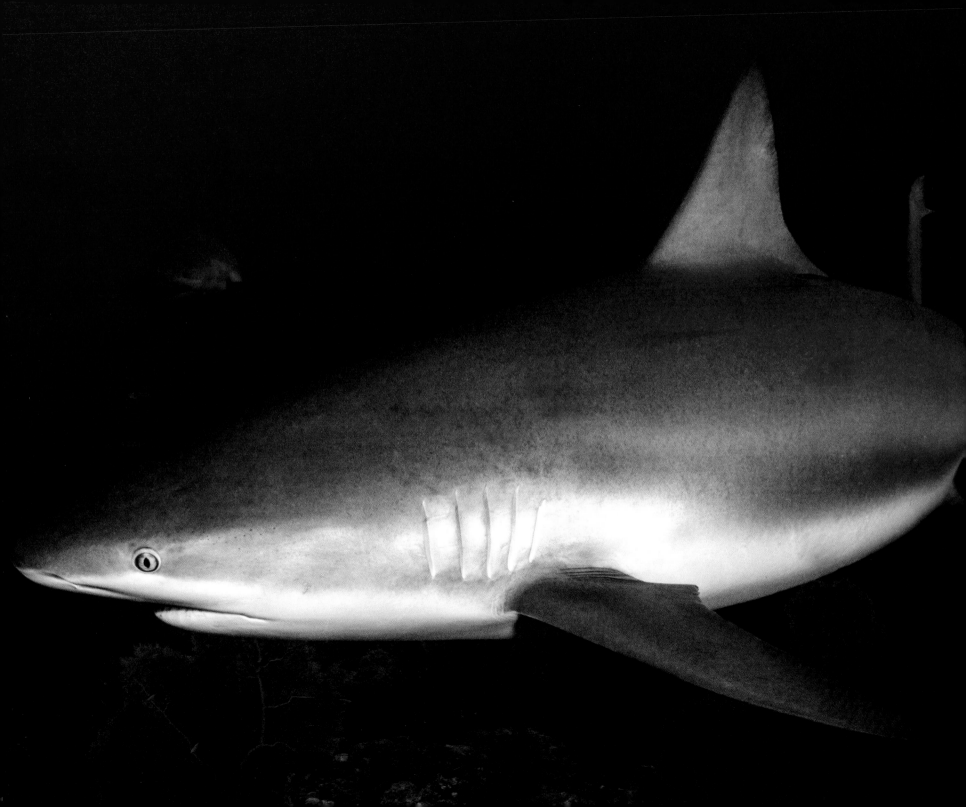

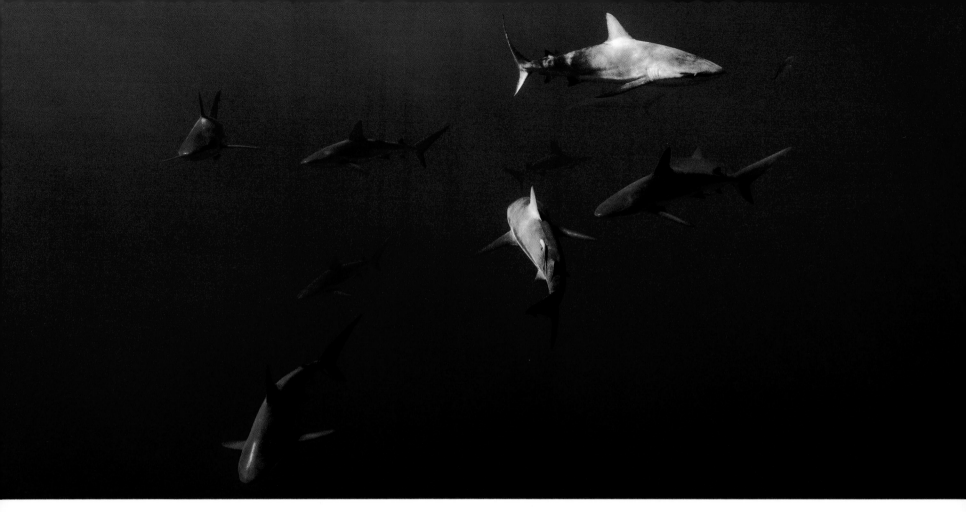

As the night shift emerged, it felt all warm and fuzzy, knowing what great chums we'd become. Scratch chum. I meant friends. Then it was time to head up.

A unique characteristic of Jardines diving is the dive time range from forty-five to sixty minutes, often to eighty or a hundred feet, followed by a safety stop at twenty feet for three minutes—or thirty minutes. Air consumption at that shallow depth is nil; a few hundred pounds lasts a long, long time, and the action actually picked up, shallow, as if proximity of the surface or the boat or the divers hanging out stimulated the sharks to swim freely among us, weaving and carousing in no set pattern or identifiable behavior other than socializing. Dusk was liveliest of all, as if the sharks too craved the drama and interplay of hovering mammals, slanting sunbeams, and themselves.

Back at the *Halcón* it was time to reflect on another glorious day of diving, eating, diving, photographing, communion, and easy friendship among marine species and people with common bonds transcending political boundaries. Amarilla served pizza and a Cuba-themed cocktail daily, either a *Cuba Libre* (cola,

lime juice, and rum) or a *mojito*. While Hawaii tourists go gaga over the complimentary *mai tai* by the glass or the pitcher, a closer look at the ingredients will explain the pain and suffering that commonly follow the mai tai bender. That is: rum is distilled from sugarcane, then sugar is added, along with pineapple juice—with the highest sugar content of any fruit—making the sugar drop and hangover inevitable.

The mojito also combines sugar and rum but from there goes to lime juice and the pièce de résistance, fresh mint. Fresh mint is abundant in Cuba. It stores well on board and was served generously. Step one in mojito prep is mashing a big grab of mint in the bottom of the glass with a muddle. The finished drink is rejuvenating. Of note here is the policy on board the *Halcón* that the passengers are allowed one complimentary quart of rum daily to consume as a group, and beyond that quart, the rum can be purchased. Well, it seemed lush and excessive to assume that nine people would finish a quart of rum on any given day, and in fact on one or two days we didn't, again demonstrating that different situations often lead to variable behaviors and appetites. And thirsts.

Sundown and its multifaceted golden glow was a time of rare relaxation but another arrival soon interrupted the reverie. On approach was a popular new personality who would return many times for social exchange: Cookie. Saltwater crocs get more attention in Queensland, Australia, where they

grow to twenty feet—or thirty feet if they need to scare Crocodile Dundee's date—and eat people. Of lesser media fame are the several species of alligator, caiman, and croc common to the region, from South Florida to farther south. The saltwater crocs at Jardines are well known as nonaggressive and appear in photos, regrettably, in the hands of a few people compelled to show themselves in a dominant position.

Any beast with formidable choppers should be respected, and Cookie looked ready to chow *down*. Yet she approached slowly, uncertain of the reception available yet also aware of her cute disposition, her legs floppy as a pup's, her snout and face rounded as a Muppet's. Cookie hung out, sometimes lolling at the stern for long whiles, anticipating snacks or a gentle pet. Hardly a day after her arrival, the inveterate among us were in and alongside with snorkel gear, moving gently to avoid scaring her. She loved the company and cruised easily, till a loud noise or too many people nearby let her fade back to cover in the mangroves. What a croc!

A month after the Snorkel Bob expedition, Miguel sent word that Cookie

Cookie sized up the situation in daylight but waited till dark to make . . . her move.

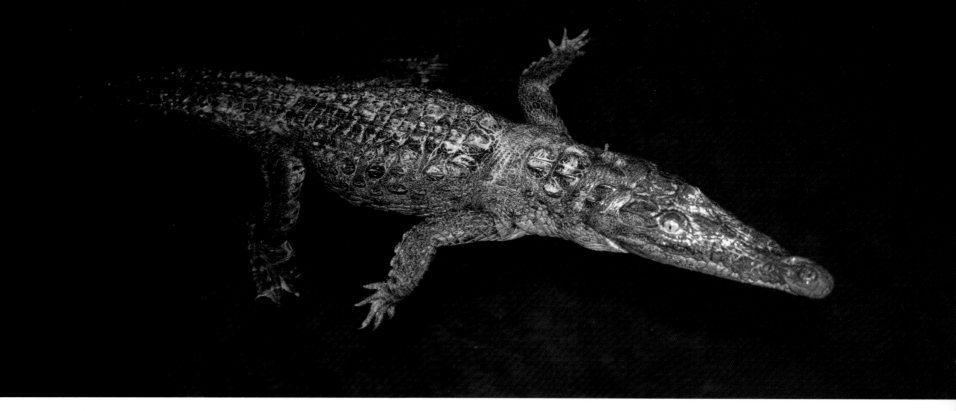

You got any cookies?

had a new friend, a much bigger croc. We assume that he's amorous—the new friend—but romantic supposition is anthropomorphic, and all we know for certain is that Jardines de la Reina is a garden of life.

After days on end of prime reef time, of great meals, friendships developed, and the gratification of physical, spiritual, and personal fulfillment, our Jardines time was up. Excellent habitat with critter abundance and variation, beauty abounding, intellectual stimulation, and no TV had displaced the world beyond, had made that world seem further removed and more unlikely in its extremes.

"What if it's not there? I mean, the world."

The question drew short laughs; it seemed so whimsical, yet the time seemed perfect for pondering new realities. Then came silence, as imaginations grasped what might wait, no less conceivably than the silly noise we'd left there.

Don't be afraid, it's only Cookie.

Chef Manuel: Did you hear the one about the divers alone in the world with a Cuban crew?

"What if it's just the Cuban crew and us?"

Then the laughter stretched with new angles on political allegiance and the odd challenge the Cuban crew might face in continuing its service fit for royalty. The notion of just the Cuban crew and us felt less whimsical, perhaps plausible in the light of such a week well served. Like children blessed with guileless honesty, we had fairly sorted our hierarchy of skills, purposes, and services, and so we pondered the whim. Of course Manuel would still cook, Amarilla would hostess, Junior would drive the skiff, Miguel and Pablo would lead dives—and so would we, spelling them and taking our turn in the daily pursuit of comfort and fun, just as people at street level do every day in Boise, Havana, Honolulu, Santiago de Cuba, Lodi, Jucaro, Waikapu, Cienfuegos, and New York.

Junior would drive the skiff.

Miguel checks out on relaxation, comfort level, confidence, and experience.

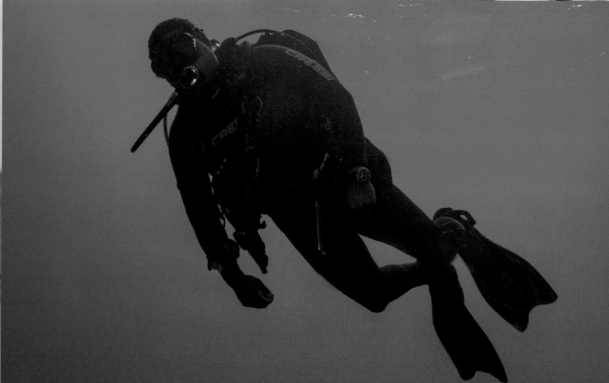

Just the Cuban crew and us was a notion so fanciful that it couldn't be, what with practical needs for groceries, fuel, scuba tanks, and so on. Still, we laughed at our random group with overlapping interests and needs that could endure interdependently on skills and insights available to the group, and that shed new light on the world that likely still waited our return. Two schools of obtuse political leadership notwithstanding, we had achieved peace in the world of Jardines de la Reina—a commercial exchange to be sure but with mutual recognition and respect that allowed us to forget and possibly undo the dogma of fear and loathing. Unspoken among the contingencies on board—Swedish, British, Cuban, and American—was the suspension of belief, the willingness to ignore the tools common to all politics: imagery, emotion, backdoor deals, failure to deliver, and a never-ending message to the uninformed. Only through hokum can vast population segments believe in something that is against their best interests.

Well, there's nothing like the end of a rigorous dive regimen with the shots and footage in the can and no mishaps to simplify a worldview.

Spencer and Sadie Burrows lived aboard the *Halcón* the same week as the *Snorkel Bob Jardines de la Reina Expedition*. Spencer and Sadie are the same age as I, Snorkel Bob, in a geological context, that is, late Plasticine epoch. Spencer represents a company selling fire-extinguishing systems in England, and he founded the Dive Club of Nottingham.

We did not approach the long-standing debate on whether photography qualifies as art or not. But apparent to any photographer are favored angles, approaches, composition, exposure, white balance, and so on—what may comprise a signature or style, a recurring motif or identifying attitude. Though impeccably mannered on board, Spencer pursued his shots aggressively and with considerable

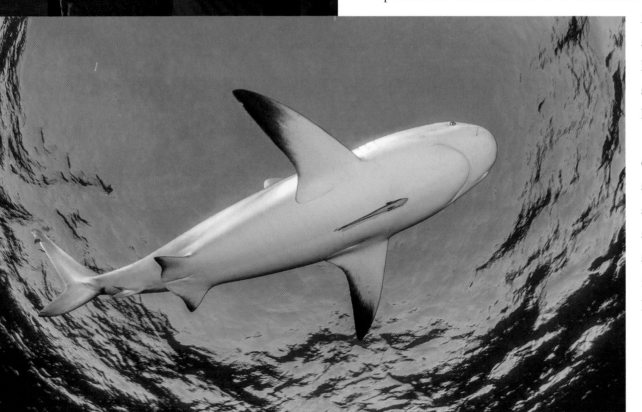

Photo by Spencer Burrows

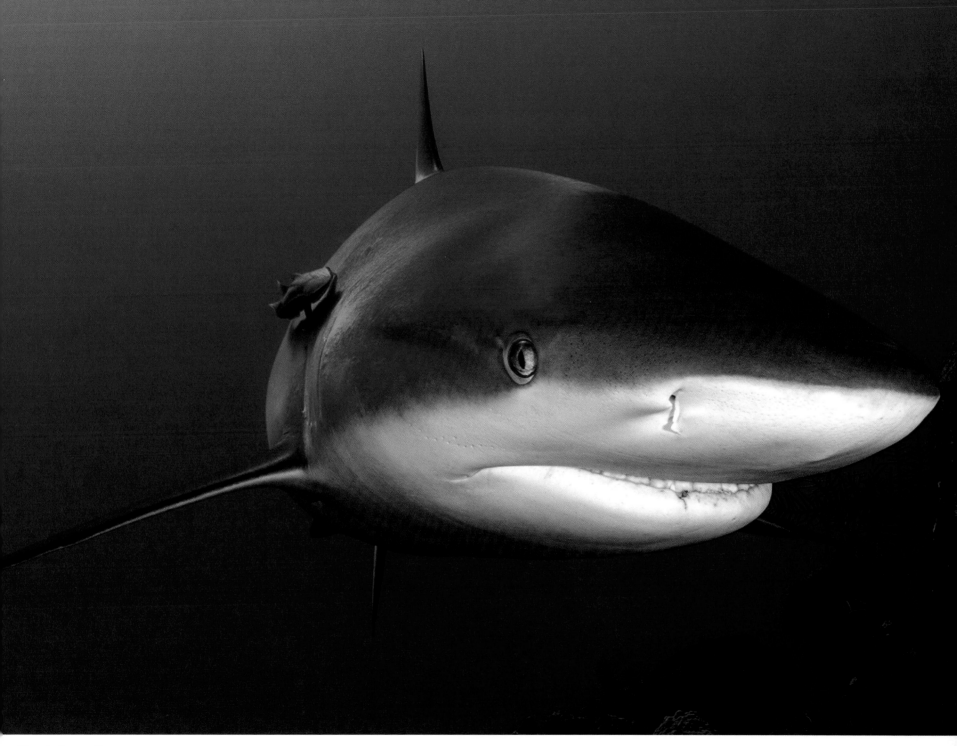

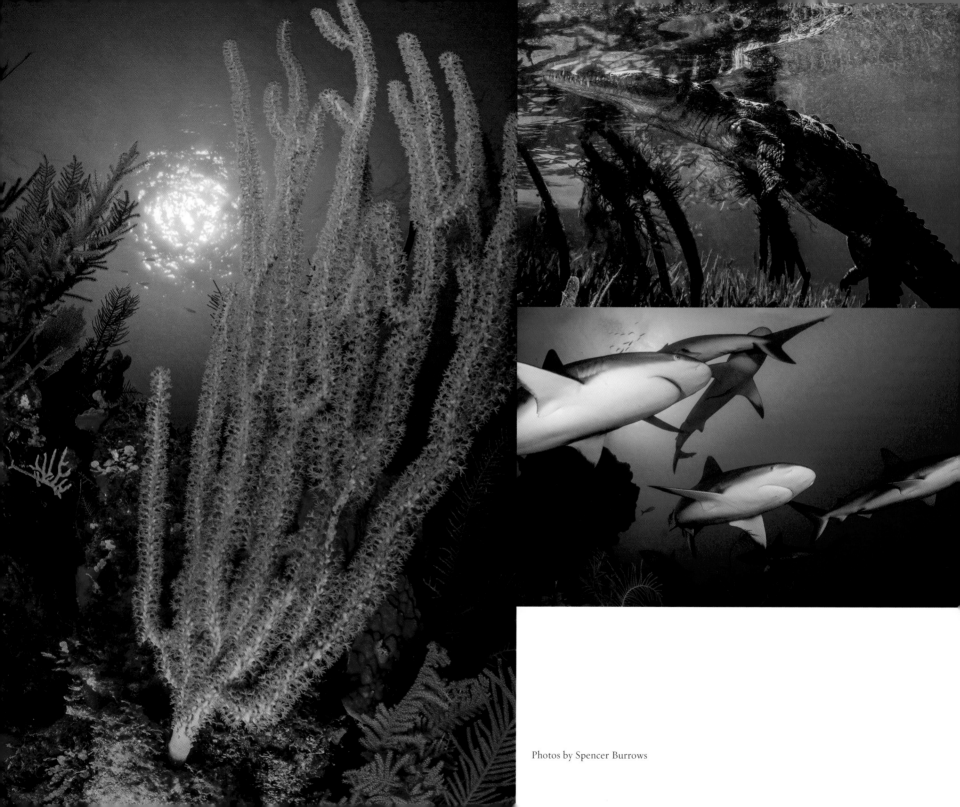

Photos by Spencer Burrows

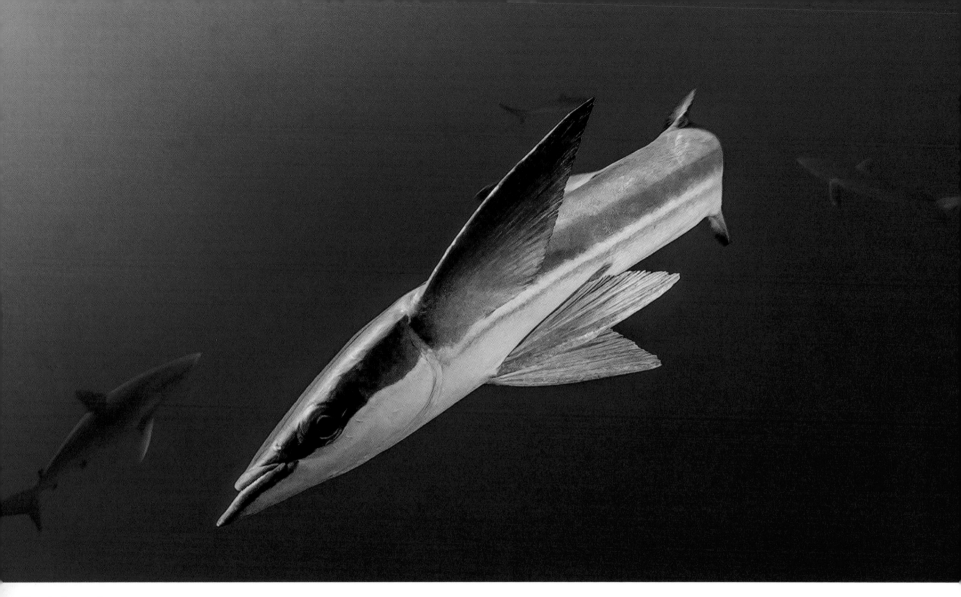

Photo by Spencer Burrows

success—and with an attachable diopter for the dimples and chin whiskers on the teensiest of critters. Spencer proved to be a wide-angle contender as well. Considering his work with the Nottingham Dive Club and its avowal to help ban the aquarium trade worldwide in support of reef recovery and recognition of reef communities, it seemed that his take on Jardines reefs could offer a sample perspective of the next generation—the generation that will take the baton for another few decades before passing it on, or seeing reefs fade away.

The Jucaro fleet needs paint, but the trawlers seem ready to go. But where to? All bottom seine nets were gone by 2014. Weren't they?

Then it was *hasta luego, mi compadres y amígos*. I know tourism. Tourism is a friend of mine. The *Halcón* crew was as good as it gets. On our last night, Miguel gave lessons in the simplest, most elusive step, or not-step, the guaguancó. He humbly accepted a million bucks from America, on behalf of a grateful Cuban nation—and a Snorkel Bob cap.

Farewells at the dock were brief but bonded. The handshakes or nods on arrival had become hugs on departure. Well, of course it's hard not to love a crew who waited on you all week, who cooked and served, who lifted your tank into the water and then back out, to spare an old guy's game disk. But love based on appreciation felt reciprocal. Insights had been traded, progress made, and so the world evolved on values shared.

Heading out with a few thousand shots in the can and backed up twice gave pause on the vicissitudes ahead, with certainty that Cuban customs would once again want to go full cavity. Would it really help to have each hard drive packed in a different bag?

What were the odds on skating through to the gate? But logistical challenges faded as the countryside blended with itself, as a second view of the pastoral beauty and time warp that are rural Cuba gave greater insight yet on the life available here, seeing it again and again.

Our cup runneth over, and the many hours ahead were blessed as well with a random scan of our time on Cuba's protected reefs.

Jucaro catchment cistern—no wonder they boggle at modern camera equipment.

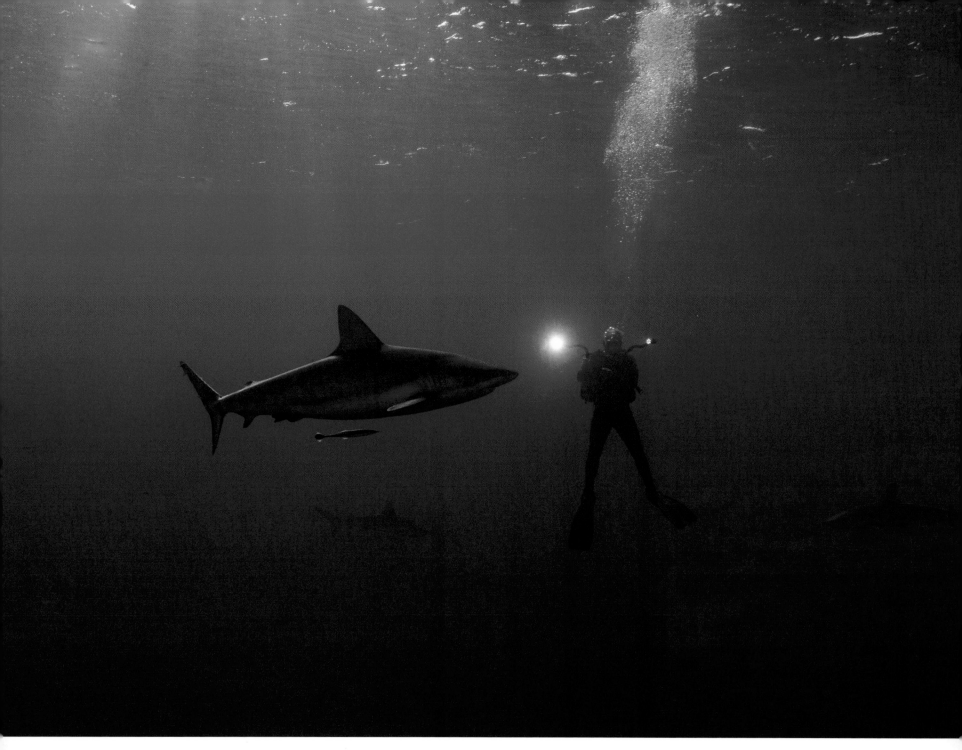

Bubba's Cuban safety stops—not the usual review of the rules.

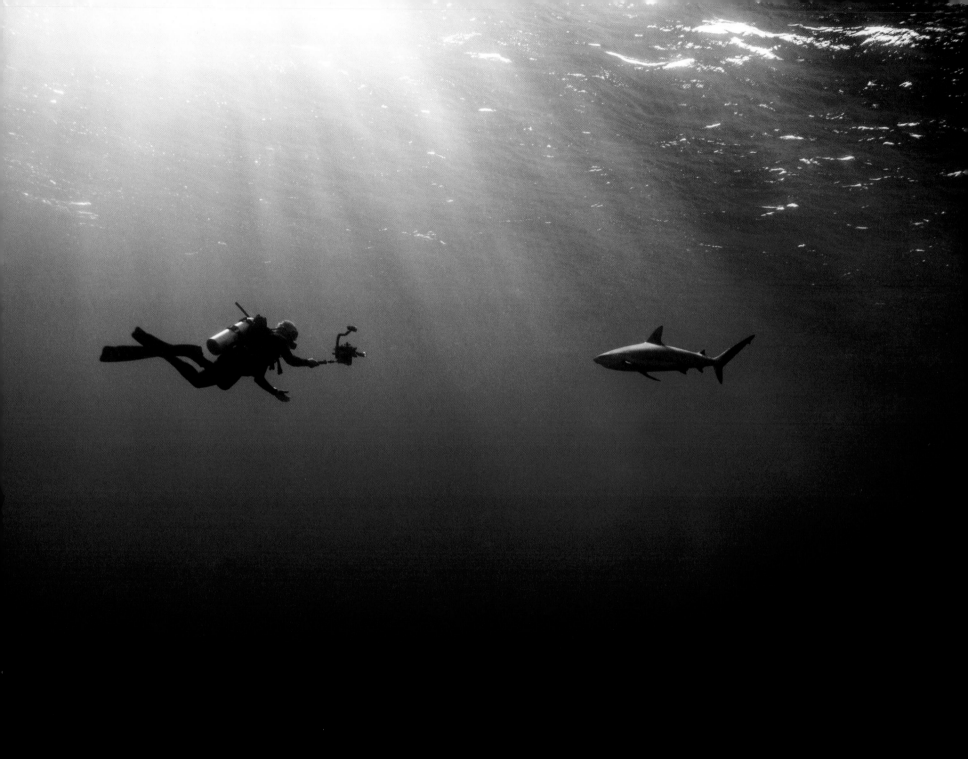

Grunts come in for the face-off.

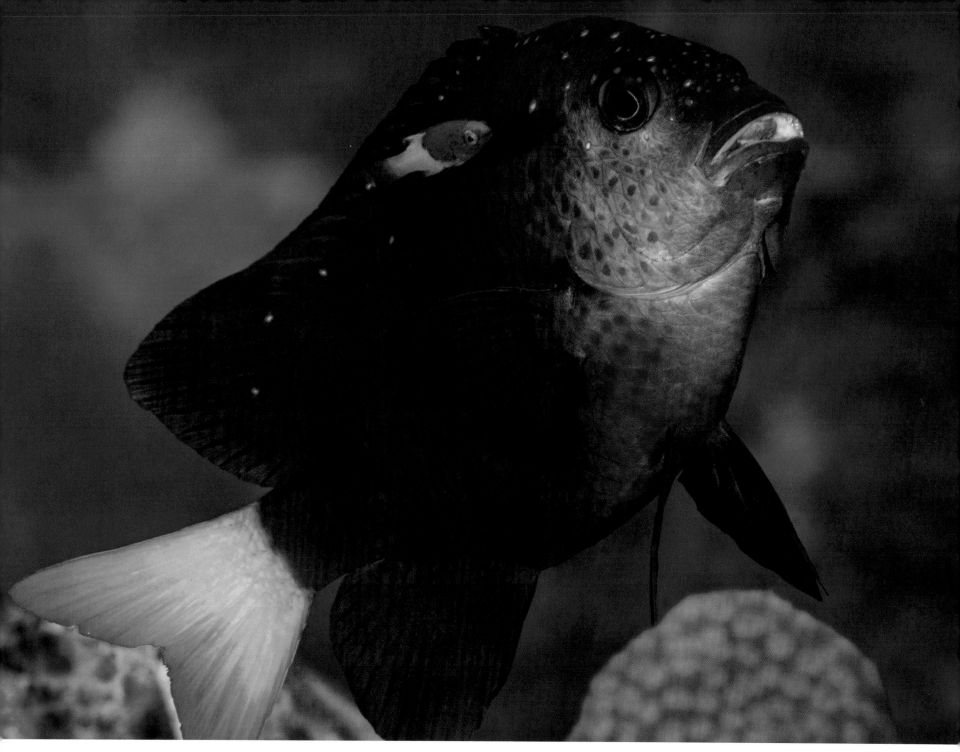

Friends, a juvie Spanish hogfish grooms his great big buddy, a yellowtail damsel.

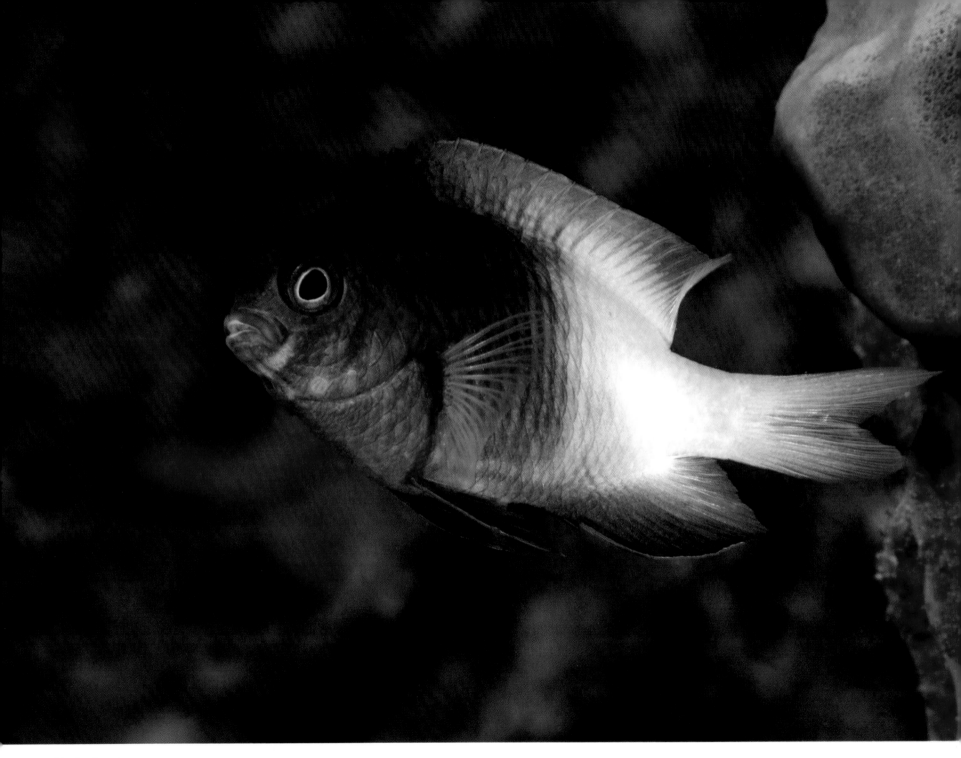

A bi-color chromis.

You know it's hard out there for a fish.

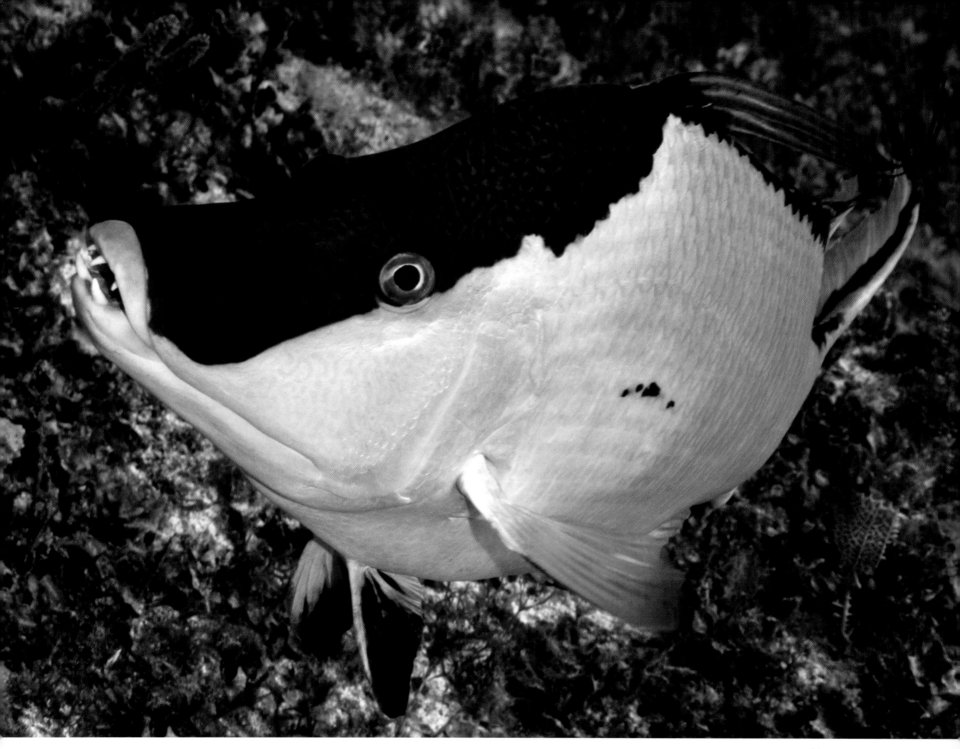

Hogfish.

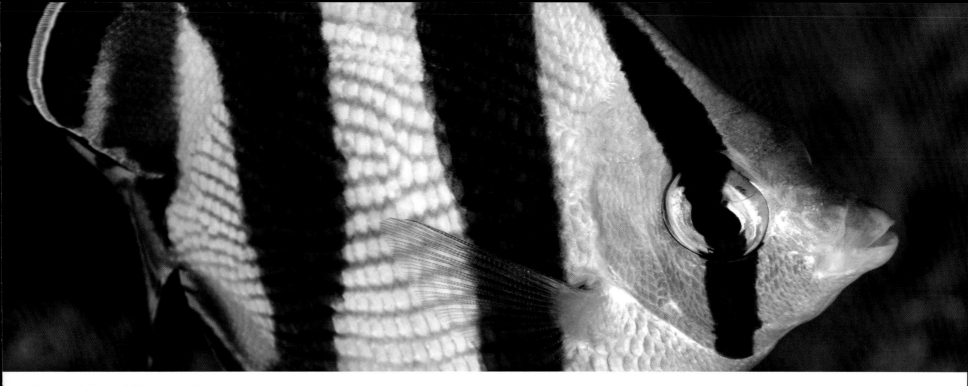

Above, Banded butterflyfish. Below, Cubanita.

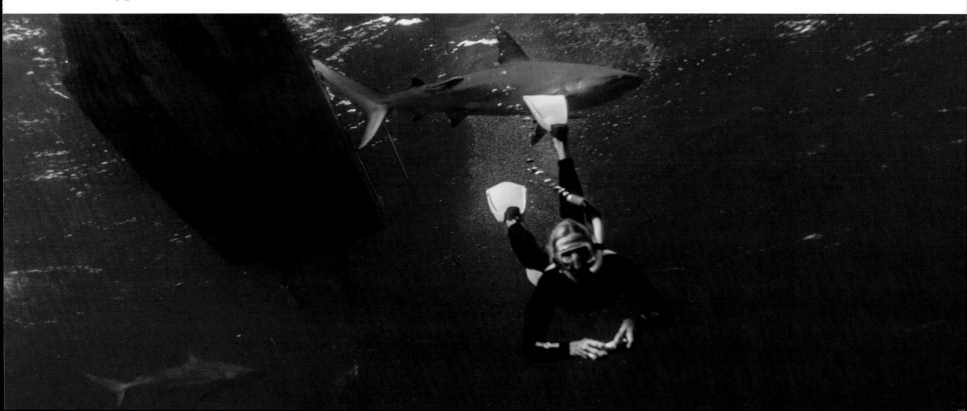

Above, Arrow blenny. Below, Hogfish.

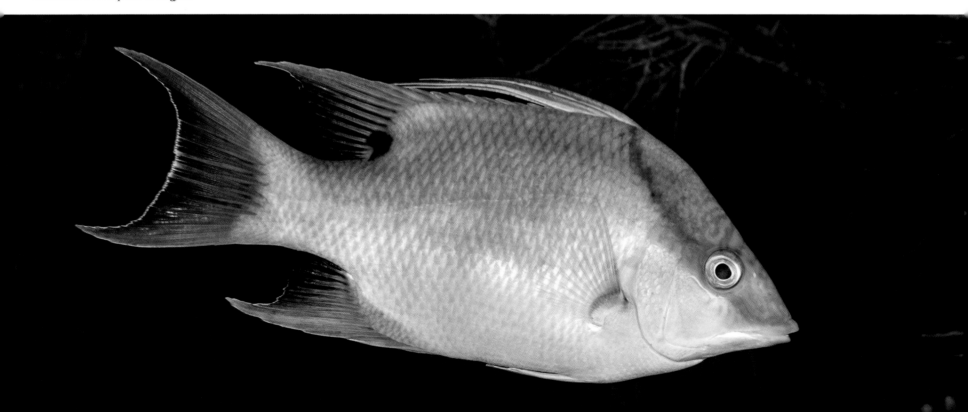

TENGO DOS

In Manuel, the *Halcón* chef, we came to know a remarkably humble man more service oriented than your average person and equally gifted in the *cucina*. Three dives daily required personal energy management and maintenance. Manuel's meals made every day joyful and left a lasting impression on the nature of having and having not, of giving and taking, of loving life to the fullest for its simplest pleasures.

Fast-forward to the end of the week, to weighing anchor and heading out, when all dive bags came down from the bridge for repacking, and a tired, satisfied crowd relaxed in the main salon for the long, bumpy ride back to Jucaro. Manuel saw that a travel/name tag on a dive bag was in the shape and coloration of a Hawaiian reef triggerfish, the sprightly fish with the unique shape known best in Hawaii for the numbers of people practicing its Hawaiian name in the mirror: *humuhumunukunukuapuaa*. In a rare moment of initiating contact, Manuel picked up my cap from where it sat on the seat arm between us, which cap also showed an embroidered version of the renowned humuhumu. Manuel asked, "Is same? Same fish?"

"*Sí. Es la misma. Humuhumunukunukuapuaa.* It's a Hawaiian reef triggerfish."

Without hesitation or doubt, Manuel said, "Humuhumunukunukuapuaa."

He looked at the stitched image admiringly, as if such a fish would be easy to love. He held it closer for a better look, ignoring the sweat stains, salt stains, fading, and wear. Or maybe he couldn't see those things; his T-shirt and chef pants were stained here and there and threadbare. So I grasped the bill near where he held it and pushed it his way. "Por favor."

"No! No, no, no, no, no. Nohhh!" The headshaking and waving off came instantly, as if he'd crossed the line of propriety.

I did not remind him that the hat had been to the moon and back, or that I, Snorkel F. Bob, am the greatest living snorkeler west of the Fertile Crescent, with more hats than a dog has fleas, or that a world of unbound material goods lies just to the north, and in that world I manufacture these hats and can have a new one or a dozen or a gross whenever I want by the simple act of wanting it, or that I can get them in colors and with different fish on the front—mixing and matching the colors and the fish as freely as a kid in an ice cream parlor can mix and match flavors and toppings far beyond fulfillment to the point of puking! . . .

No.

I only paused so he could finish his ablutions to the denial he so fervently felt was necessary, and I said, "*Tengo dos.*" I have two.

His brow bunched as the reality of the situation became reconciled between one world and another, and he asked, "*Dos? Tiene dos?*"

"*Sí. Por favor. Puedes nadarlo.*" Yes. Please. You can wash it.

Wash it? I could have told him the sky was chartreuse or the sun would set upside down. He gazed, stunned as a long-odds winner on the game of life. He took the cap and held it in gentle disbelief, like money brought back from a dream. He stared at it, stalling, I thought, to make sure I wasn't kidding or wouldn't change my mind. Finally, he set it onto his head. He didn't say *gracias*, because he was speechless, I thought. Oh, sure, we tipped the crew, both the boat crew and the dive crew—tipped them through the captain and the dive leader, and I suspected the divvy was less than egalitarian. Never mind; for Manuel the chef to be singled out as recipient of tribute from a passenger appeared to be a crowning achievement. To say that he didn't take it off for the duration of our acquaintance would miss the salient personality changes he appeared to go through. He cocked it, slid it back and again forth, spun it around backwards and in a while turned it forward again. He stood up straighter, and on arrival at Jucaro six hours later with very rough seas behind us, he marched from the *Halcón* onto the dock to promenade up and down, showing off his new self. An old hat never had it so good. And he did say gracias many times once he came to his senses. He shook my hand and hugged me and called me his friend, and I'm confident he still feels that way, and I do, too.

On the looong ride from Jucaro back to Havana, mulling the magic behind us and the journey ahead, we pondered our night in Havana. We wished for more and realized an error in judgment that would prove ghastly: we'd booked a lay day in Cancun for relaxation. The lay day was a good idea but would have been better spent in Havana. Spencer and Sadie shared their Cancun experience that occurred on their way to Jardines, and their exposure to Americans and their whacky, zany zest for binge drinking. "Woo hoo!" Spencer howled. "They wanted us to keep drinking this cheap tequila that you had to throw down your gullet if you were to get it down at all. Then they yelled at us. Woo hoo! We couldn't keep up. Didn't want to, I suppose, but we tried. Woo hoo!"

Sadie said, "They kept yelling, 'Drink! Woo hoo! English! You're our allies! Woo hoo!'"

And so it would come to pass. Surely Spencer and Sadie exaggerated the stupidity and alcoholism. But alas, we would arrive in Cancun the following night for our rude reentry, beginning at the Cancun airport, where many TV monitors trumpeted the adventures of a lifetime in live dolphin pools. We watched the program loop as an old hound sniffed rows of baggage, three times. After an hour of sniffing he peed on a bag, and we were allowed to go—to clear customs and walk outside to join thousands of people jostling for transfers to hotels. They were just happy to be warm and seemed thirsty already. Woo hoo!

Careless that night, we picked an eatery with a big, zany papier-mâché donkey in front. We knew better. The meal was tainted. The waiters, busboys, and barmaids lined up to bleat zany songs. Between songs they worked a tourist table. A plump, gray-haired woman allowed a greasy washcloth over her eyes and a battered sombrero on her head. Tilting her chair back as if for dental work, they stuck a funnel in her gob, pressed a tin pan onto the sombrero, and banged it with a shot glass. . . . Woo hoo!

Holding a bowl of rotgut over her head, they touched the surface with a flame. It flared then flowed through the funnel, into her gob. Woo hoo!

Back to vertical, she didn't choke when the blindfold came away. Dazed, she'd survived her adventure of a lifetime. One chair over, her ancient mother looked anxious—the house crew swooped. Old Mom was heftier, so the tilt was less, with more bending at the neck. Mom also survived, but hand to mouth she leaned forward and sputtered, as if to puke. She reached for something to hold on to . . . but nah! She was fine. Woo hoo!

The house crew turned our way, but if stink-eye could kill they would have been incinerated. A questionnaire on quality, service, and the experience came with the check. Woo hoo!

A great expedition shouldn't end on a shrill note, nor should time and space be wasted as it is in Cancun, on Walmart, car dealers, and miracle miles to make you blush or cringe. Not too far south of Cancun are some beach stops that recall the old charm of Yucatan. The Cancun miasma contrasted harshly to life at Jardines de la Reina, so further insight was available, however difficult. Cancun shouted out its drunken, material immersion, as Cuba had seemed subdued in its decay and deprivation. Many people use Walmart and car dealers and miracle miles, assuring their continuing propagation. Many many.

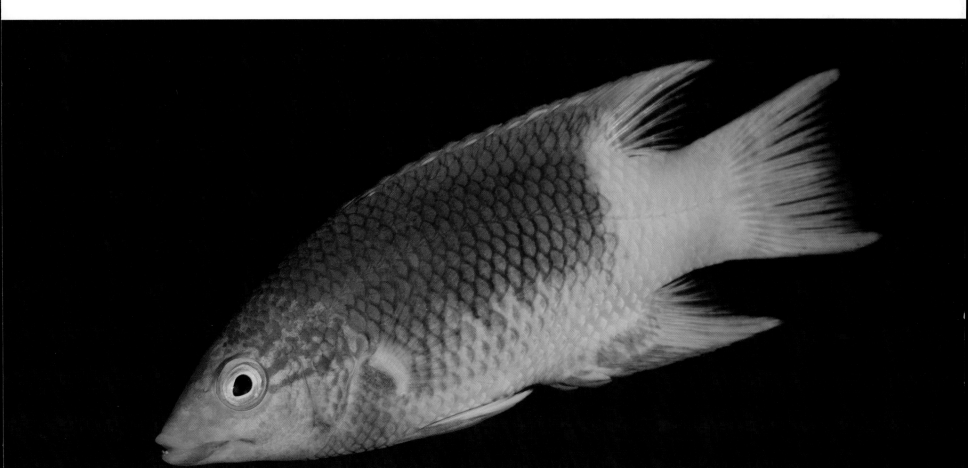

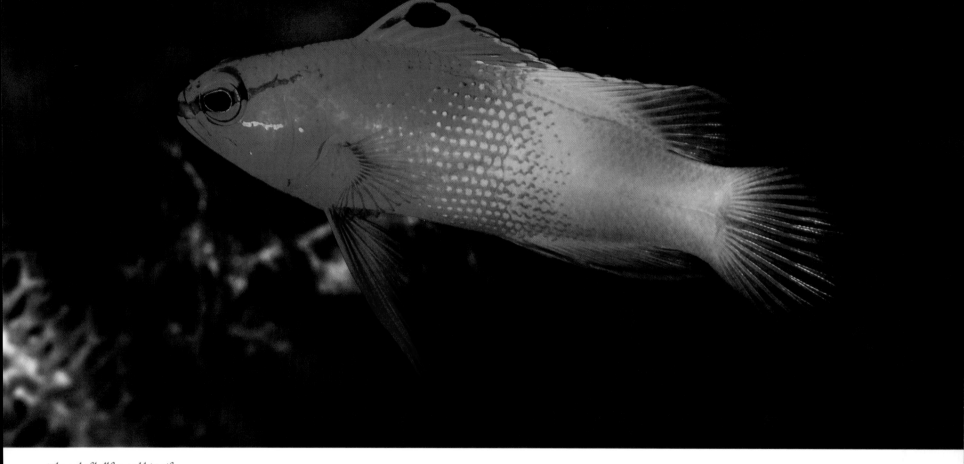

The god of hellfire and his wife.

NIGHT IN HAVANA!

Maybe it was only a night in Havana. But after so many dives, equipment checks, battery charges, grooves reamed, O-rings greased, repairs, do-overs, vitamins, stretches, and miles it seemed luxuriously carefree as a night in Havana! As noted, the Copacabana benefited from an honest refurbishment not so long ago and is not a dump. Arrival at the Iberostar Parque Central, however, is something else. What if Fulgencio Batista had fended off the Castro brothers and Ché, and Havana still had a hot, Latin rhythm? Of course he didn't, but it does. What's the difference? Again, cases can be made for the nature of the differences, from all proceeds benefiting the Cosa Nostra and the Meshpocha Kvetch to all proceeds shoring up the Revolución. The bottom line to a weary traveler who knows the muscle-easing magic of plush bedding, six-hundred-count linens, lobby latte service, and sheer, raw comfort was that this. Is. The place. It was dark but hardly seven, and check-in was turbocharged with service, no bumps, whisking up and away to posh digs where the huge hazard was simply lying down to test softness and give on the massive bed. What would they call this model: California king? No. How about Supreme Dictator? Enough! Already drifting from our moorings, it was time to rise and step out. As Sensei often counseled: Plenty of time for sleep when you're dead!

The opulence and energy of the Parque Central belie political reality. Could the PC be part of a Communist dictatorship? It is, giving rise to further questions. The bottom line yet again is the disposition of the proceeds, and maybe that is the great Cuban question.

Some towns shut down early while others never sleep. Havana is both and the same. Prime time at street level is late afternoon and dusk, the social time of day for a culture with no TV. After sundown, with electricity at a premium, darkness prevails a few blocks from the hotel hub.

A marble promenade across the street from the Parque Central is a small step for rehab but a giant stride for soulful reclamation. This was Cuba and may yet be.

Old Havana begs questions of ideology as it gives way to pragmatism. The Revolución lives! But then so did the frog, even after the princess kissed him. Was he still a frog? Never mind. Most guidebooks tell of ruinous decay in Havana, as time and gravity bear down on buildings and principles. The Revolución yields to exploitation, greed, and corruption, which is no aspersion on the Revolución but on human nature. Calling a country Communist will not change its needs or motivation. A colonial past has its shady side, what any occupying culture will leave behind in the guise of mercy—what is actually a disguise for resource allocation and export. But exquisite architecture has gone to seed in Havana, where it could have served the very people the Revolución has claimed to protect. Well, the cases for this, that, and other will be developed for generations to come. Meanwhile, tourism has planted a seed that germinates visibly in Habana Vieja, in first small steps of restoring the grand spaces.

Another block from the renovated core come dark alleys devoid of

activity. Crime is rare in Habana Vieja, maybe because of the gulag deterrent or a polite culture or a combination. The bottom line on nighttime excursions on foot is to know the destination and how to get there. Getting lost for a few blocks isn't so bad, with so much to see, like examples of colonial architecture that survived and may be candidates for refurbishment and none too soon, some of them plucked from the jaws of *derrumba*.

The pace of rehab/renovation is conjectural, though it seems that many *edificios* were in the same, very early phases of rehab/reconstruction. These projects take a long time, far longer than new construction, beginning with thorough surveys on each building's needs and proceeding to surgical deconstruction. Whatever the pace, it seemed painfully slow, another reason, based on self-interest and world peace, to end the embargo, to accelerate the rescue of Havana's beauty.

Where least expected are the benefits of restoration, ample lighting, open doors, and spaces as generous as those in a high-end art gallery. This indicates tourism beyond germination to well-seasoned roots, reaching for the high demographic. As noted, nearly all products made in Cuba are contraband for U.S. citizens with very few exceptions.

Among those rare exceptions: art.

Getting lost for a few blocks at night isn't so bad and may ease reentry onto terra firma.

A park pavilion covering an entire block, displaying the former grandeur of the Cuban Air Force. A sign in front says, "Don't stay in this area" in English, and security concerns are apparent. The aircraft is similar to the model I built as a boy, of a WWII Hellcat fighter. This bird is likely of Soviet vintage and looked very cool with the Cubano colors on the rudder.

Beyond posh galleries where least expected and paeans to winged intention came more streets and more treasures, like giant castle doors glowing with a time best remembered.

The lights indicated activity, and hunger had thoroughly displaced interest in the artsy fartsy. But what was the name of the place the doorman recommended? And did he say two blocks over and three blocks down or three blocks over and . . . Group travel can be good on a reef expedition, when familiar waterdogs cover each other from all sides, but it can degenerate in the middle of a street on an argument over what the doorman wrote on the map in the dying glow of a tiny flashlight. *Ivan? "Cheff"? Tosh?* No. Wait. We got it wrong. It was . . .

But it didn't matter what it was. Except that anyone who visits the neighborhood will want to know, because it's great fun and great cucina. We ended up finding it by chance, or by the willful leadership of the hungriest among us. Navi was I ere I saw Ivan at the end of the block, more brightly lit than most ends of blocks, with a guy standing in the doorway. "There it is," I guessed. And there it was. . . .

Okay, wait. That wasn't it. It was down another block, but gaining proximity helped immensely. We had the mooring in sight. Ivan's wasn't as bright,

and the door was much narrower with no sign, but another guy waited just inside as if expecting us. Make no mistake: the average paladar knows the value in absolute terms of five hungry tourists looking to dine. That was okay, and a big aloha welcome made things flow, on up the stairway to Ivan's . . . and the cornucopia therein, of a clean, softly lit place of ingenuity, artistry, and good things to eat. Choosing a good restaurant at the end of a rigorous adventure felt like a bonus; likewise, a bad choice would have felt different on many levels. But Ivan delivered, first with good feeling reflected on the walls.

The Hollywood archive seemed to recall the olden, golden times without the corruption—or maybe Stan & Ollie and Audrey and Marilyn were meant to make the place nostalgic and homey. But Cuban love of showbiz, music, and movies goes way back.

Stairway to Ivan's.

John and Yoko practiced a Kama Sutra exercise in pen and ink on the bathroom door—not an isolated tribute but part of a thematic tribute to sympathetic celebs around Havana. John Lennon is favored around Havana for challenging the conventional context of his times.

And the view from Ivan's window told the story of modern Habana Vieja, a mix of colonial grandeur in decomposition and decay, partial rehab, and the verge of *derrumba*.

The golden glow of the place, the great décor and warm welcome—the scent of spices and herbs applied with exquisite skill and prospect for excellent repast from a great cucina was enough to make you forget your cares and woe, not that we had any woe, but an ambitious undertaking fraught with risk, hazard, political and logistical challenge, weather variables, huge carnivorous critters, tired bones, and growing thirst felt finally done. It was time to relax in a world that felt right, except that it wasn't. Delectable as the menu appeared to be, most selections and all specialties of the casa were taken from the sea. Don't get me wrong; we ate. I had the pasta with eggplant and garlic, and felt better, or less guilty. It didn't seem wrong that millions of Cubanos couldn't have these things, but it did feel wrong that seafood should be so abundant on a menu for tourists only. Is that a Communistic sentiment? No, removing fish from Cuba tourist menus would put Cuba on the leading edge of reef redemption around the world.

Cuba's reef management strategy may transcend political systems. The Castro Revolución will endure or end or morph into something else. Whatever happens, Cuba's reef strategy should remain viable, delivering value to the Cuban people, along with natural beauty and another point of pride. Whatever political system prevails, people making policy must factor vibrant fish populations in assessing quality of life, long term.

The pasta with eggplant and garlic was superb, and millions of hungry Cubanos stand a far greater chance of getting some than they are likely to eat what the reefs can ill afford to provide.

Belaboring the point is tempting but tedious and besides, it was time for *espresso y flan* and a leisurely walk back on the night streets of Habana Vieja.

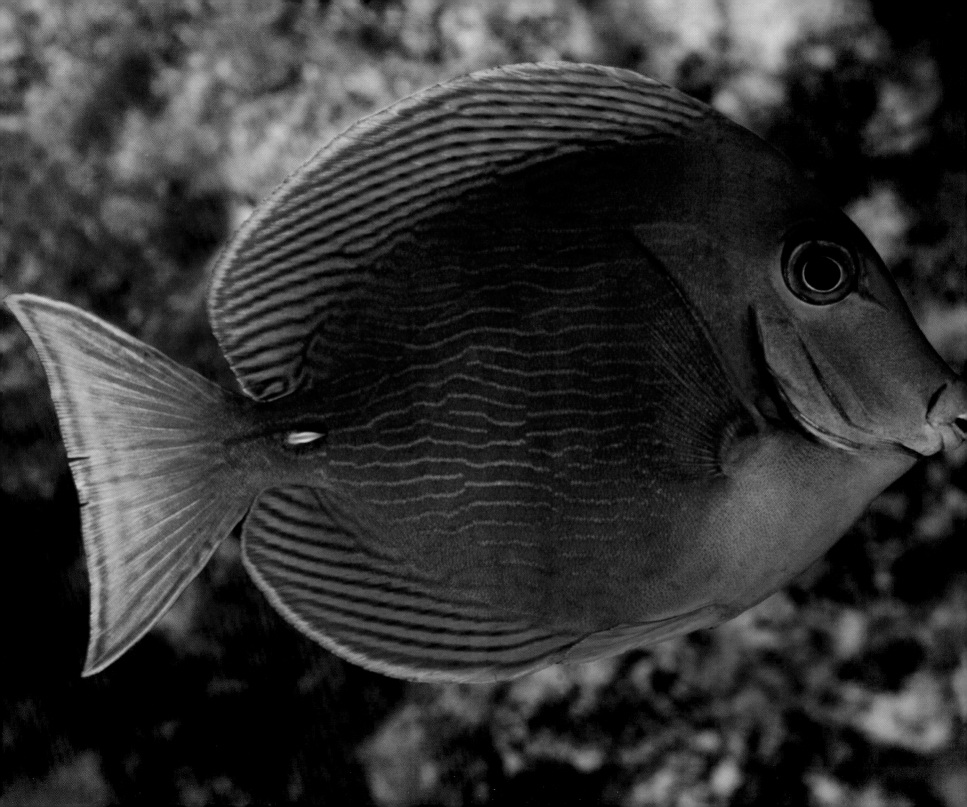

A reef crab is totalitarian dictator of his coral niche, trying to pinch everybody with his pesky little claws. But he's hardly dangerous if nobody's trying to catch him in storm-swept seas.

POLITICAL REEFS

With luck, Cuba's reefs will soon generate moolah of magnitude greater than any return on nets or hooks. With uncompromised reef ecosystems, marginal acidification, limited coral bleaching, no hideous effluent, and no fishing pressure—including no electronic fish-finders that devastate species in other

Queen Triggerfish Confidential: OMG! I'm nearly out of eyeliner! Where's the mall?

places—Cuba reefs will draw, and that draw will benefit the Cuban people. All political systems suffer failure and corruption. All are slave to self-interest. Maybe capitalism fails least because it recognizes greed as primary, calling it softly: the profit motive. The bottom line in any system is that reefs should not be held accountable for political process. Reefs should thrive, but alas, in most places they don't. *If I were king* is a sentiment that usually goes with stalemate. *If I were totalitarian dictator* has yielded a great result in Cuba's reef recovery, enabling a victory of nature over humanity.

As populations increase, suburbs sprawl across the countryside. Economy watchers call it "growth." But every living thing is contained in its growth, sooner or later. A wilderness-values person might visit any Miracle Mile USA and think: *I would not have done that*. Such a person might think most commercial growth of civilization best avoided. Asked what he thought of Western civilization, Mahatma Gandhi said it would be a very good idea.

Which isn't to say that Cuba shares context with India. Both countries are without many modern services, and India squandered its marine ecology on convenient waste disposal, as its population climbed from 448 million in 1960 to a billion in 2000. Up another quarter billion by 2010, it climbs. Cuba's population growth rate is nearly stable, rising from 7 million in 1960 to 11.1 million in 2000 and to 11.26 million in 2010. That is, India's population now doubles every forty years, while Cuba's population grew 60 percent from 1960 to 2000 and stabilized at 1 percent annual growth thereafter. China and the U.S. grow slightly slower than India, though material consumption has the U.S. at number one (!) in landfill debris, with 5 percent of the world's people consuming 30 percent of world resources. Consumers don't care; new stuff is available, packaging is disposable, and the kids are so cute when they *insist* on recycling. The U.S. is third in human population.

Meanwhile, down south, emigration may account for some population stabilization, but while a few émigrés generate media drama, growth rate stability is more likely due to legal prostitution, like in Vegas, and also to readily available family planning and plain common sense. Is the human growth rate situation in Cuba good and moral? Yes. Resoundingly. Look at their reefs.

Human population growth is a measure of local pressure on reefs. Growing tourism will measure outside pressure, and tourism can kill a golden goose. Cuba may have stumbled onto its treasure trove potential, but its reefs will thrive if Cuba's future leaders maintain current standards. Cuba waited decades for revenue and may get it through better reef management and long view than the other reef-rich archipelago in proximity to the mainland USA.

Fidel Castro's ideology and tenure will be his legacy. History will judge the Revolución's fanatical zeal and Stalin-style purges to consolidate power. Raúl may be more pragmatic, maybe motivated by another idea: that adaptation to a modern world might take the edge off the afternoon. When Raúl Castro and the Obama administration eased travel restrictions, Cuban family traffic increased to four hundred thousand persons annually. Travel became plausible. Constraints may ease further as both sides suppress the reactionary reflex.

The Revolución ended free enterprise, political choice, showbiz, and professional sports. Happily for reefs, it also brought fifty years of no industry, no sprawl, no shoreline development, no agrichemicals, and the lowest birth rate of any Third-World nation.

Elsewhere, reefs are in decline. Even the most abundant, biodiverse reefs in the world in the Coral Triangle encompassing Indonesia, the Philippines, Papua New Guinea, parts of Malaysia and the Solomon Islands, Northern Australia, and Fiji. All struggle with acidification, warming, effluent, and overfishing (poaching).

Is Cuba's population stability good and moral? It's good and moral for a redspotted hawkfish.

President Remengesau of Palau called out "the insatiable Asian appetite" when the Palau Congress outlawed the aquarium trade on Palau reefs. Pacific reefs without such leadership suffer aquarium collectors sweeping life away by hand, while food-fish vessels and poachers decimated marine populations, until only small or medium fish remain. Now species disappear, because bigger, older fish spawn far more abundantly, and those fish are gone.

Compounding the insatiable Asian appetite is daily human effluent. The dirtiest spot in the world is conjectural, but a pungent case can be made for Jakarta Harbor, with millions or billions of gallons of sewage dumped continuously, depending on urban delineation on the map, which is laminated in plastic. New York Harbor gets twenty-seven billion gallons of raw sewage each year, and that's some shit, but it seems underreported, given the discharge frequency of so many population centers—or as American TV would have it, major markets and their regularity.

Beyond aquarium collecting, fishing, poaching, and filth contamination, the Coral Triangle is acidic. My camera-housing viewfinder did not fog in Fiji; it got etched and couldn't be buffed. The service tech said, "If you dive Indonesia, Fiji, or the Philippines, you'll get etching."

So the most abundant and varied reef system in the world is compromised and headed in the wrong direction. It's being killed for money. Shark finning accelerates the process. Apex predators do not feed indiscriminately. The food chain is like a corporation, where staff complies with hierarchy. With apex predators removed, the second tier down increases its population beyond the third tier's ability to supply it. Unsupported population increase in any tier will die off from starvation and/or disease. Imbalance follows with species attempting adaptation to maladjusted systems that cannot find the optimal balance that took eons to evolve.

Healthy corals thrive at Jardines de la Reina.

Shortly after the *Snorkel Bob Jardines de la Reina Expedition*, the National Oceanic and Atmospheric Administration (NOAA) campaigned in Pacific population centers, including Hawaii. NOAA wanted to list certain coral species as endangered, and the NOAA reps sought "input from stakeholders": a gelatinous approach to conservation management that is doomed to failure, deferring as it does to the torch and pitchfork noise that any conservation issue will generate in those who exploit marine habitat. So my first question to Dr. Mark Eakin was, "Why do you want my opinion? You think these corals are endangered. We see Hawaii reefs declining before our eyes, so I believe you. So why not put these corals on the list? Besides that, who could possibly oppose listing of corals?"

Dr. Mark Eakin agreed that NOAA's approach to a dire situation was wishy-washy—a shrug, a head wag, a chin jut; he went along with nuance and gesture, like Fausto had done. Dr. Eakin emphasized "community assessment" as integral to policy process, and reef tourism professionals are "stakeholders," so . . .

Yeah, yeah, yeah. It's not so easy to hear the NOAA line when a situation requires urgent remedy and not methodical dilution. Dr. Mark Eakin said he personally valued more aggressive efforts in reef recovery to make a difference sooner rather than later. He gave the nod to Snorkel Bob's for mixing it up, calling spades and identifying problems, and he wished he could speak that freely in public, but, alas, with government funding and policy formulation in the balance . . .

Yeah, yeah, yeah . . . The exercise was predictably frustrating. NOAA had identified three primary causes of coral reef decline globally: (1) coral bleaching as a result of ocean warming, (2) ocean acidification from atmospheric contamination, and (3) toxic effluent. That sounded like banging your thumb with a hammer, then conducting studies, then concluding that the cause of pain in this application was the hammer. NOAA had once again protected the culprits—administrations, corporations, and other sources—attempting "consensus" from an amorphous group inaccurately labeled "stakeholders." Who speaks for the fish?

Yes, yes, yes—he knew this all too well, but with patience we might see policy in a few years that could make a difference. I supported that. How could NOAA bunghole an outing with such low achievement standards? NOAA has often failed, so we would wait and see if support could be sustainable. Mark Eakin seemed well intentioned and smart enough to make a difference. We stayed in touch, and a few weeks later from the Mariana Islands, he confessed frustration with the Honolulu "fishermen." The quotation marks suggest more politics than a line in the water—these guys demand their right to "take back" what is rightfully theirs, as if they're a minority oppressed. Mark Eakin called it grandstanding—without logic, without hope. The Honolulu "fishermen" opposed listing endangered corals on "their" reefs, because they knew best, because listing anything is a slippery slope that would deprive them of what they hold dear. Confrontational and repetitive, that exchange with "stakeholders" proved nonproductive.

On our first meeting I had shared Cuba adventures with Dr. Eakin, and the revelations came clear—he lit up, eyes wider than normal for a government employee, and said yes. He'd participated in two studies with Cuban scientists on the theories supported by our own Cuba reef observations. He forwarded those studies. One said: "The coral bleaching event of 2005 warmed the tropical Atlantic Ocean and the Caribbean Sea to the highest temperatures in 150 years" (Eakin

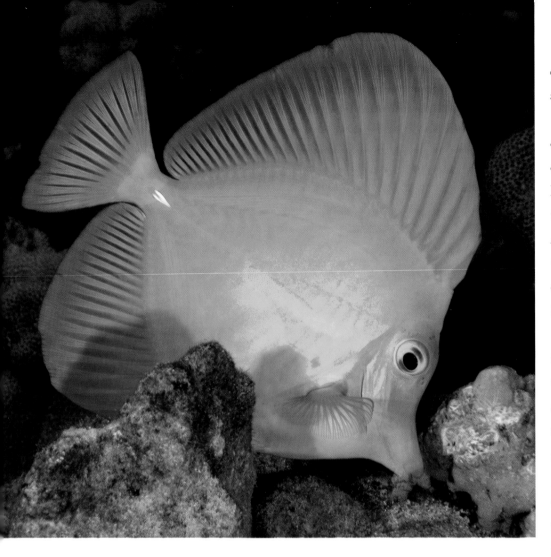

et al., "Caribbean Corals in Crisis: Record Thermal Stress, Bleaching and Mortality in 2005").

Also noted: "Marine reserves cannot protect corals from direct climate induced disturbance, but they can increase the post-disturbance recovery rate of some corals providing that macro-algae have been depleted by more abundant communities of grazers that benefit from reduced fishing pressure" (Peter J. Mumby and Alistair R. Harborne, "Marine Reserves Enhance the Recovery of Corals on Caribbean Reefs," Marine Spatial Ecology Lab, School of BioSciences, Hatherly Laboratory, U. of Exeter, Exeter, United Kingdom 1/11/2010).

Wait a minute! ". . . more abundant communities of coral grazers that benefit from reduced fishing pressure . . ." That would be yellow tangs in Hawaii—the most devastated species as targeted by the aquarium trade. Likewise in the Caribbean, the blue tang—same model in blue—appeared in optimal abundance on Cuba reefs—no aquarium extraction.

These studies included Cuban scientists and concluded: *with sharks in place, species will double*. That's biodiversity, what reefs are losing around the world. Previous data had predicted a loss resulting from more predators at the top of the food chain, and that loss would trickle down—"trophic cascading." The prior theory was that more big'uns would obviously eat more little'uns. But the cascade never happened. Balance happened.

Dr. Eakin noted another recent observation from the Cambodian killing fields so riddled with land mines that no reasonable human would walk there. Cambodian minefields have for years claimed limbs and lives. But with no human traffic, other species considered extinct for ages began to reappear. Unfortunately, their reappearance was discovered in Cambodian meat markets, where demand for rare bush-meat is strong and supply is priced at a premium. So human traffic is back at the killing fields with the worst consequence, that those species are vanishing yet again.

But the dots continue to connect. . . .

Some observers will call Cuba reefs a fluke, a serendipitous discovery with no correlation to the ill-advised, impractical, totalitarian dictatorship that has ruled since '59.

How could Communism lead to redemption in nature?

No studies show a correlation. However, Communist foibles do show a pattern and a path to natural redemption. To wit . . .

The 1986 Chernobyl meltdown in the Soviet Union released radiation equivalent to four hundred Hiroshima bombs, displacing half a million humans from 150 villages. Those villages remain deserted, crumbling in ruins. The 1,100 square miles around the Chernobyl reactor still show fifty times normal levels of radiation in the soil.

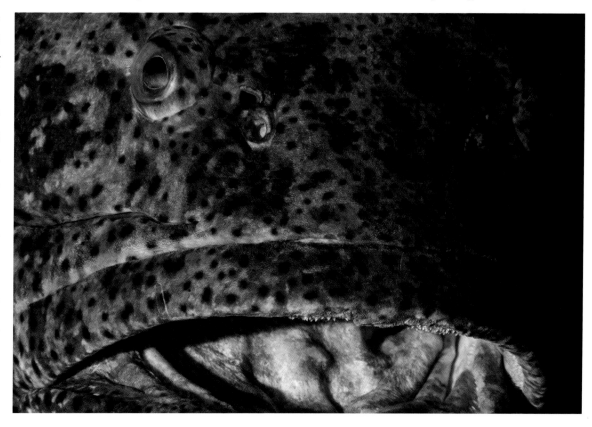

The PBS TV program *Nature* covered the "exclusion zone, unfit for human habitation." In the 1920s, the young USSR was better organized and funded than Cuba, and with no U.S. blockade it applied Communist principles across the countryside with brutal efficiency and supply-side emphasis on food production. Centuries of deprivation under czarist rule motivated new focus, so the wetlands, forests, and streams around Chernobyl were clear-cut, dredged, rechanneled, and drained to better implement the collective farm system and full production—to feed a hungry nation. The plan succeeded famously in the short and midterm, creating the Soviet breadbasket—those 1,100 acres of wetlands and forests were converted to wheat fields.

Here again the Communist system did not weigh pros and cons. No debate slowed the agricultural thrust, just as current rain forest clearing makes room for food crops and grazers in the Amazon basin. The Chernobyl breadbasket was such a solid demonstration of Soviet wisdom, they built a nuclear power plant at Chernobyl—never mind safety measures, backup systems, and fail-safe technology. They were on a roll.

Following the '86 meltdown and the futile efforts of 600,000 (yes, six hundred thousand) emergency workers trying to "clean up" the area, the exclusion zone was cordoned off; no human effort could remove radioactivity from the vegetation and soil of 1,100 acres. Once the exclusion zone was abandoned, things began to change—or rather to change back.

Wildlife rebounded with dramatic increases in amphibian, insect, otter, beaver, shellfish, waterfowl, and fish populations. The pond near the reactor is now home to catfish eight feet long, not mutants but catfish achieving maturity because humans don't catch every fish before it's grown. Big mammals rebounded, including moose and bison, though bison, indigenous since the Ice Age, were wiped out in the 1920s and reintroduced in the 1990s to rebalance the natural system. Three major bison herds thrive again in Chernobyl's exclusion zone. So does the last species of wild horse in the world—the last horse in the wild was killed in 1879 but the horses were also reintroduced in the 1990s. They thrive more tentatively, with growing threats from poachers, though the horses' radioactive home and diet may solve the poaching problem.

Wolves led the rebound. A theory prevailed: that more abundant prey attracted these apex predators from farther afield, and extreme levels of radiation kept wolf populations under control. The studies and TV program demonstrated that theory as wrong. The radioactive wolves of Chernobyl are an indigenous population returning to optimal numbers in a naturally balanced ecosystem because of no destructive human behavior. The Soviet breadbasket is gone, returned to floodplain conditions and wetlands restored far sooner than anticipated because of a thriving beaver population. The beavers dammed the waterways and rechanneled canals while feeding the wolf population that kept the beaver population in check. Other apex predators returned and also thrive, with eagles and falcons both dependent on wolf kills as a meat source during winter months when the freeze prevents fishing.

Just like Jardines de la Reina, seemingly unrelated events resulted in wilderness redemption by simply allowing apex predators to return.

In her travelogue *Enduring Cuba*, Zöe Brân seemed more or less disappointed in discovering that Cuba was a beautiful dream gone awry. Those of us who admire reef society have lower expectations on terra firma. But among Ms. Brân's strong points was the vainglorious excess recurring in 1946, when Lucky Luciano entertained Meyer Lansky in Havana—where the Italian mob met the Jewish mob. By then Franklin Roosevelt's advisors had long encouraged Fulgencio Batista to keep up the good work of keeping Cuba stable. Those powers-that-were in '46 watched that Havana Christmas from both sides of the Gulf, as Luciano closed the Hotel Nacional to the public so 1,600 guests could eat spiced snails, lemon-flavored tortoise, breast of flamingo, garlic crayfish, venison, and manatee steaks. The menu came from a similar feast a few centuries earlier, for historic value, though Frank Sinatra sang at the '46 engorgement.

How perfect could it get? Those were the days of unlimited nature—hundreds of years of days when nature was to eat. Even at that, the menu seems oppressive. Then again, eating something exotic equates with adventure for some people, like the TV geek with the pro-wrestler haircut who eats scorpions

and seahorses deep-fried on skewers. That's not culinary or adventurous but another dog 'n' pony spectacle at the expense of wildlife, another bad example of humanity rendering nature into sewerage. Few Cubans eat seafood, yet it dominates many paladar menus because tourist dollars are top priority. If reef redemption is so integrated to Cuba's values, then why are fish served carte blanche to tourists? How far down will the beaten path of tourism get beaten in Cuba? Smoke and toxin still foul Havana skies from petrochemical products imported from Venezuela, Iran, and other countries willing to defy the U.S. embargo, and sewage treatment is as ill repaired as any Cuban utility. Reef recovery may be tentative, subject to continuing filth that still skewers values in Cuba. Then again, sewerage and skewerage threaten all oceans.

Fulgencio Batista attempted the same presumption and arrogance proven "successful" to those in power in Cuba for centuries. The Revolución changed that but bogged down short of victory, except to share the deprivation. Whereas poverty in Cuba was select before the Revolución, now everybody in Cuba has the right to be poor. Irony verges on pathos when cabdrivers are upwardly mobile, part of Cuba's separate economy, exposed to tourist tips. Most Havana cabbies have their stories of advanced academic credentials and full-time university work that pays nothing. One cabby said his university professorship paid 240 Cuban pesos per month. Twenty-four Cuban pesos equal one Cuban convertible peso, or CUC. He rambled in a compelling, articulate narrative that sounded like a playback for every fare with tip potential. Which is not to begrudge his potential or his means but to point out the challenge at street level. The Cuban people seem happy, but they are not content, and they are outspoken. So said the cabby: "Raúl is different. It will change. We cannot live like this." He got a $5 tip, about two weeks' wage at university scale.

The Revolución is a blueprint for a dream construction, but the house was never built. Reasons abound, but the main excuse is that the contractor and materials were blocked by the U.S. embargo. That seems a stretch, but accuracy is incidental; what matters is the excuse that the embargo still provides to the Cuban government, though it provides no benefit to the U.S.

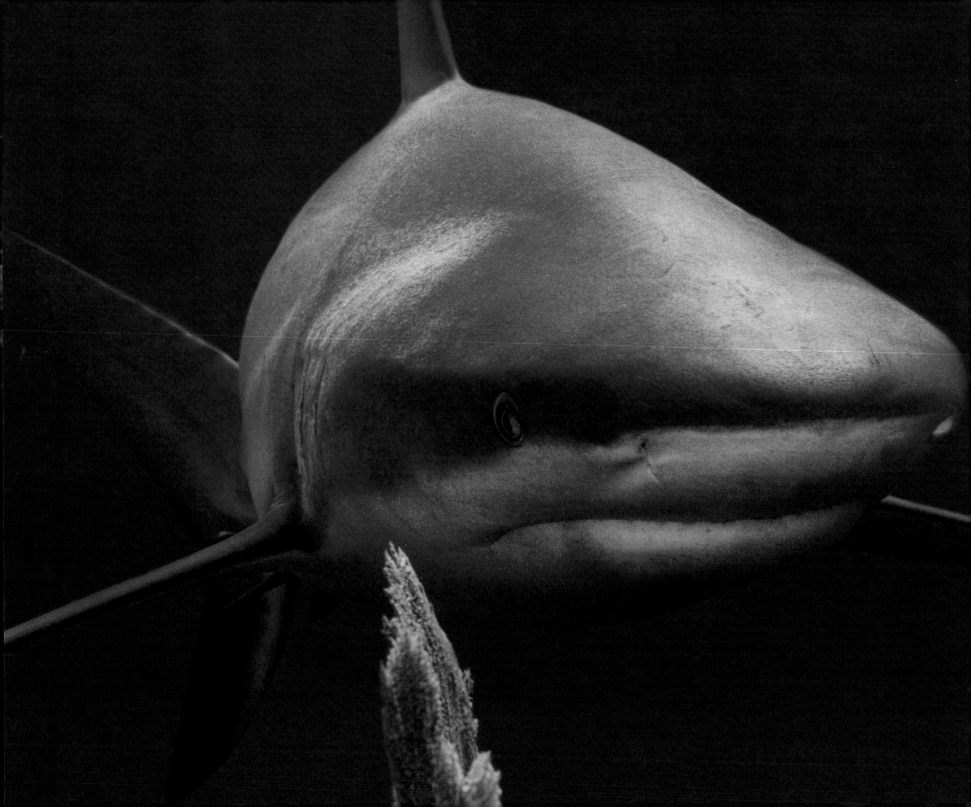

THE OLDER MAN AND THE SEA

Although Fidel Castro's image is rare in public places, he does show up from many angles on books and postcards, often with boyish, playful Ernesto "Ché" Guevara. Ché's grin is a theme, reflecting his spirit, his great good humor, and the happiness derived from the mischief he could make—ho boy, he could really piss off some *capitalistas*. Fidel, on the other hand, appears less humorous and more of a dilettante and policy wonk, evidenced by his excruciatingly long-winded diatribes on TV. Fidel did bask in the limelight like a showbiz veteran in one shot, surrounded by an admiring crowd, shaking hands with Ernest Hemingway. Hemingway had won the Nobel Prize by that time and had become larger than life, both by design and media exposure. Castro and Hemingway met eye to eye, each glowing with destiny and fame, each approving the game spirit of the other.

The Hemingway International Billfish Tournament is still annual in Havana, in deference to the validation Hemingway granted Cuba, before and after the Revolución. Hemingway moved to Idaho after, but he'd already left the Nobel Prize in Havana, saying that it belonged to the Cuban people because of their soulful place in *The Old Man and the Sea*.

The tournament continues because of its historical significance, even as such tournaments grow old and impractical, passé and cruel. Hunting big game and then aping for the photo op is ignorant, oblivious to vanishing habitat and the paucity of big game as well as blind to both nature and public sentiment. Beyond moral perception is the old joke that "sport" fish ran about $400 per pound, all told—that was with fuel at pennies per gallon.

And now we know the value of apex predators. We know their limited numbers and the long odds on superior individuals reaching maturity and their dwindling numbers and the mean-spirited stupidity of slaughtering them. Hoisted by her tail to show her immense size and former power next to the fisherman, the dead billfish served to revere the fisherman for his cleverness and mighty skills. It still happens, under one guise or another, usually with insistence that the hunter or fisherman was motivated by love, only love, and paid generously for the privilege to kill, or something. The Hemingway tournament is now catch and release, though big marlin and sailfish cannot be brought to a boat without compromise, and every waterman interviewed in Cuba agreed that many released billfish die soon after, making the tournament contradictory to recent conservation efforts all around the Hemingway tournament. The Hemingway tournament, like all big game hunting in any format, fosters a foolish notion that death with honor is good, true and good, with nobility intact. Nobility is what the photo op derives from the big game, after the sportsman has taken the big game's life.

Here's how fast and how far the world turns in a single lifetime these days: When I got older than Ernest Hemingway was when he died, I sensed that he stuck a shotgun barrel in his pie hole and whipped up a ceiling chiffon because he'd realized what he'd missed and what he'd done wrong. Profound regrets come to the best of thinkers and artists. I read that he actually set the gun butt on the floor and pressed the end of the barrel to his forehead, but

that account is burdened with the same accuracy that oppressed Hemingway at the end. His dramatic points were not accurate—they were true and good and fine, maybe, and then they were magnified in adoration, adulation, reverence, and misperception. But they were wrong. Hemingway was wrong, and in the end may have realized it.

Hemingway wrote of superiority to nature lest nature outgun him. The kill must be good and clean, or nature would make a man dead or prove his weakness. Hemingway didn't allude to a man's failure as rendering him a pussy, but that's what he meant. That's what he feared.

A few scenes in Hemingway's last novel, *Islands in the Stream*, 1961, depicted Hemingway's failing as he and nature fell from grace, both used up, commercially and prosaically. In one scene he met a land crab on a narrow trail, requiring one of them to step off. The land crab was huge by crab standards, but hardly bigger than a size 10 shoe. The land crab waved a claw in a defensive posture or display of prowess. Ernest saw it as a challenge and mockery of his own greater posture, and he, Ernest Hemingway, was packing heavy heat. And a man must do what he doesn't want to do. And the land crab insisted, though clearly outweighed, outsized, and outgunned. He stood his ground—the land crab—waving the claw. Ernest had no choice but to blow him away, according to the tenets of nature and Hemingway's humanity.

Another troubling scene had his sons swimming and frolicking over a reef while Ernest had a drink with his trusted rummy friend who represented loyalty in the clutch and no fear of death. But the trusted rummy also feared failure. His alcoholism and sun-creased face defined him, his only prospect to hang out and drive the boat for Ernest, who was hardly ever around. But that's what a man may come to, a good man, strong and true, and it was a gift—a mark of friendship and strength among men. The rummy bestowed that gift on Ernest and his sons, bonding with the men among them, old and young, strong and resilient, despite so many shortfalls. These values played out on a soulful backdrop until the scene changed when a marauder swam through the cut in the fringing reef and came into the shallows, approaching the innocent boys. It was a shark, a predator bereft of manly bonding, its dorsal fin cutting the surface like a knife and its intention underscored a few years later in the movie version with sinister music. Worse yet, its hammerhead seemed grotesque as Quasimodo's hump.

The scene was predictable, with the shark coming on for some tender boy-lunch and nothing left for it but the old rummy, Ernest Hemingway, and a gun. The old rummy fired a few times and either missed the mark or hit the shark too far underwater. The old rummy was a good man and true, and his heart was good, but he had the shakes from too much rum. At the last gasp Ernest took the gun and killed the shark, stunning the boys, the rummy, and himself in another moment of bonding, survival, failure, backup support, each other, and so on.

Maybe Ernest realized not too long after writing the land crab and the hammerhead shark scenes that he'd believed the truth of those scenes, that they were good scenes and true, scenes to clarify the context of humanity, land crabs blocking a trail, and predators.

He may have realized soon after that something was wrong. He may have been terminally macho for ages, and the jig was up. He had no choice, wrong or right. Hemingway's machismo and simplicity intersected like crosshairs on the only shot remaining. It was a true shot, which will always be a good shot, if you can make it.

Islands in the Stream seems jaded now, a caricature of quick-fisted men and their exploits with guns and women. Drinking and fishing have lost their depth over the years. But a kid is ever eager for the world of adventure, with action and tropical potential. Hollywood made the movie fifteen years after the book came out. I wasn't a kid anymore, but some lusts linger for ages.

I've visited New York a half dozen times with an average stay of five days. That might sound like a sparse sampling, but that frequency and penetration may be greater than the average New Yorker has experienced in the tropics. Five days was plenty, verging on claustrophobia with inescapable masonry, metal, flesh, and movement, especially in the Park, where mayhem lurked with no motive. But I always had a great time, intrigued by the tough love so integral to human contact in the city.

I went to see *Islands in the Stream* in '77 during its release in New York. The theater was packed for a Saturday matinee, full of New Yorkers uncertain and murmuring as each tropical scene came up on the big screen. A few viewers blurted doubts on the perfect azure beauty, the simple life on shimmering seas:

"They don't have that!"

"Get outta here!"

"It's the neighborhood!"

And so on, as if the hub of the universe precluded anything so superior, like blue sky, clear water, palm trees, balmy weather, no taxis or subways. The point came on a key scene when the young son hooked into a blue marlin. Marlin have suffered "big game" status for ages, and nobody applied more pressure than Ernest Hemingway, equating a fish's death with a measure of manhood. White marlin, striped marlin, and sailfish are also killed frequently to measure something or other, but the greatest macho measure is taken in big marlin. Blues most often weigh in at three hundred to fifteen hundred pounds, though the big fish are now extremely rare. The biggest on record was eighteen hundred pounds, a very elderly female with a brood survival rate exponentially greater than that of a smaller fish, because that's how it works with fish. Female blues are two to four times bigger than male blue marlin, but all the particulars pale as the fish pales from blue, green, blue-green, turquoise, gold, red, orange, yellow, and so on across the spectrum, fading to a weaker pulse, going gray as the fish surrenders life to the gaff, the billy club, and the payout: stringing up by the tail for the photo op. The big fish hangs dead as the angler stands nearby in a demonstration of manhood. Or, these days, real womanhood. Some dead marlin go to prisons as inmate food. A few are smoked. The rest go to the landfill. Atlantic blue marlin are now endangered.

Back to the movie: it's a beautiful balmy day on board under blue skies over blue water with plentiful bonding as the fellows drift on the Gulf Stream when the big reel squeals. All eyes turn to the young son on deck. He comes alert and straightens his posture in the fighting chair to better his chances for passing the test of manhood. Can he hang on and kill the fish to prove himself a man? Or will he pussy out?

The young son cries but doesn't let go, proving that he's not a pussy and maybe today he will kill this fish and be a man.

The fish runs out and back in, pulling all manner of fish tricks to deprive the lad of his passage and finally settles directly under the stern of the boat.

The drama intensifies with the young son's hands bleeding (just like Jesus?), his face sweating, muscles cramping. The kid whines and groans until pleas burble from his mouth. The old man watches, unable to assist in the rite of passage, according to the rule of the sea.

We don't get an underwater shot of the big blue with a big hook in her mouth, but that was decades ago. Neither the movie nor the book could weather the vicissitudes of reality over the years. The movie won't likely be remade, because nothing could salvage the dramatic point except the fishy POV on animal rights and the needs of natural systems we've learned since then. But that wouldn't leave much room for rum and guns.

Meanwhile, back in a New York theater, the rite of passage for a boy and the anguish of a huge creature suddenly ceased. In a prelude to denouement, the line went suddenly slack. Disappointment washed over the boy and the father. Manhood must wait, even with so much blood and sweat spent. But the boy rose in the fighting chair as the fish rose to the surface and beyond. Symbolically huge, this big marlin scared the snot out of popcorn-gobbling minions and warranted the budget for the huge mechanical effigy. As if that weren't enough, the camera zoomed very close to the fish's bill, head, gills, pectoral fins, and body rising, rising, rising. Would it never end? The boy, his brother and father, and the trusted rummy ogled skyward in awe of the power and manhood potential—and so it rose. . . .

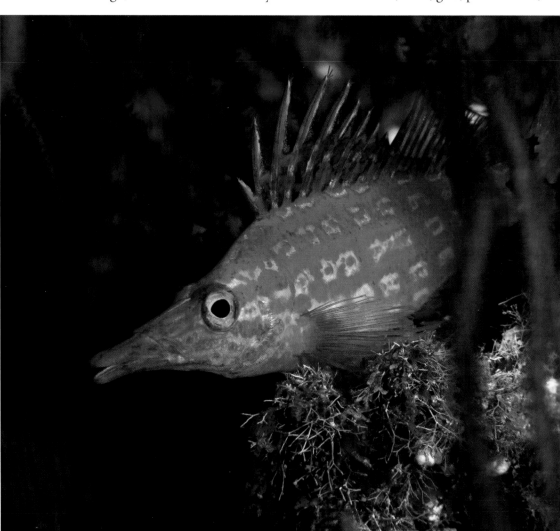

Also rising one row up, another boy's voice cried out, "What is that? Is that a fish?"

His young pal replied, "It's not a fish! They don't got fish like that! It's not a fuckin' fish!"

Finally the fish fell with grace away from the boat instead of on top of the boat, as if it knew to spare those men and boy-men because of their loving superiority. The first boy concurred with his pal: "Fuck! They don't got fish like that!"

Then many other movie watchers concurred, murmuring doubt, skepticism, and acceptable phrasing to form consensus:

It's not a fish.

They don't got . . .

Fuck.

Longnose hawkfish at 60 feet, Moku Hoʻoniki

As characters in books often say, I didn't go back for years.

And I didn't miss it, but I thought of it not so long ago on the way over to Moku Ho'oniki, an islet, or more of a big pinnacle or small seamount off the south shore of Molokai in the Pailolo Channel. Sea life and habitat is abundant on the slopes of Moku Ho'oniki. Hammerheads cruise there. I was armed with a hundred five millimeter—not caliber but lens. Macro, to be sure; call me a hardhead. I wanted small critters most of all. Hammerheads would be rare and would come in whimsically, maybe. If they approached, I'd be ready for some dimples and chin whiskers or a compelling close-up of the eye at the end of the leading edge. For years common belief in Hawaii was that longnose hawkfish could only live below a hundred feet or a hundred twenty. But that's because the black coral divers took all the longnose habitat to those depths to satisfy the marine curio trade. Black coral thrives at sixty feet at Moku Ho'oniki, and so do the longnose hawkfish.

On around, the slopes level onto rubble and sandy bottom at 110 feet. Three hammerheads cruised along the bottom, not too casually, so maybe they were hunting benthics like flounder or stingrays. We stopped to let them see us and accept our presence. They cruised on in. Raising my camera slowly and slower still, because strobe arms rising can threaten, I put my eye to the viewfinder, waiting for the distance to close on the pass-by at four or five feet. In they came till I pressed the shutter release button halfway, seeking focus, engaging the tiny motor with its tiny whir below the audible range of humans but within that of fish—and they spooked, took off like a shot for the depths.

Ah, well, I thought. *That's showbiz.*

I loved Ernest Hemingway. Any description of anything he ever did that says good or strong or strong and good seems like satire, and so it is. I love Hemingway's sparse prose and remarkable action and solitary love of nature. Like many boys, I wanted to be Hemingway but lacked the foresight to get an introductory letter to Gertrude Stein or anyone who ruled the literary roost. For decades I thought Hemingway less than true for playing the system that way, which was neither true nor good. Nor strong. I cut him slack now and admire him for playing the system and avoiding the gadabout world in favor of the tropics and the mountains. His errors in judgment were monumental, yet he captured his time like few others, and it's easy to see his grand error as a gift, to better facilitate the learning process, to teach what we know now.

Beyond that, anybody can be perfectly wrong, and most people are, sooner or later. Ernest achieved so much with so many eyes upon him that what would have been common foibles in a lesser being were bound to seem exaggerated in him. He crafted a dramatic spirit so artfully yet was proven wrong in his own lifetime. The reconciliation of art and life is different than the political processes ongoing in Havana and Honolulu. Both seek long-term, material gain, yet the process emanating from Havana gives reefs a chance, and the process in Honolulu does not. While the process in Havana may yet succumb to greed and political gain, it begins with intellectual honesty. The process in Honolulu, on the other hand, is not honestly wrong but egregiously, corruptibly wrong with profound repercussions. Giving lip service to righteousness can be dismissed as easily as Marxist rhetoric can be laughable, but that lip-service deference also twists a spirit so wrongfully that it compounds the damage. Things get personal, because people care about reef vitality, and in a reef

A classic '57 Bel Air ragtop shouldn't stand out in Old Havana but it does; concourse condition is not as soulful as the old runners. It looks shiny and new as an urban sophisticate in a high-end niche. Say what?

community, they see who lives on the reefs and how reef dwellers get along. Calling fish monstrous, inanimate, or good for the pet trade is different than calling for Hawaii reef stability. It's the difference a few decades can make—a good and true difference. A few greedy bastards should no longer be able to monetize a public trust.

Will Cuba default to greed and corruption as well? The Revolución may well be over, maybe with a few benefits attributable to the Castros. The Iberostar Parque Central Hotel in the heart of Havana with five-star service is in ultimate deference to bourgeois decadence. Cubans who live in the basic economy—the peso economy/nontouristic—cannot enter the premises, but they can see and feel what goes on inside, can watch the privileged few come and go.

A barista in the lobby with impeccable manners and a service-oriented smile prepared a café con leche in the orthodox tradition, pouring the espresso over the steamed milk. He jiggled his wrist just so on the last dark smidge, scripting the foam to read:

PC

That would be Parque Central, surrounded by heart-shaped dips in the foam. It's over.

Bring in the clowns.

The movie "Finding Nemo" took a devastating toll on anemone clownfish worldwide, including total removal from a section of the Great Barrier Reef open to the aquarium trade for three days. Those fish were mostly doomed to ten-gallon tanks. Aquarium hobbyists prefer wild-caught to captive-bred clownfish, because the wild-caught are so agitated and entertaining. A clownfish breathes easy in Palau, free at last of the aquarium scourge.

FINITO, FOR NOW

Ocean acidification and coral bleaching are global, but huge government agencies tiptoe through the tulips instead of naming culprits and stopping the carnage. The National Oceanic and Atmospheric Administration (NOAA) is hugely funded to manage these things. But NOAA is in the U.S. Department of Commerce, making its priorities commercial, its perspective arcane. NOAA should be part of Interior, but it's not. The thirty thousand staffers at Commerce include some solid conservationists, but the lost opportunity is monumental.

Take NOAA's recent studies of coral health and biodiversity. Funding many marine biologists resulted in hypotheses, experiments, data, and conclusions that coral bleaching events and Caribbean reef decline are attributable to (1) warming, (2) acidification, and (3) toxic effluent. This tiresome process begs the obvious, and though the obvious is now proven, the process supports further delay and obfuscation. The process supports commiseration on what's wrong, with no fingers pointed, no fines levied, and no change.

Take NOAA funding for Brian Tissot, PhD and defender of aquarium trade extraction around the world—that's twenty-five million reef critters annually. NOAA granted Tissot $90,000 to study the effects of fizzing on marine species captured at depth—$90,000 after thirty years of research on aquarium trade damage to reef systems. The aquarium trade calls fizzing *venting*, to better distance the practice from the fizzing sound of a fish's air bladder when it's punctured with a hypodermic needle. Fizzing is meant to reduce mortality after capture with another trauma. If a person or a fish rises too fast from depth, external pressure decreases dramatically. Innards bulge out the mouth as eyeballs pop out of sockets. People and fish die. Fizzing pierces the swim bladder while the fish is grasped. For years fizzing was covered up or ignored; it was a fish, after all, hardly a critter we'd come to know on a personal basis. Now we know better.

Nonsurgical, nontechnicians most often perform the fizzing. Fizzing is time consuming and therefore expensive. But they give it a go to preserve "inventory." Many aquarium hunters dispense with fizzing to expedite transport. Brian Tissot, PhD, said, "We will show that fizzing is helping to save fish. And if we find that they're doing it wrong, then we'll show them how to do it right." I paraphrase but stand by Brian Tissot's unequivocal defense of the marine aquarium trade. "I love my aquarium. It's relaxing. It allows me to forget the worries of the day." That was on the *Laurel Neme Show,* where Brian Tissot greenwashed the aquarium trade, a last vestige of trafficking in wildlife for the pet industry. He and his cohorts have studied aquarium trade damage to reef systems for thirty years to no avail. They are vested in the aquarium trade. What is a scientist without a problem to study and funding to study it? These vested "scientists" will study the aquarium trade for decades to come, if they can get funding, as reefs decline and species vanish, because reef ecology is secondary to job security. Nero fiddled as Rome burned.

Self-interest, money, and power won't go away. Fidel Castro's short order sprung Cuba reefs from the jaws of human consumption. Cuba's shark populations went from staple food source to total protection. Meat fishing ceased at Jardines, and Cuba reefs are recovering. Pollution, effluent, poaching,

overfishing, and the aquarium curse of misplaced lionfish are effectively contained in the thousand square miles of Jardines.

That Fidel Castro dove with a spear and fished with a hook doesn't matter. That he was a predator or a waterman doesn't matter. Motivation becomes secondary to results: Jardines thrives while many reefs around the world exist "sustainably," declining at acceptable levels of destruction. Jardines reefs demonstrate what could occur around the world. Fidel or Raúl or the next leader of Cuba will continue leveraging reefs into tourism revenue just as a huge oil rig drills the seabed near Havana Harbor with the goal common to humanity forever: moolah.

Reef advocates would prefer reef management based on love. But practical results are better than grant funding as a smokescreen on sustainable extraction and more funding to demonstrate greater sustainability. Trafficking in wildlife for the pet trade is not sustainable. Species genocide is not sustainable, and reefs should not be managed in a commercial context. We may never separate commercial interests from *pono* (PO·no) values. Pono is a Hawaiian word commonly rendered as "righteousness," as in the Hawaii state motto: *Ua Mau ke Ea o ka ʻĀina i ka Pono*—The life of the land is perpetuated in righteousness. Still, we pursue a pono process.

The Cuban government in transition has established a righteous pattern that may endure. Whether "sustainable" development will compromise Jardines de la Reina remains to be seen. What is now most evident is that key players and policy makers at Jardines are reefdogs of the first order. Fausto De Nevi said, "We will fight for Jardines. We know how to do that."

Many others will fight alongside. In Cuba, Hawaii, or wherever necessary we will assist reef habitat and species so that Neptune lives, wilderness endures, and righteousness is more than lip service cast in stone.

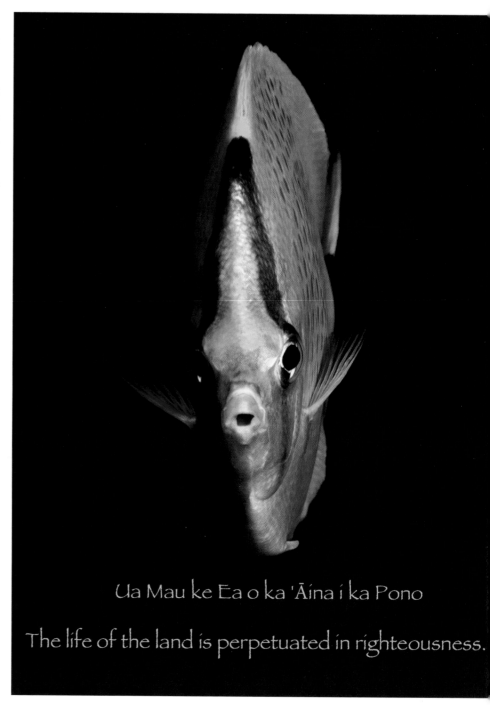

Ua Mau ke Ea o ka ʻĀina i ka Pono

The life of the land is perpetuated in righteousness.

The long flight home to Hawaii entered the U.S. where it left, at the Dallas/Fort Worth Airport, where customs and immigration are open and easy as the land of the free, home of the brave. What a top-heavy load of political/social input, facts, figures, counterclaims, opposing stats, evidence, indications, and of course data to sort through and weigh in the balance. Except that once again, none of it matters. They have their brand of corruption. We have ours. The good guys at U.S. customs waved us through with familiar smiles, a quick eye scan, and the occasionally muttered, "Welcome home." Most passengers on the flight had been to Cuba. Nobody cared.

But the reef campaign took on new fervor in light of what was learned, what seemed possible in a free system. Hawaii reefs are not a bread-and-butter issue like jobs, education, unions, and taxes, because they're taken for granted. Yet as Hawaii reefs go away, they gain recognition. Isn't that the way it goes? We returned to litigation in process, whereby Earthjustice, a public interest law firm, was suing the State of Hawaii for issuing aquarium collection permits that enable voidance of any given reef for the commercial pet trade, *with no data on the environmental or cultural impact of that extraction*. That's not lip service. That's action, flying in the face of the data dogs for hire and their grant-funding cottage industry. Three decades of studying the aquarium trade is no more than playing footsies with a devastating commercial enterprise, helping to sustain another year or two of funding.

This challenge may have federal consequences. To wit: Brian Tissot, PhD, exemplifies the data industry, with research designed to deliver results. Big Tobacco data *proved* no link between smoking and lung cancer, just as Brian Tissot's data supported a foregone conclusion (Tissot, "Trouble in the Fishbowl: Making the Aquarium Trade More Sustainable," 2011 Society for Environmental Journalists).

More sustainable wildlife trafficking for the pet trade suggests that not as much reef habitat will be destroyed, not as many reef fish will die, and not so many reef species will disappear. Brian Tissot, PhD, on fizzing:

Using a previously funded project [Tissot and Stevenson, 2010–2011, NOAA Coral Reef Conservation Program, $49,200] we began data collection to examine conflicts among resource users on Maui. During this first visit we discovered serious user conflicts between the dive industry and the ornamental trade that had virtually eliminated the trade on Maui. Because there was no fishery to study we focused our efforts on the scientific issues surrounding the conflict, which revolved around inhumane aspects of collecting, transporting and holding fish. Specifically, the Maui County Council passed an ordinance that made it illegal to vent or decompress reef fish that had been collected at depth, a de facto method of eliminating the trade. As fish come to the surface the decrease in external pressure causes their swim bladder to expand and result in internal injuries. To minimize these potentially lethal effects, fishers routinely pierce the swim bladder of the fish with a hypodermic needle to release internal pressure and/or to decompress fish by bring[ing] them to the surface gradually. Since the ordnance [*sic*] was not based on any data we decided to pursue the issue in a new study.

Tissot's "user conflict on Maui" omitted Maui residents, host-culture practitioners, a host of tourism professionals, and many conservation groups who loathed the aquarium boats voiding near-shore habitat and damaging coral in a de facto execution of Maui reefs. Brian Tissot, PhD, proceeds to facilitate commerce over conservation through NOAA funding, *proving* that fizzing saves fish, which is a bit like proving that methadone is a health product—if you're a junkie.

Brian Tissot, PhD: "The work is ongoing but preliminary results show very little mortality or sub-lethal effects in any fish subjected to venting and decompression."

NOAA funding proposals continue with:

Claisse, J., W. J. Walsh* (see below), I. Williams, B. N. Tissot, and. D. Pondella. 2012–2014. Impacts of fishery management strategies on the population biology of valuable coral reef fishery species. Hawaii SeaGrant program. $68,200. Not Funded.

Munday, E. 2011–2013. Effects of venting and decompression on coral reef fish in the aquarium trade in Hawaii. NSF Graduate Fellowship. $30,000/year for three years. Not Funded.

Spitzack, A. 2011–2012. Experimental test of resilience in coral reefs in Hawaii. Khaled bin Sultan Living Oceans Foundation Grad Fellowship. $35,000/year for three years. Not Funded.

Tissot, B. N., and E. Munday. 2011–2012. Effects of venting, decompression, transport, and holding on coral reef fish in the aquarium trade in Hawaii. NOAA's Habitat Conservation. *$90,000. Funded.*

Tissot, B. N., and A. Spitzack. 2011. An experimental test of resilience in coral reefs in Hawaii. NOAA's Habitat Conservation. $70,032. Not Funded.

*W. J. Walsh is the head of Hawaii's Division of Aquatic Resources (DAR) in Kona, hub of the Hawaii aquarium trade. He defends aquarium extraction, until recently under his former boss, natural resource director Bill Aila, a professional aquarium hunter who pulled the fourth aquarium permit ever issued by the State of Hawaii, who maintained strong ties with the aquarium trade. The administration responsible lost the last election—the first time in state history that an incumbent lost.

Walsh also depends on taxpayer and grant funding to further study the trade. Though declaiming any opinion not supported by data, Walsh often proclaims, "The aquarium trade is Hawaii's most lucrative near-shore fishery." William Walsh has no economic credentials. His business experience is limited to a T-shirt printing company he ran before heading the Kona DAR.

Brian Tissot presented "The Aquarium Trade in West Hawaii: History, Science and Lessons Learned on Maui" in 2010. In two minutes he dismissed an aquarium trade ban in Hawaii as a fringe idea. In the next two hours he reviewed twenty-five years of management research on the trade and prospects for continuing research to make the trade "more sustainable." Brian Tissot lives and works in Oregon.

Likewise, a big nonprofit conservation outfit from Washington, D.C., sent a fellow to Jardines just prior to the Snorkel Bob Expedition. Not an experienced diver, he spent considerable journal space on personal feelings relative to breathing underwater, ending with: "Many of the fishes I see here look familiar. It's a shock to realize that the prettily colored species floating in your dentist's aquarium are actually wild creatures."

Hallelujah! At last, with advanced degrees in one hand and massive funding in the other, we may wake up and smell the detritus.

Do you suffer the itch and burn of inadequate funding?

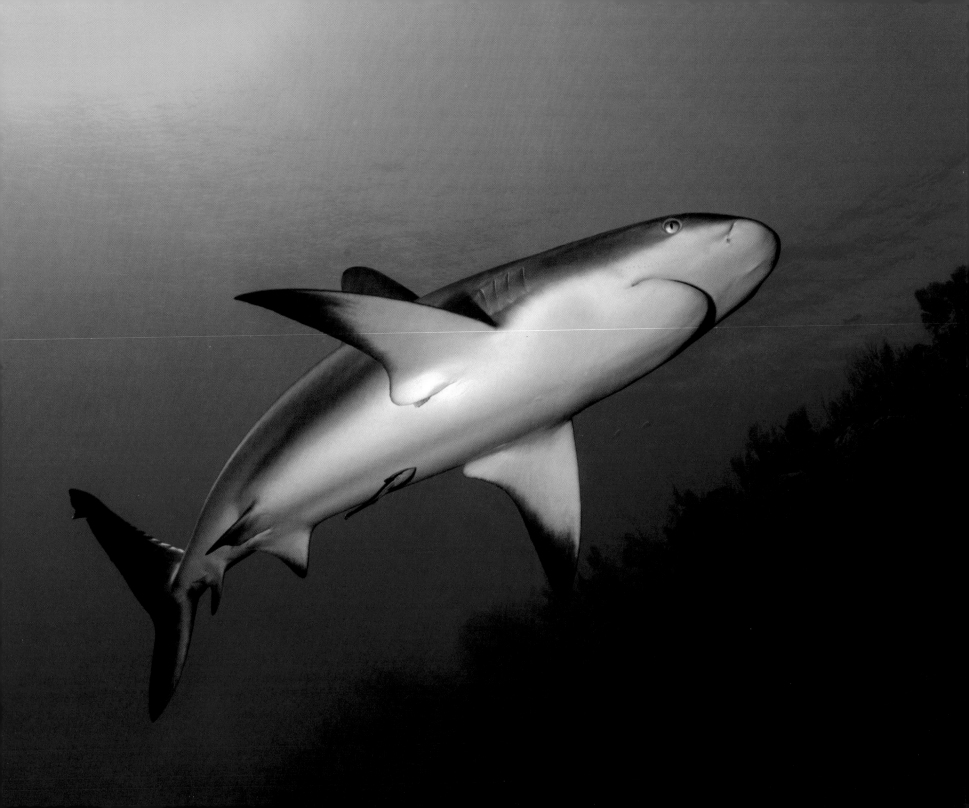

ABOUT THE COVER

The title *Reef Libre* draws on the name of the cocktail, *Cuba Libre*, made with cola and rum, lime juice optional. *Reef Libre* is in tribute to every man, woman, and child in every country of the world who loves reefs and would free them from ruinous extraction and defilement.

Cuban exceptionalism borrows from a notion widely circulated recently, that Americans are exceptional, because. The sentiment may be true but ends abruptly, without specifics. The concept here applies to reef recovery efforts in Cuba.

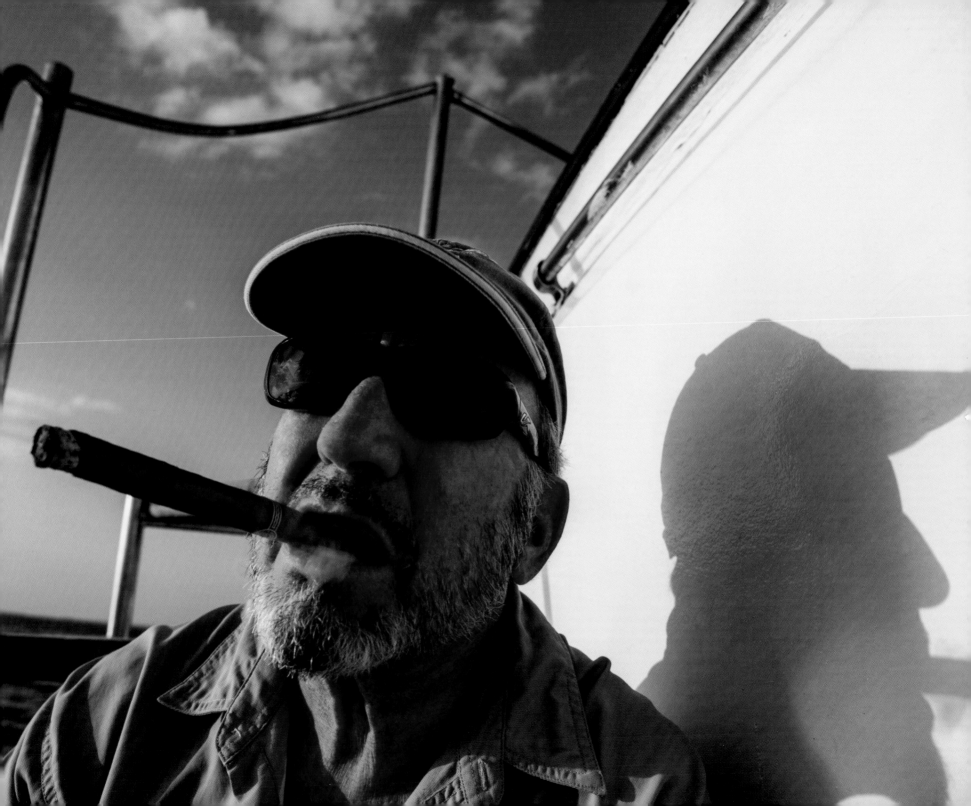

ABOUT THE AUTHOR

Robert Wintner is the *nom de plume (et de guerre)* of Snorkel Bob, Himself, founder of Snorkel Bob's in Hawaii—the only designer and manufacturer of world-class masks, fins and snorkels in Hawaii. He is on the front lines to ban the aquarium trade around the world, because it's all one reef. Among notable breakthroughs is the MoflO2—the world's first fresh-air snorkel, because you'd rather breathe deep in a forest than in an elevator.

He has authored many novels, short story collections, and reef photo books, including two recent memoirs. *1969 and Then Some* recollects a golden era and the lingering influence of those times on daily life, values, and decisions made decades later. *Brainstorm* is a memoir on cerebral aneurysm in the family and the difficult resolution between, on the one hand, a medical system based on secrecy and heroic efforts, and, on the other hand, a couple who resist treatment until the medical establishment allows them a voice in the process.

INDEX

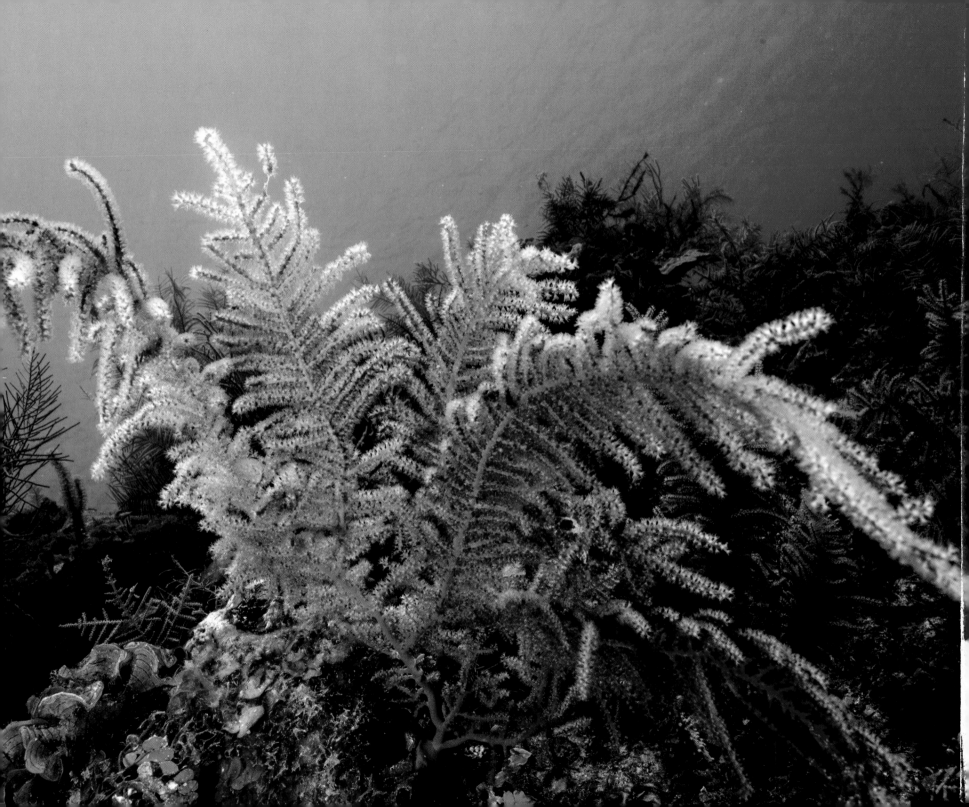